ROMAN ART

A Modern Survey
of the Art of Imperial Rome

by

George M. A. Hanfmann

W · W · Norton & Company · Inc ·

New York

Library of Congress Cataloging in Publication Data

Hanfmann, George Maxim Anossov, 1911–
 Roman art.

 Includes bibliographies.
 1. Art, Roman. I. Title.
N5740.H3 1975 709'.37 74–30063
 ISBN 0—393—09222—4

Published simultaneously in Canada
by George J. McLeod Limited, Toronto

PRINTED IN THE UNITED STATES OF AMERICA

 4 5 6 7 8 9 0

CONTENTS

FOREWORD

The purpose of this book is to put into the hands of the public a selection of pictures of Roman art which would present some of the major creative achievements of Roman artists. Ten times the number of works illustrated would not exhaust the possibilities of the subject. We are only beginning to arrive at a stage when the thousands of works of art which the Romans left on three continents will be appraised within the framework of an art history of the Roman empire. From this point of view, the selection made in this book is still somewhat Rome-centered but I have not felt that I could legitimately exclude acknowledged masterpieces in order to do justice to the arts of the Roman provinces.

Within the limitations set by the scope and size of the book I have tried to take into account the many advances which have accrued to our knowledge and understanding of Roman art by the great surge of new discoveries and the impressive advances of research. Such aspects of Roman creativity as Roman urbanism, Roman architecture, Roman portraiture, and Roman sepulchral arts have been decisively re-appraised in penetrating studies undertaken by the present generation of scholars. While much remains to be done, the subject of Roman art is acquiring new excitement as new vistas are being opened upon a field which is and will remain basic to our understanding of Western civilization.

The book was begun as a sequel to *Masterpieces of Greek Art* by Father Raymond V. Schoder, S. J. I am grateful to Father Schoder for generously making available from his own photographs some of the illustrative material used in this book. A number of color pictures were taken especially for this book by Mario Carrieri, well known for his work on the UNESCO Art Series. Thus it was possible to try to do justice to the works of pictorial arts by reproducing them in color. Exigencies of book planning have made it necessary to keep comments on the black-and-white plates relatively brief. By including some basic facts and some references to major discussions of the pieces, I have sought to give the reader an opportunity to proceed to a more comprehensive acquaintance with Roman art.

My colleagues Herbert Bloch and Mason Hammond have kindly responded to my queries on a number of problems but should not be held responsible for any shortcomings my work may display. I am grateful to the many directors and curators who have supplied photographs and information. Ingeborg Sonn, Urte Ermisch de Reyes, and Philippa Dunham Shaplin have done much of the spade work for the book. I owe a great debt to G. Burton Cumming, Director of Publications of the New York Graphic Society. His patience and understanding have been exemplary.

A sabbatical sojourn in Europe presented a welcome opportunity to check most of the color plates and descriptions before the originals.

Author's Note for the Paperback Edition

In order to reprint *Roman Art* in a more economical format, it was necessary to print the color plates of the original edition in black-and-white. The publisher has consented to add some pages so that the Bibliography could be updated. With the help of Janet Dockendorff and Ursula Pause-Dreyer, I have tried within the limited space available to add items useful to students. Bibliographical references marked with an asterisk following the captions have been expanded and brought up to date in the Addenda at the back of the book; the numerals correspond to those of the illustrations.

The decade since the appearance of the original edition (1964) has seen many discoveries and a flood of publications, but I will mention only one debate which seems to affect fundamentally our concept of early Imperial art – the contention that the 'baroque' sculptural creations such as the exciting Odyssey scenes in the cave of Sperlonga and the famous Laocoön were made by Rhodian artists not in the Hellenistic age (second century B.C.) but under Nero and the Flavian emperors (54–96 A.D.). Arguments for this view have been set forth by P. H. von Blanckenhagen ('Laokoon, Sperlonga, und Vergil,' *AA* 84:3, 1969) and R. Hampe (*Sperlonga und Vergil* [Mainz, Philipp von Zabern, 1972]; reviewed by A. Herrmann, *Art Bulletin* LVI:2, 1974, pp. 275–277). The issue is not yet settled.

Otherwise, the introductory essays seem still valid. The thrust of the book was in the illustrations and commentaries; I had hoped the selection might prove useful for teaching. This seems to have been the case. Now in smaller format and at reduced cost the book may become more readily available to students.

List of Illustrations
Identified by Arabic Numerals

Portrait Statues

9

11

List of Plates

Identified by Roman Numerals

13

INTRODUCTION

I The Problem of Roman Art

'*O, Roma Nobilis...*' sang the medieval poet; yet another medieval verse succinctly summarizes what Rome has meant to humanity: '*Roma, Caput mundi, tenet orbis frena rotundi*'... (Rome, Head of the World, holds the reins of the round orb...). This image of the Eternal City which once claimed and held sway over the civilized world has been for fifteen centuries an integral part of Western tradition. In it are contained Popes and Goths, Scipios and sibyls, Raphael and Michelangelo, the Arcadian Euander and the Barberini, Vergil, Byron, Hawthorne and *The Marble Faun*. Skeptics and believers, classicists and romantics, have responded to the call of that great city which encompasses all her past in her ever-changing present. In a certain sense Rome has overshadowed the Romans. In our views of Roman art this Rome-centered image has dominated until recent times; and even now the spell of Rome herself makes it difficult to appraise an art whose boundaries reached from Scotland to Mesopotamia and whose products traveled to Central Asia and India, to Poland, and to the Atlantic shores of Africa.

To the Romans at the height of their glory the city was the world; and conversely, '... you have made the world into a city,' *'urbem fecisti quod prius orbis erat'* exclaimed Rutilius Namatianus, the last poet of pagan Rome, looking back upon Rome's greatness when the empire was crashing to the ground. It is this gigantic process of expansion of Roman organization, of Roman urbanism, of Roman civilization which impresses the visitor to cities in faraway lands—cities, now deserted, which had flowered under the Roman rule. Roman art

L. 50, figs. 50, 72.

was international in a way that no other art has been international until our century.

Because of this continued dialogue between the Roman heritage and the greatest artists and writers of Europe and America, Roman art seems infinitely familiar. Even though few people today perhaps could say with Montaigne that they knew the Capitol before they knew the Louvre and the Tiber before the Seine, yet Capitol and Colosseum still evoke majesty and martyrdom; and a Roman portrait looks often like someone we know. This very familiarity brings its penalties; as the first classicism in European art Rome conjures associative visions of later classicisms which it helped to inspire. An age that finds Canova and Thorvaldsen artificial transfers something of this dislike to the Augustus of Primaporta. Neither can the strikingly realistic portraiture of Rome escape its associations with Donatello, with Bernini, with Houdon, with all the realistic statues that populate the public squares of European and American capitals. The functionalist rebels strike out against all banks with Roman colonnades and at the same time against their fountainhead, the Roman temple. Humanitarians fighting against the age of 'organization men' condemn the first planned experiment in urbanization for its lack of concern with the individual and for inadequate sanitation in mass housing. Above all, the towering greatness of Greece has cleaved asunder what was to earlier ages one great concept of antiquity essentially represented by Rome. The challenge of the Acropolis rising in golden splendor into the blue ether makes Rome appear earthbound in the picturesque richness of her marble and red

brick ruins set against dark-green, verdant vegetation. The normative postulate of Greek art, Rilke's '*Du musst ein Anderer werden...*', the claim of the archaic *kouroi* that will not be denied that Man is perfect and divine, the heroic spirit of the classic Greece that knows tragedy and death and yet asserts man's eternal glory in the beauty and greatness of his art and his thought—these, to an age which has exploded the boundaries of the universe but has shaken mankind from its self-asserted central position, signify more than the '*magnificenza dei Romani.*'

We have, then, to find our way to Roman art from new positions; and neither the Roman attitude toward art nor our own expanding knowledge of that world has made the path easier. The trouble with Roman art is that there is so much of it. Five centuries of research have not yet accomplished the task of sifting the wheat from the chaff. We cannot say with nearly the same conviction as we can of the Greek, 'These are the masterpieces of Roman art.' Thousands of Roman buildings, thousands of mosaics, tens of thousands of sculptured monuments are scattered over parts of three continents—and many of them still await aesthetic evaluation and appraisal.

This reveals something fundamental about Roman art. Whatever the official pronouncements about, '*tu regere imperio populosque, Romane, memento. Hae tibi erunt artes*' (You, Romans, keep your mind on ruling other peoples. *These* will be *your* arts), the massive outpouring of art products shows that art was an abiding concern of Roman life. This art has produced some of the most memorable characterizations of individuals; but as art it is, on the whole, anonymous. The Greeks structured their art history through the personalities of the artists; in Rome, not even the architects, though most honored among the artists, ever coalesce into concrete people with a recognizable artistic personality. Trajan's architect, Apollodorus of Damascus, and his imperial opponent Hadrian, come perhaps nearest to emerging out of the vague anonymity of the Imperial Works Office; but the only architect whom we really know as a personality owes his fame not to his buildings but to his writing—Vitruvius, the none-too-successful practitioner, whose book *De Architectura* became a bible of classic canons for the Renaissance, Mannerism, and the Baroque.

No Roman writer has ever tried to write a history of Roman art. The scattered names of artists in literary sources cannot be linked into a continuous story. The signatures of the artists themselves show no correlation with the quality of the work. Almost all masterpieces are anonymous, while a great many uninspired copies of Greek originals are signed. We cannot say why one Pompeian painter named Lucius put his signature on a plain red slope of a fountain house nor why one Seleukos immortalized his contribution to the wall paintings of a villa (Farnesina) in Rome.

Some 'firms' of sculptors obviously took pride in their products; their craftsmen were usually Greeks. It was apparently an asset to be 'a graduate of Athens' or a member of the school of sculptors at Aphrodisias in Caria (western Asia Minor), the work of which can be traced for nearly two centuries; but other workshops as productive and of comparable or better quality failed to advertise themselves.

The craft of mosaic-making spread enormously, and perhaps under the later Roman empire it became more usual to sign such works. Some signed mosaics provide striking information about the wanderings of their creators; for example, a mosaic in Lillebonne, France, is signed by a master from the vicinity of Naples (Puteoli, Pozzuoli). Nevertheless, signed work is a small fraction of the enormous output, and the distribution, a matter of chance: out of some five hundred high quality mosaics of Roman times found in the great, eastern capital, Antioch-on-the-Orontes in Syria, not one is signed.

Apart from the time when Greek artists were migrating in great numbers to the new capital of the world (*ca.* 150–30 B.C.), the picture of Roman art is one of anonymity unarticulated by the succession of great names such as Greek writers on art had provided for the archaic and classical periods of Greece. It is the patron, not the artist, who counts.

Part of the education of a cultured Roman was to collect Greek works of art and to know something of Greek art history. But the same highly educated Romans who could give a brilliant description of the style of Myron (Quintilian) or worry about forgeries of the works of Phidias and Praxiteles (Phaedrus, *Fabulae*) had apparently no real or methodical interest in the artistic personalities of their own time.

Here is a problem not unknown to our age. The great

L. 37, figs. 16, 27, 24; L. 38, figs. 28–30, pls. X, I, fig. 41; L. 58, fig. 117; L. 72, pl. XXI.

art of Greece, the art of the past, was something to be cherished as a cultural value, and admired; the art of one's own day was something to serve the Roman state and the Roman society, a necessity, a convenience, an adornment. Compared with the Greek emphasis on the creative individual, the Roman 'functional' attitude is closer to the attitude of primitive and 'archaic' societies, in which the artist serves certain established functions of the community and in which his personal aesthetic achievement as such gives him no claim to individual recognition. There is a striking difference here between Roman literature and Roman art: Horace's proud claim, '*Exegi monumentum aere perennius*' (I have erected a monument more durable than bronze), finds no echo in any saying of a Roman sculptor or painter.

Within Roman culture we sense a dichotomy between two major functions of art. On one side, art served the needs first of the village community, then of the Republican city-state, and finally of the emperor and the empire. This is the privileged, the official aspect of Roman art. With rising sophistication there emerges a growing desire for art as the adornment of personal life as well. This distinction reflects but does not completely correspond to the sharp distinction of public and private concerns in Roman law. To distribute land, to plan colonial cities, to build buildings for worship, for supplies, for administration, for mass entertainment (baths, theaters, amphitheaters), was a duty and an obligation of the state. To carry the message of the empire, the image of the emperor, and the propaganda of his policy was a means of communication—coins, triumphal arches, and statues were in this sense the equivalent of newspapers, radio, and television. Within the private sphere art had certain traditional obligations in supplying images of the domestic gods, the ancestral portraits, and the sepulchral monuments. Between the official and the private spheres artistic activity was called for by the officially recognized professional corporations and colleges. For the adornment of individual life there was not the same obligatory established pattern; and it is in this private sphere that the impact of the sophisticated Hellenistic world was at its highest.

The truly creative achievements of Roman art tend to center in the fields in which there was an authentically Roman concern—public architecture, statues, and reliefs L. 41, pls. V–VII, XVI, XVIII, XL, XXVIII–XXX.

celebrating the achievements of the state, and portraits either honoring individuals for their service to the community or perpetuating them as members of a family.

One final complexity remains. Many keen students of art have called Roman art Greek art in the Roman period—as Greek literature of the Roman empire from the first century B.C. to the fifth century A.D. is Greek and not Roman. Others have compared Roman art to modern art in the nineteenth century, as an art which had so many earlier arts to draw on that it was in danger of succumbing to a purely synthetic method of selective imitation. There can be no question that Roman art is not and could not be original in the same sense as that of the Egyptians, the Sumerians, the Greeks, and the Chinese. It never went through the same continuous sustained struggle with nature—whether for or against —which is the hallmark of a truly original art.

When the Romans began to feel the urge to create an art expressive of their own concerns, they lived in a world which had just seen the full development of the most revolutionary cycle art has ever witnessed—that of anthropomorphic Greek art. Everything that man could wish to express seemed to be at hand. The Romans sought to appropriate this heritage to their ends; and the dramatic conflict between the adaptation of Greek art and the outbursts of original creativity sways Roman art like a pendulum. Yet to see Roman art only as a foil to the Greek does no justice to the Roman achievement. At the end of the Roman development, when the west was sinking into a darkness from which only the Rome-inspired Carolingian renaissance was to rouse it, and when in the east Roman cities were transmitting the heritage of antiquity to the Byzantine and Islamic worlds, we see Roman architecture of a boldness and magnificence totally different from anything known before, while the best achievements of the representational arts, notably in portraiture and in epic narration, had explored artistic avenues not entered by the Greeks. Below these truly original creative accomplishments there lay the vast treasury of the Graeco-Roman arts, multiplied, preserved, and made accessible to future ages by the *interpretatio Romana*.

Roman art, then, is vast and impersonal. It is essentially unreligious. It is an art of organized humanity

ecumenical in concept but centered on the legal and political state rather than, as Greek art, on the heroic ideal.

For a long time Roman art was viewed purely as the decadent stage of Greek. The first attempts toward a positive valuation were made by Franz Wickhoff and Alois Riegl. Wickhoff sought to understand Roman art as a formal phenomenon related to impressionism; Riegl, as the expression of an inexorable *Zeitgeist* which changed the artistic vision of humanity from the plastic intuition of the Greeks to an optic intuition of the moderns. Here, as in the lively controversy of whether Roman or Oriental architecture had anticipated the structural features crucial for the domed architecture of Byzantium, the growing awareness of the immense historical significance of Roman accomplishment for the foundations of European, Byzantine, and Islamic art cycles was the determining motif.

It is perhaps a measure of Roman art that these constructive assessments and significant interpretations have come from the retrospective appreciation by art historians and architects concerned with later European art cycles rather than from students of classical art involved with the attempt of separating Greek and Roman elements within the Roman heritage. Whatever views one may take of the aesthetic merits of Roman works, the overriding importance of Roman art as the first comprehensive stage of western European art cannot escape any thoughtful student of western culture.

Is there in Roman art anything beyond its historic role as propagator and preserver of the classical heritage? For surely, with the better knowledge of classical Greece, the role of Rome as interpreter of the classic tradition has been reduced if not eliminated; and in the vast 'museum without walls' which is at the beck and call of the modern world, arts are judged by standards much more comprehensive and severe than ever before.

I can give only a personal opinion. There is, first, the Roman concern with individual personality which struck out on new paths and which holds challenge and stimulation for the modern inquiry into the unity and the complexity of *persona*. Then again, the task of the organization and urbanization of undeveloped regions of the world lends renewed interest to the greatest experiment of ancient history in attempting to civilize the world. Finally—and here the problem of Roman art touches upon a problem as profound and acute as any facing the modern world—is humanity capable of creating in art the symbols for that vision of a unified and civilized human community under fair and just law which constituted Rome's most vital heritage to Europe and America and which our world is striving to achieve?

II Magnus Nascitur Ordo
A Great Order Rises

It is customary to begin the story of Roman art with the prehistoric huts on the Palatine; and after the most recent discoveries one might even go back to potsherds of the Bronze Age. In actual fact, an art that is specifically
5 Roman does not appear until the time of the late Republic (200–30 B.C.), and does not find a comprehensive formulation until the era of Augustus (*ca.* 30 B.C.– 14 A.D.). Until then the story is that of an 'art in Rome,' a center which had first been several villages of the Iron
10 Age, then an Etruscanized town, then one of the many focal points of provincial Hellenistic arts in Italy, itself a marginal province on the frontiers of Greek art.

As an illustration of the unique drama of the political and military rise of Rome, an account of art monuments
15 of Republican Rome is fascinating and deserves telling. The questions for us are different: 'When does a conscious quest for Roman art begin?' 'When did the Romans first create works of art which are clearly recognizable as Roman?' Roman art was not the achieve-
20 ment of one great creative epoch but a gradual process. Characteristically, it is in city planning and architecture that Roman creativity is first recognizable. The Roman reinterpretation of Greek geometry was perhaps originally applied to distribution of newly conquered colonial
25 lands. It was followed by a Roman adaptation of the Greek grid plan for towns. Here the Romans introduced an emphasis upon the ritual heritage from the Etruscans in the two crossing major axes, the east-west *decumanus* and the north-south *cardo*. Ritual reasons determined the
30 number and the location of the city gates and the need for a special height, the *arx*, reserved for temples. The earliest example of the axial cross may have been realized in Ostia (fourth century B.C.), the port of Rome; the ritual location of gates is attested in the Roman
35 colony of Cosa (*ca.* 260 B.C.).

After the terrible trial of the Second War with Carthage (218–201 B.C.) and during the subsequent victorious expansion into the Mediterranean, there follow in rapid succession the formulation of typically Roman civic centers (fora), and of halls for courts and commerce (basilica), especially in the civic center of Rome herself (Forum Romanum). Simultaneously, the technological revolution produced by the invention and improvement of concrete created a new architectural language of arch, vault, and dome; like the ferro-concrete architecture of 45 modern times, the Roman architectural revolution started with utilitarian structures, with bridges, supporting terraces, and harbor sheds, of which the Porticus Aemilia, at the river port of Rome on the Tiber, is a magnificently accomplished example. The new style then 50 invaded the official architecture of the state. The records office in Rome (Tabularium, 78 B.C.) is at once a great example of city planning in creating a stage-like façade for the Roman Forum and a normative synthesis of Greek post and lintel with the new processional rhythm 55 of arches.

The cultural desire to possess fine works of Greek art rather than the traditional desire to possess the goods and the gods of the enemy makes the capture of Syracuse in 211 B.C., the sack of Corinth in 146 B.C., and the sack 60 of Athens in 86 B.C. milestones for Roman art. The puritan defenders of the good old times considered these events to be steps on the road to perdition, and condemned them as such. The desire to own Greek art came first, the desire to rival it, later. One can hardly 65 blame the Roman generals for wanting Rome, the new capital of the world, to equal and surpass in splendor the cities of the eastern kings whose armies had been scattered to the winds by the Roman legions. Their aim, as the historian Livy justly observed, was to make art 70 the outward manifestation of Roman rule over the world, 'not only to their own glory but to increase the majesty of the Roman people.' Henceforth the imperial spirit determines the Roman attitude toward art. It finds its first expression in the colossal architectural designs like 75 the replanning of the old sanctuary of Fortune in Praeneste under the dictator Sulla (82–78 B.C.), or Caesar's sweeping expropriations in the very heart of Rome for his, the first un-Republican, imperial showpiece of a Forum (51–46 B.C.). Sprees of domestic luxury are 80

L. 35, figs. 3, 4; L. 40, figs. 5, 6; L. 42, figs. 1, 2; L. 48, fig. 15; L. 52, figs. 1, 2; L. 76, fig. 11; L. 79, fig. 16.

I

'He built up his villa at Tivoli in a marvellous fashion so that he inscribed in it the most famous names of provinces and places and called them the Lyceum, the Academy, the Prytaneum, the Canopus, the Poecile, and Tempe...'
(*Life of Hadrian* 26).

An architectural complex grouped around a long pool in the southern part of the villa has been identified as 'Canopus' by modern scholars. How closely did this monumental 'souvenir' resemble its prototype, a fashionable suburb of Alexandria and shrine of Serapis? Colonnaded porticoes were strung out along the waterfront of many ancient cities and may have been used in the Egyptian resort; but surely no prototype contained such a museum of sculpture. Along the western side stand copies of the famous caryatid maidens of the Erechtheum on the Acropolis of Athens (ca. 420 B.C.). Two Amazons copy statues of the two most famous sculptors of classical Greece, Phidias and Polyclitus. The two sileni next to the maidens are probably after Hellenistic images. Poised on a fish-covered marble 'rock' in the water, a Scylla evoked the Homeric Odyssey. A crocodile, native to Egypt, perched on another rock; that the Nile has been brought to the Tiber is conveyed by statues of the two river gods, Nile leaning on a sphinx, Tiber with the Roman Twins suckling the wolf.

Formal in its layout, an 'open air interior' rather than an urban waterway, picturesque in its interplay of green slopes, white marble and blue water, Hadrian's 'Canopus' was intended to evoke a definite mood and special memories. Only a Roman intellectual was capable of this romantic vision uniting Hellas, Rome, and Egypt; only an emperor-architect could translate it 'literally' into marble, brick, and stone.

Euripus (pool) 398 ft. (121.4 m.) by 68.5 ft. (18.6 m.); fountain house with melon (segmental) vault, alternating niches for statues and fountain jets. Brick, concrete, mosaic roofs, marble columns. The statues have been replaced by casts. The originals are in the small museum at the east end of the Canopus. The crocodile now sits on the edge of the pool (background, far right). Ca. 121–127 A.D. (Aurigemma).

L. Crema, pp. 466 ff., with literature. A. W. van Buren, *AJA* 59, 1955, pp. 215–217, pls. 62 f. S. Aurigemma, pp. 100–133, pls. VI f., full treatment. *Scriptores Historiae Augustae, Life of Hadrian* 26. *

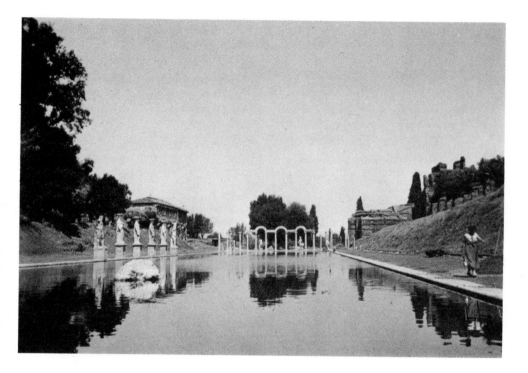

I Hadrian's Villa at Tivoli — The 'Canopus'

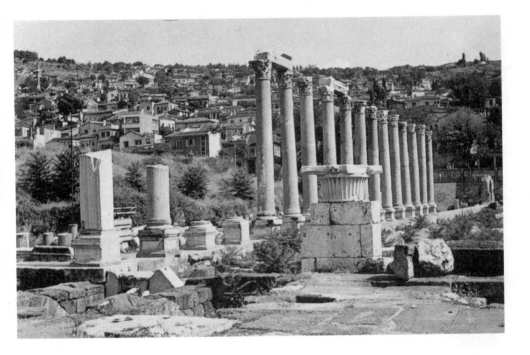

II Smyrna — An Imperial Forum in Asia Minor

II

Izmir's oldest and liveliest quarter, Namazgah, climbs up a hill in buzzing, crooked streets, spilling overflow of the excitement of the bazaar. About mid-height this warren of houses and humanity reaches a platform. Over the red roofs and the green hill the eye moves upward to the Byzantine citadel on Mount Pagos, successor to the fortress of King Lysimachus (361?–281 B.C.), who shifted Smyrna from its archaic concealment in the corner of the bay to the broad waterfront where it now lies.

Smyrna owed its greatest Roman monument to a disaster. In 178 A.D. the earth shook. 'Smyrna lies prostrate!' cried her devoted native son, famous orator, and teacher Aelius Aristides. His pleas released the flood of imperial bounty. A bust of the Empress Faustina (on the arch in right background) declares the vast complex to be an imperial present.

Although only half excavated, the Forum is an impressive example of Roman monumental magnificence and of Roman practical ingenuity. To create the vast platform on the slope of the hill, vaulted chambers of limestone masonry were constructed along three sides of the level area. Shops and offices occupied the underground chambers, with a promenade between them.

Above this underground market stood the vast, two-storied hall, the Basilica, 500 ft. long. Following a plan developed by Greek architects of Ionia, two Corinthian colonnades with monolithic columns on tall pedestals adjoined the Basilica to make a ⊓-shaped plan. Again following Greek precedent, the long side of the Basilica was treated as an open colonnade so that one could walk in the shade all around the sun-baked piazza. But in the center of the Basilica an arched portal placed on the axis of the piazza announced that a Roman sense of symmetry and discipline has ordered the Greek heritage.

The view is taken from the interior at the point where the Basilica (left) joins the west colonnade (right). The re-erected columns are the front row; two more rows ran parallel in the interior.

Length of Basilica, ca. 541 ft. (165 m.), length of excavated side colonnade, 350 ft. (105 m.). Barrel-vaulted and arched substructures of limestone, otherwise white and colored marble, granite.

S. Kantar and R. Naumann, 'Die Agora von Smyrna,' *Istanbuler Forschungen*: 17, 1950, pp. 69–114, pls. 20–48. L. Crema, pp. 371 f., figs. 442–444. J. B. Ward-Perkins, *PBSR* 26, 1958, pp. 178 ff., perhaps a *Kaisareion* devoted to a cult of emperors. *

reported, and the *multa signa nobilia*, the many noble statues taken from Tarentum, were followed by thousands more from all over the Greek lands. In 187 B.C. 285 bronze images and 230 marble statues, mute counterparts of the living prisoners of war, were marched in just one triumphal procession.

For some hundred and fifty years, from the early second century B.C. to the time of Augustus, Roman art is of extreme unevenness, torn, as it was, between desire for magnificence beyond anything the world had ever seen and moralistic lamentation that Greek arts were corrupting Roman virtues.

Those who approved Rome's claim to heritage of Greek culture faced a grave problem, one which was equally fundamental for Roman literature and Roman thought. Which of the many-faceted achievements of Greek art during the five centuries of its development (*ca.* 650–100 B.C.) were truly congruous with the Roman genius—the austerity of the archaic, the majesty of the classic, the luxurious and exuberant vitality of the 'Asianic' baroque of Hellenistic courts, or the synthetic nobility of the neo-classical revival? The late Republican age was one of social disintegration and untrammeled individualism, and individuals of diverse backgrounds and tastes took the lead in experimenting with the adaptation of Greek art to Roman needs.

As power passed from the aristocracy of the Senate to autocratic leaders, art began to be swayed by their tastes and predilections. Sulla brought Corinthian columns from the temple of Olympian Zeus in Athens (built by King Antiochus IV of Syria, ca. 175 B.C.) to renew the shrine of the Roman Jupiter on the Capitol. The act symbolized the transition of power from the supreme god of Greece to the supreme god of Rome; it also brought to Roman architecture the very exemplar of Hellenistic regal baroque style. In general, Sulla's art program was inspired by the grand building practices of the Hellenistic kings and was essentially Hellenistic baroque in taste. Thus the new image of Jupiter for Sulla's restoration of the Capitoline shrine was made by Apollonius, son of Nestor, an Athenian, whose realistic baroque style is known to us through his famous torso in the Belvedere and his brutal, defiant bronze statue of a boxer. Caesar's choice of a forum for his major building enterprise appealed to Roman tradition; yet

his Greek architect was creating an entirely new type of architectural propaganda for the leader of the state and his family. Caesar seems to have favored a Greek classicism. Thus the image of Venus for her temple in the Forum (designed to recall the divine ancestry of the Julian family and their connections with Aeneas, legendary founder of the Roman state) was made (in 46 B.C.) by Arcesilaus, a Greek sculptor from Athens who adapted for this purpose a famous Aphrodite of classical Greek art.

Other aristocrats, less powerful but no less ambitious than Sulla or Caesar, strove mightily as art patrons, art plunderers, and art collectors to bring art into Roman life. From this struggle there emerged an original Roman contribution to world architecture, the Italian villa. This was a totally new concept in which architecture, sculpture, painting, and nature were combined to create a setting suitable for a life of cultured leisure. Cicero's letters bear eloquent testimony to his loving concern for his seven villas—'my dear villas, those jewels of Italy.' The 'Villa of Mysteries' in Pompeii and the villa of Boscoreale, with their unusual and magnificent monumental paintings, show us something of the realities that were Cicero's delight; and even more impressive was the famous villa of Caesar's father-in-law, L. Calpurnius Piso at Herculanum, rediscovered in 1750, with its gardens on two levels, its sculpture gallery of famous Greek masterpieces (in copies), and the extensive library of the Epicurean Philodemus, house philosopher of the owner.

The Roman scene of the late Republic was constantly exploding with violent and dramatic clashes of individuals struggling for power. A new concern with the individual emerged, and the late Republican portraiture brought together the disparate strands that had run parallel in the different kinds of portraiture previously known in Rome: the Etruscan, expressive but barbarous; the Hellenistic, oscillating between disillusioned observation and dynamic glorification of supermen; and the Roman, in which the concept of personality ran the gamut from utmost factuality in the so-called 'Death Mask' group to attempts at penetrating psychological analysis of the leading actors on the world stage (the Younger Cato, Pompey, Cicero, Caesar).

In painting, space-creating illusion comes to the fore

L. 21, figs. 47, 49; L. 37, figs. 11–14, pl. XXVI; L. 48, figs. 67, 68; L. 56, figs. 47, 64, 99; L. 66, pls. XVI, XVIII, XXXIX, XL; L. 67, pl. VI; L. 82, figs. 48, 63; L. 83, figs. 47, 64; L. 89, figs. 66, 65, 67, 68.

in the so-called Second Pompeian style (*ca.* 60–30 B.C.). At first, regal porticoes such as were found in royal palaces are painted on the walls. Then stage decorations are used to recall the cultural values of Greek drama and perhaps to remind the beholder that 'life is a stage' —a sentiment engraved on drinking cups found at Boscoreale. Finally, the real wall disappears and views are opened out to climbing mountain cities and idyllic villas.

The late Republican art in Italy is a last stage of Greek Hellenistic art as well as the formative stage of Roman imperial art; certain major artistic trends initiated by Greek Hellenistic artists continue and reach their highest development in Rome—the grandiose planning in architecture, the concentration on the individual in portraiture, and the exploration of space both in architectural expansion of interiors and in landscape painting. The magnificent landscapes from a luxurious villa on the Esquiline which illustrate the *Odyssey* in a spirit of nature worshipping pantheism are a striking monument to the transition from Hellenistic to Roman art.

The majority of artists were Greeks freshly transplanted to Rome. They were still thinking and working in terms of their own traditions, and were not as yet systematically impressed by Roman ideology and Roman environment. This was to change with the rule of Augustus (27 B.C.–14 A.D.); no longer were the Romans to experiment individually: Roman art became an Art with a Mission.

In the capital of modern Turkey, Ankara, there stands, behind a mosque, a Greek temple of yellow marble built originally by Celtic chieftains to worship an Asiatic moon god. Their descendants, the Galatians, were soon to listen to St. Paul. On its walls is engraved in Greek and Latin the summary of the deeds of the Deified Augustus, as the emperor himself had composed it. In this extraordinary document Augustus seeks to create the image of the 'First Citizen' who, acting with strictly constitutional means, rescued the world from chaos and restored the Roman state. His building program is an important part of the image, a roll call of benefactions to gods and Romans: Council House, Temple of Apollo on the Palatine, Temple of Deified Caesar, Lupercal, portico at Circus Flaminius, Portico of Octavia... 82

temples, the theaters of Pompey and of Marcellus, Capitol... aqueducts, Forum of Caesar, Basilica Iulia... Forum of Augustus. In private conversation Augustus summarized it more succinctly: 'I took over a Rome of mud-brick, I left it a city of marble.' 50

As only the Persian kings before him and Louis XIV after, Augustus created an imperial art. We know how he strove to immortalize his concept of the Roman empire in literature—Vergil gave him *The Aeneid*, and Livy, a great official history of the Roman people. 55 Augustus was no less determined in the visual arts. The impressive architectural monuments in Rome and in the western provinces (Pont du Gard, near Nîmes) and the sculpture created in his immediate environment (Augustus of Primaporta, Ara Pacis, Gemma Augustea) 60 bespeak a clear direction both on the ideological and the artistic level. To lift Roman history and the new Roman empire to mythic and epic grandeur and to endow it with dignity, nobility, and the restraint of classic Greek art were clearly his goals. In the main, Augustus suc- 65 ceeded. The general types of official Roman architecture and the iconography of imperial propaganda were formulated and left for later times to elaborate.

With the unique concentration of power in the hands of the emperors of the first century A.D., Roman art 70 displays a unique sensitivity to their tastes. Nero (54– 68 A.D.), whose appetite for the colossal was insatiable, tried to transform the center of Rome into an imperial villa, his famous 'Golden House.' One of the many Greek masterpieces to be seen in this extraordinary 75 palace was the famous 'Laocoön' (*ca.* 150 B.C.); the contemporary opinion is recorded in Pliny's extravagant praise: 'A work to be preferred to all other works of painting and sculpture.' In the sensational cave of Sperlonga Faustus, a highly placed Roman at the court 80 of the Emperor Domitian, assembled an outstanding collection of the works of the same Rhodian baroque masters who had carved 'Laocoön.' Thus Hellenistic baroque exuberance was once again admired and appreciated, but now in a vigorous creative spirit which 85 makes the so-called Flavian baroque perhaps the greatest of all epochs of Roman art.

The 'Golden House,' with its gold-gleaming façade, its mile-long colonnades, its perfumed dining rooms of

. 3, pls. V, VII; L. 7, pl. VI; L. 13, figs. 11, 13; L. 18, pls. XXVII, XXVIII; L. 58, fig. 35; L. 60, figs. 50, 72, 102–105, . XVII; L. 72, fig. 73; L. 74, pl. VIII; L. 88, pl. VIII.

ivory, its lake, its 'meadows, vineyards, pastures and woods with every kind of wild and domestic animals' (Suetonius, *Nero* 31), sank quickly into oblivion. Nero's civic-minded successors built over its lake the huge 'crowd-container,' the Colosseum, to amuse the populace with gladiatorial games, and used its vast parks to erect bathing establishments in which the growing proletariat might find temporary escape from Rome's crowded, noisy slums. The heritage of the architects of the 'Golden House,' Severus and Celer, lived on. Their bold experimentation with curved, segmented, domed spaces flowing into each other in truly baroque motion introduced one of the most fertile ideas in the history of architecture, which henceforth becomes a Leitmotiv of Roman building.

It was the great conflagration of Rome in 64 A.D. that had swept clear the vast spaces subsequently occupied by the 'Golden House.' Rome rose again, the first example of a modern metropolis constructed according to a comprehensive building code—we hear of zoning laws, of requirements for open spaces between houses, of fire walls, of porticoes to be attached to the long fronts of apartment houses. These are now standardized for mass housing. The rebuilding of Ostia under Hadrian three generations later has preserved for us the actual appearance of a totally novel urban form, in which the continuous façades of brick buildings up to five stories in height foreshadow urban forms of the modern Industrial Revolution.

The Flavian Age inspired the apogee of Roman literature in the somber drama of heinous crime and servile depravity unfolded in staccato rhythm and violent contrasts by Tacitus and Juvenal. Here imperial Rome appears as sinister darkness lit by flashes of lightning. '*At Romae, ruere in servitium* (in Rome, they rushed into slavery) the consuls, the senators, the knights...'

While imbued with the same sense of tension, excitement, and contrast, the visual arts reveal more positive aspects of this extraordinary age. In architectural wall paintings, dream palaces of towering rich formations recede majestically into the distance. Their ornaments are living things, aglow with color. These painted visions outdistance even the magnificent realities of the imperial Flavian palaces on the Palatine, which the great architect

Rabirius endowed with the vastest spanned space man had yet seen and with unheard-of combinations of architecture and nature in the ponds, gardens, and islands brought into the very dining room of the emperors.

Richly textured, nervously alive with highlights, the best paintings of the Fourth Pompeian style represent the highest extant achievements of antiquity in pictorial conception of the world. Even the potential of chiaroscuro is explored. In night scenes such as that of the fall of Troy the ghostly light imparts to the vast scene a sense of doom as foreboding as in the Tacitean drama of the rise and fall of Caesars.

Bold and novel conjoining of reality and illusion opens two windows on history to those who pass under the Arch of Titus (*ca.* 82 A.D.). Their designer supposes that the spectator is walking in the footsteps of that great triumph which heralded the fall of Jerusalem. Suddenly, on both sides, the triumph of stone comes to life, sweeps out of the side walls of the arch and back again. Overhead, the deified emperor is lifted to heaven on an eagle. For the moment we are carried back on the tides of time.

Although celebrated as a paragon of beauty and darling of mankind the emperor is square-headed and bull-necked. Consciously, perhaps a trifle self-consciously, Flavian portraitists strove to make their sitters look like stern old Republicans—short of belonging to real aristocracy, the best course for newly arrived provincials to follow in order to be 100 per cent Roman was to admire ancient Republican virtues. But the habit of trenchant analysis, evident in Tacitus, could not be suppressed; there is good and bad in a person, and the balance is equivocal. The Emperor Vespasian (69–79 A.D.) is both a Napoleonic profile and the man who made jokes about money from the tax on latrines ('it does not smell'). The banker Caecilius Iucundus is an epitome of bonhomie and avariciousness. In their complete mastery of formal and psychological means these portraitists reach the high point in the synthesis of Greek Hellenistic tradition and Roman will for a Roman art.

With the collapse of unrestrained imperial rule, when Domitian (81–96 A.D.) was assassinated, not only powerful chapter of Roman creativity ends, but also that phase of it in which Hellenistic art was still a living force

L. 5, figs. 37, 36; L. 24, figs. 20–22; L. 40, pl. IX; L. 51, pls. XXXI, XXXII, XXXIV, XXXV; L. 55, pl. XXXIII; L. 60, figs. 108, 109; L. 68, fig. 54; L. 78, fig. 74; L. 81, fig. 75; L. 83, pls. XLI–XLIV, fig. 78; L. 87, figs. 76, 110–113.

III Pax Romana
The Roman Peace

For many centuries the Mediterranean world was to look back with longing upon an age in which Trajan (98–117 A.D.) had carried the imperial eagles to Rumania and the Persian Gulf and Hadrian (117–138 A.D.) had built his wall in northern England to secure final peace. The Roman world flourished. Commerce linked east and west. Hundreds of prosperous cities doubled and trebled their populations; the millions of people of many tongues and races finally attained the formal status of fully privileged Roman citizenship with the 'Antonine Constitution' under Caracalla (212 A.D.). A prosperous middle class joined the imperial authorities in providing the cities with magnificent civic centers, baths, and gymnasia. The younger Pliny, friend and helper of the great Emperor Trajan, loved his villas as much as had Cicero; but rather than plunder his province of its art, he, as imperial representative in Bithynia (111–113 A.D.), later the heartland of Byzantium, strives to embellish the provincial cities with theaters, temples, aqueducts, and baths, and to improve their water supply. He pleads with the emperor to send architects and surveyors from Rome. Roman art spreads on the crest of the wave of the new prosperity.

This is the Golden Age of Roman urbanism. In the hot sands of Africa, in the forests and fens of the bleak north, in Germany, Gaul, and Britain, Roman legions were building cities, many of which were to become famous in European history. No longer was the architecture even of military foundations confined to standards of immediate utilitarian necessity; Timgad in North Africa, planned and built by Trajan's Third Augustan Legion (ca. 100 A.D.), eventually boasted a library. Emperors and local millionaires showered the older cities of the Greek-speaking east with imposing public structures or even entire new city quarters. In Athens where an arch stands amidst the swirling modern traffic proclaims in monu-

mental letters on the side toward the Acropolis, 'This is Athens of Theseus, the city of yore'; but on the other side, turned toward a new residential quarter, a new founder is celebrated: 'This is no more the city of Theseus, this is the city of Hadrian.' Gradually, the great provincial centers of east and west, Ephesus, Antioch, Alexandria, Lepcis Magna, Arles, Trier come to exemplify art nearly as Roman as that of Rome herself.

In this great unfolding of Roman imperial architecture the traditional Greek forms of elegant colonnade and rich architectural marble ornament survive, but they are put to new uses. They are piled up in rising vertical accents of the façades of city gates, theaters, and libraries. They are used in unending files for the long colonnaded avenues which become a feature of urban planning in the eastern part of the empire. Even more frequently, Greek architectural features are applied as surface ornamentation for that architecture of brick and concrete which now realizes its full space-creating potential in the vast domed and vaulted interiors of imperial palaces and—even more impressively—imperial baths. The clear strength of its exteriors is best displayed in utilitarian structures, in the Market rather than the Forum of Trajan, in the great warehouses of Ostia, or in ruins where the adventitious ornamentation has dropped away. Its colossal interiors dwarf men; and light, which had been largely negated in the Greek interiors, becomes a powerful if dispersed force which pours into the upper reaches of the lofty space through huge windows.

All through the age a ground swell of religious sentiment was gaining steadily in strength. A florid rhetorician, Apuleius (123–ca. 180 A.D.), author of the zestful novel *The Golden Ass*, ended his tale with a moving account of his conversion to the loving omnipotence of the Egyptian goddess Isis, 'Holiest of the

.. 26, figs. 9, 10, 18, 19; L. 30, fig. 17; L. 33, fig. 8, pl. II; L. 46, figs. 127, 7, pl. XXXVII, fig. 34; L. 61, figs. 34, 39, 40; .. 63, figs. 23–25; L. 66, fig. 39, pl. X.

Holy, perpetual comfort of mankind, you whose bountiful grace nourishes the whole world; whose heart turns toward all those in sorrow and tribulation as a mother's to her children...' Apuleius' experience was not atypical; this is also the age of the first Christian apologists. Nevertheless, religious architecture remained on the whole traditional, although sometimes enlarged to colossal scale—never more strikingly than in the sunbathed ruins of Syrian Baalbek. The cool and perfect geometry of Hadrian's Pantheon (*ca.* 126), with the cosmic eye of its dome opening onto the dome of the skies, is for the religion of the mind, not of the heart.

The sheer bulk and volume of the efforts involved in the mushroom growth of art was staggering. Had an astronaut of Lyncean vision been able to rise high above the Roman empire at that time, he would have seen prisoners condemned *ad metalla* sweltering in the mines of the Porphyry Mountain of Sinai, toiling in the fastnesses of Phrygia, on the gleaming islands of Greece, and amidst the rough crags of the Balkans, quarrying endlessly the shining marbles,—yellow, green, black, and white. He would have seen fierce columns of smoke billowing up from the huge imperial brickworks to provide millions and millions of bricks for the never-ending construction of fora, baths, shops, granaries, and aqueducts. He would have seen heavy-laden boats wallowing in the seas as they carried huge, luxuriously carved marble caskets from Greece to Africa, from Asia Minor to Italy, from Rome to Spain. He would have seen a forest of marble statues on the move.

The sculptor's skill, long a Greek prerogative, was spreading into the far corners of the empire. Almost on its eastern frontier, in a small town on the Euphrates, a young man named Lucian dreamt that he must choose to decide between the grimy goddess of sculpture and the elegant Lady Paideia (literary career). Lucian chose the latter and became famous as an irreverent wit; but others had less choice and perhaps no desire for one. To their unsung labors we owe Roman art and our knowledge of many masterpieces of the Greeks.

For the Greek past continued to be admired; but it was a past which was dead and gone, and the admiration was becoming more imitative and more romantic. Hadrian (117–138 A.D.), perhaps the only Roman emperor with a vision of a supra-national imperial culture, included Egypt as well as Greece in his evocation of the past in his incredible villa at Tivoli, but his indoor and outdoor museum was populated with copies, not originals. The time of large-scale plunder of Greek masterpieces was over; instead, mechanical copying of famous Greek statues flourished as never before, and the cultured Roman made his grand tour of Greece, a guidebook in hand.

The use of famous Greek sculptures and of famous Greek pictures as models for the plastic and pictorial decoration of public buildings and private residences was of one piece with the use of Greek architectural vocabulary. Increasingly, sculpture and painting became adjuncts or components of abstract decorative schemes in which the over-all effect was the primary concern; the individual figure, group, or scene mattered less and less.

Sometimes these ensembles served a propagandistic purpose; in the ostentatious city gates with niched façades the top row might display statues of the imperial family and of the local benefactors, while underneath there appeared the legendary founders purloined from famous Greek legends to shed the luster of a glorious past upon the city. At other times, as in the many mausolea which lined the approaches to the cities, the abstract compositional designs applied to walls and vaults may express allegorical schemes in which the myths were interpreted as poetic guises for a pseudo-philosophical morality. The dead claim the virtue possessed by immortal mythological heroes shown in the tomb (Tomb of the Pancratii, Rome). This is sometimes made explicit on the reliefs of the marble sarcophagi, as when the Greek heroine Alcestis, who gave her life for her husband, is shown with the portrait head of a Roman matron, and her husband, the king Admetus with the features of a Roman businessman (Alcestis sarcophagus of Euhodus).

A world of innocent childlike bliss which perhaps awaits the dead was often displayed in marble reliefs. A hope to join the cosmic life of the universe is at times expressed by figures such as the Seasons (Season Sarco-

L. 9, fig. 8; L. 10, figs. 29, 30, pl. X; L. 29, figs. 131, 130; L. 50, pl. I, fig. 41, pl. XXXVI; L. 58, figs. 55, 56, 117, pls. XXXVII; L. 61, pls. XII, XIII; L. 78, pl. XI; L. 84, fig. 120; L. 88, figs. 128, 129, pl. XIII.

phagus, Metropolitan Museum). Other adaptations of famous Greek mythological compositions are more difficult to explain. Why, for instance, would a Roman nobleman want to be buried in a casket which displays the matricidal deed of Orestes?

Here, perhaps, and more certainly in the wall paintings and mosaics of Roman houses, we find a kind of visual rhetoric, parallel to that formalistic handbook education in which future writers and orators were taught how to declaim upon the fall of Troy or the crime of Medea in accordance with carefully prescribed formulae and examples. Both literature and art used famous Greek models; both simplified and reduced the richness of the originals. Both aimed to glorify the traditional educational and aesthetic values. Many Roman mosaics are clearly illustrations of schoolbook knowledge, the visual counterparts of Homer, Euripides, and Menander and other canonical authors who continued to be read in schools.

More creative use of famous Greek works of art is seen in reliefs, again especially on sarcophagi, which illustrate themes of Roman life. The original inspiration is not direct, but derived from the example set by the state art of imperial reliefs; thus great Hellenistic battle scenes adapted to Roman wars appear first on the reliefs of the imperial columns and then on the sarcophagi of Roman generals. As the thunder of war approaches closer to the capital, glimpses of contemporary realities flash up within the pre-set molds of these imitative compositions. The soldiers are no longer the semi-mythical heroic nude warriors of Greek tradition, but real Roman legionaries; the enemy, no longer the romantically glorified primitive of Hellenistic art, but the shaggy, coarse-featured, crafty German of the day. Nevertheless, even in works which purport to represent purely Roman themes, the artists always start from the general typological schemes of their inheritance, not from a direct, spontaneous account of their own experiences.

There are, to be sure, differences of degree. That an attempt was made to give a different, a Roman, view of what constitutes history is the dramatic revelation unfolded in the authoritative imperial reliefs. Despite its derivative vocabulary, the column of Trajan (dedicated in 113 A.D.) remains the one great epic about the imperial army which Rome has left to us. Ever-present leadership of the emperor, disciplined courage, calm confidence—contrasted with the wild passions of the barbarian opponents—high competence of organization and a scientific reporter's interest in technology—these are the keynotes of a marvelous war documentary in stone.

Made but eighty years later (before 180–193 A.D.), the column of Emperor Marcus is an apocalyptic revelation of war as hell, prophetic of the approaching doom of the empire, touched with a sense of violence as bitter and passionate as Goya's 'Disastros della Guerra.' Although its compositions presuppose all the previous Roman absorption of Greek art, its basic ideology is a rejection of the Greek belief in the beauty and dignity of man. This brief and bitter contact with reality, with its sense of passionate pessimism and its direct, accusing transcription of emotional realities, might have opened a new path to Roman art. But the unknown genius who directed the decoration of the Marcus column found no successors. In the reliefs of the triumphal arch which the Emperor Septimius Severus erected in his native city of Lepcis Magna (ca. 204 A.D.), the accent shifts—for the first time—to victory as a symbolic preordained event, to the emperor as a super-human frontal image expressive of the 'miracle, mystery, and authority' of Oriental kingship.

The portraits of the emperors are our clearest lead to the changing temper of the times. Since they served as the objects of loyalty oaths (the refusal of the Christians to worship the empire through the genius of the emperor was a major reason for the persecutions), they were mass produced; yet the officially recognized versions had to convey the individual view which each emperor held of himself and his position. Trajan (99–117 A.D.), an elderly hero in classic stance; Hadrian (117–138 A.D.), enigmatic, quizzically thoughtful, and the sensuously languorous Antinous, his favorite; the calm and detached Antoninus Pius (138–161 A.D.); the blankly meditative Marcus Aurelius (161–180 A.D.), philosopher on the throne; Septimius Severus (194–211 A.D.), wavering between the divinity of a Zeus or Serapis and a pretended

L. 5, fig. 119; L. 25, figs. 114, 121; L. 34, figs. 123–125, 134–135; L. 46, figs. 114–116; L. 55, figs. 122–125; L. 69, fig. 127; L. 80, fig. 55; L. 81, fig. 80; L. 83, figs. 117, 81; L. 85, pl. III.

resemblance to Marcus Aurelius; and his son Caracalla (211–217 A.D.), dynamic, powerful, and brutal—all of them set the tenor for the interpretation of personality throughout the empire and put their imprint on the stylistic fashions emanating from the capital.

For Rome was unmistakably in the van, and for once we can see the changes of artistic form spreading in waves to the provinces. Although echoes of Flavian baroque recur in some of his monuments, the style under Trajan is a dry classicism moderated by factual elaboration of setting.

Almost saccharine sweetness is imparted to the surface of marble in the work most characteristic of the Hadrianic era. No other period of ancient art did more to saddle Europe with the delusion that the ancient world was populated with shining white, 'coldly fair' statues. This polished radiance already relies to some degree on the play of light and, as yet discreetly, on the pictorial value of shadows. All through the Antonine era (*ca.* 140–190 A.D.) the optic contrast of polished whiteness and drilled shadow increases as the unity of plastic form yields to the virtuoso dissolving of plastic units. In the Severan baroque (*ca.* 190–230 A.D.) the process reaches its culmination; and although this dissolution of sculpture had sought to work within the inherited Greek types, the result was that the very essence of sculptural conception was undermined.

By spreading technical skill and anthropomorphic figurative vocabulary into the provinces, Roman art provided the subjugated races with the means to express their own spiritual and artistic aspirations. Not all were to profit by it equally. To the eastern provinces with traditions of Greek art, the invasion of Roman art brought new tasks and new vigor; but in Egypt the millennial art which had survived the Greek onslaught finally died in Roman times.

Matters were different in the west. Southern France, conquered first, became virtually an extension of Roman Italy. The large area encompassing northern France, western Germany, and Britain grew more slowly into the ambient of the classical world. The rift between the zoomorphic arts of the Celts and the Germans and the classical emphasis on the human figure was never completely bridged, but by the second century A.D. Romanization had sufficiently advanced to produce in the local schools of Trier and Cologne sculptures expressive of contemporary life and native religious ideas. In the strange apparitional 'Mothers' worshipped in the Rhineland, or in scenes concerned with local environment—'The School' or 'A Wineboat on the Moselle'—such is the impact of the local element that we recall first seeing similar faces and figures in Romanesque portals or even in Veit Stoss' Madonnas and Dürer's Apostles, and only then become aware of the classical postures and compositional devices used to produce this impression.

If there is any common trend in this vast arena of the empire, it is the trend toward de-materialization of the plastic ideal of the Greek tradition, an increasing reliance on contrasts of light and shade in sculpture, an increasing flattening and reduction of three-dimensional effects in painting and in mosaics; but in the over-all view abstraction is as yet latent, and the great bulk of Roman art moves within the framework of the inherited classic vocabulary.

L. 1, figs. 56, 82, 127, pl. XLVIII; L. 5, pls. XLV–XLVII; L. 10, figs. 55, 79; L. 20, figs. 83, 118–121, 131; L. 23, figs. 126, 129; L. 25, fig. 130; L. 32, pl. II, figs. 56, 131, 130, 117; L. 53, figs. 133, 138; L. 60, fig. 127; L. 61, fig. 84; L. 63, pls. XII, XIII; L. 64, pl. XLVIII.

IV Nutans Mundus
A World Shaken in Its Foundations

The catastrophe was sudden and disastrous. Between 235 and 284 A.D. the empire went through a series of convulsions which broke its unity, even if the pieces were retrieved and patched together again. Despite the political restoration under Diocletian (284 to 305 A.D.), the belief in the eternity of the empire was gone, the laboriously cemented edifice of its cultural entity shattered. Rome herself was pushed off her pinnacle by rival temporary capitals in Asia Minor (Nicomedia-İzmit), Greece (Thessalonica), northern Italy (Milan), and Germany (Trier).

The break with the past is made irrevocably clear in the arts. Interestingly, it was not the development of architecture which was disrupted. There remained enough areas in the empire where the creative impetus continued although building activity might be reduced; military architecture and fortified palaces gave the architects new assignments in accordance with the changed conditions. These bring to the fore the commanding order of disciplinarian planning and the austere strength no longer concealed by traditional ornamentation. At Deutz, near Cologne, the Constantinian fortress looks almost like a medieval castle. Diocletian's retreat, the fortified city-palace at Spalato (305 A.D.), orders the buildings of an imperial court in the strict plan of a military camp. The motif of the arcaded colonnade, so popular in avenues of eastern Roman cities, is used not only in the two intersecting thoroughfares but is now integrated with the fortress wall, of which it forms the upper story. It points toward the use of colonnades as multi-storied screens in Byzantine art.

In Rome the basilica begun by the pagan Emperor Maxentius (before 312 A.D.) states in bold and grandiose isolation the problem of the colossal vaulted unit which had been previously treated within the large structural complexes of imperial baths. Thus there emerges the new and independent type of the long towering hall, subsequently developed with clear monumentality in the Imperial Hall of the palace of Constantine at Trier. The same insistence on the large unencumbered oblong 'space-box' distinguishes the Senate House 45 of Rome, restored under Diocletian (284–305 A.D.).

Creation of simple, clear colossal spaces is also advancing in the last examples of imperial baths, those of Diocletian in Rome (finished in 306 A.D.) and those of Constantine in Trier. Their architects accentuate the 50 power of the walls and the vertical dimension of the architectural volumes, which are more clearly subordinated to the central body of the building and, in Trier, arranged to form a gradual vertical ascent.

To call these mighty efforts 'the last flowering of 55 Roman architecture' (G. Rodenwaldt) is justifiable if one thinks of them as expressing the last stage of the pagan, secular Roman civilization; their artistic spirit, however, is already 'late antique,' pointing toward the abstract absolutism of the Byzantine world. 60

In figurative arts the break was fundamental. The social and economic system which had been supporting the vast network of workshops was rapidly disintegrating. Only in the major centers did individual ateliers maintain anything like the level of technical skill which 65 had been taken for granted in the time of Roman Peace. 'Folk art,' confined to carvers of shop signs and painters of wall posters under the early empire, had subsequently played its part in the art of lower status carried by the Roman legions to western Europe. Its 70 'anti-classical' expressionistic forms began to reach higher levels of art in the Antonine era, just as vulgarisms of common speech were becoming part of written literature in the *elocutio novella* of an Apuleius. In the column of Marcus Aurelius much of the 'drastic' expressionism, 75 to use E. Kitzinger's term, must be owed to masters no

L. 22, fig. 46; L. 24, fig. 45; L. 32, figs. 32–33; L. 43, fig. 34; L. 45, fig. 31; L. 74, figs. 122–125.

longer indoctrinated by assiduous training in copying classical sculpture. With the crisis of the mid-third century this forthright primitivistic expressiveness expands in pagan arts; it also plays a major part in the art of the catacombs.

This style abandons the belief in the beauty of the human figure and in the natural canon of proportions. Disintegrating, simplified patterns replace organic coherence; flat stocky figures with angular gestures and torn, ugly faces make mockery of the traditional organic designs. When, exceptionally, the high competence of marble work is maintained by one of the court masters, we are faced with interpretations of man which are soul-shaking in their tragic intensity. Not until the 'Man of Sorrows' will physical agony be so piercingly rendered as in the heads of the barbarians from the 'Ludovisi Sarcophagus' (*ca.* 250 A.D.), those masterly details from a luxurious, but lamely composed, fitfully crowded marble casket of a Roman general.

Such costly, majestic marble caskets as the 'Ludovisi Sarcophagus' and the imperial sarcophagus found at Acilia near Ostia (*ca.* 270 A.D.) were now becoming rare in Rome. Hundreds of smaller, cheaper sarcophagi had to serve. Their reliefs are eloquent witness to a general longing for salvation, vague and diversified on the part of the pagans, increasingly powerful and intensive in those of the Christians. The latter bend traditional pagan compositions to stand for scenes of the Old Testament which pre-figure salvation and embody the prayers for the dead in the figure of the *orans*: 'Hear my prayer as Thou didst hearken to Daniel in the den of the lions.'

Both pagan and Christian works share the 'style of crisis' which turns reliefs into woodcuts slashed with dark lines or spotted with drilled dots in a kind of sculptural pointillism. They are carried by the same ardent spirit and have the same moving appeal enhanced by the naïve simplicity and directness of 'vulgar tongue' as the early accounts of the passions of Christian martyrs —the *Passion*, for instance, of Saint Perpetua. The unique flagellation of Aelia Afanasia found in the Catacomb of Praetextatus is particularly striking in that no clear pagan prototype was at hand for this scene of Christian martyrdom and the sculptor dared to create a scene directly from life.

The paintings on walls and ceilings of pagan mausolea and Christian catacombs develop the abstract tendencies foreshadowed in the preceding era. In the case of the Christians we know that the connection of the various subjects represented is programmatic, not visual; this is probably true of many pagan compositions as well.

In late paganism many Romans had begun to worship the Invincible Sun. As cosmic charioteer, he appears at the apex of the vaults of sepulchres, just as the real sun reaches its apogee at the apex of the dome of heavens. In Christ as the Sun of Salvation, *Sol Salutis*, the Christians found an equivalent image which conveyed the quality of cosmic, universal splendor. The mosaic of the Mausoleum of Julii, discovered under St. Peter's, is revolutionary not only in portraying Christ as charioteer but also in making the abstract golden (yellow) background a symbol of celestial eternal light.

Portraiture was the one art where the demand could still be most readily satisfied, at least for the heads. Bodies were often purloined from statues of earlier times. Thus a complete bronze statue like that of the Emperor Trebonianus Gallus (251–253 A.D.) is a rarity. Nor did the body matter any longer, now that the soul was acknowledged to be the essence of personality.

Frankness was the order of the day; most of the emperors did not stay alive long enough to develop an 'image' stylized in any special direction. The mood varies from attentive suspicion, marked in the Late Severan heads, to truculence (Trebonianus Gallus 251–253 A.D.), to unrelieved brooding despair (Priest of Magna Mater Ostia). Gallienus (253–268 A.D.), who ruled long enough to have given some attention to his portraits, may have had thoughts of demanding in his portrayals the classic dignity of Zeus or the Neoplatonic emphasis on the soul so marked in the teachings of his friend and contemporary, the great philosopher Plotinus. What we see however, is the shadowed glance of a man who expects no assured blessings from his appeal to heavenly powers.

Underneath the superficial diversity of this kaleidoscopic parade of emperors, slowly, inexorably, th

L. 13, fig. 91; L. 16, figs. 134, 135; L. 22, fig. 137; L. 41, fig. 132; L. 48, pls. XIII, XI; L. 61, pl. XIV; L. 70, fig. 58; L. 76 figs. 84, 85; L. 77, figs. 58, 86; L. 78, fig. 93; L. 79, fig. 89.

human head petrifies into stone and the spirit turns to inwardness—away from this uncertain world. Whatever the superficial revivals—and the imperial portraitists looked sometimes back at Republican art (Trebonianus Gallus), sometimes back at Hellenistic ruler portraits (Gallienus)—the way was well prepared when, with the introduction of Oriental court ritual, Diocletian set the seal of his approval upon a stony abstract expressionism which strove to state the concept of the 'dominate' in terms of an unchanging staring image, immune to human emotions. The portraits of the Tetrarchs, co-rulers with Diocletian (284–305 A.D.), are not as yet icons; they are no longer individual Roman rulers. These 'born gods and creators of gods,' as they are addressed in official 15 proclamations, are automatons with blank stares, puppets subject to unknown fate. Even as gods they could not save the empire; the time of Roman paganism was fulfilled.

L. 1, figs. 90–92; L. 2, pl. XLIX; L. 5, figs. 58, 86; L. 6, fig. 89; L. 12, pls. IV, L.

V Vicisti Galilaee
Thou Hast Won, Galilean

Once again there was a great building program—the program of Constantine (306–337 A.D.), directed to the glorification of God, in whose sign he had won the rule over the empire. The enormous and novel task of creating an architecture for the Church Triumphant 'to express the belief and house the celebrations of those for whom the Incarnation and the Atonement were the very substance and meaning of the universe' (W. Mac-Donald) provided an almost explosive motivation for the outburst of pioneering Christian creativity. These buildings are symbols of faith, parts of the *Credo*, memorials of the myth of Christianity: the Church of the Nativity at Bethlehem; the Holy Sepulchre and the Anastasis, memorials of Passion and Resurrection at Jerusalem; St. John's and St. Peter's in Rome; and the Church of the Holy Apostles at Constantinople. Constantine, the second Moses, who 'like Moses was brought up in the very palaces and bosoms of the oppressors' (Eusebius), the *Isapostolos* of the eastern church, equal in rank to the apostles, initiated, guided, and aided this creation of Christian architecture. Yet politically and constitutionally Constantine was continuing much of Diocletian's work. His secular building program in Rome and especially in Trier was imperial in character and formed a continuation of Diocletian's *cupiditas aedificandi*. The crowning touch of Constantine's imperial building activities, the foundation of Constantinople (324–330 A.D.), was the consequence of the experiments of the Tetrarchs to find a capital better suited to the perilous situation of the empire than Rome.

Constantinople was to be a Christian Rome, but a Rome nonetheless, with fora, with senate, and with an imperial palace. Once again a Roman emperor foregathered masterpieces of Greek art for his capital, including some of the same 'idols of demons' which were being overthrown by zealous Christians all over

L. 24, fig. 34; L. 33, pl. LI; L. 48, fig. 140; L. 69, fig. 141.

the empire. It was hardly Constantine's aim to expose these pagan sculptures to ridicule and contempt as some pious Constantinopolitans elected to think. Rather, he seems to have had a sense for the necessity of adorning the new imperial city with famous works of art as symbols of its imperial position.

Imperium was still the primary concern. The reliefs hastily pilfered to adorn the Arch of Constantine in celebration of his victory over Maxentius in 312 A.D. were taken only from monuments of emperors considered exemplary—Trajan, Hadrian, and Marcus Aurelius. Even though the entire triumphal arch is placed under the concept of a conqueror *instinctu divinitatis*, 'by divine inspiration,' as its inscription proclaims, even though Christians might interpret the reliefs representing the drowning of the host of Maxentius in the Tiber, as an analogue to the drowning of the host of the Pharaoh in the Red Sea, Constantine is envisaged by the designers of the arch not as 'servant of God clad in heavenly panoply,' as a second Moses, but as the latest and greatest in the line of Rome's great rulers.

This, to be sure, was the Roman view, and may have represented special pleading for Rome. The monument itself, with its imposing architectural form and its confession of poverty in the re-use of sculptural decoration, is symbolic of Rome's waning, ambiguous position. Less than a century later the capital of the world fell to the Goths.

Those reliefs made for the Arch of Constantine by contemporary sculptors are almost certainly products of Christian workshops, the height, as it were, of the development of Christian folk art, sufficiently inspired to turn the traditional scenes of imperial liberality into humble, urgent appeals by masses awaiting salvation. They are the culminating point of that Roman expressionism which had developed during the period of crisis.

We may doubt that they pleased Constantine. The portraits of the emperor and of his family indicate a striving for dignity and majesty and as his rule progresses, even the Christian reliefs on sarcophagi seek to retrieve something of classic proportion and beauty.

'Constantinian classicism' is inspired not by an aesthetic desire to imitate classic form, as was the case in the revivals under Augustus and Hadrian. Rather, the confidence that an *imperium* had been reconstituted seems to have impelled the artists to recall those elements of traditional form which connoted clarity and order. Some influence, too, must be allowed to the enormous 'pump-priming program' which the founding of Constantinople must have represented for the artists of Asia Minor, where the revolutionary 'style of crisis' had not reached forms as disruptive as in Rome, and where the local style of the new capital carried on some of that rich elegance which had characterized 'Asiatic' workshops under the empire. In Rome, the sarcophagus of the Consul Junius Bassus (died 359 A.D.), in which a soft 'beautiful' style is applied to Christian themes, probably mirrors a Constantinopolitan inspiration.

The soft but somewhat squat figures of this tentative return to the classic are succeeded by the poetically linear, attenuated, rhythmically patterned images of the delicate style often described as 'Theodosian classicism' (*ca.* 380–410 A.D.). The 'Missorium' of Theodosius I, which commemorates the tenth anniversary of his accession (388 A.D.), is the masterpiece of this disembodied evocation of classical formulae, so well suited to the luxurious patterns of the court workshops of Byzantium. Some imperial portraits made in Asia Minor are of similar elegant delicacy; the crowning achievement in marble sculpture is the beautifully carved sarcophagus of a child, the so-called 'Prince's Sarcophagus' found in Constantinople.

If it is true that this art mirrors the taste of Theodosius I (379–393 A.D.) and of his court, then the same emperor, whose edicts effectually led to the destruction of pagan temples and sent thousands of classical statues to the limekilns, was invoking the beauty of classical art in his own immediate environment. The hauntingly unreal classic form transmuted into patterned beauty make this the first Byzantine style.

Consonant with the new style of Proto-Byzantine palatial luxury, some extraordinary residential buildings were erected, for example in Ostia; the splendor of their marble-faced, marble-paved interiors is enhanced by graceful use of arcaded loggias which were to live on in urban houses of medieval Italy.

All through the fourth century artistic production of marble sarcophagi and mosaics continues in Rome and other centers in Italy. Arts not dependent on large-scale labor or large-scale supplies of material, the courtly arts of ivory carving and beautiful metalwork, flourished briefly at Milan, temporary imperial capital and the city of St. Ambrose (bishop from 374–397 A.D.). The art of manuscript illumination expands greatly as parchment books replace papyrus rolls. More than any other medium the book was to prove the lifeline of survival for classic art and classic thought.

But the Roman west was declining. In 407 A.D. Britain was abandoned for good. The frontiers on the Rhine and on the Danube were collapsing. Franks, Alamanni, Vandals, Suebi poured into Gaul and Spain. The wealthy middle class, backbone of Roman urbanism, was rapidly being squeezed out of existence, unable to bear the burdens of public offices now that the economy was disintegrating. Fortified manors rose in the countryside.

In a symbolic sweep over the two classic lands the Visigoths despoil Greece (399 A.D.) and capture Rome (410 A.D.), shattering Vergil's dream of *imperium sine fine*, an empire without end. St. Augustine's 'City of God' is to take the place of imperial Rome. With the melancholy spectacle of Rome's most cherished statues being dragged from the Capitol to Vandal ships of Genseric, to be taken to the new German capital at Carthage (455 A.D.), the role of Rome as center of Roman art is ended.

The heart-lands of eastern Hellenism, Asia Minor and Syria as well as the rich agricultural domains of North Africa, had survived the calamities of the third century

L. 2, figs. 94–98; L. 4, fig. 142; L. 16, figs. 132, 141; L. 18, figs. 131, 130; L. 20, fig. 139; L. 27, fig. 145; L. 35, fig. 143; L. 52, pl. XV, fig. 43; L. 56, pls. XXIV, XXV, L; L. 59, fig. 144; L. 67, figs. 9, 10; L. 86, pl. XXXVIII.

better than Italy. In cities like Nicaea, Nicomedia, Ephesus, Sardis, Aphrodisias in Asia Minor, or in the great cosmopolitan capital of Antioch in Syria, there was no sharp break in the artistic tradition so drastic as that which befell Rome. As the imperial palaces, hippodrome, fora, columns, baths, and aqueducts rose in Constantinople, other Asiatic cities followed suit with schemes of 'urban renewal.' Some of the most imposing colonnaded avenues were constructed late in the fourth century A.D. (Ephesus, Sardis).

Construction and destruction went hand in hand. In Ephesus the pious lady Scholastikia (late fourth century), whose Christian zeal was celebrated, pulled down the pagan sanctuary of the Hestia of the Council to reconstruct a huge Roman bath—including the bordello. Temples and sepulchres were despoiled to build churches and martyria. Entire regions of marble buildings were pulled down and their columns and pediments built into fortress walls. Of necessity, military architecture flourished, most impressively in the great walls of Constantinople. The cities retrenched behind their towered barricades but lived on. Productive workshops of mosaicists throve in the service of both the ecclesiastic and the imperial or secular patrons. Until the sixth century A.D. sculptors of high skill could still be found to carve monumental portrait statues in Constantinople, in Ephesus, and in Aphrodisias.

The mosaics of Antioch continued to illustrate the traditional themes of classic education made acceptable by the emergence of Christian *paideia*—with nary a reference to Christianity. Yet this was the city of St. John Chrysostom, the city where Julian the Apostate found nobody except one old priest with a meager goose for sacrifice at the famous temple of Apollo at Daphne. (361 A.D.)

Another complex of traditional secular subjects centered on the celebration of the emperor and his virtues in council, battle, and hunting. From the pagan imperial villa of Piazza Armerina to the Sacred Palace of Constantinople these secular scenes, as well as scenes of entertainment—circus races, acrobats, dancing girls, mime and theater—escaped the brunt of iconoclastic tendencies directed by many Christians toward the images. Even mythological scenes were acceptable if

understood as part of cultural education, as learned quotations and allusions; Christian poets did not hesitate to compare a Christian bride and bridegroom to Venus and Adonis. Claudian (*ca.* 395–404 A.D.), perhaps a nominal Christian, wrote in Latin on 'the Rape of Proserpina'; Nonnus (*ca.* 450 A.D.), wrote a huge poem on Dionysos and a paraphrase of the Gospel of St. John in Greek; Procopius of Gaza (*ca.* 500 A.D.), certainly a noted Christian theologian, wrote with equal eloquence on the Resurrection and on mythological pictures depicting the adulterous love of Phaedra. In its urban and secular aspect the so-called First Golden Age of Byzantium under Justinian (527–565 A.D.) had some right to call itself 'Roman'—even if these *Rhomaioi* spoke Greek.

The new concept of a Christian emperor by Divine Grace was unquestionably the great force which kept Roman imperial tradition alive. 'Thus the God of All, the Supreme Governor of the whole universe by His own will appointed Constantine to be prince and sovereign... the only one to whose elevation no mortal may boast of having contributed...': in these historic words the Bishop Eusebius of Caesarea, Constantine's Christian adviser, had formulated the emperor's position in a Christian universe. This Constantine may have believed. Time and again he emphasized in his own utterances his direct responsibility to the Divine Being. He seems to have considered, too, that he was responsible for the peace and well-being of the Church. Here lies the root for the growth of Byzantine imperial position which eventually made the emperor superior to the patriarch.

The new ideal of imperial majesty independent of mortal concerns and gazing in direct communication to the world eternal found powerful embodiment in such masterpieces as the colossus of Constantine, which originally presided over his basilica in Rome. With early Roman emperors divinity had been a matter of legal procedure, a *pour les merites* awarded after death for good performance. In the time of crisis a feeling began to grow that the position of the emperor as such had a loftiness which made him akin to the gods. But the relation was vague, and wavered between subordination, equality, and special kinship with individual divinities. To be the unique anointed vice-regent of Christ on

L. 2, fig. 91; L. 27, fig. 60; L. 39, pls. XXIV, XXV, L; L. 40, pl. LI; L. 85, fig. 94.

earth, mediator between the worlds invisible and visible, implied a far more sublime vision.

Something of the dignity and charismatic grace of the emperor is reflected upon the members of the imperial family. On the other hand, despite their superhuman stony dignity, the sculptured portraits of the house of Constantine retain a touch of the Roman concern with the individual. If not as individuals, they are still recognizable as members of a family.

By contrast, the same Roman quest for recognizability is bathed in unrelieved gloom in the portrait from Ostia of a man in the traditional official Roman garment, the toga. He has been identified as a member of that circle of highly educated, consciously Roman pagans who to the end of the fourth century waged a losing battle to salvage something of the Roman tradition in the rising tide of Christianization. His is one of the last significant statues made in the Roman west. It is tempting to recognize in this worried and depressed countenance Quintus Aurelius Symmachus, leader of the last great opposition to Christianity in the Roman Senate, whose dreams were of a return of pagan greatness, beauty, and piety.

Wholehearted devotion and adoration of Roman antiquity was the major tenet of this die-hard pagan circle—'vetustas... nobis semper adoranda est' (we must always worship antiquity), wrote Macrobius, one of its members. And thus we must understand the antique costume, the toga of the statue, which probably was about as common in Rome at the time as the barrister's wig is today. Claudian, the poet of this circle, speaks of 'Winged Victory... the protector of the Roman toga...' as the two symbols of this last phase of Roman paganism (in a poem on the Sixth Consulate of the Emperor Honorius, 404 A.D.).

The 'Victory' he refers to had come to Rome with the 'noble images' from Tarentum in 212 B.C., and helped Hellenize the capital. As a symbol of the triumphant establishment of the empire she was carried in the great funeral procession of Augustus. The last emperor before the crisis (Alexander Severus, d. 235) saw himself borne on her wings up to heaven. Now, after five hundred years of victorious protection of Rome, 'Victory' had

been evicted from the Roman Senate by the Christian Emperor Constantius on his visit to Rome in 357 A.D.

The attempt of the leader of paganism, Symmachus, to bring 'Victory' back (in 384 A.D.) and the thundering rebuttal of his petition by St. Ambrose are symbolic both of the enormous spiritual strength of the Church and of the extent to which both contestants still have before them the notion of the greatness of Rome and the Roman empire. If Symmachus claims that Rome has won its greatness by the virtues and customs of its ancestors, Ambrose takes the view that Christian Romans are the true Romans. Writing *On Faith*, he held: '*Ut ibi primum fides Romano imperio frangeretur, ubi fracta est Deo*' (Where loyalty to the Roman empire is broken, the faith to God is broken). Both speakers revive in an ancient rhetoric device of Cicero the image of Roma as the living mother of the emperor and the empire. 'Noble princes... respect my age... let me use the ancestral rites that have put the earth under my laws... don't let me be subject to derision in my old age...'; thus the pagan Roma of Symmachus. To which the Christian Roma of Ambrose replies: 'Why do you daily pollute me with worthless blood of innocent flocks... By courage of men, not by rituals, have I subjugated the world... Even though I am aged I am not ashamed to convert myself [to Christianity] with the entire world... As to Victory, which the pagans threaten will leave Rome, she is a present; she is not a [divine] power; given by legions, not by religions...; *legionum gratia, non religionum potentia...*' But neither pagan nor Christian exhortations could keep 'Victory' alive; while fleeing the legions, Victories were turning into angels, as on the 'Prince's Sarcophagus' made just about this time.

Throughout the 'great debate' one has the feeling of the emperor being enthroned between two urgent supplicant figures, as is indeed the case in pagan and Christian compositions of this time. Ever more did the imperial *auctoritas* and *maiestas* shape the rising Christian art. If the emperor became a second Moses, Moses became, in representations of the Old Testament, if not Roman emperor, at least a Roman tribune, a leader of people. For it was the Roman sense for concreteness and continuity of grand historical actions rather than the

L. 7, figs. 94–96, 98; L. 11, fig. 59; L. 77, fig. 143; L. 83, figs. 139, 141, 145.

III

If any Roman statue can claim to be a symbol of the Eternal City, it is the horseman of bronze in the center of Michelangelo's Piazza di Campidoglio. From the twelfth century on, he stood in front of the Lateran Palace revered—mistakenly—as the sainted Christian Emperor Constantine, or as an anonymous hero who had saved ancient Rome from a siege. When Cola da Rienzi sought to restore the ancient grandeur of Rome and took a bath of purification in Lateran Square, wine and water flowed from the nostrils of the horse (1347 A.D.). To the artists of the renaissance, the horseman was an awe-inspiring example of superhuman technical prowess and enormous artistic skill of classical antiquity. Brought to the Capitol by Pope Paul III in 1538, the group was integrated into Rome's most festive space when Michelangelo placed Marcus Aurelius on the oval base which echoes the oval of the piazza.

The emperor reviews and addresses the army and the people. Marcus wears his actual battle dress; the short tunic and a cloak held by a round brooch on his shoulder, as on the reliefs of the Marcus column (Figs. 122–125). With his left hand, he reined in the horse. Parts of the bridle survive, linked by large ornamental metal plaques. A broad leather saddlecloth with fringes is held by a belt; saddles were as yet unknown. The flame-like vertical lock of the horse was by medieval fabulists explained as a bird, a cuckoo in one story, an owl which will announce the coming of the Last Judgment in another.

The view shown emphasizes the typical elements of authority and command, the majestic gesture, the unruffled calm of the bearer of *imperium*. The horse, massive and fiery, is barely tamed. Seen close-up, the face of Marcus Aurelius is thoughtful, uninvolved with the momentary situation, the face of the philosophic thinker whose *Meditations* preach the acceptance of the universe as arranged by providence.

> Piazza di Campidoglio, Rome. Bronze with traces of gilding. Originally on the Capitol, toward Forum side. A medieval guide, *Mirabilia Urbis* speaks of the small figure of a 'king' (subjugated barbarian) under the horse's right front hoof. Some scholars accept, others (M. Wegner) reject this reconstruction. Comparing coin portraits, Wegner dates the statue to 164–166 A.D. as monument for victory over the Parthians in Mesopotamia. Height 13 ft. 7 7/8 inches (4.24 m.).
>
> K. Kluge and K. Lehmann-Hartleben, 2, pp. 85 ff., pl. 25. M. Wegner, II:4, pp. 42, 100, 190 f., pls. 22 f. M. R. Scherer, fig. 2, pls. 5, 7, 8, 22, 66, 211–214, medieval, Renaissance representations. J. S. Ackerman, *Renaissance News* 10:2, 1957, medieval and renaissance interpretations. *

III The Philosopher as Emperor — The Equestrian Statue of Marcus Aurelius

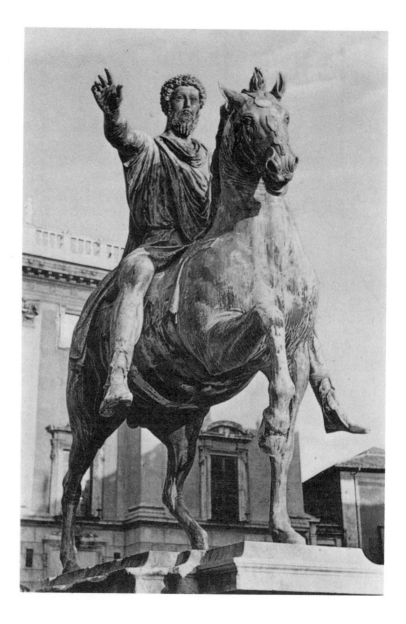

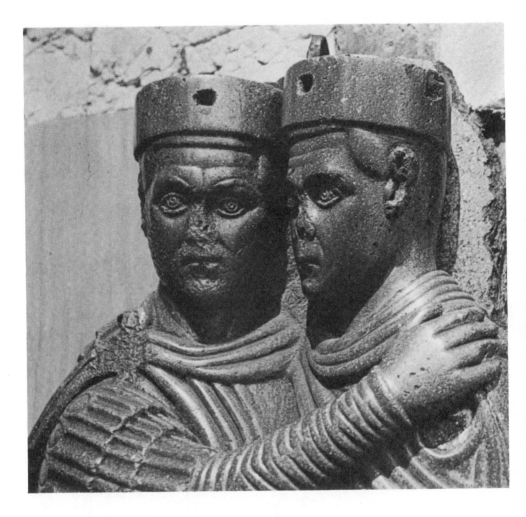

IV Four Imperial Rulers — The Tetrarchs of San Marco, Venice

IV

Expressionism burst upon European art of the twentieth century like a bombshell in the upheaval of values that preceded, accompanied, and followed the First World War. For the first time the eye became sympathetic to works of ancient art which sacrificed the beauty of man to anti-classical values. Among the most important of these are the quadruple statuary portraits now at Venice.

The Emperor Diocletian had by sheer force stopped the seemingly irresistible disintegration of the Roman Empire. There was abstract symmetry in his plan to divide the rule among two senior emperors (*Augusti*) and two junior emperors, or Caesars. There was conscious transcendentalism in his avowal of the god-given, autocratic position of emperors, in his adoption of divine names for the rulers and of the age-old Oriental court rituals of supreme kingship. *Dominus*, the Lord, replaced *Princeps*, the First Citizen.

The revolutionary response of art cannot be explained by political ideology alone. The transition from love of this life to other-worldly abstraction both goes beyond and falls short of the immediate requirements of the imperial program. These figures do not convey overpowering authority; they cling to each other in foreboding. The closely related, cruder groups of the Vatican make the four rulers look like scared monkeys.

There is much that indicates a decisive break between the classical world and the Middle Ages. Instead of marble with its resemblance to human skin, porphyry, purple, the color of Eastern royalty, makes the kings unreal if regal. In the Venice sculptures, two pairs of stony abstractions are presented in ceremonial embrace symbolizing the hoped-for (but not realized) concord of the rulers. The other hands grasp eagle-headed swords, symbols of readiness to defend the empire. The bodies are puppet-like, stiff displays of tunic, armor, and cloak. The faces are staring masks gazing not toward each other, not toward the people; immobile, tensely attuned to some message from far away. Our illustration shows only the heads of the Caesars, Galerius and Constantius Chlorus.

Piazza di San Marco, Venice, immured in south corner of the cathedral. Four figures originally carved of one piece of porphyry, presumably from Porphyry Mountain (*Mons Claudianus*) in the Sinai, reserved for imperial sculptures. Height of entire block 4 ft. 3⅛ inches (1.30 m.). According to one tradition, brought to Venice from Acco in Palestine by the Doge Lorenzo Tiepolo in 1258. The emperors wear long-sleeved tunics, cuirasses with jeweled lower border, long cloaks fastened by four-leaf pins, and the low cylindrical caps known as imperial headgear only in this period. Holes in caps are perhaps for attachment of jewels. At extreme right (not shown in our plate), Diocletian then Maximian, the Augusti; extreme left, Galerius, persecutor of Christians, Constantius Chlorus, father of Constantine, the Caesars. Made by an imperial court workshop in one of the Eastern provinces (Egypt?) where the expressionistic style flourished more markedly than in Italy. Date 295–305 A.D.

R. Delbrueck, *Antike Porphyrwerke*, 1932, pls. 31–34. H. P. L'Orange, *Studien*, pp. 16 ff., pp. 100 ff., figs. 32, 34, 41. H. Peirce and R. Tyler, *L'Art byzantin I*, 1932, p. 83, pls. 2, 3. W. F. Volbach and M. Hirmer, pl. 25. *

Greek summation of the dramatic essence of history which gave the visual form to Christian epic.

Christ as imperial ruler, as a Roman judge, as the *Praeses* of a circle of sacred philosophers, gave form and grandeur to scenes of the Tradition of Law and of Majesty of the Lord.

The continued appearance in art of the cuirassed imperial warrior is paralleled by the appearance of archangels and other warrior saints.

A keen student of this *Birth of the Middle Ages* (H. St. L. B. Moss) has well characterized the fourth century A.D. as 'an Age dominated by the Unseen.' 'Never was the divine voice heard more frequently and plainly,' by both pagans and Christians. 'Visions became ever more prominent and the world of dreams steadily encroached upon man's waking hours... The internal conflict and emotional experience take on a heightened value, beside which the outer world fades into irreality.'

This total shift of attitude toward reality is reflected in art. The abstract symbolizes the invisible, which is now the real, and the concrete and visible becomes the unreal. Christian buildings are no longer subject to Vitruvius' criteria of *firmitas, utilitas, venustas* (sound construction, usefulness, attractive appearance). Already the un-classical monumental architecture of Diocletian and Constantine had relied on the union of functional necessity with monumental unadorned authority. It had relied on 'the moulding of masses for the composition of spaces' (W. MacDonald). Christian architects seek to thin out the massive severity of these masses in order to create a spiritualized, visionary, mysterious splendor of interior. At the same time the entire building is now subject to symbolic interpretation as a celestial universe. The *via triumphalis* of the basilica toward the altar, the dome, the crossing, the apse, the number of windows are primarily symbols of faith translated into perishable matter and only secondarily physical, architectural problems.

The celestial hierarchies of a Christian cosmos are best expressible in terms of abstract shapes of architectural forms. For visual art, abstract compositional arrangements must serve to symbolize them. The human form, and, indeed, all forms of nature, are now the realm of the unreal; hence their flattened shadowy quality; hence,

too, the decline of sculpture, which by its three-dimensional concreteness resists this reduction to a symbol of a dematerialized world.

The terrestrial hierarchy of the imperial court corresponds to the celestial hierarchy like a mirror image, as its organization proceeds from the ceremonious to the symbolically ceremonial. The frontal dignity of the iconic image prevails, as in the *missorium* of Theodosius. Divinely defined essence, not action, is the true quality of the Christian universal ruler; and thus action, so important in the Roman ruler concept, is reduced to the position of an attribute.

To express the visionary splendor of the unseen, abstract patterns of jeweled gorgeousness come into use. They are not confined to art. The change in 'style of life' (Huizinga) led to a change from the costumes of antiquity, with their easy rhythmic flow of many folds, to garments of heavy fabric with great displays of ornamental splendor. Imperial purple and jeweled diadems, golden vestments and tiaras still preserved in the Eastern Church come into use. This abstract basis and jeweled quality appear even in seemingly classic figures. The development toward the abstract had been building up gradually over a long time, but the irreversible break with the Greek and Roman past occurs now.

Banished from the classical world, the Miraculous has returned to the images. Pagan idols weep, Christian images heal. The concept of miraculous, magic power is most clearly revealed in the emergence of *acheiropoieta*, of images not wrought by human hand.

Now that they are reflected images of invisible essences, imperial effigies acquire something of the nature of miraculous icons.

Modern scholarship has often envisaged the birth of Christian art in its triumphant phase as a process of the spirit building its body, '*der Geist, der sich den Koerper baut...*' Clearly, right after the Edict of Milan (313 A.D.), Christian architects deal sovereignly and inspiredly with the traditional Roman building types, with Roman basilicas and Roman domed rotundas.

In sculpture, the first triumphant explosion of Christian themes out of the catacombs onto the world-wide daylight scene of the Roman state leads to an ecstatic density of crowded narration, as on the Lateran sarcophagus, as

L. 5, fig. 139; L. 25, fig. 45; L. 26, figs. 32–34; L. 53, fig. 145; L. 64, pls. L, LII; L. 67, fig. 144; L. 89, fig. 142.

42

if the sculptors cannot find enough space to profess and praise all the miracles of the Lord.

But in sculpture, as in mosaics and in architecture, the structuring element of Roman disciplined authority becomes manifest, as well-pondered arrangements of arcaded sarcophagi (as in that of Junius Bassus and in the series of the so-called 'city-gate' sarcophagi) and the grandiose apsidal compositions of the churches begin to take canonic shape. This authoritative loftiness and majesty speak from the basilicas and central buildings. There is a similar structuring and, in a sense, a classicizing process to be observed in the rise of the great Latin-Christian literature of the west, from the witnesses of the time of persecution (Arnobius, 305 A.D.) through St. Jerome's majestic, classically purified, Latin rendering of the Scriptures, to the soaring arches and domes of St. Augustine's (354–430 A.D.) majestic edifice of a philosophically founded Christian universe.

If we look back upon the entire course of Roman art, we perceive that with all their imitation of Greek form, with all their looking at the world through other people's eyes, the Romans have yet expressed a world view. It is clearest in their urbanism and their architecture, but is a constant undercurrent in figurative art as well. To set humanity into the framework of an ordered and disciplined society; to recognize the concrete and factual differences from individual to individual and from group to group and yet encompass them in this *auctoritas*; to express this ultimately ecumenical ideal by allegoric symbols concerned with war and peace, prosperity, justice; to encourage service to this society by the display of exemplary Roman behavior in real events of history— these are the underlying constants for which Roman art strove to create the necessary aesthetic forms. Their

L. 6, fig. 139.

ultimate summation is the *imperium*, and they raise Roman art to a symbolic level which has kept its appeal through the ages.

'The Heaven is our Fatherland.' In a world which had turned its highest aspirations to the beyond, there would [40] seem to be no place for that belief in the validity of the human form which, even in Roman interpretations, was the vital aspect of classical art. Yet the new religion could not discard its appeal. That ancient art survived to form the foundations of Byzantine art in the east, of early [45] medieval art in the west was the final achievement of Rome. Without its creation of imperial iconology applicable to the Lord of Hosts, without its conserving power and its reinterpretative adjustment of the Greek tradition to new historical and ideological concepts, [50] Christian art, like that of the Islam, might have turned un-iconic and relinquished any representation of man and of this world. Without Rome's creative revolution in architecture, Christian religion might not have found that immense reservoir of dignified and impressive forms [55] which formed the starting point for medieval architecture.

Just as classical education, Roman art did not die at once nor completely. Great mythical hunters are still shown as symbols of manly virtues on the floor mosaics [60] of early Byzantine villas of Antioch. Idyllic shepherds of Pompeian antecedents still pasture their flocks on imperial silver plate in the time of Heraclius (610–641 A.D.). Roman book illustrations continue to be copied, causing classic revivals in east and west; but the creative vision [65] of the age is seen in golden splendor in the mosaics of the 'Sacred Fortress' Ravenna and in the soaring dome of Santa Sophia.

HISTORICAL OUTLINE

including dates of some monuments discussed in this book. If no location is indicated, buildings and monuments are understood to be in Rome. A complete chronological index of these will be found in S. B. Platner and T. Ashby, *A Topographical Dictionary of Ancient Rome* (Oxford University Press, 1929). For select literature on Roman history see C. A. Robinson, *Ancient History* (Macmillan, 1951); a one-volume treatment, A. E. R. Boak, *A History of Rome to* 565 A.D. (Macmillan, 1955); for extensive treatment, *Cambridge Ancient History* (Cambridge University Press) volumes IX–XII.

Dates before birth of Christ:

| 2000–1000 | Copper and Bronze Age settlements in Rome. |

1184 Legendary arrival of Trojan Aeneas in Italy.

800–600 Iron Age huts and burials in Rome.

753–510 Traditional dates for the seven kings of Rome.

600–510 Growth of Rome as city under Etruscan influence.

509–27 THE ROMAN REPUBLIC

509 Lucius Junius Brutus, first consul. Dedication of the Temple of Jupiter on the Capitol.

498 Temple of Saturn in Forum (rebuilt 42 B.C. and fourth century A.D.).

484 Temple of Castor in Forum dedicated (restored 117 B.C., 6 A.D.).

390 Gauls raid Rome.

366 Temple of Concord dedicated (restored 121 B.C., 12 A.D.).

350, approximately. Rome completes city wall, enclosing largest area of any city in Italy.

343–270 ROME CONQUERS CENTRAL ITALY

325–304 War with Samnites.

298–290 War with Samnites, Etruscans, and Gauls.

281–272 War with Tarentum and King Pyrrhus of Epirus.

280 Volsinii captured. 2,000 Etruscan bronzes taken to Rome.

273 Colony of Cosa founded.

264–146 ROME CONQUERS MOST OF THE MEDITERRANEAN

264–241 First Punic War, with Carthage.

263 Triumphal paintings of war—scenes displayed for the first time.

218–201 Second Punic War.

211,209 Sack and plunder of Syracuse and Tarentum. Greek works of art taken to Rome.

200–60 FORMATIVE PERIOD OF ROMAN ART

200–60, approximately. First Pompeian style of wall decoration.

200–196 Second Macedonian War. Roman general Flamininus proclaims 'freedom of Greece.'

193 Porticus Aemilia (storage warehouse) on Tiber.

192–189 War with Seleucid King Antiochus III of Syria.

190 Battle of Magnesia, defeat of Antiochus.

179 Basilica Aemilia in Forum (restored 54, 32 B.C., and in Augustan age).

171–167 Third Macedonian war.

168 Macedon defeated at Pydna.

166–88 Roman and Italian merchants in Delos. Statues of Romans by Greek sculptors.

149–146 Third Punic War, Carthage destroyed.

146 Corinth destroyed and plundered. Corinthian bronzes found in graves.

133 Rome inherits kingdom of Pergamon, art center of Asia Minor.

133–31 DECLINE OF THE REPUBLIC. REVOLUTIONS AND CIVIL WARS

133–121 Attempts at social and agrarian reforms by Tiberius and Gaius Gracchus.

129 Province of Asia organized.

121 Province of Gallia Narbonensis organized.

111–105 War with King Jugurtha in Africa.

109 Aulus Postumius Albinus defeated by Jugurtha. His brother Spurius Postumius Albinus condemned for defeat.

101–102 Invading Germans (Teutones, Cimbri) defeated by Marius (157–86).

100–80,	approximately. Forum and Basilica, Pompeii. House of Griffins (paintings), Rome.
90–88	Uprising of Italic allies (Social or Marsic War).
89–85	War with King Mithridates VI of Pontus.
88	Delos sacked by general of Mithridates.
86	Athens sacked by Sulla. Mithridates defeated.
88–82	Civil war between Marius Sr. (to 86) and Jr. (to 82) for popular party and Sulla (138–78) for senate.
81–79	Dictatorship of Sulla.
80,	approximately. Building program initiated under Sulla. Sanctuaries of Fortune, Praeneste; Jupiter, Anxur; 'Vesta', Tivoli. Nile mosaic, Praeneste.
80	Pompeii becomes a Roman colony.
78	Tabularium built.
73–71	Verres as governor plunders art in Sicily.
69	Dedication of restored temple of Jupiter on the Capitol. Statue by Athenian sculptor Apollonius.
60–30,	approximately. LATE REPUBLICAN ART
60–30	(or 20) Second Pompeian style of wall decoration.
59–48	Struggle for power between Pompey and Caesar.
59–53	First Triumvirate: Pompey, Caesar, Crassus.
58–50	Caesar in Gaul and Britain (54).
55	Pompey consul. Theater of Pompey. Statues of provinces (and Pompey)? by Coponius; 106–48, Pompey; 102–44, Caesar; 106–43, Cicero; 95–46, Cato Uticensis.
53	Parthians defeat and kill Crassus at Carrhae, capture Roman standards.
49–45	Caesar's Civil War against senatorial party, Pompey, Alexandrians.
48	Death of Pompey; his party continues fight.
46	Pompeians defeated in Africa. Suicide of Cato at Utica.

54–46	Forum of Caesar. Venus statue by Greek sculptor Arcesilaus.
50–40,	approximately. Paintings of Villa of Mysteries, Pompeii; of Villa at Boscoreale; Odyssey landscapes, Rome.
46	Arelate (Arles) founded as colony.
44	Caesar murdered by conspiracy of anti-monarchic senators.
44–31	Octavian (Augustus) struggles for and wins sole leadership. 63 B.C.–14 A.D., Augustus; 82–30 B.C., Mark Antony; 63–12 B.C., Agrippa, first helper of Augustus; 58 B.C.–29 A.D., Livia, wife of Augustus.
43	Second Triumvirate: Antony, Octavian (Augustus), Lepidus.
42	Battles of Philippi. Last Republican army of Caesar's slayers, Brutus and Cassius, defeated by Antony and Octavian.
36	Pompey's son Sextus defeated in Sicily. Lepidus deposed.
36–32	Antony in the east; marries Cleopatra, queen of Egypt.
32–31	War between Antony and Octavian. Octavian wins at Actium.
30	Octavian invades Egypt. Suicides of Antony and Cleopatra.
34	Basilica Aemilia reconstructed. Frieze with legends of Rome.
27–B.C.–14 A.D.	PRINCIPATE OF AUGUSTUS
27	Octavian receives the name of Augustus. Reorganizes the Roman state; rebuilds Rome.
30 B.C.–	AUGUSTAN AND JULIO-CLAUDIAN
50 A.D.	CLASSICISM IN ART
25 B.C.	Baalbek settled as Roman colony (Heliopolis) by Agrippa.

Dates after the Birth of Christ

A.D.	
71–75	Forum of Peace.
75,	before. Temple of 'Jupiter', Heliopolis (Baalbek).
79–81	Rule of TITUS
79	Eruption of Vesuvius destroys Pompeii and Herculanum. Death of Pliny the Elder, author of *Natural History*, source for art history, especially Greek art in Rome.
80	*Amphitheatrum Flavium* (Colosseum) dedicated by Titus.
81–96	Rule of DOMITIAN.
82?	Arch of Titus dedicated.
83	War with Germans. German frontier fortifications (*Limes*) including Saalburg established.
85–89	War with Decebalus, King of Dacians.
92	'Flavian Palace' on the Palatine by architect Rabirius.
96?	Friezes from a monument of Domitian ('Cancelleria' friezes).
96–180	THE ADOPTIVE EMPERORS IN HEIGHT OF POWER AND PROSPERITY Great building activity in the provinces.
96–98	Rule of NERVA.
97	Forum of Nerva *(Transitorium)* dedicated.
98–117	Rule of TRAJAN (born 53 A.D.).
100–120,	approximately. TRAJANIC 'FACTUAL CLASSICISM' IN ART.
100	Thamugadi (Timgad) founded as colony.
104?	Frontinus *On the Water Supply of Rome* (basic book for Roman water systems and aqueducts).
101–106	Wars in the Balkans against Decebalus, King of Dacians. Suicide of Decebalus, capture of treasure of 5 million pounds of gold.

A.D.	
112	Forum of Trajan, including Basilica Ulpia, column of Trajan dedicated, after designs by Apollodorus of Damascus, architect and military engineer of Trajan.
112	or later. Trajan's harbor at Ostia. 'Market of Trajan' in Rome.
113	Death of Marciana, sister of Trajan.
113–117	Campaign against Parthians, advance to Persian Gulf, retreat.
115	Earthquake in Antioch. Reconstruction and beginning of series of mosaics continuing to sixth century A.D.
115,	approximately. Temple of 'Bacchus', Heliopolis (Baalbek).
117	Death of Trajan in Cilicia.
117–138	Rule of HADRIAN.
120–160,	approximately. HADRIANIC AND EARLY ANTONINE 'ROMANTIC CLASSICISM' IN ART.
118–128	Pantheon, by Hadrian as architect.
120–	Mass production in brick industry in the service of Hadrian's building program in Rome and Ostia.
121–125	Hadrian travels in Gaul, Britain, Spain, Greece.
128–133	In Africa, Greece, Asia, Syria, Egypt.
130	Death of Hadrian's favorite Antinous in the Nile Cult, statues, and relief of Antinous. Antinoe (Antinoopolis) founded in Egypt; source of some Fayoum portraits.
130,	approximately. Earliest mythological sarcophagi made in Roman and Attic workshops.
130–138	Main construction period (under Hadrian) of his villa in Tivoli.
138–161	Rule of ANTONINUS PIUS.

150 approximately. Tomb of the Pancratii (stucco reliefs), Villa of the Nile, Lepcis (fishing mosaic).

160–235 ANTONINE AND SEVERAN 'EXCITED STYLE' IN ART Sometimes also described as 'baroque'. Mythological, battle, marriage sarcophagi made in Rome, mythological, battle, amorini sarcophagi in Athens. Beginning of Asiatic workshops of columnar sarcophagi.

161 Temple of Antoninus and Faustina (Sr., his wife).

161–169 Joint rule of LUCIUS VERUS AND MARCUS AURELIUS.

161–180 Rule of MARCUS AURELIUS.

161–170, approximately. Sarcophagus of Euhodus.

162–166 Verus conducts war against Parthians.

166? Equestrian statue of Marcus Aurelius.

166–168 German tribes penetrate to Northern Italy, are defeated by Marcus.

170–175 War with Germans and Sarmatians.

176 Triumph over Germans and Sarmatians. Triumphal reliefs of Marcus.

177–180 Second War with German tribes.

178 Earthquake in Smyrna. Reconstruction with help of Marcus in honor of Faustina Jr. (his wife). Agora.

170–180 Pausanias, *Guide to Greece*, describes art treasures seen by Roman artists and patrons.

180–193 Rule of COMMODUS.

180–190, approximately. Column of Marcus Aurelius.

193–235 RULE OF THE SEVERAN DYNASTY

193–211 Rule of SEPTIMIUS SEVERUS. (Wife, Julia Domna; sons, Geta, Caracalla.)

197–199 War against Parthians in Mesopotamia.

202–203 Severus in Egypt and North Africa.

203 Arch of Septimius Severus in the Forum.

204 Arch of Septimius Severus in his native city, Lepcis Magna.

211–212 Joint rule of GETA and CARACALLA.

212 Geta murdered.

212–217 Rule of CARACALLA.

212–216 Baths of Caracalla.

212 Caracalla's 'Antonine Constitution' gives Roman citizenship to almost all free inhabitants of the empire.

227–636 SASSANIAN EMPIRE IN PERSIA

235–284 CRISIS OF THE ROMAN EMPIRE; MILITARY ANARCHY. Rome attacked in the east by Persians and Palmyrenes, in the north by German tribes. Some twenty emperors in fifty years in struggles for the throne.

235–280 CRISIS OF ART: BREAKDOWN OF CLASSICAL FORM. 'Pointillistic' and 'woodcut' styles in sculpture.

243–249 Rule of PHILIP THE ARABIAN. Celebration of Millennial Birthday of Rome, April 21, 248.

250–260, approximately. Battle sarcophagus 'Ludovisi'; Asiatic sarcophagus from Sidamara; Sarcophagus from Acilia?

251 Emperor DECIUS killed by Goths.

251–253 Rule of TREBONIANUS GALLUS.

253–259 Rule of VALERIAN.

253–268 Rule of GALLIENUS, son of Valerian.

253 German Limes, including Saalburg, abandoned.

257–263 German tribes raid Greece, Asia Minor; sack Athens.

256 Persians in Antioch.

259 Capture of Valerian.

270–275 Rule of AURELIAN.

A.D.	
271	Palmyrenes invade Alexandria, Asia Minor.
272	Palmyrenes defeated.
273–	Aurelian fortifies Rome ('Aurelian Wall').
282–285	CARINUS rules in the west.
283–4	Rule of NUMERIANUS.
280,	approximately. Relief of Aelia Afanasia.
283–393	THE LATE ROMAN EMPIRE
284–305	RESTORATION AND REORGANIZATION OF THE EMPIRE BY DIOCLETIAN. System of Four Rulers (Tetrarchs), two Augusti, two Caesars. New Imperial capitals: Nicomedia, Milan, Sirmium, Trier.
280–315,	approximately. TETRARCHIC EXPRESSIONISM IN ART.
286–306	Villa of Maximian (?) at Piazza Armerina (mosaics).
300,	approximately. Curia restored by Diocletian.
300–305	Palace of Diocletian, Spalato.
305	Porphyry statues of Tetrarchs, Venice.
306	Baths of Diocletian, Rome.
310	Basilica Nova of Maxentius (finished by Constantine).
306–337	AGE OF CONSTANTINE. VICTORY OF CHRISTIANITY
307–324	LICINIUS as co-ruler. Wife Constantia, sister of Constantine.
311	Last persecution of Christians (by Galerius).
312	Constantine defeats Maxentius at Milvian Bridge.
313	Edict of Milan. Christianity legalized.
315	Arch of Constantine.
320–410	LATE ANTIQUE REINTEGRATION OF FORM. 'ABSTRACT' STYLE AND SURFACE CLASSICISM IN ART.

A.D.	
320–,	approximately. Christian frieze sarcophagi. Constantinian palace and Basilica in Trier (300 on?).
324	Constantine eliminates Licinius.
325	Ecumenical Church Council at Nicaea.
324–330	Foundation of Constantinople as 'New Rome'; famous works of art brought from Greece.
326–	Christian building program of Constantine: St. John Lateran; Old St. Peter's; Nativity, Bethlehem; Holy Sepulchre, Jerusalem.
330,	approximately. Colossus of Constantine in Basilica Nova.
337	Constantine baptized on deathbed.
337–361	Rule of CONSTANTIUS II. Wars with Persia.
350,	approximately. Late patrician houses in Ostia.
361–363	JULIAN tries to re-instate paganism.
375	Invasions of the Huns start PERIOD OF MIGRATIONS.
378	Emperor Valens killed by Goths in battle of Adrianople.
378–393	THEODOSIUS I, last ruler of a united Roman empire, defeats the Goths, suppresses other pretenders.
380–400	Destruction of pagan temples all over the empire (stimulated by imperial decrees about prohibition of sacrifices).
384	Controversy between pagans and Christians about the Altar of Victory in the Senate. Quintus Aurelius Symmachus (340–402) and St. Ambrose (337–397).
380–410,	approximately. REFINED, ABSTRACT, PATTERNED 'THEODOSIAN CLASSICISM' IN ART, especially in the eastern empire.
380?	Silver patera of Parabiago.

50

A.D.	
388	'Missorium' (silver plate) of Theodosius I.
400,	approximately. 'Sarcophagus of a Prince', Istanbul.
393	DIVISION INTO WESTERN AND EASTERN ROMAN EMPIRE
395–432	Rule of HONORIUS (West).
395–408	Rule of ARCADIUS (East).
400–500	DOWNFALL OF THE WEST
406	Britain abandoned.
410	Goths under Alaric sack Rome.
415	Visigoths in Gaul and Spain.
450	Burgundians and Franks in Gaul.
455	Genseric's Vandals plunder Rome of treasures and art.
476	Last emperor of the western empire deposed. ·
488–525	Ostrogoths occupy most of Italy.

A.D.	
400–500	SURVIVAL IN THE EAST. GRADUAL TRANSITION TO EARLY BYZANTINE STYLE IN ART.
400,	approximately. Urban re-planning in Ephesus, Sardis.
400–500	Survival of sculptural workshops in Ephesus, Aphrodisias.
400–527	Survival of mosaic workshops in Antioch.
408–450	Rule of THEODOSIUS II. Struggle with Huns. Land fortifications of Constantinople. Palace and mosaics (date controversial).
527–565	AGE OF JUSTINIAN. He briefly reunites most of the Roman empire. FORMULATION OF EARLY BYZANTINE STYLE IN ART.
610–641	Rule of HERACLIUS. Persians overrun Asia Minor, are finally defeated. LAST PERIOD OF CLEAR CONTINUITY WITH CLASSICAL TRADITION.
634	Rise of ARAB POWER AND ISLAM.

BIBLIOGRAPHY

Works listed in this bibliography are cited by the author's name only in the text. When authors have several books listed in the bibliography, abbreviated titles are added. For each category, there is an addendum of items gathered particularly for this new paperback edition. Most cover items published since preparation of the first edition was completed in the early 1960s.

For the abbreviation of periodicals, see either of two lists published by the *American Journal of Archaeology:* vol. 62:1, Jan. 1958, pp. 3–8, or vol. 74:1, Jan. 1970, pp. 3–8.

General Aspects

S. AURIGEMMA, Villa Adriana (Rome, Libreria dello Stato, 1961)

M. BRION, Pompeii and Herculaneum, The Glory and the Grief (N.Y., Crown, 1961)

G. CALZA, E. NASH, Ostia (Florence, Sansoni, 1959)

CAMBRIDGE ANCIENT HISTORY, Fourth and Fifth Volumes of Plates, prepared by C. T. Seltman (Cambridge University Press, 1934, 1939) – *CAH* IV, V

L. CURTIUS, Das antike Rom (Vienna-Munich, Schroll, 1944) – Rom

P. DUCATI, L'arte in Roma dalle origini al sec. VIII (Bologna, Cappelli, 1938)

A. FROVA, L'arte di Roma e del mondo romano (Turin, Unione Tipografico Editrice, 1961)

Q. GIGLIOLI, L'arte etrusca (Milan, Fratelli Treves, 1935)

M. GRANT, The World of Rome (N.Y., Mentor Books, 1961)

A. GRENIER, Manuel de l'archéologie gallo-romaine (Paris, Picard, 1931)

H. KÄHLER, Rom und seine Welt (Munich, Bayerischer Schulbuchverlag, 1958) – Rom

KIRSCHBAUM, S.J., The Tombs of St. Peter and St. Paul (N.Y., St. Martin's Press, 1957)

P. MACKENDRICK, The Mute Stones Speak (N.Y., St. Martin's Press, 1960)

A. MAIURI, Ercolano, I nuovi scavi (1927–1958), Vol. I (Rome, Libreria dello Stato, 1958) – Ercolano

A. MAU, F. W. KELSEY, Pompeii... Its Life and Art (N.Y., Macmillan, 1907)

R. MEIGGS, Roman Ostia (Oxford University Press, 1960)

E. NASH, Pictorial Dictionary of Ancient Rome (London, Zwemmer, 1961, 1962)

G. C. PICARD, L'art Romain (Paris, Presses Universitaires de France, 1962)

M. POBÉ, J. ROUBIER, The Art of Roman Gaul (University of Toronto Press, 1961)

D. T. RICE, M. HIRMER, The Art of Byzantium (N.Y., Abrams, 1959)

G. RODENWALDT, Die Kunst der Antike (Berlin, Propyläen Verlag, 1927)

M. I. ROSTOVTZEFF, Social and Economic History of the Roman Empire, 2nd ed. rev. by P. M. FRASER (Oxford University Press, 1957)

A. RUMPF, Stilphasen der spätantiken Kunst (Cologne, Arbeitsgemeinschaft für Forschung des Landes Nordrhein-Westfalen, 1957) — Stilphasen

M. R. SCHERER, Marvels of Ancient Rome (London, Phaidon, 1955)

H. SCHOPPA, Die Kunst der Römerzeit in Gallien, Germanien, und Britannien (Munich-Berlin, Deutscher Kunstverlag, 1957)

V. SPINAZZOLA, Pompei alla luce degli scavi nuovi di Via dell'Abbondanza (Anni 1910–1923) (Rome, Libreria dello Stato, 1953)

J. M. C. TOYNBEE, Art in Roman Britain (London, Phaidon, 1962) – Britain

W. F. VOLBACH, M. HIRMER, Early Christian Art (N.Y., Abrams, 1961)

(Items new in the paperback edition)

E. AKURGAL, Ancient Civilisations and Ruins of Turkey (Istanbul, Haşet Kitabevi, 1973) – Civilisations

G. BECATTI, The Art of Ancient Greece and Rome, from the Rise of Greece to the Fall of Rome (N.Y., Abrams, 1967)

R. BIANCHI-BANDINELLI, Rome, the Center of Power, 500 B.C. to A.D. 200 (N.Y., Braziller, 1970) – Center

R. BIANCHI-BANDINELLI, Rome, the Late Empire, Roman Art, A.D. 200–400 (N.Y., Braziller, 1971) – Late Empire

J. J. DEISS, Herculaneum, Italy's Buried Treasure (N.Y., Apollo, 1970)

ENCICLOPEDIA DELL' ARTE ANTICA, R. Bianchi-Bandinelli, ed., s.v. "Arte romana" and under specific topics and monuments (Rome, Istituto della Enciclopedia Italiana, 1958–1973)

R. GNOLI, Marmora Romana (Rome, Edizioni dell' Elefante, 1971)

M. GRANT, The Cities of Vesuvius: Pompeii and Herculaneum (London, Weidenfeld and Nicolson, 1971)

G. HAFNER, Art of Rome, Etruria and Magna Graecia (N.Y., Abrams, 1969)

G. M. A. HANFMANN, From Croesus to Constantine, The Cities of Western Asia Minor and Their Arts in Greek and Roman Times (Ann Arbor, University of Michigan Press, 1974)

W. HELBIG, H. SPEIER, eds., Führer durch die öffentlichen Sammlungen klassischer Altertümer in Rom, 4th ed., 4 vols. (Tübingen, Wasmuth, 1963–1972)

A. H. M. JONES, The Later Roman Empire (284–602), 3 vols. (Oxford, Blackwell, 1964)

H. KÄHLER, Rome and Her Empire (London, Methuen, 1963) – Empire

TH. KRAUS, Das römische Weltreich (Berlin, Propyläen Verlag, 1967)

H. P. L'ORANGE, Art Forms and Civic Life in the Late Roman Empire (Princeton, Princeton University Press, 1965) – Art Forms

H. P. L'ORANGE, Likeness and Icon, Selected Studies in Classical and Early Medieval Art (Odense, Odense University Press, 1973) – Likeness

P. MACKENDRICK, Romans on the Rhine, Archaeology in Germany (N.Y., Funk & Wagnalls, 1970) – Rhine

C. MANGO, The Art of the Byzantine Empire 312–1453 (Englewood Cliffs, N.J., Prentice-Hall, 1972)

G. A. MANSUELLI, The Art of Etruria and Early Rome (N.Y., Crown 1964)

E. NASH Pictorial Dictionary of Ancient Rome (London, Zwemmer, 1968): Reprinted articles have reference to the first edition (1961–1962); those in Addenda to second edition.

J. J. POLLITT, The Art of Rome c. 753 B.C.–337 A.D. Sources and Documents (Englewood Cliffs, N.J., Prentice-Hall, 1966)

D. SCHLUMBERGER, L'Orient hellénisé, L'art grec et ses héritiers dans l'Asie non méditerranéenne (Paris, Edition Albin Michel, 1969)

H. TEMPORINI, ed., Aufstieg und Niedergang der römischen Welt: Geschichte und Kultur Roms im Spiegel der neueren Forschung I. Von den Anfängen Roms bis zum Ausgang der Republik I. (J. Vogt zu seinem 75 Geburtstag) (Berlin-N.Y., De Gruyter, 1972)

J. M. C. TOYNBEE, The Art of the Romans (New York, Praeger, 1965) – Romans

J. M. C. TOYNBEE, Art in Britain under the Romans (Oxford, Clarendon Press, 1964) – Art in Britain

J. M. C. TOYNBEE, Death and Burial in the Roman World (Ithaca, N.Y., Cornell University Press, 1971) – Death and Burial

C. C. VERMEULE, Roman Imperial Art in Greece and Asia Minor (Cambridge, Mass., Harvard University Press, 1968) – Imperial Art

M. VILIMKOVA, Roman Art in Africa (London, Hamlyn, 1963)

SIR M. WHEELER, Roman Art and Architecture (N.Y., Praeger, 1964)

Architecture

M. BIEBER, The History of the Greek and Roman Theater, 2nd ed. (Princeton University Press, 1961) – Theater

A. BOËTHIUS, The Golden House of Nero (University of Michigan Press, 1960)

F. E. BROWN, Roman Architecture (N.Y., Braziller, 1961)

F. CASTAGNOLI, Topografia di Roma antica, Vol. X: III Enciclopedia Classica, Sez. III (Turin, Società Editrice Internazionale, 1957)

L. A. CONSTANS, Arles antique (Paris, Boccard, 1921)

C. COURTOIS, Timgad: antique Thamugadi (Algiers, Service des Antiquités, 1951)

L. CREMA, L'architettura romana, Vol. XII: I, Enciclopedia Classica, Sez. III (Turin, Società Editrice Internazionale, 1959)

R. DELBRUECK, Hellenistische Bauten in Latium (Strassburg, Trübner, 1907–1912) – Bauten

E. ESPÉRANDIEU, Le pont du Gard et l'aqueduc de Nimes (Paris, Petites Monographies des grand Edifices de la France, 1926)

F. FASOLO, G. GULLINI, Il santuario della Fortuna Primigenia a Palestrina (Università di Roma, 1953)

J. A. HANSON, Roman Theater-Temples (Princeton University Press, 1959)

H. KÄHLER, Hadrian und seine Villa bei Tivoli (Berlin, Mann, 1950) – Hadrian

D. KRENCKER, E. KRÜGER, H. LEHMANN, H. WACHTLER, Die Trierer Kaiserthermen, I, (Augsburg, Filser, 1929)

G. LUGLI, Roma antica, il centro monumentale (Rome, Bardi, 1946)

S. B. PLATNER, T. ASHBY, A Topographical Dictionary of Ancient Rome (London, Oxford University Press, 1929)

D. M. ROBINSON, Baalbek Palmyra (N.Y., Augustin, 1946)

H. SCHÖNBERGER, Römerkastell Saalburg, 21st ed. (Bad Homburg, Zeuner, 1962)

R. E. M. and T. V. WHEELER, Verulamium, Report of the Research Committee, II (Society of Antiquaries of London, 1936)

T. WIEGAND, ed., Baalbek (Berlin-Leipzig, de Gruyter, 1921)

(Items new in the paperback edition)

R. BIANCHI-BANDINELLI, E. VERGARA CAFFARELLI, G. CAPUTO, Leptis Magna (Rome, Impresa Astaldi, 1964) – Leptis Magna

A. BOETHIUS, J. B. WARD-PERKINS, Etruscan and Roman Architecture (N.Y., Penguin, 1970)

G. CARETTONI, A. M. COLINI, L. COZZA, G. GATTI, La pianta marmorea di Roma antica (Rome, Bretschneider, 1960) – Pianta

F. CASTAGNOLI, Orthogonal Town Planning in Antiquity (Appendix with literature to 1970) (Cambridge, Mass., Massachusetts Institute of Technology Press, 1971) – Orthogonal

D. R. DUDLEY, Urbs Roma: A Source Book of Classical Texts on the City and Its Monuments (London, Phaidon, 1967)

H. KÄHLER, Der römische Tempel (Berlin, Mann, 1970) – Tempel

R. KRAUTHEIMER, Early Christian and Byzantine Architecture (Harmondsworth, Middlesex, Penguin, 1965)

W. L. MACDONALD, The Architecture of the Roman Empire, vol. I: An Introductory Study (New Haven, Yale University Press, 1965)

J. E. PACKER, The Insulae of Imperial Ostia (Rome, *MAAR* 31, 1971)

B. TAMM, Auditorium and Palatium (Stockholm, Studies in Classical Archaeology 2, 1963)

J. B. WARD-PERKINS, Cities of Ancient Greece and Italy: Planning in Classical Antiquity (N.Y., Braziller, 1974) – Cities

Sculpture

M. BIEBER, Sculpture of the Hellenistic Age (N.Y., Columbia University Press, 1961) – Sculpture

R. DELBRUECK, Spätantike Kaiserporträts (Berlin-Leipzig, de Gruyter, 1933) – Kaiserporträts

W. H. GROSS, Das römische Herrscherbild, II:2, Bildnisse Traians (Berlin, Mann, 1940)

P. G. HAMBERG, Studies in Roman Imperial Art (Copenhagen, Munksgaard, 1945)

G. M. A. HANFMANN, The Season Sarcophagus at Dumbarton Oaks (Harvard University Press, 1951)

A. HEKLER, Greek and Roman Portraits (London, Heinemann 1912)

H. KÄHLER, Die Augustusstatue von Primaporta, Monumenta Artis Romanae I (Cologna, Dumont Schauberg, 1959) – Primaporta.

H. KLUGE, K. LEHMANN-HARTLEBEN, Die antiken Grossbronzen (Berlin-Leipzig, de Gruyter, 1926)

H. P. L'ORANGE, Apotheosis in Ancient Portraiture (Oslo, Instituttet for Sammenlignende Kulturforskning, 1947) – Apotheosis

H. P. L'ORANGE, Studien zur Geschichte des spätantiken Porträts (Oslo, Instituttet for Sammenlignende Kulturforskning, Serie B:XXII, 1933) – Studien

F. MATZ, Ein römisches Meisterwerk (Berlin, de Gruyter, 1958)

V. POULSEN, Les portraits romains, I (Copenhagen, Ny Carlsberg Glyptotek, 1962)

I. S. RYBERG, Rites of the Roman State Religion (Rome, Memoirs of the American Academy, XXII, 1955)

B. SCHWEITZER, Die Bildniskunst der römischen Republik (Leipzig, Koehler & Amelang, 1948)

J. M. C. TOYNBEE, The Flavian Reliefs from the Palazzo della Cancelleria in Rome (London, Oxford University Press, 1957) – Cancelleria

J. M. C. TOYNBEE, The Hadrianic School (Cambridge University Press, 1934) – Hadrianic

C. C. VERMEULE, A Graeco-Roman Portrait of the Third Century A.D. (Dumbarton Oaks Papers 15, Harvard University Press, 1962)

O. VESSBERG, Studien zur Kunstgeschichte der römischen Republik (Lund, Gleerup, 1941)

M. WEGNER, Das römische Herrscherbild, II:3, Hadrian, Plotina, Marciana, Matidia, Sabina (Berlin, Mann, 1956), II:4, Die Herrscherbildnisse in antoninischer Zeit (1939)

R. WEST, Römische Porträtplastik (Munich, Bruckmann, 1933)

(Items new in the paperback edition)

P. H. VON BLANCKENHAGEN, 'Laokoon, Sperlonga und Vergil' (AA 84:3, 1969)

J. D. BRECKENRIDGE, Likeness, A Conceptual History of Ancient Portraiture (Evanston, Ill., Northwestern University Press, 1968)

R. BRILLIANT, The Arch of Septimus Severus in the Roman Forum (Rome, MAAR 29, 1967)

R. BRILLIANT, Gesture and Rank in Roman Art, The Use of Gesture to Denote Status in Roman Sculpture (New Haven, Connecticut Academy of Arts and Sciences, 1963) – Gesture

D. M. BRINKERHOFF, A Collection of Sculpture in Classical and Early Christian Antioch (N.Y., New York University Press, 1970)

R. CALZA, Iconografia romana imperiale, da Carausio a Giuliano (287–363 D.C.) (Rome, Bretschneider, 1972)

G. DALTROP, U. HAUSMANN, M. WEGNER, Das römische Herrscherbild, II:1, Die Flavier (Berlin, Mann, 1966)

P. R. FRANKE, M. HIRMER, Römische Kaiserporträts im Münzbild (Munich, Hirmer, 1961)

R. HAMPE, Sperlonga und Vergil (Mainz, von Zabern, 1972)

G. M. A. HANFMANN, Classical Sculpture (Greenwich, Conn., New York Graphic Society, 1967)

J. INAN, E. ROSENBAUM, Roman and Early Byzantine Portrait Sculpture in Asia Minor (London, Oxford University Press, 1966)

H. G. NIEMEYER, Studien zur statuarischen Darstellung der römischen Kaiser (Berlin, Monumenta Artis Romanae VII, Mann, 1968)

D. E. STRONG, Roman Imperial Sculpture (London, Tiranti, 1961) – Sculpture

G. TRAVERSARI, Aspetti Formali della Scultura Neoclassica a Roma dal I al III sec. D.C. (Rome, Bretschneider, 1968)

C. C. VERMEULE, Roman Imperial Art in Greece and Asia Minor (Cambridge, Mass., Harvard University Press, 1968) – Imperial Art

L. VOGEL, The Column of Antoninus Pius (Cambridge, Mass., Harvard University Press, 1973)

H. WIEGARTZ, Kleinasiatische Säulensarkophage (Istanbul, Deutsches Archäologisches Institut, Forschungen vol. 26, Berlin, Mann, 1965)

H. B. WIGGERS, M. WEGNER, Das römische Herrscherbild, III:1, Caracalla bis Balbinus (Berlin, Mann, 1971)

H. WREDE, Die spätantike Hermengalerie von Welschbillig, Untersuchungen zur Kunsttradition im 4. Jht. n. Chr. und zur allgemeinen Bedeutung des antiken Hermenmals (Berlin, De Gruyter, 1972)

Painting

H. G. BEYEN, Die pompejanische Wanddekoration (The Hague, Nijhoff, 1938)

M. BORDA, La pittura romana (Milan, Società Editrice Libraria, 1958)

P. H. VON BLANCKENHAGEN, C. ALEXANDER, The Paintings from Boscotrecase (Deutsches Archäologisches Institut, Römische Mitteilungen, Suppl. vol. 6, 1962)

L. CURTIUS, Die Wandmalerei Pompejis (Leipzig, Seemann, 1929) (reprinted Olms, Hildesheim, 1960) – Wandmalerei

C. M. DAWSON, Romano-Campanian Mythological Landscape Painting (Yale Classical Studies 9, 1944)

G. V. GENTILI, La villa Erculia di Piazza Armerina (Milan, Sidera, 1959)

G. GULLINI, I mosaici di Palestrina (Rome, Archeologia Classica, 1956)

. HERRMANN, Denkmaler der Malerei des Altertums (Munich, F. Bruckmann, 1904–)

. W. LEHMANN, Roman Wall Paintings from Boscoreale (Cambridge, Archaeological Institute of America, 1953)

D. LEVI, Antioch Mosaic Pavements (Princeton University Press, 1947)

H. P. L'ORANGE, P. J. NORDHAGEN, Mosaik (Munich, Bruckmann, 1960)

. MAIURI, Roman Painting (Geneva, Skira, 1953) – RP

. MAIURI, La villa dei Misteri (Rome, Libreria dello Stato, 1931) – Misteri

NOGARA, Le nozze Aldobrandine ed i paesaggi con scene dell' Odissea (Milan, Hoepli, 1907)

PACE, I mosaici di Piazza Armerina (Rome, Casini, 1955)

. J. T. PETERS, Landscape in Romano-Campanian Mural Painting (Assen, Van Gorcum, 1963)

PFUHL, Malerei und Zeichnung der Griechen (Munich, Bruckmann, 1923). – MuZ

PFUHL, Masterpieces of Greek Drawing and Painting, translated by J. D. Beazley (London, Chatto and Windus, 1955) – Masterpieces

RUMPF, Handbuch der Archäologie, IV (Berlin, de Gruyter, 1953) – Archäologie

K. SCHEFOLD, Pompeijanische Malerei (Basel, Schwabe, 1952)

M. H. SWINDLER, Ancient Painting (Yale University Press, 1929)

F. WIRTH, Römische Wandmalerei vom Untergang Pompejis bis ans Ende des 3. Jh. (Berlin, Verlag für Kunstwissenschaft, 1934)

J. DE WIT, Spätrömische Bildnismalerei (Berlin, Verlag für Kunstwissenschaft, 1938)

H. ZALOSCER, Porträts aus dem Wüstensand (Vienna, Schroll, 1961)

(Items new in the paperback edition)

COLLOQUES INTERNATIONAUX DU CENTRE NATIONAL DE LA RECHERCHE SCIENTIFIQUE, La Mosaïque gréco-romaine, (Paris, Centre National de la Recherche Scientifique, 1965)

J. M. CROISILLE, Les natures mortes campaniennes: Répertoire descriptif des peintures de nature morte du Musée National de Naples de Pompéi, Herculanum et Stabies (Brussels, Latomus, 1965)

W. DORIGO, Painting in the Late Roman Period (Milan, Feltrinelli, 1966)

H. P. L'ORANGE, P. NORDHAGEN, Mosaics from Antiquity to the Middle Ages (London, Methuen, 1966) – Mosaics

K. PARLASCA, Mumienporträts und verwandte Denkmäler (Wiesbaden, Steiner, 1966)

G. CH. PICARD, Roman Painting (Greenwich, Conn., New York Graphic Society, 1970)

C. L. RAGGHIANTI, Pittori di Pompei. Monumenti d'arte italiana 4 (Milan, Edizioni del Milioni, 1963)

K. SCHEFOLD, La peinture pompéienne: Essai sur l'evolution de sa signification. Edition rev. et augmentée (Brussels, Latomus, 1972)

A. F. SHORE, Portrait Painting from Roman Egypt (London, British Museum, 1962)

V. M. STROCKA, 'Theaterbilder aus Ephesus' (Heidelberg, Gymnasium, 80:4, 1973)

Minor Arts

E. C. F. BABELON, La gravure en pierres fines, camées et intailles (Paris, Quantin, 1894)

A. FURTWÄNGLER, Geschichte der Steinschneidekunst im klassischem Altertum (Leipzig, Berlin, Giesecke and Devrient, 1900)

K. LANGE, Antike Münzen (Berlin, Mann, 1947)

H. MATTINGLY, Roman Coins from Earliest Times to the Fall of the Western Empire, 2nd ed. (London, Methuen, 1960)

(Items new in the paperback edition)

G. M. A. RICHTER, Engraved Gems of the Romans (London, Phaidon, 1971) – Gems

D. E. STRONG, Greek and Roman Gold and Silver Plate (London, Methuen, 1966) – Plate

M. L. VOLLENWEIDER, Die Porträtgemmen der römischen Republik (Mainz, von Zabern, 1972) – Porträtgemmen

M. L. VOLLENWEIDER, Die Steinschneidekunst und ihre Künstler in spätrepublikanischer und augusteischer Zeit (Baden Baden, Grimm, 1966) – Künstler

CAPTIONS

FOR THE ILLUSTRATIONS

IDENTIFIED BY ARABIC

NUMERALS

ARCHITECTURE

1–2 The Roman Forum

The history of the Roman state is written in the buildings and monuments of the Roman Forum. Here, at the foot of the Capitoline Hill the legendary founder, Romulus, established the cult of the god of fire (near 2) and, some Romans thought, found his last resting place (so-called 'Sepulchre of Romulus,' under the 'Black Pavement,' 5). There at the other end of the marshy hollow, Vestal Virgins guarded the fire of the hearth in a round prehistoric hut and kept the image of Athena which the other, even more legendary founder Aeneas, had saved from burning Troy (Temple of Vesta, 16). Here stood the House of the Kings (Regia, 17), later residence of the highest priest, the Pontifex Maximus. On its walls the Roman could read the great deeds of his Republic in official annals. At the foot of the Capitol were the places where the two powers in the Roman state met and fought their century-long contest—the Curia, the Senate House of the aristocratic patricians, and the comitium (6), meeting place of the people. Here the earth had opened to swallow a Sabine knight when the Sabines attacked Rome (Lacus Curtius, 10). Here the King Servius Tullius was flung down the steps of the Senate House by Lucius Tarquinius. Here the bronze tablets with the first written laws of Rome were placed (450 B.C., near 5). Here an agreement in the constitutional struggle of patricians and plebeians was commemorated by the Temple of Concord (366 B.C., rebuilt 10 A.D.; Templum Concordiae in plan). Here Cicero thundered against Verres' exploitation of provinces (in

the Temple of Castor) and Catiline's high treason (in the Curia). Here in 44 B.C. Caesar's body was burned and Mark Antony gave his famous speech 'to bury Caesar not to praise him.' (Templum Divi Iulii.)

Ever since the victory at Lake Regillus (499? B.C.), commemorated in the Temple of the Heavenly Twins who intervened on Rome's behalf (Temple of Castor), army after army had marched along the Sacred Way as their generals rode in triumph up the Clivus Capitolinus (along the west side of the Temple of Saturn). The Arch of Titus (19) at the summit of the Sacred Way commemorates the capture of Jerusalem, 70 A.D.; the Arch of Septimius Severus (3), victories over the Parthians and the Arabs in the East (203 A.D.).

The last chapter in the history of ancient Rome reverts to the Forum. The Emperor Diocletian repaired the Basilica Iulia, rebuilt the Senate House (Curia, Fig. 31) as we see it now, and erected five great columns in front of it for Jupiter and four emperors (Tetrarchs, 303 A.D.). The statue of Victory, object of the last great contest of pagans and Christians (384 A.D.) stood in the Diocletianic Curia. A leader of pagan traditionalists, Vettius Praetextatus, Prefect of the City, restored the Portico of the Twelve Gods in 367 A.D. The venerable Temple of Saturn, (founded 498 B.C.) long keeper of Roman State Treasury, and the great Basilica Aemilia (179 B.C.) were restored in this late effort to keep intact the self-projected image of Roman myth and history which the Goths of Alaric brought down in their world-shaking sack of Rome (410

A.D.). The last monument of antiquity was the bronze statue of the Byzantine Emperor Phocas placed in 608 A.D. on an earlier monument by the Byzantine governor of Rome (8).

As in the civic center of Athens, so in Rome an attempt was made to create a regularized monumental piazza by placing public and commercial buildings along the four sides. The design was inspired by a school of Hellenistic urbanism which operated with individual structures rather than with one continuous enclosure of colonnades. Its major steps were the fencing-in of the two long (north and south) sides by the Basilica Aemilia (179 B.C.) and the Basilica Iulia (54 B.C.). An imposing, stagelike vertical façade was created for the western end in the Tabularium (Records Office, 78 B.C.). In the final, imperial version, this structure of native stone had its massive base concealed by the marble elegance of the façades of the Temples of Concord (Tiberius, 10 A.D.), and Saturn (42 B.C.) joined later by the Temple of the Deified Emperor Vespasian (after 81 A.D.). The venerable House of the Kings and the Temple of Vesta were perhaps originally envisaged as the eastern end of the Forum but the building of the Temple to Deified Caesar (Plan, *Templum Divi Iulii*) in 29 B.C. provided a more emphatic closing.

Considering the small dimensions of the oblong thus left open (ca. 300 ft. long, ca. 200 ft. wide on the west, 150 ft. on the east) the effect of the Forum must have been much like that of an interior, dominated by two-storied rhythms of columns and arcades.

The picture (Fig. 1), taken from the modern ascent to the Capitolium shows, on the right, columns of the Temple of Saturn (as restored in the fourth century A.D.), Basilica Iulia, three columns of the Temple of Castor (Augustan), the House of the Vestal Virgins, and in the distance, the Arch of Titus (after 81 A.D.).

In the center: Speakers' Platform, rebuilt by Augustus, column of Phocas (608 A.D.), ruins of Temple of Caesar and House of Kings, Temple of Venus and Roma (135 A.D.), the bell-tower of the Church of Santa Francesca Romana (twelfth century).

On the left: the Arch of Septimius Severus (203 A.D.) which conceals from view the venerable archaic monuments under the 'Black Pavement'; Diocletian's Curia (as restored in 1935–1937); Basilica Aemilia; the Church of San Lorenzo (Temple of Antoninus and Faustina, 141

A.D.), the Basilica Nova of Constantine (after 313 A.D.), and the Colosseum (Amphitheatrum Flavium, 80 A.D.).

S. B. Platner and T. Ashby, pp. 230–236, with the complementary E. Nash, p. 543, under *Forum Romanum* and ancient names of individual monuments and buildings. F. Castagnoli, pp. 102–112. C. Huelsen, *The Forum and the Palatine* (transl. H. Tanzer, 1928). M. R. Scherer, pp. 64–65, pls. 11, 17, 33, 54–6, 65, 102, 104, 108, 110, 115–16. P. MacKendrick, pp. 67–84.

3–4 Cosa, an Early Latin Colony of the Roman Republic

'The ancient unguarded ruins and grim walls of desolate Cosa' which had lain abandoned when the poet Rutilius Namatianus passed them on his journey to Gaul (416 A.D.) have been awakened to new life by recent efforts of the American excavators (1948–1954). Through their work the town on the steep gray cliffs over the Tyrrhenian Sea has become for us the best example of standardized urban planning in the service of military and naval strategy and agricultural expansion of Rome. By masterly use of such colonies, the Roman Republic conquered first Italy, then the western Mediterranean.

Planted in 273 B.C. in a superb position over a small port on the coastal highway (Via Aurelia), this strong naval base played a vital part in Rome's struggle with Carthage. Area planning rather than town planning was the concept realized. The surrounding land was surveyed, divided into a grid of plots, and distributed among probably 2,500 families. Only about half of them, perhaps three thousand people, could have lived in the walled town, the others in the country using the fortress as refuge. The city wall, nearly a mile long, 40 ft. high, was built of irregular 'Cyclopean' masonry. Its designers followed the most advanced concepts of the day; portcullis and square towers a bow shot apart.

In accordance with traditions hallowed by religion, the town was provided with three gates, a circumferential street was laid out just inside the city wall, and the highest natural hillock was used as sacred area, *arx*, counterpart of the Capitoline Hill in Rome. With its shrine to the Capitoline triad (Jupiter, Juno, Minerva), its forum, senate (Curia), and theater-like people's assembly *(comitium)*, its basilica and baths, Cosa perfectly illustrates Roman saying: 'Colonies are small images of Rome.'

Aerial photograph and plan show the outline of the forum, the rectangular grid of streets, the *arx* with the Capitolium (1) and another temple (2), the Forum (3), bath (4), and a temple by the northwest gate (5). Elaborate provisions including rock-cut canals were taken to prevent the silting up of the port entry. For earlier buildings local limestone and sandstone, often mortared; imported tufa for cut-stone elements.

Area.: ca 33¾ acres within the walls.

F. E. Brown, 'Cosa I,' *MAAR* 20, 1951. E. Richardson 'Cosa II,' *MAAR* 26, 1960. F. Castagnoli, *Ippodamo*, 1956, * fig. 39. P. MacKendrick, pp. 98–112, figs. 4.4–7.

5 Pompeii from the Air

Rome was a metropolis which had grown irregularly over the ages; its transformation under Augustus (27 B.C.-14 A.D.), its rebuilding and re-zoning after the devastating fire under Nero (64 A.D.), its final retrenchment behind the great wall of Aurelian (270-275 A.D.) were partial measures of urban renewal which did not affect the plan of the entire city. Cosa, the totally planned, with its standardized colonial plan, is at the other end of the scale. In Pompeii we meet a city which had developed before it was conquered by the Romans and refounded as Colonia Veneria Cornelia Pompeianorum in 80 B.C.

Located on the fertile slopes of the volcano Vesuvius, above the valley of the river Sarno in the vicinity of the considerable Greek colony Neapolis (Naples), this 'Five-town' or 'Fifton' (from Oscan *pompe*, 'five') had started as a small settlement in the sixth century B.C. Parts of an early layout, based on two thoroughfares intersecting at the northern end of the Forum, can still be traced in the southwest part of the city. The conscious éffort to replan and fortify the city was made in the fifth century B.C. very shortly after the concept of rationalized planning began to spread from mainland Greece. The grid is not rigidly rectangular. The main southeast-northwest street (Via Stabiana) crosses the two major thoroughfares (Via di Nola; Via dell'Abbondanza) at an angle. The house plots, of set width, may be oblong or nearly square; in contemporary Greek urban plans (Olynthus) they were rigidly equal and laid alongside the streets rather than with the short side fronting on the street. The major complexes of civic and religious life (forum, temples) and amusement

(theaters, amphitheater) were planned along the south side. The four public baths were placed at main intersections. Relatively easy communication and access to the town were achieved by numerous (eight) gates in the city wall.

Inspired by Greek planning of the classical age, this ambitious town plan was built up under the Samnites, warlike competitors of Rome who seized Pompeii in 425 B.C. The rise in wealth and ambition of Hellenistic Italy is mirrored in the subsequent impressive development of palatial residences of the so-called Tufa Period (280?–80 B.C.) which continued to be built in the first phase of Roman occupation when famous Romans like Cicero had villas or houses in and around Pompeii.

Life in Pompeii stopped dead in its tracks when Vesuvius erupted in 79 A.D. Just then the city was undergoing an interesting sociological transformation 'from the patrician residence to the plebeian dwellings,' to smaller housing units, shops, and workshops. This commercial-industrial development had not, however, reached the phase of mass-dwellings represented in imperial Ostia. Embalmed in ashes, Pompeii has become a laboratory case, the ancient city where we can study every detail of Roman life.

Area: 166 acres (five times larger than Cosa); estimated population: 15,000–20,000.

L. Mumford, *The City in History*, pl. 14. A. Mau and F. W. Kelsey. A. Maiuri, *Pompeii: Guide Books to the Museums and Monuments of Italy*, 1957 and later ed. R. C. Carrington, *Pompeii*, 1936. A. von Gerkan, *Der Stadtplan von Pompeii*, 1940. P. MacKendrick, ch. 8.

For urbanism: J. B. Ward-Perkins, 'Early Roman Towns in Italy,' *The Town Planning Review* 26:3, 1955. A. Boëthius, 'Urbanism in Italy,' *Acta Congressus Madvigiani* 4, 1954, pp. 87–108 (housing, shops). F. Castagnoli, *Ippodamo*, 1956, pp. 26–34, figs. 9–11 (dates the replanning).

6 The Forum of Pompeii

Although it unites the pre-Roman layout with adaptation to architectural traits required in a Roman colony, the Forum of Pompeii is the most important example of the early phase in the development of Roman civic centers. It was clearly planned as a unified courtlike space enclosed on three sides by a continuous colonnade. The orientation is roughly north-south, the proportions 3 1/2:1. The

aversion of Roman planners to making their fora centers of traffic is in evidence. Four major streets lead up to the Forum (Strada delle Scuole from the south, at the bottom; Strada dell'Abbondanza from the east; Strada Marina from the west; Via del Foro and Vico delle Terme from the north, at the top) but no vehicles could enter. The axial view is dominated by the Capitolium, temple of the three gods who protected Rome and Roman colonies. Along the west side (center left) lies the older, pre-Roman Temple of Apollo. At the east side, at right angles to the main axis (center right) is the shrine of *Lares Publici*, protectors of the city; next to it, the temple devoted to the cult of the emperors. The political aspect of a city is expressed in the triple halls of the City Council (Curia) at the south end (bottom), and in the voting precinct *(comitium)* at the southeast corner. Below the Temple of Apollo (center left) we see the internal colonnade of the majestic basilica, seat of law and business. This is the best preserved early (ca. 100 B.C.?) example of a building type which became one of Italy's great contributions to world architecture. Commerce and trade are represented by the large food market *(macellum)*, top right, and by a building of the college of fullers, given to them by the city priestess Eumachia (cf. Fig. 52).

The formal symmetry of the inner quadrangle does not extend to the buildings behind the colonnades.

430 ft. by 120 ft. (131 m. by 36.6 m.).
R. C. Carrington, *Pompeii*, 1936, fig. 20. A. Maiuri, *Pompeii: Guide Books to the Museums and Monuments of Italy*, 1957, p. 21, pl. 9. E. Gjerstad, 'Die Ursprungsgeschichte der römischen Kaiserfora,' *Opuscula Archaeologica* 3, 1944, p. 64, fig. 37. A. Boëthius, pp. 67 ff., figs. 27–28.

7 The Theater and Amphitheater of Arles

Greek theaters were part of nature. The Romans moved their theaters and amphitheaters onto level ground within the cities. They were never roofed over except with temporary canvas awnings; modern stadia are their true successors. Although such auditoria are functional in the Mediterranean climate, their isolated rounded masses are not easily reconciled with either domestic or public architecture. For reasons of safety—riots were common —they were often placed near the city wall.

Gladiatorial games were religious in origin, a sacrifice

of captives over the grave of the fallen warrior; later they took place in the Forum (Vitruvius, *On Architecture* V:1). Amphitheaters for these dangerous games posed new problems: safety of spectators, visibility, special passages for combatants and beasts, for dragging of corpses, and in some cases provisions for flooding the arena for mock naval combats. The standard plan, a polycentric curve already appears in the earliest preserved example in Pompeii (ca. 70 B.C.).

Arelatum (Arles-sur-Rhône) in southern France was used by Caesar as a naval base and veterans' colony *(Colonia Iulia Paterna Arelate Sextanorum)*. Its theater (seen at bottom) dates from the Augustan period; and the amphitheater is not later than Hadrian. Built over by medieval houses, it survived as a fortress and town quarter, and today is used for bullfights.

The main entrances are on the long axis. Galleries sweep around the structure on two floors, the lower vaulted lengthwise, the upper radially. Radial walls and vaults carry the auditorium.

Local limestone masonry faced with marble; amphitheater ca. 350 by 450 ft. (107 by 136 m.); theater 334 1/2 ft. (102 m.) diameter; estimated capacity of amphitheater 26,000. Decumvir Gaius Iunius Priscus reconstructed podium and gates; other inscriptions mention seats reserved for priests, teachers, and students. L. Mumford, *The City in History*, pl. 16 (top). L. Crema, pp. 95 ff., pp. 436–438, figs. 547, 550. L. A. Constans, pp. 298–324. A. Grenier, III: 2, pp. 611–639. J. Durm, *Baukunst der Römer*, 1905, pp. 693 ff., *Handbuch der Architectur* II: 2, 2a (2nd. ed.). R. Peyre, *Nimes, Arles, Orange, St. Remy* (1st. ed., 1903), pp. 66–68. M. Bieber, *Theater*, pp. 177 ff., pp. 196 ff.

8 The Sanctuary of Baalbek from the Air

'The Palace of the Sun rose high with columns of shining gold and flaming brass...' Baalbek's ruins, originally heightened by gilding, recall Ovid's vision. 'Heliopolis (City of the Sun) was the Greek name for the sanctuary whose originally Semitic gods were Romanized after Rome conquered Syria in 64-63 B.C.

Baalbek is a gigantic *tour de force*, the disciplined symmetry of its main plan enhanced by vertical build-up of terraces, and the whole nearly overwhelmed by baroque exubérance of architectural ornament. The main precinct rises 24–42 ft. over the valley of Bek'aa, against dramatic

mountain chains. The majestic entrance gate and wide ascent of steps were calculated to inspire awe and reverence. The colonnaded hexagonal court, some 200 ft. in diameter, contained the worshipper before releasing him through a triple gate to the vast expanse of court dominated by the Temple of Jupiter. Towers flanked the passageway.

Both the hexagonal court and the Great Court of the Altar stand on platforms within which barrel-vaulted galleries run along the sides under the colonnades. The vast temple court, some 150 yards long and 125 yards wide, centered on two altars. Remains of a Christian church are visible in the picture on either side of the smaller altar. On three sides double colonnades prefaced sequences of rectangular and semicircular halls, the latter covered by half domes.

Ascending a second staircase, the worshiper came to the temple of Jupiter into whose platform is set the famous 'trilithon,' three perfectly fitted blocks 63 by 12 by 11 ft. The columns of the temple rose 65 ft., topped by an ornate 16-ft. horizontal crowning. On a lower platform, echoing the larger temple in its effect and proportion, stands the Temple of Bacchus, with columns and niches moving picturesquely in and out of the walls.

Overall dimensions nearly 1,000 ft. (300 m.); Jupiter temple 170 ft. by 302 ft. (51.8 m. by 92 m.), 10 ft. by 19 ft. (3 by 5.8 m.) Corinthian columns; Bacchus temple 110 ft. by 214 ft. (33.5 m, by 65.2 m.), 8 ft. by 15 ft. (2.4 m. by 4.6 m.), Corinthian columns. Jupiter precinct apparently begun ca. 60 A.D., Bacchus temple probably early second century A.D.

L. Crema, pp. 285, 389-395, figs. 463 f. H. Seyrig, *Syria* 10(1929), pp. 314-356. P. Collart, P. Coupel, *L'autel monumental de Baalbek*, Institut Français d'Archéologie de Beyrouth, *Bibliothèque Archéologique et Historique*, LII, 1951. * O. Eisseldt *Tempel und Kulte syrischer Städte* 1941.

launus, opponent of Caesar's first attempt to invade Britain (54 B.C.), Tasciovanus (15 B.C.-10 A.D.), and his son Cunobelin (Cynbeline), 'King of the Britons' (10-41 A.D., Suetonius, *Gaius*, 44). Outside the Roman city, St. Albans Abbey commemorates the site where St. Alban, *Promartyr Angliae*, was executed some time in the third century A.D.

Roman settlement in the valley began along the arterial highway (Watling Street) which ran twenty-one miles straight from London, crossing the road to Chester (Deva) at St. Michael's ford. The timber buildings and huts of this first Roman settlement were destroyed by Queen Boudicca in the uprising of the Iceni (61 A.D.).

Under Hadrian and Antoninus Pius (ca. 125-150 A.D.) the town was replanned on a modified grid scheme and some 200 acres enclosed in powerful fortifications. Built of flint rubble with lacing brick courses, their semicircular salient towers and monumental gates some 100 ft. wide, these city walls have been termed 'the most impressive of their kind in Britain.' A forum, large courtyard houses with mosaics, and several temples, one a Celto-Roman temple with a square plan, another a peculiar triangular shrine, typify Romano-British towns. Unique in Britain are the theater and the two triumphal arches, one in front of the triangular temple, the other just north of the theater.

After a period of decay in the third century A.D. the town was briefly restored in the fourth century, then dwindled to a squatters' slum around the market area.

Circumference of city wall ca. 2 miles, area ca. 220 acres; flint rubble and brick; some timber structures. Estimated population ca. 8,000.

R. E. M. and T. V. Wheeler. For the theater, K. Kenyon, *Archaeologia* 84, 1934, pp. 213-261; recent excavations and discoveries regularly reported in *JRS* and *AJ*. *

9-10 Verulamium, an Outpost of the Empire in Britain

Verulamium (St. Albans), Hertfordshire, is an example of that northernmost venture of Roman urban civilization which began with the conquest of Britain under Claudius (43 A.D.) and ended four centuries later when the pressure of Picts and Saxons forced abandonment of Britain. The pre-Roman town on the height above the river Ver recalls the names of great Catuvelaunian kings, Cassive-

11 The Sanctuary of Fortuna Primigenia, Praeneste

'The most splendid monument in Italy of the Roman Republic' (MacKendrick), the venerable Sanctuary of Fortune, first-born child of Jupiter, was famous for its oracular shrine. Here a boy drew from a miracle-working olive chest inscribed lots of oak which predicted the future (Cicero, *De Divinatione* 2:85).

During the fierce war between democrats and aristoc-

racy the dictator Sulla, who considered himself a favorite of Fortune, first sacked the city (82 B.C.), then rebuilt it as a colony. The grandiose expansion of the sanctuary probably was undertaken at this time. Allied bombing in 1944 destroyed the medieval buildings covering the upper sanctuary. In a great program of research and restoration Italian scholars (Fasolo and Gullini) have retrieved the essential features of the vast complex.

The lower sanctuary (not shown in the reconstruction) contained the structure where the oracular lots were cast. The upper sanctuary begins (at bottom I, II) with huge supporting walls. Ramps sweep up toward the center on the next terrace. The front of the terrace base is magnificently fashioned as a two-storied colonnaded façade with semicircular recesses in each wing (V). Staircases ascend to the great colonnaded precinct (VI), open toward the valley to afford magnificent views. This precinct (VI) rests on a façade of arches with half columns, a revolutionary motif for the time. Arches are used again in the screen between two fountain-houses which serves as a façade for the highest major complex, the theater-like hemicycle where sacrifices were performed at an altar. Palazzo Barberini, a Renaissance structure rebuilt in the seventeenth and nineteenth centuries, now stands over the hemicycle walls. A graceful round temple at the very top contained the statue of Fortune and served as the culminating point of the composition.

The stress upon disciplined symmetry, and the grandiose quality of the design make Praeneste the first unmistakable manifestation of the imperial spirit of Rome.

Height of combined upper and lower sanctuaries 725 ft. (221 m.), width on central axis (at III) 780 ft. (237.8 m.), (at VI) 360 ft. (109.75 m.), greatest depth (at VI) 170.6 ft. (52 m.); limestone, tufa masonry, and marble, hydraulic concrete for foundations and vaults. Time of Sulla (ca. 80–75 B.C.) according to most scholars.
F. Fasolo, G. Gullini. L. Crema, pp. 52–57, fig. 48. F. E. Brown, pp. 20 f., fig. 18. P. MacKendrick, pp. 116–132, * fig. 5:2. A. Boëthius, pp. 62 ff., fig. 26.

12 The Two Temples at Tivoli

Climbing a steep rise of the Sabine mountains some twenty miles from Rome, Tivoli, ancient Tibur, enjoys from its perch the open loveliness of the plain and the panoramic vistas of receding mountain chains. Passing

across the ridge, the visitor is suddenly in another world —the narrow defile of the Anio between steep mountain flanks, its noisy waters cascading over precipices, shady dark green trees creating a mood mysterious and romantic. In Vergil's *Aeneid* (VII:85 ff.) Latinus... 'visits the oracle of his father Faunus the soothsayer, and the groves deep under Albunea, where, queen of the woods, the Sibyl echoes from her holy well, and breathes forth a dim and deadly vapor... hither the priest bears his gifts, and when he has lain down and sought slumber under the silent night on the spread fleeces of slaughtered sheep, sees many flitting phantoms of wonderful wise, hears manifold voices, and attains converse of the gods.'

Suspended at half height on a platform across from the waterfalls are two temples, one round on a high podium with columns of so-called Italic-Corinthian kind crowned by a frieze showing garlands of flowers and fruit hung on bucrania, the other of Ionic order, rectangular in plan. Both turn their backs on the gorge whose inspiring mystery would have been visible during ritual at the altars in front of the shrines. Here as in Praeneste the sublime positioning bespeaks a new sense for unity of nature and architecture.

The soft, somewhat provincial style of architectural ornament characterizes the temples as creations of the age of Sulla (ca. 80 B.C.). Although they are popularly known as 'Temple of Vesta' and 'Temple of Hercules,' these designations are uncertain.

Round temple: height of podium, ca. 8 1/2 ft. (2.59 m.), or columns, ca. 23 ft. (7.10 m.), entire preserved height, ca. 36 ft. (11.03 m.), diameter, 46 3/4 ft. (14.25 m.). Podium and wall *opus incertum*, brown tufa pieces in mortar, wall originally covered with stucco; gray travertine for door frame, frame for an interesting window (originally there were two), cassettes of ceiling, and the famous Corinthian capital with large flower (imitated by Soane in the Bank of England). High podium, 18 columns (10 preserved). Shape of ceiling and roof uncertain.
R. Delbrueck, *Bauten* 2, 1912, pp. 11–22. *CAH* IV, pp. 102 f. L. Crema, pp. 48 ff., figs. 32, 42. F. E. Brown, p. 20, fig. 17.

13 The Arcaded Substructures of the Temple of Jupiter at Anxur

Towering over the Roman colony of Anxur (modern Terracina) on the great southward highway, the Via

Appia, the sanctuary of Jupiter 'is designed to capture attention from the colony below, to become more impressive as one approaches, and to give a gradually widening view of the sea, as one ascends' (P. MacKendrick). It is an example of the same sovereign planning, the same authority over architecture and nature, as Praeneste.

The close-up view shows the major revolutionary elements in structure and aesthetic of the new style—rhythmically repeated gigantic arches marching in front of a wall of concrete. This buttressing arcade and curtain wall conceal a corridor of vaulted chambers placed in the substructure along the edge of the vast platform for the sanctuary.

Starting from inconspicuous experiments with some mortar which would bind better than clay, the Romans had during the two preceding centuries perfected concrete, a monolithic mass of broken stones bound together with a mortar which hardened when it set. They had used it, sometimes more timidly, sometimes more boldly for various kinds of utilitarian tasks. Sulla's architects perceived the enormous artistic possibilities of a material which is molded rather than joined, piece by piece, as masonry. They saw that arches and vaults, hitherto treated as problems in segmental geometry, could now be created as masses enveloping space. The ungainly surface of concrete posed a problem. The solution at the time was to face the core with small polygonal stones, at first irregularly, eventually in a diagonal (reticulate) pattern. Corners of the piers, faces of arches, imposts continued to be made of masonry and later of brick; but the essential work is done by concrete piers, arches, and vaults. As in the 'Modern Architecture' of the twentieth century, there was an interplay between the new technological possibilities and a new aesthetic.

Stone for arches of substructure, *opus incertum* for facing of exterior half columns and piers of substructure.

G. Lugli, *Anxur-Terracina* (*Forma Italiae* I:1) 1926, pp. 166 ff. L. Crema, p. 52, fig. 56 (reconstruction of sanctuary). A. Boëthius, fig. 33. P. MacKendrick, fig. 5:8, reconstruction. F. E. Brown, p. 20, fig. 16. The conservative date of 100–60 B.C. for the 'concrete revolution' has been disputed by F. E. Brown, *Cosa I*, *MAAR* 20, 1951, who dates Terracina and other important examples to the mid-third century B.C., G. Gullini, *Archeologia Classica* 6, * 1954, pp. 185 ff. to mid-second.

14 Substructures of the Sanctuary of Hercules Victor, Tibur ('Villa of Maecenas,' Tivoli, by Giovanni Battista Piranesi 1763)

A true son of the late baroque, Giovanni Battista Piranesi (1720–1778) had as no other graphic artist before or after him conveyed the vastness and grandeur of Roman architecture, its overpowering dimensions set off by tiny human figures. The play of light and shade, the cosmic reference to poetically clouded skies, a romantic touch of picturesque decay as nature engulfs the greatest works of man—these are the components of a vision which both interprets and exceeds the achievement of the late Republican architect. To the eighteenth century, antiquity was the setting of great men. It was known that many famous Romans had their villas at Tivoli and thus the vast Roman structure west of the city became for Piranesi a 'Villa of Maecenas,' a worthy setting for the fabulous patron of literature and arts.

An inscription has helped to identify the complex as the sanctuary of Hercules Victor and to place its construction in the time of Cicero (ca. 60 B.C.). The raised precinct with its theater's half circle, axial temple, and three-sided colonnade is inspired by the upper sanctuary of Fortune at Praeneste. The side shown is that toward the gorge of the torrent Anio where a two-storied arcade supports the back of the sanctuary, the lower arcade clinging with powerful buttressing piers to the rock, the upper, enframed by half columns opening into a long chain of cross-vaulted chambers, a *cryptoporticus*, 'hidden portico,' over which in turn, originally rose the double-storied colonnade of the precinct.

Piers of masonry, walls and vaults of concrete, columns and arch facing of *opus incertum*.

F. Fasolo and G. Gullini, pp. 354, 424, pl. 28, reconstruction. L. Crema, pp. 57 f., fig. 53, 52, 54 f. P. MacKendrick, pp. 135 f., fig. 5:10, reconstruction. *

15 A Supply Base for Rome: The Porticus Aemilia

The population of Republican Rome mushroomed after the crucial victory over Carthage in the Second Punic War. There were 137,000 citizens in 208 B.C. as against 337,000 in 164 B.C. Not since Babylon had any city faced

the demand for feeding multitudes on such a scale. Enlargement and improvement of Rome's river port and its storage facilities posed an urgent challenge. If G. Gatti's brilliant reconstruction is right, the challenge was met with a solution breath-taking in scope, which pioneered essential traits of Roman architecture, and tackled boldly completely novel problems in statics. Alongside the river quays the *aediles* (construction officers) L. Aemilius Lepidus and L. Aemilius Paulus erected in 193 B.C. a vast storage and market hall 1,500 ft. long, 200 ft. wide. Here concrete was first used on such a tremendous scale. Barrel-vaulted 'naves' marched across the three long aisles on arcades of concrete piers and arches. The shaping of interior vaulted spaces is completely revolutionary and the anticipation of the 'modern' trends by imperial architecture would be complete if the lighting system by clerestory windows over the lower roofs were assured. The arcuated doors and windows in the walls are actually preserved.

Even should the scanty ruins still extant date from a reconstruction of 174 B.C., their unknown architect would stand as a genius of modernity. The reconstruction is based on the coincidence of the structure as drawn on the Roman city plan of the early third century A.D. *(Forma Urbis)* with stretches of concrete walls and piers still seen on the site.

> Length 1,597 ft. 4 in. (487 m.), width 196 ft. 9 1/2 in. (60 m.). *Opus incertum* (irregularly faced concrete), arches faced with small masonry voussoirs. Gatti advocated a date in the first quarter of the second century B.C. Crema and Nash accept 174 B.C.
> G. Gatti, *Bull. Comm.* 62, 1934, pp. 134 ff., pl. 4. E. Nash 2, pp. 238–240, figs. 985–989. L. Crema, p. 61, fig. 59. F. Castagnoli, p. 41. F. E. Brown, fig. 30.

16 Plan of the Imperial Fora

If the Roman Republican Forum (Fig. 2) shows the first impact of Hellenistic planning, the famous series of imperial fora displays Roman architectural theory and practice fully matured after three centuries of urban planning. Nevertheless, the series is not a master plan realized step by step, but five complexes added to each other over a period of a century and a half. Trajan's great architect, Apollodorus of Damascus, sought to impose a semblance of unity upon this series. Since large parts of the imperial

fora remain concealed underground, we cannot judge the total effect, but it is doubtful whether this unity would have been marked even from high vantage points such as the Capitoline Hill.

The imperial fora represent a conception totally different from the traditional 'functional' civic center of an average Roman town. The Forum of Caesar (46 B.C.), the Forum of Augustus (2 B.C.), and Vespasian's Forum of Peace (75 A.D.) are essentially monumental open-air interiors, separated out of the hubbub of the metropolis. Their purpose is to monumentalize the imperial idea, not to serve as a place of assembly. Traditionally, the temples of those gods who were personal protectors of the individual emperors, loomed large as the central focus of attention, but in the crowning formulation in the Forum of Trajan, the large body of Basilica Ulpia, a secular structure, formed the back wall. The true focal point of this Forum was the equestrian statue of Trajan, perhaps the first in history for which an entire monumental piazza was designed. This is the point of the shrewd remark made by the Persian prince Ormisda to the Emperor Constantius who, on his first visit to Rome (356 A.D.), expressed the wish for such a statue: 'Why want such a horse unless you can build a similar stable?' (Ammianus Marcellinus XVI: 10,15).

Official acts of state continued to be performed and official religious bodies were housed in the vicinity along with libraries, schools, and museums. Some business (banking), and trade functions were retained especially in in the earliest forum, that of Caesar. In the most developed design, however, the Forum of Trajan was reserved entirely for imperial display.

> P. H. von Blanckenhagen, 'The Imperial Fora,' *Journ. Soc. Archit. Hist.* 13, 1954, pp. 21–26 for unity of design. L. Curtius, *Rom*, at end of vol. A. Boëthius, Fig. 31. F. E. Brown.

17 Timgad, the 'African Pompeii'

Timgad, Colonia Marciana Traiana Thamugadi, was founded at the apogee of Roman military might by Trajan's Third Augustan Legion. It was built about 100 miles from the Mediterranean on an important military highway to keep in check the African mountaineers and promote Romanization of the region. Laid on a 3,500-ft.

(1,050 m.) high plateau at the foot of the Aurès range, the city was planned with great precision, on a grid of 1,200 by 1,200-ft. (335 m.) squares. From these were subtracted the width of the streets (15 ft. except for major thoroughfares); then multiples of block units were re-served for the forum, theater, baths, and public buildings. Residential blocks, 70 ft. square, each contained two houses planned around a colonnaded courtyard. The sacred height, *arx*, with its imposing Temple of the Capitoline triad lies on a small elevation, outside.

The street plan is the 'reversed T' scheme common in Roman military camps. The great highway forms the long top-bar of the T; the north-south thoroughfare goes only through the northern half of the town up to the civic center. Irregular growth of suburbs soon quadrupled the area of the town.

With its monumental gates, colonnaded streets, and well-built temples, fountains, markets, shops, baths, and atrium houses preserved to a considerable height, Timgad has become known as an 'African Pompeii.' By the mid-dle of the third century a prosperous resident was able to bequeath 400,000 sesterces (ca. $20,000) for a municipal library. This recalls that provincial Africa gave to Rome writers such as Apuleius and St. Augustine, one of whose treatises (ca. 420 A.D.) is directed against the heretic Bishop of Timgad.

Area: 29 acres (12 hectares), increasing to 123 1/2 acres (50 hectares). Estimated population: 2,000 increasing to 15,000. Streets paved with blue and white limestone; structures of limestone, sandstone, brick, decorative African marbles. Founded 100 A.D., destroyed by Moors in the sixth century A.D.

E. Boeswillwald, R. Cagnat, and A. Ballu, *Timgad, une cité africaine*, 1905. H. S. Jones, *Companion to Roman History*, 1912, pp. 29 f., pp. 38 f., pp. 138 f. H. F. Pfeiffer, *MAAR* 9, 1931, pp. 157–165 (restoration). C. Courtois, ✷ with bibliography, L. Crema, fig. 408. A. Boëthius, fig. 22.

18 Saalburg—A Roman Frontier Fort in Germany

The great river systems of the Rhine and the Danube come close together near the sources of the two rivers, forming a kind of triangle in southwestern Germany. To insure communication between the western (Germany and France) and the eastern provinces (southern Germa-ny, Austria, Hungary, and the Balkans), the Romans under the Flavian dynasty advanced their frontier beyond the Rhine and established a long, permanent fortification line, the Upper German-Raetian frontier *(limes)*. It ran east from the Rhine along the Taunus range (north of Andernach on the Rhine), swung south to Welzheim (east of Stuttgart), then turned east again to reach the Danube (Enning, east of Regensburg). A palisade of wood or a stone wall with one thousand rather closely spaced watchtowers was backed up by one hundred forts *(castella)* where auxiliary troops were stationed. A road network connected these frontier outposts with legion-ary headquarters. This frontier was successfully main-tained from the late first to the mid-third century A.D.

Saalburg (not an ancient name), a typical *castellum*, was excavated from 1870 on and restored between 1898 and 1907. It presents to the modern visitor the unique picture of a Roman frontier post in western Europe. Founded as a small camp at a pass in the wooded Taunus range some 18 miles north of Frankfort and 6 from Bad Homburg, during the offensive of Domitian (83 A.D.) Saalburg was enlarged to a sizable (eight acres, 221–147 m.,) camp under Hadrian (117–138 A.D.) and Antoninus Pius (138–161 A.D.). Here was stationed a garrison of ca. 500 soldiers of the 'Second Raetian Cohort of Roman Citizens.'

A cemented stone wall with battlements, nearly 16 ft. (4.80 m.) high, and two steep moats protected the camp. The central building of the camp, the *principia*, consisted originally of a courtyard flanked by rooms where armor and supplies were kept, a large cross-hall with offices in the corners and, in the center, the military shrine *(sacel-lum)* where the standards of the cohort (corresponding to our flags) and the treasury were kept, and divinities protecting the army were worshipped. Thus, a statue of a genius with horn of plenty bears the dedication 'In honor of the Divine (Imperial) House the centurion Sattonius Aeneas has set up this dedication to the Genius of the Centuria.' Barracks, magazines, baking establishments, and a small bath filled the camp. Soldiers' families and camp-followers lived in a small village outside. Here, too, was a larger bath with a warm air heating system, and sanctuaries of gods both native, such as the Celtic god of the underworld Sucellus, and imported by the soldiers, such as the militant Persian Mithras, and the Oriental Cybele.

I9 Saalburg—Entrance Gate

Nowadays picturesquely situated in the midst of a wooded landscape, the camp originally stood in a large clearing. In its use of native materials and timber framework construction it forms a first chapter in the architectural history of western European civilization in this region. And views such as that of the main gate and fortress wall of Saalburg, with their turreted and arched windows, recall the earliest medieval buildings and are visible symbols of that thin but vital thread of continuity which linked the Roman occupation to the origins of Romanesque France and Germany.

Area: about 8 acres (3.2 hectares). Initially much wood and framework, later cemented rubble, tile in baths. First camp 83 A.D., enlarged 120–140 A.D., stone-rubble wall and buildings 209–213 A.D. abandoned under pressure of Alamanni 251–253 A.D. Population: garrison ca. 500; with village perhaps 1,500 or more.

L. Jacobi, *Das Römerkastell Saalburg*, 1897. E. Fabricius, *Der Obergermanischraetische Limes*, Abt. A, vol. 2:1, 'Die Limesanlagen im Taunus,' pp. 126–151. A. Oxé, 'Die römischen Flächenmasse der Limeskastelle," *Bonner Jahr-*
* *buch* 146, 1941, pp. 133–140. H. Schönberger (Guide).

20 Multiple Dwellings in Ostia

The picture looks familiar. This might be a view of twentieth-century housing. Actually, it is the courtyard of an apartment house block in ancient Ostia, port of Rome. There, during the rapid increase of population in the late first and early second century A.D., a town of individual single family houses was transformed into a city of tall multiple dwellings. The restoration shows the courtyard of a typical city block *(insula)*.

Roman apartment houses often seem to have allowed more units and more space in terms of cubic feet than their modern counterparts. In the 'House of Paintings,' each suite had twelve rooms arranged on two floors. The living and dining rooms went the height of two floors, nearly twenty feet; the smaller units, some of which were bedrooms, were connected by an internal staircase. Mosaic floors, and wall paintings, from which the house takes its modern name, adorned the rooms on the ground floor. Each of the apartments on the upper floors was accessible by a separate staircase, a standard arrangement in Roman tenement houses.

The exceptionally large court, ca. 165 by 45 ft. (50 by 14 m.), provided light and air, but the effectiveness of lighting was reduced because the panes seem to have been of selinite rather than glass. Although the Romans did first-class work on the heating systems of their communal baths, no provision for furnace heating has been found in the apartment houses. There were no private baths. Water was not piped up to upper floors. Waste disposal was taken care of by vertical pipes leading into a sewer system, but only de luxe suites had individual toilets. Other apartment houses had communal facilities on the ground floor. Cooking and heating was apparently done on braziers, as there are no chimneys.

Since traces of plants have been found even in the smallest courts of Pompeii and Herculanum, those of Ostia were undoubtedly landscaped. The court shown had a little shrine of Jupiter near the center. No basement space was provided in Ostia, but at one end of the garden large terra cotta jars were sunk into the ground to store oil or grain, perhaps for the row of shops which backed on this unit.

Ostia, III: iv, restoration by I. Gismondi. House unit, ca. 65 by 42 ft. (20 by 12.5 m.), building lot ca. 88 1/2 by 230 ft. (27 by 70 m.). Estimated height: 41 to 52 1/2 ft. (12.5 to 16 m.), brick construction. Time of Hadrian (ca. 130 A.D.).
Architettura e arte decorative 3, 1923–4, fig. 28. M. I. Rostovtzeff, pl. 23:3. P. MacKendrick, pp. 258–260, fig. 10:3. M. E. Blake, *MAAR* 13, 1936, p. 90 (mosaics). R. Meiggs, pp. 244 f., fig. 14 (plan), 437 (paintings). *

2I An Apartment House in Rome

'In view of the Imperial dignity of Rome, and the unlimited number of citizens, it is necessary to provide dwellings without number... by the use of stone piers, crowning courses of brick, and concrete walls high buildings are raised with several stories, producing highly convenient apartments with views.'

Thus wrote the architect Vitruvius (II, 8, 17) early in the reign of Augustus (25 B.C.). When the northern slope of the Capitoline Hill was cleared of medieval and later accretions in 1927 there came to light parts of a Roman apartment house of brick built against the hill. The first floor now lies below the level of the street; the second, third, and fourth stories are preserved. A row of shops

with a mezzanine floor screened by an arcade occupied the ground floor. A balcony of travertine consoles projects under the windows of the second floor. The façade seen in the reconstruction originally faced an interior court. The major street façade was turned toward a street located approximately where Michelangelo's Cordonnata now ascends the hill. The bell tower and Chapel of St. Biagio di Mercato (thirteenth century or earlier) stand within the ruin.

We tend to think of ancient Rome as a city of temples, palaces, and colonnaded piazzas, forgetting the vast sea of apartment houses, forty-five thousand of them, which occupied three quarters of the city area and housed ninety per cent of the population, possibly as much as one and a half million people. Their height, though limited by law to four or five stories (70 ft. under Nero, 60 under Trajan) would have put most of the streets in shadow all day.

Rich people living in luxury apartments paid high rents, but most of the tenants like the poet Martial (I: 117, 7 f.) who lived on the third floor had plenty to say about noise and squalor, heat and cold.

Extends under the staircase of Sta. Maria Aracoeli to the south; exact limits unknown. Brick, concrete, travertine. Estimated number of residents 40–50 (Calza). First half of second century A.D.

A. Boëthius, pp. 137 ff., fig. 73. E. Nash, I, pp. 506 f., figs. 623 f. S. B. Platner, T. Ashby under *Insula*. A. L. Homo, *Rome impériale et l'urbanisme dans l'antiquité*, 1951, pp. 340, 638.

22 A Street in Ostia

What a Roman street looked like is seen here. The view, along the Via dei Balconi, shows the west frontage of the famous 'House of Diana'; in Fig. 20 we saw the courtyard of another Ostian house.

Large, semicircular or flat, relieving arches appear over the ground floor shops, which in Ostia were distributed all over town, not concentrated in a bazaar or market. Brackets and projecting segmental vaults prove the existence of balconies. Something is also seen here of the competent brick construction with upgoing walls, usually two feet thick, and occasionally made of cemented rubble. The 'House of Diana' is one of the highest preserved.

The little rectangular windows are for the mezzanine floors over the shops. An interesting effect was attained by the flatter curve of brick profile and the decorative, more strongly projecting balconies above. At the end of the street is an intersection where Via dei Balconi joins Via Diana.

Ostia underwent considerable 'urban renewal' in the time of its sudden growth, particularly under the Emperor Hadrian (117–138 A.D.), who honored it by serving twice as chief city official *(duovir)*. The street seen here is over 20 feet wide; it was paved with flagstones and had raised sidewalks. The drainage and sewer system ran under the center of the street. As the port where the vital grain supplies for the hungry masses of Rome were landed from overseas, Ostia must have been a town with considerable traffic. To be sure, the bulk goods were for the most part transferred to river barges going up the Tiber, but large granaries in the city had to be reached by vehicles or mule trains. Only the main avenues would permit two-way traffic of heavy carts; side streets allowed for only one-way passage. Some think vehicular traffic was confined to the night hours, as in Rome.

Ostia in its prime was a town of about 50,000 people with a cosmopolitan, largely middle-class population, remarkable for its urban density and upward growth.

Ostia, I, Casa di Diana and Via dei Balconi. Height of shops of lower floor ca. 10¼ ft. (3.1 m.). Brick and concrete.

R. Calza, E. Nash, pp. 17 ff., fig. 16. R. Meiggs, pp. 145, 240 ff., pl. viii b. *

23 The Market of Trajan: A Business Quarter of Ancient Rome

Apollodorus of Damascus redesigned the entire slope of the Quirinal Hill to permit unhampered realization of his Forum of Trajan (Fig. 16). In the center of the eastern flank of the Forum, he placed a large semicircular hall which later served as a lecture and research institute. He insured the isolation and dignity of the Forum by building a high wall of fire-resistant stone. He picked up the semicircular motif in a paved street outside the wall, then repeated it in a magnificent structure for shops and offices which girds the lower half of the hill in three streamlined belts. Two halls at the end of this 'hemicycle' echoed the half-circle motif in plan and superstructure; it was caught

up again in the large arches of the ground floor and the 'double-quick' of the arcaded gallery of the second floor. The third floor was set back and its shops fronted on a street behind (Via Biberatica, Fig. 24).

The granite columns in the foreground are those of Basilica Ulpia (Fig. 27). A modern houseblock is seen on the extreme left; next to it is the northern end of the great 'hemicycle.' Structurally, the 'hemicycle' supported the excavated slope; aesthetically, it screened a terraced shopping center characterized by a mighty hall (perhaps the 'Basilica of Trajan'), one of the boldest structural experiments in the Roman world. Its tall nave, crossed by seven intersecting vaults, thrusts along 'ribs' of concrete against two-storied aisles. The thrusts are caught on imposts of travertine buttressed by counterthrusting arches in a system which anticipates Gothic architecture. Its façade on the Via Biberatica reaches a height of four stories which are seen in our picture just below the tall medieval Torre delle Milizie. Most of this complex of 150 shops was probably a food market; smaller units on upper floors may have housed an imperial bureau *(arcarii Caesariani)* concerned with sales and free distributions of wine, olive oil, and grain *(congiaria)*.

> Area 2.43 acres (ca. 1 hectare) exclusive of the hemicycles and tribunals. Brick, concrete, travertine for door frames.
> E. Nash, 2, p. 49, figs. 733–743 (best pictures). *Guida d'Italia*, TCI, 1962, *Roma e Dintorni* pp. 145 f. (plan with ancient and modern buildings). C. Ricci, *Il Mercato di Traiano*, 1929. G. Lugli, pp. 299–309. L. Crema, pp. 363 f.
> * On *arcarii:* G. Lugli, *Dedalo* 10, 1929/30, pp. 527–551.

24 'Via Biberatica,' A Roman Street

The medieval name 'Biberatica' has been explained as a corrupt form of the Latin *Via Pipetaria* or *Piperatica*, 'Pepper Street.' Presumably pepper and other spices were sold in some of its shops; others show clear traces of tanks for fish, channels for spilled liquid such as wine or oil. Part of Apollodorus' layout, this street is shown here in the stretch when it turns uphill after making a semicircular sweep on the roof of the second story of the 'hemicycle' (Fig. 23). The towering street façade is the long northwest side of the 'Basilica of Trajan'; the lower story forms a terracing substructure; the two stories with windows are part of the double-storied aisle with shops,

described in the preceding caption. Ground and second floor show relieving arches of brick. A very similar massive, three-storied shop building stood on the other side of the street.

With its carefully fitted stone pavement and sidewalks and its canyon-like effect, this street suggests as perhaps no other Roman street extant how far Roman imperial architects had gone toward creating a metropolitan business center. To get the full effect we should have to envisage it swarming with people, for it was also a short cut across a hill for pedestrians. The size and type of shops opening directly with full door width on the street suggests that they were individually owned, not communal stores. Their number indicates the kind of retail specialization which still persists in Italy today.

Relatively new and never realized before on such a scale was the concentration of shops in independent covered buildings, rather than as parts of basilicas or dwellings. Forerunners of the concept existed in Republican times at Ferentinum and Tibur and in Augustan times at Ostia. Its successors are the covered bazaars of Constantinople.

> Travertine (for door frames), concrete (for vaulting).
> E. Nash, 2, figs. 488–490. L. V. Bertarelli, *Guida, Roma* TCI, 1938, pp. 78 ff., figs. 41 (great hall) pp. 129 ff., fig. 68 (Via Biberatica). On concentration of shops in covered markets: A. Boëthius, pp. 78 f., fig. 40 (Ferentinum). R. Meiggs, pp. 273 f.

25 A Roman Warehouse

'Horrea Epagathiana et Epaphroditiana' (Warehouse of Epagathus and Epaphroditus). Thus reads in a very modern way the marble sign over the monumental portal of a remarkable business structure in the First Region of Ostia. Two freedmen built the large complex, perhaps as an investment venture during Ostia's most prosperous era under the Emperor Antoninus Pius (138–161 A.D.). Laid out around a courtyard, the warehouse contained sixteen large rooms on the ground floor. Separate entrance stairs led to second and third floors. Some have surmised that the upper stories housed the offices and apartments of the two owners.

As in marble entrances of nineteenth-century banks, the customer was to be impressed. The portal was well over twice human height; its Corinthian brick columns

and pediments continue the successful exploitation of brick for decorative purposes foreshadowed in the Market of Trajan. Considerable attention was given to security. The passage from street to courtyard had a double gate with iron bolts.

The street façade featured the usual shops, their bays separated by brick piers, and a continuous balcony on the second floors. The inner courtyard, paved with mosaics, was surrounded by brick arcades. Its resemblance to a Renaissance cortile is striking and has led to speculations that Roman buildings of this kind may have been seen by Renaissance architects.

The multi-storied court structure developed for residential housing is here successfully adapted to commercial purposes.

Brick construction, ca. 140–160 A.D.
R. Calza, E. Nash, p. 25, fig. 30. L. Crema, p. 458, fig. 583 (reconstruction). R. Meiggs, p. 277, pls. XIa, XVa. G. Calza, *Palladio* 5, 1941, p. 19. G. Calza, G. Becatti, * *Ostie*, 1956, p. 31, figs. 30–31.

26 A Secret Sanctuary: The 'Basilica' Near Porta Maggiore

This building, hidden deep underground, was a small assembly hall of an 'unlicensed religion' *(religio illicita)*. The vault's clear pattern of the stucco panels explains it as a round, effortless span, and advises an ordered march toward the apse. The same clear, simple, thoroughly Roman rhythm governs the progress of the arches. Traces of a base in the apse conjure up tantalizing visions of the ritual. The group who met here in secret had pioneered the adaptation of the new architecture of massive walls and cavelike space to religious use. Three centuries later these elements were integrated into Early Christian architecture.

In 1917 a landslide revealed the unique structure some 24 ft. below the ancient street level. The 'basilica' consists of a barrel-vaulted nave and two aisles, all of equal height. Six thick square piers connected lengthwise by arches divide the interior. The building was entered by a long corridor sloping down, then turning into a small vestibule.

In the central panel of the vault (Fig. 107) a youth is carried heavenward by a genius, perhaps Time *(Aion)* personified. Four scenes at the corners of the main panel exhibit legends of abduction and elopement, allegories of souls freed by virtuous heroes. In the apse the poetess Sappho is urged by Love to take the leap into the sea which will bring her immortality and reunite her with her beloved Phaon. Whatever religion was practiced here was both literate and learned, and perhaps believed in suicide as a leap into immortality. The gardens of the ex-consul Statilius Taurus who committed suicide when accused by the Empress Agrippina of practicing 'magical superstitions' were in the vicinity (Tacitus, *Annales* xii: 59). Furthermore, the 'basilica' existed only a very short time, was then plundered and filled in with earth. It may have belonged to the family of the Statilii.

Rome, east of Porta Maggiore, entrance from Via Praenestina. Unusual technique; concrete poured into trenches and pits for the walls and piers, earth removed after vaults and half-domes had been cast. Stucco, mosaic. Dimensions: 39 ft. 4 inches by 29 ft. 6 inches (12 by 9 m.), ca. 50 A.D.
L. Curtius, *Rom*, fig. 178. G. Lugli, 3, pp. 495 ff. P. MacKendrick, pp. 182 ff., figs. 7:8–7:10. E. Nash, 1, pp. 169 ff., figs. 184–187. J. Carcopino, *La basilique pythagoricienne de la Porte Majeure*, 2nd ed., 1927. A. D. Nock, *JHS* 46, 1926, pp. 47 ff. E. Wadsworth, *MAAR* 4, 1924, pp. 79–87, pls. 36–49:1 (stuccoes). *

27 Basilica Ulpia. Reconstruction

The great Basilica Ulpia which forms the accentuated backdrop of the Forum of Trajan reshapes the Roman type of hall with the classic means of geometric rectangular space defined by widely spaced vertical columns and by the continuous horizontals of the cornices and the ceiling. Its descent is from the interior of the classic Parthenon. What is new is the effect of a triumphal processional street, flanked by colonnades, yet used as an interior. Take off the roof and you see a street such as Greek Hellenistic architects had often designed for the great royal capitals. Trajan's architect Apollodorus of Damascus must have seen many colonnaded streets in his native Syria. In stressing this processional aspect of the interior he yet made the building symmetrical. The visitor could equally well march along the 'street' toward the east as toward the west. The architect enlarged the capacity of the first floor and of the galleries on the second floor, by doubling the colonnades all around. In this the plan resembles that of a Greek temple. Yet at the same time the round apses integrate the structure with the

decoratively patterned, typically Roman design of the Forum.

The northeast apse contained a shrine of Liberty where slaves were set free; the other apse may have contained a shrine for the imperial cult. Today only part of the area remains exposed and the granite columns do not belong to the Basilica. The nineteenth century Italian architect Luigi Canina stresses magnificent space and picturesque light in his reconstruction.

> 522 ft. by 180 ft. (159 by 55 m.), length of rectangle 426 1/2 ft. (130 m.), total height 138 ft. (42 m.). Ninety-six Corinthian columns in gray granite and polychrome marbles (*giallo antico* from Numidia, striated green *cipollino*, 'onion-stone,' purple-streaked *pavonazzetto*, 'peacock-stone' from Synnada—all from imperial quarries), architraves Pentelic marble, walls faced with Carrara marble, roof plated with gilt bronze. 112 A.D.
> L. Canina, *Gli edifici di Roma Antica* 2, 1848, pl. 123. F. E. Brown, fig. 62. S. B. Platner, T. Ashby, p. 241. E. Nash, 1, pp. 450–454, figs. 548–554. P. H. von Blancken-
> * hagen, *Journ. Soc. Archit. Hist.*, 13, 1954, pp. 23–26.

28 The Plan of the Pantheon

The Pantheon was not a free-standing building. A hall, the Basilica Neptuni built by Agrippa (25 B.C.) and rebuilt by Hadrian, adjoined the Pantheon at the back (south). The apse of the Basilica repeats in reverse the shape of the major axial niche of the Pantheon. Lateral extensions of the complex embraced the sides of the Pantheon and linked with the colonnades of the forecourt to the north. Thus only the porchlike façade of the Pantheon was clearly visible. It rose on five steps above a colonnaded forecourt which was at a level some four feet lower than the modern street level. Flanked by the colonnade of the forecourt the entrance porch would have appeared more classical, better motivated than it does when seen against the massive shape of the rotunda.

To join a circular temple to a rectangular porch was always a problem. Hadrian's solution was unusual. He planned a deep porch like that of rectangular Roman temples, but placed it so that it just touches the circle at the inner entrance. He then divided the porch rather like a basilica, the central passage a nave, the side aisles ending in apses for imperial statues. Actually, the apses, the central arch over the outer entrance, and the segmental

parts (with stairs to roof) between the porch and the rotunda are all included in a separate intermediate unit which is as high as the rotunda wall and rectangular in front.

Hadrian had cut into the wall of the rotunda three semicircular and four trapezoidal niches. Intervening parts of the wall work as eight piers with screens between. Eight small semicircular voids with openings running outward, but actually closed, are placed in the 'piers.'

The floor pattern indicates that Hadrian was fascinated by the circle and the square. We cannot tell to what extent details were to him symbolic and meaningful; but we can imagine the imperial draftsman bending over his drawing board, rejoicing in the sensation which his bold design would produce among conservative architects.

> Length of porch 45 ft. (13.5 m.). Width 101 ft. (33.1 m.). Internal diameter of rotunda 144 ft. (43.3 m.). Sixteen monolithic columns, three of them replacements (on the left with coat-of-arms of the Barberini and the Chigi, Popes Urban VIII and Alexander VII): gray granite (front), red granite. Capitals and entablature of Parian marble. Diameter of column almost 5 ft. (1.48 m.); height 42 1/2 ft. (12.5 m.); weight ca. 60 tons. For a view of the interior see pl. X.
> The marble frieze of Basilica Neptuni can still be seen from Via Palombella, behind the Pantheon. E. Nash p. 196, fig. 222.

29 A Section Through the Pantheon

Although fanciful in some details, this section has the merit of showing clearly the manner in which the Pantheon builds up from the porch, drawn out, as it were, to the outside, through the step-up in the rectangular unit over the door to the great harmonious rise in the rotunda. The exterior porch and the interior are not closely correlated; the columns and entablature of the porch rise much higher than the columns and entablature of the 'first floor' inside the temple. Hadrian obviously assumed that the effect of the porch and the impact of the highly centralized, self-contained interior would be experienced separately. Finally, the drawing conveys, as photography cannot, the total effect of changing light upon the interior.

Of the details, the section discloses the trussed bronze framework on which the roof of the porch was carried. The bronze beams were removed by the Barberini Pope Urban VIII in 1632 to make cannons for Castel Sant'Angelo and columns for the baldacchino in St. Peter's. The acts are recorded in an inscription and gave rise to the famous bon mot: *Quod non fecerunt barbari, fecerunt Barerini.* 'What barbarians did not do, Barberinis did.'

Above, in section, is the second pediment which adorns the 'step-up' rectangular unit between porch and rotunda. We can also see how the vaulting of the entrance steps down from the porch to the interior. The half dome in the great niche opposite the entrance forms a counterpart to the vault of the dome. The rosettes decorating the coffers of the dome are not documented but plausible.

Inscriptions: on the frieze of the porch, alluding to the earlier Pantheon of Marcus Agrippa, M · AGRIPPA · L · · COS · TERTIUM FECIT (27 B.C.), CIL VI:31196. Under it, inscription recording a restoration by Septimius Severus and Caracalla in 202 A.D., CIL VI:896.

V. Bartoccetti, *Santa Maria ad Martyres* (Pantheon), Rome, 1960, pp. 13 f., 77, fig. 19. L. Crema, p. 376. A. Terenzio, *Enciclopedia Italiana*, Pantheon, 1935. W. MacDonald, *Journ. Soc. Archit. Hist.* XVII:4, Winter 1958, p. 5, n. 19, literature.

30 The Eye in the Dome of Heaven

The design of the dome of the Pantheon is justly famous. Horizontal rings emphasize circularity; radial ribs the accent; both are actually parts of the coffered ceiling of the dome. Each coffer recedes in four steps. This recession and the upward taper give greater depth and relief to the geometric pattern. At the same time the hollow shape reduces the weight of the dome.

At the apex, a window opens into the sky, an *oculus*, an eye looking straight to heaven. One can see blue radiance or white clouds passing by. With each passing hour the building changes its light and its mood. One can scarcely imagine a more direct, one might almost say a more literal response of a building interior to celestial powers. If the Pantheon was sacred to the seven planetary divinities, they could indeed constantly communicate with their proper sphere.

Just as the use of two circles of equal diameter for plan and elevation seems like a revival of the old Pythagorean worship of numbers, so does this almost literal pantheism reveal Hadrian's attitude toward religion—a half intellectual, half aesthetic yearning for the vastness and everlasting, everchanging life of the heavens.

A total of 140 concrete coffers, originally gilded. Bronze ring around the sky light. Width of skylight 30 ft. (9 m.). Inner diameter of dome 144 ft. (43.3 m.), larger than the domes of St. Peter's, (42.52 m.) and Santa Sophia (32.7 m.). The height of the dome is one half of the total height (144 ft.).

S. B. Platner, T. Ashby, pp. 383 ff. P. MacKendrick, pp. 285 ff. L. Crema, 375 ff., with literature. On the 'Dome of Heaven,' K. Lehmann, *Art Bulletin*, 27, 1945, pl. 22. ff. V. Mariani and L. von Matt, *L'Arte in Roma*, 1953, pp. 166, f., fig. 31. *

31 Curia—The Senate of Rome

For nearly a millennium the Senate considered itself the rightful guardian of Roman tradition. The concept of an upper chamber of experienced, responsible statesmen lives on in many constitutions of our modern times. Even though the Curia Julia, the 'new' Senate, was built precisely when the Senate lost its leadership (44–29 B.C.), and has survived in the form given to it by Diocletian, one of Rome's most autocratic rulers, any imaginative reader of Roman history will look with some excitement upon the stage where so much of the drama of Rome's history was played.

Diocletian's architects supposedly repeated the earlier plan, but the effect of a tall, austere 'space box' lit by large windows near the ceiling, dwarfing the individual, is decidedly late antique. Originally the walls were revetted with marble. The sweep of steps along the sides would have been broken by the senators' chairs. The uncompromising directness of the steps and the floor pattern received its meaning and goal in the altar and statue of Victory—an object of great controversy between pagans and Christians in 384 A.D.—and the platform for the presiding officer at the center of the back wall.

The present structure has huge buttresses at each corner, one of them containing a staircase. The entrance wall from which the picture was taken had one main door and three windows at mid-height.

The size of the Senate under the empire varied from 600 senators under Augustus to 2,500 under Constantine. The seating capacity seems to be for rather less than 600.

73

Exterior white stucco imitating masonry, interior brick and concrete faced with marble revetments. Floor of colored marble in *opus sectile*, partly ancient. Present state largely from the restoration of 1935–1938. Length 84 ft. (25.2 m.), width almost 59 ft. (17.6 m.).

Built as the Curia Julia by Caesar, completed by Augustus, restored under Domitian, 94 A.D., and Carinus, 283 A.D. Rebuilt under Diocletian, ca. 300 A.D. Survived as the Church of St. Hadrian (625–638 A.D.); 1935–1938 restored, partly on the basis of Renaissance drawings (Du Perea). High proportions for curia buildings were already recommended by Vitruvius, V: 2.

S. B. Platner, T. Ashby, pp. 143 ff. A. von Gerkan in F. Krischen, *Antike Ratshäuser*, 1941, pp. 34–44. L. Crema, pp. 580 f., figs. 769–771 with literature. E. Nash, p. 301,
* figs. 357–360.

32 The Basilica of Constantine: View from Above

One wonders what went on in this mighty ruin when the 30-ft. colossus of Constantine (Fig. 96) presided over it. But literary sources are nearly silent; two hundred years after its construction the Romans thought it was a Temple of Roma.

The three huge cavelike vaults, familiar landmark of the Roman Forum, are actually three bays of the northern aisle of the Basilica Nova begun by Maxentius between 306 and 310 A.D. Gone is their southern counterpart, over 60 ft. high, and the vast central hall (nave) which rose above the side aisles to a towering hundred feet. Hanging on top of the north aisle and supported by external flying buttresses is the springing of the gigantic groined vaults which spanned the nave. Through huge half-circular windows, one for each bay, a new kind of clerestory lighting illuminated the nave. All of the richly marbled and stuccoed interior is shorn away. Only traces of the capitals show where eight nonfunctional monolithic columns adorned the piers.

From the arcaded platform to the end walls, arches and vaults are used in a continuous, conscious rhythmic display rising, as it were, from the smaller sequences of doors and windows to the larger gates between the bays, to the overarching vaults above them, to the apogee in the quadripartite groins over the nave. The creative aspect of Constantine's basilica lies in the totally new relation of wall and window, with each wall a series of large rhythmic openings, each triad topped by a 'blind'

arch. The picturesque red brick was not visible on the exterior which was completely covered with white stucco imitating masonry.

Rome, Forum. On an artificial platform of concrete over 300 ft. (100 m.) long and 215 ft. (65 m.) wide. Brick-faced concrete; marble floor, revetments, columns, marble seat in eastern apse (preserved). Walls 20 ft. (6 m.) thick. Nave (east-west) almost 270 ft. (80 m.) by 83 ft. (25 m.), greatest height 114 ft. (38 m.); aisles 53 ft. (16 m.) wide. Vaults with brick ribs. Staircase to roof in west corner pier. Bronze tiles on roof. A tunnel through the northwest corner of the platform led from the Forum to the populous district of Carinae.

Fundamental, detailed publication with reconstructions by A. Minoprio, *PBSR* (1932), pp. 1–25, pls. 1–14.

33 The North Side of the Basilica

Mussolini's clearance of Via dei Fori has revealed the majestic composition of the exterior. The vast scale of the windows on the second floor would have a most striking effect if glass were used. Normative and autocratic, evoking the Middle Ages in the massive wall and rhythm of arcade, yet thoroughly Roman in the imperial scale and the assured balance of arch and wall, this was the last great statement of imperial architecture in Rome.

As the view clearly shows, Constantine changed the original design and orientation (east-west) by adding a central apse to the north wall; and to balance it, a staircase and entrance on the south side toward the Forum. A paved Roman road leads around it.

In the original plan of Maxentius, the basilica had a vestibule 23 ft. (8 m.) deep on the west side from which five doors led into the basilica. Constantine's entrance had a porch with porphyry columns.

Begun 306–310 A.D. by Maxentius, finished by Constantine after 313 A.D.

S. B. Platner, T. Ashby, pp. 76–78. E. Nash, I, p. 180, figs. 200–204, with literature.

34 The Constantinian 'Basilica' in Trier

Founded under Augustus as *Augusta Treverorum*, Trier in the wine-famed Moselle valley was an important road center. It served as an official capital of the empire from

Diocletian to the late fourth century A.D. and gave to Roman literature the poet Ausonius, who celebrated the Moselle in a charming poem (ca. 370 A.D.).

Trier's great building period was under Constantine (306-337 A.D.), whose parents Constantius Chlorus and St. Helena had resided in the city (293-305 A.D.). 'Imperial' baths, a forum, a circus, a basilica, and a palace were parts of his program for an imperial residence.

The 'Basilica,' actually the great audience and throne hall *(palatium)*, continued to be used through the ages as medieval castle, baroque residence of archbishops, and since 1856 as Lutheran church. After the bombing of Trier in 1944 the building was reinvestigated (1950–1954) and restored as church along the lines of the Roman structure in 1956.

The great hall was originally flanked by two colonnaded courts and prefaced by an atrium but the low flanking units did not impair the impression of rising strength which the hall conveys. A greater emphasis on horizontals resulted, however, from two cantilevered wooden balconies which ran under the windows. At the sides of the apse two towers had doors opening on the galleries and spiral staircases to the roof.

One needs to look back to Constantine's basilica in Rome (Fig. 33) to realize that in Trier a new late antique style of monumental exterior was being created out of late Roman functionalism. The tall volumes of hall and apse are conjoined in geometric harmony. Sweeping up nearly the entire height of the building, the arches emphasize its vertical unity and dramatize the wall with a play of shadows not seen since the Greek temple. From here the road leads to such milestones of Early Christian architecture as the Church of Santa Sabina in Rome.

Trier, Evangelical Church ('Basilica'). Concrete foundation, brick walls, gray-white stucco on exterior, painted rinceaux in window niches. Wooden galleries. Marble floor and internal wall revetments. Gold and polychrome mosaic in apse. Heating system (hypocaust) under floor. Length 223 1/3 ft. (67 m.). Width 91 2/3 ft. (27.5 m.). Height 100 ft. (30 m.). Same brick stamps as at Deutz (Fig. 46), dated 310 A.D.

CAH V, p. 222 b (as of 1846). W. Reusch, *Germania* 33, 1955, pp. 180 ff. and *Die Basilica in Trier, Festschrift zur Wiederherstellung 9. Dezember 1956*, pp. 11–39, reconstructions fig. 5, pl. 6 (interior, exterior), pls. 1–5, 26 (as of 1956). *H. Schoppa, pls. 128, 131. L. Crema, p. 579, fig. 766.

35 Pont du Gard—A Roman Aqueduct

Roman civilization rose and fell with its aqueducts. Hellenistic rulers had already taken measures to provide their capitals with water but it was the Romans who methodically developed water supply as an integral part of urban planning. Rome, herself, built her first underground aqueduct, the *Aqua Appia*, around 300 B.C. and her first high level aqueduct, the *Aqua Marcia*, in 144 B.C. By the third century A.D. eleven major aqueducts brought water from distances of up to 57 miles.

The famous Pont du Gard is the bridge of the aqueduct for the city of Nîmes *(Colonia Augusta Nemausus)* which ran for 31 miles (49,750 m.) from the spring at Eure. One hundred gallons per day were provided for each inhabitant. The bridge is one of the finest examples of Roman engineering.

The structure was built of uncemented masonry with stone quarried in the valley of the river. A lower story of six large arches is surmounted by a second longer story of eleven arches. The largest central arches have a span of 82 ft. (24.52 m.). The covered water channel formed a crowning attic.

In an intentional quickening of rhythm the 35 smaller arches of the top story are set in triads over the large arches. However, there are four small ones at the center and two at one end. Considerable mechanical proficiency was required to build such arches over wooden centering and to place blocks weighing two tons into position some 160 ft. above the river.

Near Remoulins, 13 miles (21 km.) from Nîmes, southern France. Height 162 ft. (48.77 m.). Length 900 ft. (275 m.). Width at top 10 ft. (3.06 m.). Local limestone. The arches are actually barrel vaults composed of parallel arches, 23 ft. (6.36 m.), 15 ft. (4.56 m.), and 10 ft. (3.06 m.) wide in the three stories. Restored in 1855–1859. The modern bridge along the east side was built in 1743–1747. A plausible conjecture is to consider the Pont du Gard as part of the great building activity of Augustus' minister, Agrippa, while governor of Gallia Narbonensis. He visited Nîmes in 19 B.C.

É. Espérandieu, with literature. L. Crema, p. 146, fig. 136, with literature on aqueducts, H. S. Jones, *Companion to Roman History*, Oxford, 1912, pp. 141-151, good short account of Roman aqueducts. T. Ashby, *The Aqueducts of Ancient Rome*, Oxford, 1935. E. B. Van·Deman, *The Building of the Roman Aqueducts*, Washington, 1935. *

36 The Interior of the Colosseum

Ave Caesar, mòrituri te salutant! We are standing over the
'Triumphal Gate' where the procession entered at the
beginning of the games; and look toward the dread 'Gate
of Libitina,' goddess of undertakers, where the dead were
dragged out. What we see is the skeleton of the building
—the steeply (37 degrees) pitched supporting walls for
the auditorium, the entrances, and the installations under
the arena. We must envisage, on the right, the marble
stall for the emperor, the Vestal Virgins, and consuls;
across from it another, for the prefect of the city, the
magistrates, and the priests; front rows of marble benches
for senators; two rising tiers; and at the top the 'chicken
coop,' where women of the people were permitted to go.
A colonnade ran around the highest part; and from tall
poles above, the top awnings spanned the entire building.

The floor of the arena, partly of wood, strewn with
sand, was often drenched with blood. The elaborate
underground system of corridors and chambers for
machinery, elevators, and wild beasts communicated
also with the gladiatorial barracks.

As exposed now, the Colosseum seems a very efficient
device for murder as well as for pleasure; it was more
impressive when more ruinous and when its sinister
beauty could inspire romantic sentiments in Byron,
Longfellow, and Henry James.

282 ft. (86 m.) by 207 ft. (54 m.).
S. B. Platner, T. Ashby, pp. 6–11. G. Lugli, pp. 319–347.
L. Crema, pp. 293–298, figs. 331–333. E. Nash, 1, p. 17, figs.
5–14.

37 The 'Colosseum' from the Air

Much of ancient Rome forms the setting for the 'Flavian
Amphitheater' in this view. To the left, the Arch of Con-
stantine and the Palatine with imperial palaces; just above
the Colosseum, the platform of Hadrian's huge Temple
of Venus and Roma; at the end of the straight road, the
Arch of Titus, and behind it all of the Roman Forum and
the Capitol; while the imperial fora lie to the right and
left of the asphalt of the Via dei Fori.

In Nero's time the site of the Colosseum was a lake of
his 'Golden House' villa. The bronze colossus of Nero
(120 ft. high) was moved close to the amphitheater by the
Emperor Hadrian and from it the medieval name 'Colos-
seum' derives. To the Romans it was known as the Fla-
vian Amphitheater.

The opening show lasted one hundred days. Five thou-
sand animals were shown in one day, nine thousand
animals killed in the hunting shows; men fought animals
and animals fought each other—lions, leopards, bears,
aurochs, bison, boars, deer, perhaps even a rhinoceros—
and three thousand combatants fought a mock sea fight
in the flooded arena. There were hundreds of gladiators.
Fifty thousand Romans enjoyed the excellent visibility
and rejoiced in the ease with which the crowds could get
in and out.

In the Colosseum, the Roman amphitheater reached
its largest and most sophisticated form, perfecting the
arcaded masonry exterior initiated by late Republican
architects. The four stories of gray limestone from Tivoli
rise in solid, if monotonous, clarity. The vertical-horizontal
framework of the Greek columnar façade in three stories
is carefully adjusted to provide the frame for the contin-
uous series of open arcades which spring from piers
flanking the columns. The closed arcades and big con-
crete supporting wall are modern restorations. The fourth
story, pierced only by windows, sits like a heavy crown
above. Radial barrel vaults and concentric corridors
provide the supporting system and circulation arteries
for the auditorium. Four major entrances were located at
the ends of the two axes. The genius of the architect lay
in functional planning, in efficient construction proce-
dures, and in ingenious solutions of problems of vaulting
which the complex circulation plan entailed.

600 ft. by 500 ft. (188 m. by 156 m.), height 161 ft.
(48.5 m.). Exterior and lower internal walls of travertine,
upper inner walls of peperino and concrete, with and
without brick facing. Orders of exterior from bottom up:
Doric, Ionic, Corinthian columns, Corinthian pilasters.
Stucco decoration on inner vaults. Begun by Vespasian
(69–79 A.D.), dedicated by Titus in 80 A.D. Built by prison-
ers taken in the Jewish war. Finished by Domitian (81–
96 A.D.). Last animal games in 523 A.D. Restorations
1828, 1845, 1901, 1938–40.
M. R. Scherer, pp. 80–89, pls. 132–141.

THE BATHS OF CARACALLA

In the six years of his rule (211–217 A.D.), the Emperor Caracalla gave Roman citizenship to almost everybody and gave the biggest bathing establishment to the people of Rome. One wonders what the Romans appreciated more; certain it is that the unruly populace of the capital considered bread, baths, and circus games their birthright. It is symbolic of the last stage of the empire before the crisis that the last great building theme is not a religious building, not a memorial to the power of the empire, but a contribution to the 'standard of living' designed for leisure.

38 Plan of the Baths of Caracalla

With its symmetrical, ornamental pattern, the plan has a beauty of its own. A contemporary American architect remarked: 'This is the kind of plan I would draw to impress a customer.' The design tries to group as compactly as possible the units for different functions forcing them into a rigid oblong. The elevation is not unified; its multiplicity of roofs cannot have presented a coherent logical build-up. A different evaluation, however, is given by J. B. Ward-Perkins, who sees 'a very fair measure of progress toward the creation of a new and vital exterior aesthetic... a three-dimensional play of thrust and counterthrust which looks... forward to a long history of experiment and refinement in the Middle Ages...'

The original reason for the symmetrical, so-called imperial, plan may be economical. By placing the large heated units on a central axis one could double the capacity of the other parts without doubling the heating installation. Customers would undress at L, proceed across or around the units for exercise (G, F), possibly through units C, E (which some experts interpret as heated rooms preparatory to entry into the hot bath). From this circular hot *caldarium* (D) the bather could go on to C (thought by some to be the *tepidarium*, heated room without tanks), and on to the large hall (B) and the swimming pool (A).

The capacity of the baths has been estimated as 1,600 bathers at one time. The doubling brings up the question whether one half might not be for men, the other for women. The common access to the swimming pool, the hall (B), and the hot bath (D) contradicts this notion. Women's baths were strictly separated or else they used the baths at different hours. 'The manager shall make the bath available from daybreak to the seventh hour for women and from the eighth hour to the second hour of the night for men,' states a regulation for the bath of a Roman mining town in Portugal.

That some women did sometimes bathe together with men is mentioned and condemned by several ancient authors. It happened often enough to cause scandal and make emperors legislate against the practice; but such 'mixed bathing' was not the rule.

Gigantic baths like that of Caracalla put high demands upon utilities. A great reservoir (Z) was fed by a special aqueduct. An elaborate underground system of corridors, big enough for vehicles, and service staircases in the piers were used to move fuel and other materials. It has been estimated that 650 tons of wood coal were needed to heat the imperial baths in Trier for 150 days. 'Radiant heat systems' which came into general use around 50 A.D. made the large baths possible. Heated by basement furnaces the air circulated under floors suspended on low pillars of brick, then rose in tubes or hollow tiles through the walls and sometimes into the vaults.

The baths were centers of sociability where the Romans spent much time. Athletes, swimmers, masseurs, ball players; bathroom singers, thieves, hair-removing specialists; cake and sausage sellers and waiters—all contributed to the din and commotion. There were athletic performances, and perhaps literary ones, in the libraries.

Much of the interpretation of the individual units is controversial. Only the hot bath (D), drawn out southward to get more sun, and the swimming pool (A) are undisputed. The huge central hall (B) is by some considered a 'cold bathing' room as it is unheated and is adjoined by four basins. Unit S is perhaps a stadium.

Precinct 1,180 ft. (353 m.) by 1,120 ft. (335 m.). Main building 715 ft. (214 m.) by 366 ft. (110 m.).
Plan after L. Curtius *Rom*, insert at back. Different interpretations: D. Krencker, pp. 180, 187, 269 ff., figs.

239e, 399, 400. L. Crema, pp. 531–536, figs. 698 f., with discussion of controversial issues. S. B. Platner, T. Ashby pp. 520 ff. H. Wachtler in D. Krencker, pp. 320 ff., ancient comments on baths. J. B. Ward-Perkins, *The Italian Element in Late Roman and Early Medieval Architecture*, Brit. Acad. Proceed. 33, 1947.

39 A Reconstruction of the Baths of Caracalla

The reconstruction by C. V. Rauscher (1894), a masterpiece of perspective drawing, conveys the gigantic scale and reveals the manipulation of interior spaces which in turn shaped the architectural volumes composing the structure. The building is seen opened with the swimming pool (A, upper left) showing the beginning and the round tower of the hot bath (D) showing the end of the central axis. Part of the huge central hall (B) is to the left; the view of the floor displays the attached oval pools for cold baths. Around the colonnaded court (G) is seen one of the galleries of the second story which afforded facilities for sun bathing.

After S. A. Ivanov and C. Hülsen, *Architektonische Studien* 3, 1898, pl. B. L. Crema, fig. 701. E. Brödner, *Untersuchungen an den Caracallathermen*, 1951, pp. 18 ff., sun terraces, with a different reconstruction pl. 13.

40 Aerial View of the Baths of Caracalla

What survives is the ancient shell, the main bearing walls and massive piers of brick and concrete. They are witnesses to enormous feats of engineering—the central hall (B) spanned by groined vaults was 80 ft. (24 m.) wide. For the Romans, however, it was not the grandeur of space but the marble revetments and marble architecture of the interiors which made the baths appear as sensational displays of luxury. On the walls 'the porphyry gleams and that purple-speckled marble which in the hollow caves of Phrygian synnada, Attis bedewed with drops of his blood. There is scarcely space for the Laconian marble which in thin green lines sets off the Synnadian marble... The ceiling shines with many-colored glass mosaics of animated figures. Everywhere the sunlight floods the halls from above with all its rays.' This description of a private commercial bath, paraphrased after the Roman poet Statius, is but one of several enthusiastic poems in praise of the glorious materials which made each bather feel like a king.

Fragments of this splendor are still to be seen in the baths of Caracalla; and one of the eight gigantic granite columns of the central hall (B) now stands in Piazza della Trinità. Gone are millions of the marble plaques and hundreds of architectural parts of marble; and of the museum-like display of sculpture we have only the colossal statues of Hercules and Flora and the dramatic group of Dirce tied to the bull which were removed by Pope Paul III and came with the Farnese collection to Naples.

E. Nash, 2, pp. 434 ff., figs. 1230–1241. On the baths of Etruscus: Statius, *Silvae* III; 5, 36 ff. and Martial VI, 42 ff. Restorations of decoration of large hall: G. A. Blouet, *Restauration des Thermes d'Antonin Caracalla*, 1828, pl. 15. *

41 The Villa at Piazza Armerina

One of the most celebrated and sensational exploits of archaeology in recent times, the excavation of an imperial villa at Piazza Armerina, has given us a series of mosaics of extraordinary interest (Pls. xxiv, xxv, L).

Ingeniously spread over four terraced levels on the slope of Monte Mangone, the architectural design of the villa shows deliberate avoidance of axiality with loosely attached units flung out at odd angles from the central colonnaded court, a free-wheeling exploitation of curvilinear spaces, and an appreciation of optical surprises. Its essence has been described as 'persistent deviousness, eternal changing of direction, and hiding of the goal' (N. Neuerburg). Hidden in a lush, wooded, intimate valley, it 'huddled in the landscape but ignored it' (F. E. Brown). On a much smaller scale some of these features recur in the late Roman houses of Ostia. The unrepentant experimentalism of Piazza Armerina stands in the most marked contrast to the authoritarian, rigid geometry of Diocletian's contemporary fortress palace at Spalato (Fig. 45).

This dichotomy repeats the contrast in an earlier phase of Roman architecture, between the disciplinarian imperial planning of Trajan and Hadrian's 'unusual and elusive spatial effects,' 'studied evasiveness' and generally 'modern attitude toward architecture as organization of space' (J. B. Ward-Perkins). In Hadrian's villa, too, is found the informal conjoining of complexes. We must perhaps admit that even under the late autocratic 'dominate' there survived among Roman architects an adventurous spirit of creative play with space; some of its

forms found their way both into the Christian ecclesiastic and Byzantine palatial architecture.

> Three and a half miles (5 km.) southwest of Piazza Armerina, Sicily. Rubble masonry, concrete, granite and marble columns and revetments; pavement and ceiling (glass) mosaics. Area, approx. 3.3 acres (100 by 135 m.). Excavated 1881, 1929, 1937–1943.
> G. V. Gentili, *The Imperial Villa of Piazza Armerina* (Guide) 2nd ed., 1961. B. Pace, with the isometric reconstruction by I. Gismondi, pl. I. P. MacKendrick, pp. 327–340. N. Neuerburg, *Marsyas* 8, 1957–1959, pp. 22–29, with an important analysis. L. Crema, pp. 605 ff., fig. 805, F. E. Brown, pp. 46 f., fig. 94. I. Lavin, *Art Bulletin* 44, 1962, pp. 6 ff. on the survival of the triconch motif.
> According to H. P. L'Orange, Gentili, MacKendrick, villa of the Tetrarchic Emperor Maximian, 286–306 A.D.;
> * Pace advocated a date around 400 A.D.

42 Hadrian's Villa at Tivoli

Located on a gentle rise some 18 miles from Rome, Hadrian's Villa in Tivoli is the unique, private dream world of an emperor architect; it is a colossal example of the Roman attempt to combine civilized living with the enjoyment of nature. I. Gismondi's model helps to visualize the general layout.

A low-lying platform between two brooks at the foot of the mountain chain, the site affords beautiful views over the Campagna. The emperor abandoned any ideas of imposing approaches, axiality, and symmetry for the over-all plan. Rather, Hadrian has worked here with several large complexes, loosely linked, placed perhaps intentionally at odd angles to each other. Within each complex, however, the designer operates with the usual Roman vocabulary of palatial, axial, closed units. The landscaping, too, was originally formal.

With its thousands of columns and its marbled exteriors, Hadrian's Tivoli was a classicistic vision enlivened by the emperor's unorthodox experiments with contracting and expanding curvilinear spaces. In the purposeful use of water in pools and fountains as an element of his compositions, Hadrian made an important, though insufficiently studied, contribution to the history of landscape architecture.

Entrance units, including a fountain house and two theaters lie to the left. In the foreground is the famous pool and belvedere known as the Poecile (after the 'Painted Porch' in Athens). Adjoining its upper left corner is Hadrian's round temple-study (so-called 'Teatro Marit-

timo') and the palace buildings including the reception hall famous for its segmental dome ('Piazza d'Oro') in the center background. In the right foreground is the 'Canopus' with the half-dome of the 'Serapeum' shown in color in Pl. I. At the right edge is a three-storied pavilion and another palace unit ('Small Palace'). Baths, libraries, gymnasia, stadium, housing and service quarters for hundreds of people are included in this luxurious imperial residence in the country.

> Tivoli. Area ca. 12 acres (5 hectares). Probably begun shortly after the accession of Hadrian, 118–138 A.D.
> H. Kähler, *Hadrian*. P. MacKendrick, pp. 273–283. S. Aurigemma, *Villa* and *Hadrian's Villa*, Guide, 1953. with history of discoveries. F. E. Brown, pp. 42 f., pls. 86–90. *

43 A Late Roman Loggia—House of the Nymphaeum, Ostia

The revival of luxurious residential dwellings in late Roman architecture was a striking and unexpected revelation of the excavations made in Ostia after the Second World War. As the urban population dwindled and apartment houses decayed, the rich noble families expanded and embellished their abodes. Although their forerunners were traditional Roman court houses of Pompeian type, the architectural language of these late antique residences belongs to a different world. The graceful loggia seems at first glance to express early medieval or early Renaissance rather than Roman taste. The splendor of the interlaced colored marbles on the floor and originally also on the walls is heavily ornamental, a far cry from the light fantasies of the Pompeian wall decoration.

To enjoy the shade, the breeze, and the gentle music of the fountains while enthroned in a regal setting of polished marble was the new style of life which would soon lead to Byzantine luxury in the east, medieval manor in the west. Country life was the subject of large figurative wall paintings in the vestibule.

> Ostia, III i: vi, 'House of the Nymphaeum.' View of Courtyard 'A' from the west. House ca. 167 ft. by 69 ft. (51 m. by 21 m.), Courtyard 'A' 72 ft. by 19½ ft. (22 m. by 6 m.). Brick arches and walls; marble columns, floor and wall revetments. 350–400 A.D. according to R. Meiggs, p. 552.
> G. Becatti, *Case ostiensi del tardo Impero*, 1949, pp. 109–112, figs. 9–11. G. Calza, G. Becatti, *Ostia* (Itineraires, 3d ed., 1956) fig. 46. R. Calza and E. Nash, 1, p. 36, fig. 46. *

44 The 'House of Amor and Psyche'— A Jewel of Late Roman Architecture

No story in Roman literature is as charming as the fairy tale of Amor and Psyche told by Apuleius. Something of this mood, elegant, artfully simple, was to be evoked in a house which has been justly called the jewel among the late Roman residences of Ostia. To make his meaning clear the owner put a group of Amor and Psyche in tender embrace upon a pedestal in one of the intimate little rooms which still shines with the white elegance of its marbled walls (Pl. xv).

Center and high point of the house is a very sophisticated unit in four parts, in which each part adds a different gradation to the symphony of light and color, each skillfully contributing to picturesque vistas.

The room of Amor and Psyche was one of the four small bedrooms aligned in a row, lit originally only by subdued light from the court and small high windows. Laid across the doorways, a hall was treated on the other side as an open arcade of rather tall and strong columns, a zone of transition from the closed intimacy of the bedrooms to the green charm of the garden, the *viridarium*, open to the sky.

Echoing the arcade of the hall, another arcade, more slender and delicate, swings over five niches. Giving constant life and motion, water streamed from the niches down over inclined marble ramps. The semicircular rhythm of the arcade was repeated in the semicircular niches, once brightened by multicolored mosaics, and was reiterated in the projecting and receding marble pedestal below the arcade.

Today, in the sharp clarity of daylight, there is a harsh contrast between the roughly textured brick and the brilliance of the polished marble revetments. When Amor and Psyche ruled over the house, mosaics and wall paintings would have combined with the marble floors and dadoes to maintain an unbroken vision of color.

Small rooms ca. 9¾ ft. by 12¼ ft. (3 by 3.75 m.), entire unit 32½ ft. by 52⅓ ft. (13 by 16 m.). Brick, marble columns, floors, revetments in fountain niches; glass mosaic in vaults of niches. Fourth century A.D.

G. Calza, G. Becatti, *Ostie* (series 'Itinerari dei musei e monumenti d'Italia,' 3rd (French) ed. 1956), pp. 33 f., figs. 39 f., G. Becatti, *Case Ostiensi del tardo Impero* (1949). A. Boëthius, fig. 60. R. Meiggs, pp. 253 f., 553 (date), * pl. 14b.

45 Tetrarchic Architecture—Diocletian's Palace at Spalato

The Emperor Diocletian had a geometric mind. Between 284 and 305 A.D. he molded the Roman Empire into a geometric scheme of four rulers (Pl. IV). He applied the same simplifying, static geometry to the palace in his native Dalmatia to which he retired (305 A.D.) after abdicating.

Diocletian built his palace as a fortress. The plan of the Roman camp, with headquarters placed at the intersection of two major avenues, served as a model. The most progressive defenses were used in the gates with advanced octagonal towers and in the regular spacing of tall towers on the land sides.

Diocletian was not only a superlative general but also a prolific, masterful builder. In Spalato he compressed into the four quarters of the plan an entire imperial court—a 'Sacred Palace.' The axial colonnaded avenue serving as processional approach led to a gate where, according to ceremonial, the emperor showed himself. The approach with screens of arches resting directly on columns has been interpreted as a basilica without a roof (*tribunalion*) or as an atrium preceding the *konsistorion*, imperial hall of ceremonies. Placed symmetrically behind the screening units were the temple to Zeus and the mausoleum for the emperor, circular in the interior and octagonal on the exterior. Imperial halls and apartments occupied the most desirable side toward the sea. The composition is in compact, disciplined blocks.

The massivity of fortress architecture was relieved on the sea side by the rhythmic arcade, within the castle by colonnaded avenues with richly developed ornamentation.

Split, Yugoslavia. Largely limestone masonry, concrete for domes, marble columns. Area, under 10 acres. Plan slightly irregular, sea, front, south, 600 ft. (181 m.), north side 575 ft. (175 m.); east and west sides 720 ft. (215.5 m.). 300–305 A.D.

E. Hébrard, J. Zeiller. *Le Palais de Dioclétien*, 1912, reconstruction by Hébrard. K. M. Swoboda, *Römische und romanische Paläste*, 1919, pp. 148 ff. L. Crema, pp. 612–619, figs. 775, 810–813, 824.

46 A Late Roman Fortress—the Castellum at Deutz

At first glance we seem to see a medieval city; but we tend to forget how 'medieval' Hellenistic fortifications looked. The fortified city in the Pompeian painting (Pl. xxxiv) has the same round towers, and strong masonry walls as the fortress which Constantine built in 310 A.D. to safeguard a bridge across the Rhine. After the Hellenistic age when primitive stone-slinging 'artillery' was improved by better devices for mechanical propulsion, there was no striking increase in offensive firepower until the advent of powder; and thus no radical changes were made in defensive architecture.

As in the wall built by Aurelian around Rome (ca. 275 A.D.) gates were flanked by semicircular towers. Other circular towers rise ca. 25 ft. (8 m.) higher than the top of the wall, presumably to permit defense from above during scaling attempts.

Military architecture, limited to frontier regions in the times of Roman peace, now becomes indispensable for the fragmented human community and exerts an influence upon the aesthetic of late antiquity and the early Middle Ages. The city yields to the castle.

Model by the Historical Institute of the Engineering Corps of the Italian Army. Museo della Civiltà Romana, Rome. Deutz lies on the east bank of the Rhine across from Cologne (Colonia Agrippina). Masonry. L. 513 ft. (154 m.) by 506 ft. (152 m.). Height of wall over 65 ft. (20 m.). Area, over 3 acres. The tents of the garrison are shown in the reconstruction. L. Crema, p. 624, fig. 820. A. Grenier, I, pp. 403 ff. *Mostra Augustea, Catalogo*, 3rd ed., 1937–1938, pp. 386 f., pl. 66.

STATUES

47 A General of the Time of the Civil Wars

The statue was found in the substructures of the 'Temple of Hercules' in Tivoli where it was placed to honor an important military personage probably shortly after the war between Sulla and the partisans of Marius (87–82 B.C.). The grim, weatherbeaten face, contracted brow, bitter mouth, and shadowed eyes speak of the sanguinary

era, 'the Roman Revolution,' when ambition, treachery, and strife nearly tore Rome apart. The energetic dynamism, the pictorialization of drapery, even the brutal vigor have their forerunners in portraits of Greek Hellenistic rulers. The pose goes back to statues of gods such as Poseidon, unruly earthshaker (whose statue from Melos shows the aggressive pose and a similar arrangement of drapery). The cuirass with the Gorgon's head, thunderbolt, and two rows of very long lappets is of a Greek type.

The stamp of *Romanitas* is imprinted upon the insistent descriptiveness of facial traits. Viewed from the left, the statue presents a most shapely nude Greek athlete. The cuirass seems to be added as an afterthought. The Greek sculptor was struggling with an unfamiliar variant of a familiar theme, something the patron may have required. In an ideological sense, the statue is a forerunner of the Roman cuirass statue.

'One of Sulla's lieutenants' is perhaps as far as we can go with the identification. The dates suggested have ranged from 100–60 B.C.

Rome, Museo Nazionale delle Terme 106513 (45). Height 6 ft. 6 inches (1.94 m.) with base. White Greek marble with large crystals. Restored: right shoulder, part of cuirass.
R. Paribeni, *NS* 1925, p. 252. B. Schweitzer, pp. 49 f., 60 ff., pls. 63–65. O. Vessberg, pp. 209 ff., pls. 48 f. B. M. Felletti Maj, *I ritratti*, Museo Nazionale Romano, 1953, p. 33, pl. 45, with literature. *

48 The 'Arringatore'—An Etruscan in Roman Guise

Rome owed much to her Etruscan neighbors. In religion and in art the Romans freely acknowledged their debt. Archaic Etruscan sculptors had made the venerable terra cotta images of the first Temple of Jupiter. The Romans paid a back-handed compliment to Etruscan bronze sculpture when in 264 B.C. they carried off two thousand bronze statues from the conquered Etruscan city of Volsinii (Pliny the Elder, *Natural History* 34:34).

The remarkable prowess in casting a life-size figure may well be part of Etruscan technological tradition, but were it not for the Etruscan inscription on the lowest hem of the toga of the statue, we would probably accept this worry-lined, sober-featured man as the very

exemplar of the portrait statues with which the Roman state honored those who had done well by the Republic.

Even if we disregard the grandiloquent gesture of the restored right arm, a sense of awkwardness remains. The artist was struggling to adjust a dynamic, strongly emotional Greek type of statue to the paraphernalia proper to a Roman public speaker; the short toga, again probably borrowed from Etruscan nobility, the high-laced shoes, worn by Roman senators.

The statue was found in 1573 at Sanguineta near the Trasimene Lake, in the territory of Perusia (Perugia). This Etruscan city was under Rome's effective control, but the Etruscan language remained in use until the time of Augustus. The man honored bears a Roman name, Aulus Metellus, written in Etruscan form; his parents have Etruscan names. One wonders whether the use of Etruscan in the inscription was not a patriotic, anti-Roman gesture. The style of the statue is Roman, characteristic of disillusioned realism of the late Republic.

Florence, Museo Archeologico 249. Bronze. Right arm and left index finger restored. Height 6 ft. (1.795 m.). The inscription: *auleśi meteliś ve vesial clenśi cen fleres tece sanśl tenine tuθines Xisvliſ*, 'To Aule Meteli, son of Vel and Vesi, this dedication has placed' (remainder uncertain, translation by M. Pallottino, *Elementi di lingua etrusca*, 1935, p. 85). 100 B.C. or later.
W. Amelung, *Führer Florenz*, no. 257. E. Q. Giglioli, pls. 369 f., references. F. J. Riis, *An Introduction to Etruscan Art*, 1953, pp. 109 f., fig. 107. E. H. Richardson, *MAAR* ✴ 21, 1953, p. 113. For a picture of the head see Fig. 63.

49 A Portrait Statue of an Unknown Man from Delos

This colossal marble portrait statue was found on the island of Delos in 1894. Delos was an important commercial center with a large colony of Italian merchants. It declined in importance after it was sacked by King Mithridates in 88 B.C. and by pirates in 69 B.C. It is generally assumed that this statue and others similar in style were made before the decline of Delos. The heroic nude body was inspired by earlier classical Greek art and is related in style and pose to the portrait statue of C. Ofellius signed by Dionysios and Timarchides of Athens as well as to another statue by Ophelion, son of Aristonidas, in the Louvre. To the ideal athletic body

the Greek sculptor simply added an individualized portrait head. Some think that the man portrayed was a professional athlete, but this is quite uncertain. C. Ofellius Ferus was apparently an Italian businessman; this may be a Roman official.

This work is almost a head-on collision between the Greek revival of classicism and the Roman quest for individualism. Nudity had been considered un-Roman; for a Roman to have wanted a portrait of himself as a nude hero meant a surrender to the Greek ideal and implied an enormous admiration for Greek art. This early, unsophisticated attempt illustrates very strikingly the beginning of the long creative struggle to combine Roman spirit with Greek form.

Athens, National Museum 1928. Found on Delos. Height 8½ ft. (2.55 m.). White, large-grained marble Before 100 B.C.
S. Papaspyridi, *Guide du Musée National d'Athènes*, 1927, p. 96. C. Michalowski, 'Les portraits héllenistiques et romains,' *Exploration archéologique de Délos*, 1932, Paris, pp. 17–22 pls. 14–19. G. M. A. Richter, 'Who Made the Roman Portrait Statues, Greeks or Romans?' *Proceedings of the American Philosophical Society*, vol. 95, no. 2, 1951, pp. 184 f. M. Bieber, *Sculpture*, p. 172, figs. 728–730.

50 The Founder of the Empire— Augustus from Primaporta

All through the civil wars of the late Republic the threat from the east hung over Rome. In 53 B.C. the Parthians had decimated Roman legions at Carrhae in Mesopotamia and Roman standards, symbols of Rome's invincibility, went on display at the Parthian capital. Augustus was urged to take revenge. He succeeded without a war. 'I forced the Parthians to give back the standards and spoils of three Roman armies and to seek as suppliants the friendship of the Roman people,' is the terse statement he makes in his own *Deeds*.

This event of the year 20 B.C. is celebrated in the great statue, which stood in front of the imperial villa 'At the White Hens,' some ten miles north of Rome. Like the Altar of Augustan Peace and the 'Gemma Augustea' the statue is a work of highest quality and authority. The artist was a Greek with a great flair for classic heroic dignity and dramatic skill in pictorial treatment of relief developed by the late Hellenistic Age. What he has created is an exemplar of the new Roman imperial art.

The emperor is proclaiming the victory to the army or the people; the situation is partly real and partly ideal. The emperor is bare-foot, like Greek heroes; a cupid on a dolphin alludes to the divine descent of the Julian family from Venus. He is at the same time a 'mythological portrait' of Augustus' grandson Gaius born in the year of Parthian victory.

The ornate figurative display on the cuirass, however, is a revolutionary innovation. The central scene shows a bearded Oriental who returns the eagle-topped standard to a Roman warrior accompanied by a dog. Some have identified the warrior as the emperor's stepson, Tiberius, the barbarian as the Parthian King Phraates IV. Two provinces are already pacified. 'Standards lost by other army leaders I retrieved from Spain, Gaul, and the Dalmatians [25 B.C.],' *Deeds* 23. The province on the left holds an eagle-headed sword (Spain), that on the right a dragon-headed trumpet. A boar stands in front of her (Gaul or Dalmatia?). Now that peace has come, the Sky God spreads his celestial cloak over the world; the Earth Goddess, reclining at the bottom, pours out her horn of plenty as she nourishes the Roman Twins. A new age is dawning. On the right, Venus with torch is borne away by a female winged figure, 'thaw bringing Dawn,' *Aurora roscida*. The personal gods of Augustus, Apollo with lyre on a griffin and Diana on a stag, converge upon the center to bring their blessings. A trophy on the back of the cuirass refers probably to the triumphs in the west. The sphinxes on shoulder flaps may refer to wisdom or to prophecies. Lifting his eyes from the study of this military, historical, and cosmic announcement, the spectator saw the calm, determined face and the preternaturally large and steady gaze of Augustus (see Fig. 72), bringer of this new Golden Age for Rome and the world.

Vatican, Braccio Nuovo 14. Marble, with traces of blue, yellow, red, pink and gold colors. Missing: fingers of right hand, except ring finger, left index finger, scepter. According to Kähler's recent investigation probably stood against the north wall of a large garden terrace which opened southward on the Tiber Valley. Height: almost 7 ft. (2.08 m.). 19–15 B.C.; Kähler: after Augustus' death in 14 A.D.

CAH, IV, pls. 148–151. Text, Vol. x, p. 558. E. Simon, 'Zur Augustusstatue von Primaporta.' RM 64, 1957, pp. 46–68; *Der Augustus von Primaporta, Opus Nobile*
* 13, 1959. H. Kähler, *Primaporta*, with literature.

5 I A Boy of the Julio-Claudian Family

Bronze statues were more expensive than marble statues and very often finer. The beautifully modeled and cast statue, somewhat under life size, is a success in its tactful fusion of classic simplicity with a knowledgeable study of nature. It is also a sympathetic and charming study of adolescence. As E. Strong justly noted, 'the mingling of childish form with boyish seriousness is admirably rendered.' A glance back to Aulus Metellus (Fig. 48) reveals how mellifluous is the rhythm, how delicately subdued the mood.

The boy stands in a graceful, easy pose. The heavy striped garment gliding down his left arm swings across and falls in heavy folds. Traces of some object on his fingertips suggest that the boy held a ribbon or garland; surely he is so solemn because he performs some religious act. As his facial traits are unmistakably those of a member of the family of Augustus, the statue may represent one of Augustus' beloved grandsons, Gaius (20 B.C.–4 A.D.) or Lucius (17 B.C.–2 A.D.); or Nero Drusus, Sr. (38–39 B.C.), the brother of the Emperor Tiberius. There is a resemblance to Tiberius in the shape of the head but all identifications are guesswork.

New York, Metropolitan Museum of Art, 14.130.1. Height 4 ft. 1½ inches (1.232 m.). Both feet, fingers of the left hand, and eye insets missing. Breaks across body and right arm repaired. Precise dating is difficult; perhaps between 10 B.C. and 12 A.D.

G. M. A. Richter, *Greek, Etruscan, and Roman Bronzes in the Metropolitan Museum of Art*, New York, 1915, # 333, pp. 149–52, detailed description. G. M. A. Richter, *Handbook of the Classical Collection in the Metropolitan Museum of Art*, New York, 6th ed., 1930, pp. 296–298. *CAH*, IV, 170a (Nero Drusus). G. M. A. Richter, *Roman Portraits*, New York, 1948, pl. 29.

5 2 A Roman Benefactress

The imperial family held the foreground of the stage and had the lion's share of honorary statues; but in accordance with a custom firmly established in Greek cities and widely followed in Italy, statues were erected to benefactors, public and private. Pompeii, in the first century A.D., was a lively, mercantile middle-class community whose citizens did not hesitate to proclaim such senti-

ments as 'Profit is joy!' in inscriptions. Yet prosperous families did something for their fellow citizens.

Eumachia (a Greek name) may have inherited her fortune from a family active in the wool trade. She donated a large building in Pompeii's most desirable location, the Forum, to the fullers' guild, Pompeii's most influential commercial association. The fullers were duly grateful: 'To Eumachia, daughter of Lucius, public priestess, the fullers,' reads the inscription on the pedestal of the statue.

Glancing sentimentally from beneath the cloak (palla) cast over her head, Eumachia is shown in her role as priestess. The nearly weeping expression of the full, unindividualized face probably came from the Greek statuary type, a late classic one often used for statues over graves. The sculptor was more accustomed to the copying of Greek statues than to the making of portraits.

The statue's artistic merit is in the carving. Folds begin to gain a metallic precision; they rise in long arcs; deeper shadows induce pictorial effects. The change from the first, calm Augustan phase of Roman classicism to the more dissolved, sophisticated delicacy of the Tiberian and Claudian era is well under way.

Naples, Museo Nazionale 6232. Found in the building of the fullers dedicated to 'Imperial Concord and Piety'. Height with base 6 ft. 4 inches (1.94 m.). Marble. Reddish color (underpaint) in hair. A few drapery folds restored.

A. Mau, pp. 108, 463, fig. 274. A. Hekler, pl. 205b.
* R. West, I, p. 199, pl. 51 : 230.

53 Caius Fundilius Doctus—A Roman Actor

In the first century A.D. the Roman could see theatrical performances on forty days of official religious observances. Funeral games, imperial celebrations and triumphs, all offered an occasion for additional stage plays. Theatrical performances were also part of religious celebrations in sanctuaries outside Rome; and a theater was an integral part of Roman city planning. Greek as well as Latin plays were performed. The acting profession reached a risky pinnacle when the Emperor Nero appeared on stage in person to compete against professional actors (54–68 A.D.). Nero's tutor, Seneca (5 B.C.–65 A.D.), wrote plays which became models for European drama.

Fundilius Doctus may have seen Nero and Seneca. He took pride in his profession. C. Fundilius Doctus, *parasitus Apollinis*, is inscribed twice, once on the base, once on the circular container with manuscripts of the parts Fundilius has played. 'Parasite' referring to an actor does not have its usual connotation but rather 'one who sits at the table of laurel-crowned Apollo,' as the Roman poet Martial wrote (*Epigrams* IX, 29). Typically, Fundilius was a freedman. Statues and two other portraits of Lady Fundilia, who had given him freedom, were found in the same chamber of the venerable sanctuary of Diana at Nemi as the statue of Fundilius.

An elderly, intelligent man with mobile features and a somewhat nervous expression, Fundilius, dressed in tunic and the official Roman toga, attends or performs a religious function. The formal and psychological refinement within a simple self-contained volume of the head is characteristic of the time of Claudius and Nero (41–68 A.D.). As a study in loosening of drapery composition, the statue is closer to Titus (Fig. 54) than to Eumachia (Fig. 52).

Copenhagen, Ny Carlsberg Glyptotek 536. Found in a room of the Sanctuary of Diana, Nemi, in 1887. White, veined marble. Height with base 6 ft. 1 inch (1.83 m.). The attached lower arms lost, head and garment fragments replaced. Ca. 45–64 A.D. Inscription: *C. Fundilius Doctus Apollinis parasitus*.

F. Poulsen, 'Nemi Studies,' *Acta Archaeologica* 12, 1941, pp. 1 ff. V. Poulsen, 1, p. 113, no. 77, pls. 135–137, with previous literature.

54 Emperor Titus, 'Darling of the Human Race'

'Titus...was the darling of the human race; such surpassing ability had he, by nature, art, or good fortune to win the affections of all men....'

'Even in boyhood his bodily and mental gifts were conspicuous and they became more and more so as he advanced in years. He had a handsome person, in which there was no less dignity than grace, and was uncommonly strong, although he was not tall of stature and had a rather protruding belly. His memory was extraordinary and he had an aptitude for almost all the arts, both of war and of peace. Skillful in arms and horsemanship, he made speeches and wrote verses in Latin and Greek with ease and readiness.... He was besides not

unacquainted with music, but sang and played the harp agreeably and skillfully' (Suetonius, *Titus* 1, 3).

Others might think differently of Titus Flavius Vespasianus (39–81 A.D.) and his short rule as emperor (79–81 A.D.). The cold and determined general who suppressed the Jewish rebellion and despoiled the Temple in Jerusalem—yet had an affair with the Jewish princess, Berenice—cannot have been all sweetness and light. Even so, there is a striking contrast between the literary portrait given by the historian Suetonius and the extraordinary analysis of personality by the sculptor of the Vatican statue. A fat, bull-headed man may be jolly, intelligent and impressive; but that an emperor so greatly idolized could be represented in a fashion so far from ideal throws an interesting light upon the taste of Titus.

In over-all design and style of carving the statue brings to fruition what was adumbrated in the statue of Eumachia (Fig. 52). The toga swings out in difficult, fragile displays of thin marble folds. A mighty oval encircles the upper part of the figure, seconded by the great swing from right foot to left hand. The statue reaches out, turns, and while in outline it seems to present a broad façade, the body is actually in an unbalanced, complex position. Compared with this dynamic pose, Eumachia's statue looks tightly closed in outline, timidly uniform in its treatment of detail.

Vatican, Braccio Nuovo 26. Found in 1828 near the Lateran Baptistry. Fine grained white marble with traces of pink on tunic. Height 6 ft. 5 inches (1.96 m.).
W. Amelung, *Vatican* I, p. 40, pl. 7. *CAH*, V, pl. 88b.
* P. Ducati, pl. 104. H. Kähler, *Rom*, pl. 152.

55 The Best Ruler—A Heroic Statue of Trajan

Optimus Princeps—the best ruler, the best leader of the state was the claim made within five years of his accession (98 A.D.) on coins of Marcus Ulpius Traianus (53–117 A.D.), Spanish-born warrior under whom the Roman empire reached the culmination of its military might. Setting prosperity, security, equity, and justice as his aims, Trajan showed himself a fair and efficient administrator and a masterly military organizer, whose great campaign in the Balkans brought huge treasures to Rome and enabled him to build the Forum of Trajan as an unsurpassed symbol and memorial of Rome's *imperium*. In his letters to his financial administrator in Bithynia (northwest Asia Minor), Pliny the Younger, Trajan is brief, business-like, and impatient of fuss. He had a clear conception of the large issues and responsibilities of his office; and he recognized the necessity of impressive ideological propaganda. The desire to combine in official art the attributes of majesty, authority and dignity with matter-of-fact objectivity is a keynote of 'Trajanic classicism.' Greek classical art was to provide again the ideal aspect as it had for Augustus; but Augustan classicism was poetic, Trajanic classicism factual. The quintessence of Augustan Rome is the *Aeneid*, an epic retrojection into the mythical past; the quintessence of Trajan's empire is his column, a documentary chronicle extolling the legions and the engineering corps.

The artist of the excellent statue of Trajan in Copenhagen came close to a successful synthesis. The body of a Polyclitan hero, treated with emphasis on structure, not flesh; the defiant turn of head of Diomede carrying the Palladium out of Troy; then the head held to large simple forms but unmistakably Trajan's in the keen watchful glance, the tight mouth, the two folds of age. The cloak over the shoulder with the round clasp is Roman, not Greek, as was the sword in his left hand which was attached by a metal pin to the marble knob on the left thigh.

Copenhagen, Ny Carlsberg Glyptotek 543a. Found in Rome, perhaps in the Forum of Trajan. Height 4 ft. 4 inches (1.32 m.). Italian marble. The heroic type goes back to Diomede by Cresilas, ca. 430 B.C., and was already used to portray Augustus. 110–115 A.D.
F. Poulsen, *Katalog over antike skulpturer*, *Ny Carlsberg Glyptotek*, 1940, pp. 372 f. with literature. W. H. Gross, pl. 1. V. Poulsen, *Guide*, *Ny Carlsberg*, 1953, p. 45. *

56 Severus—Barbarian or Bureaucrat?

'He was implacable toward the guilty; at the same time he showed singular judgment in advancing the efficient. He took a fair interest in philosophy and oratory, and showed a great interest for learning in general... The senate declared that Severus either should have never

been born at all or never should have died, because on the one hand he had proved too cruel, on the other, too useful to the state.... In person he was large and handsome. His beard was long; his hair gray and curly, his face was such as to inspire respect. His voice was clear but retained an African accent even to his old age' (*Historia Augusta* 18:7–19:1).

Even though this account was written a long time after the Emperor Septimius Severus died in England (at York in 211 A.D.), the same antithesis has inspired controversies among modern historians. Was the native of Africa, who fought his way to the throne (in 193 A.D.) the first 'barbarian' ruler of the empire? Or was he an efficient administrator, who recognized the need for far-reaching administrative, military and financial reforms, and who should receive some credit for the heights reached by Roman law in his reign?

The portraits of Severus do not give a clear answer to this question. Some are designed to emphasize his 'legitimacy' by stressing his likeness to Marcus Aurelius, whose family name Severus took; others stress kinship to the gods. The bronze statue found at Chytri is in the latter category. Although unmistakably individualized in such features as the low forehead, short nose, and full mouth, the bearded countenance and powerful body would awaken associations with Zeus or Jupiter and the lowering brow reminded the spectator that, like Jupiter, the emperor could strike quickly and hard. The statue remarkably sustains the rhythmic, living quality of the late classical type on which the body was modeled.

Nicosia, Cyprus Museum. Found in 1928 at Chytri, an ancient town of Cyprus, nine miles east of Nicosia, in several pieces. Feet and some other areas restored. Bronze. Height 6 ft. 9 inch (2.08 m.). Position of the arms thought to indicate speaking. For detail of head cf. Fig. 82.

P. Dikaios, *Illustrated London News*, Dec. 8, 1948, p. 641, and *Archaeology* 1, 1948, pp. 146 f., description, * history, repairs.

57 An Equestrian Statue as Seen by a Pompeian Painter

The detail from a Pompeian wall painting in the 'House of the Ancient Hunt' makes an instructive comparison with the famous statue of Marcus Aurelius (Plate III) which it antedates by a hundred years. The gait of the horse and the posture of the rider are almost identical. Only the hind legs of the horse are more forward and the arm of the horseman is a bit too large. It is interesting to see what the ancient pedestal was like—a simple rectangle with a profiled edge. The statue is envisaged as standing in front of a temple or a public building, facing the spectator. Blocked out impressionistically, enlivened by highlights from the upper right, this very competent sketch may have been inspired by equestrian statues which stood in the Forum of Pompeii.

Pompeii, VII: iv: 48, 'Casa della Caccia Antica.' Fourth Style, ca. 70 A.D.

W. Helbig, *Die Wandgemälde Campaniens*, 1868, no. 221. L. Curtius, *Wandmalerei*, p. 196, fig. 122.

58 A Short-lived Emperor

The Emperor Caius Vibius Trebonianus Gallus (251–253 A.D.) is no favorite of ancient historians. They accuse him of treason. Supposedly he betrayed the Romans in a battle with the Germans in which the preceding, equally short-lived Emperor Decius (249–251 A.D.) was killed. Gallus then concluded a treaty in which he promised to pay tribute to the Germans. New German invasions followed. They were stopped by Aemilianus, who immediately was proclaimed emperor by his army; and Gallus was killed by his own soldiers.

The fifty years of cataclysmic whirl (235–284 A.D.) when the empire was assaulted from east, north, and west are a period of crisis for art, in which the classical tradition all but breaks. The over-all trend is one of devitalization and abstraction but the sculptors concerned with imperial portraits show short-term changes based on temporary predilections of their patrons—if not of the emperors, than of the senate and officials who ordered the portraits.

In this remarkable, over-life-size bronze statue, the hardening of anatomy, the simplicity of volume of the head, the short-stroked rendering of the hair are all part of a continuing development toward 'late antique' art; but the furrowing of the contracted brow, recalling some Severan portraits, may have been a conscious attempt to emulate such 'baroque' late Republican portraits as that of Postumius Albinus (Fig. 64).

Apparently the temper of the two catastrophic periods of strife tended toward similar realistic revelation of brutal, determined personalities.

New York, Metropolitan Museum of Art 05.30. Allegedly from the region of the Lateran in Rome. Bronze, restored from many fragments. Height 7 ft. 11 inches (2.406 m.). The identification is based upon a comparison with coins.

G. M. A. Richter, *Greek, Etruscan and Roman Bronzes in the Metropolitan Museum*, 1915, 154 ff., no. 350, detailed history and description. Id., *Roman Portraits*, 1948, pl. 109. K. Kluge, K. Lehmann-Hartleben 2, 1927, pp. 45, * 100, 129 ff.; 3, p. 133, pl. 31.

59 The Last Pagan

In 1940 a remarkable statue was found in the *palaestra* (athletic court) of the Forum Baths at Ostia. The sad-faced man wears the traditional toga, which had long gone out of fashion. By comparison with the toga statue of Titus (Fig. 54), flattened frontality, static posture, tight closing of outline, woodcut folds characterize the Ostian togatus. A bundle of book rolls identifies the man as a person of literary pursuits. From this petrified, disjointed body rises a large head with a thick cap of rough hair, a sagging mustache, and a thickly drilled beard. Emotionally intent, with a large-eyed staring glance, the face is a mask of brooding despair, far from the ecstatic exultation of late antique Christian 'soul portraits.'

Raissa Calza has proposed that the statue portrays Quintus Aurelius Symmachus (340–402 A.D.), leader of the pagan last stand in the senate. As *praefectus annonae* (Superintendent of the Corn Supplies) he had close connections with Ostia and he often stayed at his villa nearby. An eloquent writer of letters and speeches and a member of a philosophic-literary circle of Neo-platonists described in Macrobius' *Saturnalia*, Symmachus could well lay claim to being a man of letters.

An alternate identification suggests Vincentius Ragonius Celsus, *praefectus annonae* 385–389 A.D., honored by other statues set up in Ostia, who is known to have repaired the baths where the statue was found.

Ostia, Museo Ostiense 10(55). Height 6 ft. 1½ inches (1.85 m.). Greek marble with large crystals. Ca. 380–400 A.D.

R. Calza, E. Nash, p. 115, pl. 157. M. Napoli, *BdA*, 1959 pp. 107 ff. R. Calza, M. F. Squarciapino, *Museo Ostiense*, 1962, p. 81, fig. 46. Symmachus, Ragonius at Ostia: R. Meiggs, pp. 213, 264, 96. *

60 The Pneumatic Portrait—A Forerunner of Byzantine Saints

The political division of the empire into East Rome and West Rome (395 A.D.) formally acknowledged a difference in essence which had been growing for over a century. Even though Byzantines called themselves *Rhomaioi* and felt themselves heirs to Rome's claim of a God-given empire, the Greek-speaking east and the Latin-speaking west were developing differing attitudes on fundamental issues. In art, the rise of Constantinople and the relative prosperity of the eastern provinces insured that architecture and sculpture continued without a drastic break into the First Byzantine Age.

The city of Aphrodisias in Caria had served for centuries as one of the major training grounds of sculptors. The statue of an official made there in the fifth century A.D. illustrates artistic aims strikingly different from those expressed in the togatus from Ostia (Fig. 59). Both share the immobilization, simplification, patterning; and the cap of disheveled hair reflects a similar fashion. Though the statue of the man from Aphrodisias is uncarved in the back, it displays in the large expanse of his cloak, the aggressive turn of the body and the head, an abstract motion which is most surprisingly revealed in a sinuous curve of the profile. The simple round folds have a euphonious quality which faintly echoes classic formulae. There is an intentional ugliness and roughness in both faces, dynamic in the Eastern, static in the Western. Although not as yet completely otherworldly, the intent visage would suit an ascetic, in whom inner fire overcomes the decay and ugliness of flesh.

Istanbul, Archaeological Museum 508. From the baths in Aphrodisias, hence a civic, honorary statue. Height 5 ft. 11¼ inches (1.81 m.). Marble. 400–450 A.D.

H. P. L'Orange, *Studien*, 1934, pp. 80, 144, figs. 202–205. J. Kollwitz, *Oströmische Plastik*, 1941, pp. 83, 96, pls. 17, 38. A. Rumpf, *Stilphasen*, p. 30, figs. 98–99, literature. W. F. Volbach, M. Hirmer, pp. 23, 324, pls. 66–67. *

HEADS

61 Lucius Junius Brutus—Founder of the Republic

This head broken off from a bronze statue is shown in color in R. V. Schoder's *Masterpieces of Greek Art*, plate 63. The unfortunate black tarnishing of the bronze is less perceptible in the black and white photograph which brings out the wonderful plastic quality of modeling; the quiet, self-contained outline; and the masterly, sharp work of the chisel on eyebrows, hair and beard. Their dry crispness forms an effective contrast to the large, intentionally simple expanse of forehead and cheeks.

Nobody can resist the impulse to see in this stern, determined, forceful countenance the very embodiment of virtues which made Rome win out against desperate odds. Who is better suited to represent them than the founder and first consul of the Republic (509 B.C.) who drove out the tyrannical King Tarquinius? A bearded head of Brutus on coins of his descendant (Fig. 62), the slayer of Julius Caesar, makes a plausible case for this identification. There is, of course, no question of a contemporary portrait. Scholars who advocate this identification assume that at some later time Brutus was honored by a portrait statue which could only be imaginary.

More important for the history of Roman art is the question when this masterpiece was made. Dates proposed range over three centuries (350–50 B.C.). The intentional simplicity of volume, the juxtaposition of soft and dry forms, the psychological emphasis on indomitable will are combined in this manner in portraits of the third century B.C., for which the famous portrait of Demosthenes by Polyeuktos (280 B.C.) set an example. Perhaps the head was made by a Greek sculptor from southern Italy or Sicily active in Rome. Ca. 260–220 B.C.

Rome, Palazzo dei Conservatori 5482. Sala dei Trionfi no. 1. Bronze, eyes inlaid with white paste; brown-red glass iris. Jagged break from neck to nape. Bust modern. Height 16½ inches (0.32 m.) with neck.

H. S. Jones, *Catalogue of the Palazzo dei Conservatori* Oxford, 1926, p. 43, no. 1, pl. 60. G. von Kaschnitz Weinberg, *RM*, 1926, pp. 146 ff. O. Vessberg, pp. 123 ff., 169 ff., pl. 15.

62 The First Consul of the Republic— an Ideal Portrait

Roman coinage is a special art to which we cannot do justice in this book. It is the very foundation for the history of Roman portraiture as almost all identifications of historical personages have been made on the basis of coins. With a very few notable exceptions, portraits begin to appear on Roman coins shortly before the middle of the first century B.C.; and even then it is a rule that they are portraits of famous people safely dead, not of contemporaries. Often the mint officials took pride in recalling famous ancestors. A likeness of Lucius Junius Brutus, the Liberator and First Consul of the Roman Republic (509 B.C.), appears on the coins of that Brutus, 'the noblest Roman of them all,' who was to lead the plot against Caesar. The bearded, furrowed, determined head on the coin must have been copied from an image of Italian-Hellenistic style of the third century B.C. It is tempting to think that the fine head in the Palazzo Conservatori (Fig. 61) might have served as a model. In any case, if not this stern portrait, the likeness which inspired the coin must have been one very much like it.

The work of the die-cutter is on the dynamic side of the late Republican style. Nor was it by art alone that such coins were important. Thoughts of the Liberator must never have been far from the mind of Marcus Junius Brutus.

Silver denarius of Q. Caepio Brutus; this was the legal name by adoption of Marcus Junius Brutus, the most famous of the men who murdered Caesar on the Ides of March, 44 B.C.

Cambridge, Mass., Fogg Art Museum 1942.176. Photograph by American Numismatic Society. Diameter 11/16 inches (1.75 m.). Weight 3.73 gm.

H. A. Grueber, *Coins of the Roman Republic in the British Museum* 1, 1910, p. 480, no. 3684. O. Vessberg, pp. 122 ff., pl. 2:3. E. A. Sydenham, G. C. Haines, L. Forrer, C. A. Hersh, *The Coinage of the Roman Republic*, 1952, p. 150, no. 907, pl. 25.

3 Head of 'Arringatore'—Aulus Metellus

here is hardly a need to prove that the calm strength
'Brutus' and the worried indecisiveness of the 'Arrin-
atore' (Fig. 48) cannot belong to the same age. The
stless times of the Social War, of the struggle between
timates and *populares* found their best expression in
enesses which are restless and complex. What is
rprising and revealing is the extent to which the
rrents and crosscurrents of this experimental period
e found in a provincial work like the 'Arringatore.'
: first glance the rounded simplicity of the head recalls
her Roman Republican and certain late Hellenistic
rtraits of the more sober, 'classicistic' tenor; yet there
much unquiet heaving in the play of facial features, a
acy of the baroque 'Asiatic' style. The kinship to
stumius Albinus (Fig. 64), to the general from Tivoli
g. 47) and even to Pompey (Fig. 65) is evident. Only
s play of features is more superficial, broken into
aller, shallower accents in the 'Arringatore'; and the
pression is prosaic-descriptive rather than theatrical.

Florence, Museo Archeologico 249. Detail of bronze
statue, Fig. 48. Ca. 100 B.C. or later. In addition to
literature cited with Fig. 48: *CAH*, IV, pl. 48d. B.
Schweitzer, pp. 8, 72, 81.

4 Spurius Postumius Albinus

is striking portrait is known in several copies. It must
resent a personality well known in the turbulent
tory of Rome during the first half of the first century
. The impact is vitiated by the restored blank lot
the forehead and adjacent crown with far too opulent
ks, nose, and neck. Yet the breathing, speaking,
wning intensity is irresistible. Suspicious, contemp-
us, the aging, coarse-featured man sees something
does not like and will do something about it. The
le is very close to the most realistic achievements of
siatic' Greek sculptors then active in Rome. Among
portraits we have considered, the general from
oli is nearest (Fig. 47) in the contemptuous, provoc-
e self-assertion and the drastic, dynamic depiction
personality. B. Schweitzer proposed that the man is

Spurius Postumius Albinus, an adherent of the aris-
tocratic party who was sent as consul in 110 B.C. to fight
the war in Africa against King Jugurtha. His failure was
seized upon by the democrats to secure his condemna-
tion. The commemorative portrait would have been
created later, during Sulla's dictatorship (82–79 B.C.)
when the *optimates* ruled supreme. The identification is
uncertain.

Vatican, Museo Chiaramonti, Braccio Nuovo 60. Light
gray marble with fine crystals. Much restored; bust
modern. Height 12½ inches (0.32 m.). Schweitzer's dating
ca. 80 B.C. seems preferable to Vessberg's, ca. 40 B.C.
W. Amelung, *Katalog Vatikan*, 1 Berlin, 1903, no. 60,
p. 78. O. Vessberg, pp. 219 f., pl. 56:1. B. Schweitzer,
pp. 37, 60.

65 Pompey

With the likeness of Pompey (106–48 B.C.) Roman
portraiture enters upon the brilliant series of *imagines
illustrium*, famous personalities safely identifiable and
well-known from historical sources. The original
identification of Pompey's extant marble portraits was
made from the splendid coin portraits struck for
Pompey's son Sextus during his struggle with Augustus
(42–36 B.C.) The two best portraits known seem to go
back to one statue conjectured to be that image which
stood in the Curia of Pompey's Theater where Caesar
sank to the feet of his dead rival. The statue in the Curia
(55–52 B.C.), again on grounds of probability, is thought
to have been made by a sculptor with the Roman name,
Coponius, because he made the statues of provinces
which stood around the image of Pompey in the Curia.

Pompey posed a problem for the portraitist. Only a
person of exceptional power and ambition could contend
with Caesar. Yet in the end, Pompey lost and posterity
condemned him as weak and indecisive. With extra-
ordinary perceptiveness, the contemporary likeness re-
veals both sides of the man. That Pompey affected the
lion-like-mane of Alexander the Great was small wonder;
the wonder is that the artist did not make one of Rome's
greatest generals look more like the great Macedonian
conqueror. The broad fleshy face, large nose, small eyes,
a mobile mouth, and wrinkled brow disclose by their
changing interplay a man both powerful yet weak,

commanding yet plebeian, earnest yet with a hint of a smile breaking out. A 'great captain' (F. E. Brown) but also the 'old man' who knew how to crack a joke with his soldiers. This masterly probing in depth, the psychological balancing of strength and weakness show how Roman portraiture reached a grasp of the 'unique pattern' rarely matched in history of portraiture.

Collection of Professor F. E. Brown. Found in Rome. From a statue: forelock, nose, chin chipped, surface eroded, back of head missing. Parian marble. Height 11½ inches (0.285 m.).
F. E. Brown, *Studies D. M. Robinson* I, 1951, pp. 761–64, pls. 95–97. G. M. A. Hanfmann, *Latomus Monographs* 11, 1953, pp. 42 f. For the Copenhagen (Hadrianic?) copy cf. R. V. Schoder, *Masterpieces of Greek Art*, 1960, pl. 94; and V. Poulsen, pp. 9 f., 39 ff., no. 1, pls. 1 f. According to Brown 'either the original or a contemporary copy' ∗ of a statue of ca. 55 B.C.

66 Cato—Defender of the Republic

Victrix causa deis placuit sed victa Catoni, 'The winner pleased the gods, the loser—Cato.' The young poet Lucan (39–65 A.D.) who was forced to commit suicide by Nero summed up in this burning line for posterity what lovers of the Roman Republic thought of Cato Uticensis (95–46 B.C.), the great opponent of Caesar. He was enshrined as the incorruptible defender of the Republic who did not wish to outlive the death of freedom. Even the added name, Uticensis, stems from this final act, his suicide at Utica in North Africa, after the defeat and death of Pompey gave Caesar uncontested supremacy. Cato's image appeared in aristocratic funerary processions for over a century after his death as a symbol of staunch resistance to tyranny (Tacitus, *Annals* 3:76 and Pliny the Younger, *Letters* 1:17:3). Enhanced by Plutarch's Life of Cato, this admiration echoed through the ages.

At last, a bust inscribed CATO was found in the Roman colony of Volubilis. It revealed Cato with features more youthful than many may have imagined and an unimaginable nose. The over-all handling of forms is already in the mold of classicism; the furrowed, disillusioned face is more typical than individual. This Cato is no more tragic than the 'Arringatore,' whom he greatly resembles in expression. The original portrait

was contemporary (50 B.C.); the shape of the bust show that the bronze is a copy made after the middle of the first century A.D.

Morocco, Musée Rabat. Found in the House of the Cortège of Venus, third century A.D., at Volubilis, hence a collector's item. Bronze with traces of gilding on the inscription. Height 18½ inches (0.47 m.).
R. Thouvenot, *Mon. Piot* 48, 1949, pp. 71 ff., pl. 1. G. M. A. Richter, *Greek Portraits III*, Collection Latomus 48, 1960, pp. 47 f., figs. 209–214, with other Cato portraits. G. C. Picard, p. 178, pl. 26 (bust Augustan). For the house, cf. R. Étienne, *Le quartier Nord-Est de Volubilis* 1960, pp. 77–79.

67 Caesar

'In this first classicism of truly Roman stamp Roman art achieves the final form for the portrait of the Roman emperor and ultimately of the world ruler,' thus has B. Schweitzer aptly described the still individualized but stylistically monumental, psychologically heightened and subtly dramatized approach which is displayed in the earliest types of the portraits of Caesar.

What was Julius Caesar (102–44 B.C.) like? The picture of himself in his accounts of the wars in Gaul (58–51 B.C.), tersely sober, deliberately understated: or is it 'the die is cast,' the irresistible, revolutionary crossing of the Rubicon and meteoric rise to power in five short years, dreams and plans of world kingship? Nobody can be sure and everyone will form his own image of Caesar, but few can escape the sensation that here, for once, was genius. And genius is hard to capture in stone or paint. There are contemporary portraits of Caesar on coins but not one of the dozens of Roman busts and heads of Caesar known to us can, with assurance, be claimed contemporary.

The 'Pisa-type' named after the head shown here, once we can forget the disfiguring break of the nose, tries to do justice to the commanding glance, the tense energy burning away this nobly fashioned, emaciated head—a man who foresees his fate but will unflinchingly forge ahead. The individual physical traits, long neck, flattened skull, strong chin, are subordinated to the emphasis on character. It has been suggested that Octavian-Augustus at the end of his bloody struggle for power (30 B.C.) may have approved such an image

is adoptive father. One senses at least a lingering memory of the actual man; later generations were to represent Caesar as a majestic, almost entirely symbolic image of an *imperator*.

Pisa, Camposanto Museum, Inv. mod. XXXVII. Nose, chin, piece in right cheek restored. Italian marble. Height 12½ inches (0.32 m.).
R. Papini, *Catalogo delle cose d'arte e di antichità d'Italia*, Pisa, 1932, no. 166. B. Schweitzer, pp. 108 f., 146, figs. 161, 166. Attributed by Schweitzer to his 'Chiaramonti Master' and dated ca. 30 B.C.

58 An Egyptian Caesar

In October 48 B.C. Caesar, then fifty-four years old, landed in the great cosmopolitan capital of Alexandria in Egypt. Siding with the twenty-one-year-old enchantress, Cleopatra, against her thirteen-year-old brother-husband, Ptolemy XIV, Caesar found himself besieged for six months by the Alexandrians. 'His greatest favorite (among women) was Cleopatra with whom he often feasted until daybreak and he would have gone through Egypt with her in her state barge almost to Aethiopia, had not his soldiers refused to follow him' (Suetonius, *Julius Caesar* 52). Subsequently, Caesar installed Cleopatra queen of Egypt.

In 1776, Frederick the Great of Prussia bought a bust of green schist. The head was interpreted as a head of Caesar—and allowing for the rules governing Egyptian (rather than Roman) portraiture, the identification seems correct. Only recently has an expert in late Egyptian sculpture, B. V. Bothmer, shown that the Egyptian Caesar belongs to an important group of realistic late Egyptian portraits which emerged in the second century B.C. and continued to be made well into the first century B.C. The portrait of Caesar is a fascinating attempt by the Egyptian sculptor to depict a Roman personality and meet the Roman demand for individuation, different from the traditional Egyptian as well as Greek 'dynamic realism.' The portrait may have been made between 47 and 44 B.C. when Cleopatra had good reason to hope that her son, Caesarion, might be acknowledged by Caesar and succeed her on the throne.

Berlin (East), Staatliche Museen Inv. Sk. 342. Head with part of toga around neck and tunic over chest. Eyes of white marble, probably eighteenth century. Bits of ear,

tunic, toga restored, face overpolished. Height 16½ inches (0.41 m.). Blümel dates 'not later than 1st century A.D.,' Bothmer, in the time of Caesar.
A. Hekler, pl. 158a. C. Blümel, *Römische Bildnisse*, Staatliche Museen, Berlin, 1933, pp. 4 f., no. R9, pl. 5, with literature. B. V. Bothmer, *Egyptian Sculpture of the Late Period*, Brooklyn Museum, 1960, p. 165.

69 A Bronze Portrait from the Last Years of the Republic

Restless, brooding, tight-lipped, this unknown man fascinates by his uneasy vitality. In any exhibition of Roman portraits this masterly portrayal of human indecision will stand out against the prosaic precision of most of the marble portraits. Even within the more select rank of toreutic portraits, its fluid, shifting configurations hold their own with the best. In form and spirit this is a work of the late Republican era. Artistically, the 'Arringatore' (Fig. 63) is its grandfather, Cato (Fig. 66) a very close cousin.

In an uncertain world falling in ruins, the spirit of worry and doubt dominates. There is contrast and conflict here between two approaches to personality—Hellenistic dynamism and Roman analytical descriptiveness, more highly refined, more closely combined but as yet not completely resolved. This portrait was made before the Augustan Peace stabilized Roman society and gave it direction.

Cleveland, Museum of Art 46.28, John Huntington Collection. Bronze bust (for insertion in herm?). Eyes missing, patina restored through electro-chemical action. Height 15 inches (0.39 m.). 40–30 B.C.
Cleveland Museum, *Bulletin* 15:7 (July 1928) pp. 145, 147 f. M. Bieber, *Art in America* 32:2 (April 1944), pp. 65–83. M. Milkovich, Worcester Art Museum, *Roman Portraits*, 1961, p. 18, pl. 5.

70 Livia

The same grace and beauty which distinguish the Augustus of Primaporta are seen in the head of a woman which was placed on a somewhat less striking, amply draped body to adorn the Villa of Mysteries in Pompeii. Here, for once, enough of the colors was preserved to make us see how much the Roman portraits depended

upon the enlivening effects of painting. The rich texture of hair, the immediate appeal of the attentive eyes overcame that marbly coldness which now casts a chill upon any large collection of Roman heads.

A. Maiuri identified the portrait head as Livia (58 B.C.–29 A.D.), the wife of Augustus, mother of Tiberius. The identity has recently been denied by W. H. Gross but can be maintained on the basis of coins which seem to show Livia as Salus, goddess of health.

Livia was well loved and well hated. At the time when Augustus tried to re-establish good morals in Roman society he (but nobody else) forgot that he had abducted Livia, then twenty and pregnant, from her first husband (38 B.C.). Together they weathered the stormy years when new order was being forged in a sea of blood; and Livia matured into an imperial queenly personality. 'Even his conversations with individuals and the more important of those with his own wife Livia he (Augustus) always wrote out and read from a notebook, for fear of saying too much or too little if he spoke offhand' (Suetonius, *Octavius Augustus, 84*).

Tacitus made her the villainess of his *danse macabre* around the imperial throne, but although Livia was ambitious for her sons neither sound evidence nor her character seem to fit the bill for a multiple murderess.

> Pompeii, Antiquario. Found in the Villa of Mysteries, Pompeii. Marble. Edge of cloak overhead and diadem missing. Brown pupils, black iris, red-blond hair, red lips. Height of statue 6 ft. 4½ inches (1.91 m.), head 15 inches (0.32 m.). Between 14–29 A.D.
> A. Maiuri, *Misteri*, pp. 223 ff., pls. 96–98. *CAH, IV*, pl. 168. A. de Franciscis, *Il ritratto romano a Pompeii*, 1951, pp. 55 f., figs. 56–58. H. Kähler, *Rom*, pl. 123. W. H. Gross, *Iulia Augusta*, Akademie Göttingen, *Abhandlungen*, Phil.-Hist. Klasse 52, 1962, pp. 129 f. (denies * identification).

7I Livia as Widow

An older Livia appears to be represented in this sensitive head. A leaner, older face, a different hairdo which was in vogue during the reign of Tiberius (14–37 A.D.); if both the head from the statue in the Villa of Mysteries (Fig. 70) and this head were made after the death of Augustus, the head in Copenhagen must portray the empress very near her end (29 A.D.). She does not look a woman in her seventies or eighties—Livia was eighty-

six when she died. The idealizing Augustan style sti casts its spell of beauty over the widowed empress; bu this is a woman who has known grief and suffering There is something of stoic resignation, of withdraw in the expression of the thoughtful, slightly downcas eyes.

The head gives no hint of that queenly dowager wh pressed the claim to be raised to equal heights with th deceased deified Augustus. Even less is she 'a mothe evil for the state, a stepmother evil for the house o Caesars' (Tacitus, *Annals* 1:10). One thinks more of th unswervingly faithful, self-controlled, dedicated wi and mother who did not break down when during th hardest winter she went with Augustus to north Ital to meet the mournful procession bearing the body of h favorite son, Drusus, so suddenly taken away by deat (9 A.D.).

> Copenhagen, Ny Carlsberg Glyptotek I.N. 747. Foun in the Sepulchre of the Licinii, Rome. White marbl ivory patina. Parts of hair restored in plaster, bridge nose in marble. Height almost 13 inches (0.27 m.). 14– A.D. Identification as Livia denied by Goethert and Gros
> A. Hekler, pl. 209. *CAH* IV, pl. 166b. F. W. Goether *Festschrift Rumpf*, 1952, p. 93. W. H. Gross, *Iulia Augus* 1962, pp. 126 f. V. Poulsen, I, pp. 74 f., no. 39, pls. 64– with literature.

72 A Profile of Augustus

This unusual view of the head of the great statue Primaporta (Fig. 50) shows what the imperatorial fro does not—that Augustus was handsome and human. ' had clear bright eyes... His hair was slightly curly a inclining to golden. His eyebrows met. His ears were moderate size' (Suetonius, *Octavius Augustus*, 79); and had an exemplary 'Roman nose.' There is a fam resemblance to Julius Caesar, his uncle (Fig. 67); b Caesar is aged, almost wasting away, Augustus youn yet fully mature. If the statue was made between 19 a 15 B.C., he was then between thirty-four and thirty-eig years old. It is useless to argue about exact age; the art has, ever so subtly, infused something of the etern youth of the gods into the image and yet retained a m who is recognizable, touching in being so intently serio and responsible for one who seems so young.

The unknown sculptor of the statue had an ext

ordinary sense for animated plastic form. This telling head with deliberately understated hair of almost bronze-like precision, its subdued rhythm of facial features, its simple yet far from stony surface, is an inspired portrayal of a great man by a great sculptor.

Vatican. Head of statue from Primaporta (Fig. 50). Height of head 14 inches (0.30 m.). For literature see Fig. 50; and E. Simon, *Der Augustus von Primaporta*, * *Opus Nobile* 13, Bremen, 1959.

73 Nero

Nero Claudius Caesar, Roman emperor from 54 to 68 A.D., was seventeen years old when he came to the throne. Historians give him five years of good rule and nine in which he acquired the reputation of world's most monstrous ruler. The scandal chronicle of Rome, ready to find vice in any emperor, is unmitigatedly horrible in his case. The people were ready to believe that Nero had set fire to the capital (64 A.D.) so that he might fiddle while Rome burned. He made Christians the scapegoats. When several generals rose in rebellion, Nero, oscillating and play-acting to the end, finally managed to kill himself.

He is described as having a body marked with spots, weak blue eyes, a thick neck. His portraits break with the sober tradition of the Julio-Claudian house established by Augustus which emphasized Romanity. The upswept hair is arranged in tiers of curls probably intended to make him resemble Apollo, god of the arts, of whom Nero, singer, actor, dancer and builder felt himself to be a close kinsman, if not a reincarnation.

The brutal dynamism of his portraits owes something, too, to portraits of Hellenistic rulers.

The evil superman excited so much interest during the Renaissance and baroque that most of Nero's sculptured portraits have come under suspicion as products of later ages. His own gold coins, however, have preserved portraits of undeniable authenticity and great artistic merit.

Cambridge, Fogg Art Museum 334.1942.1. Aureus of Nero. Obverse: laureate head of Nero, slightly bearded, inscribed NERO CAESAR AVGVSTVS. Reverse: Jupiter, seated on throne, holding fulmen and long scepter, inscribed IUPPITER CVSTOS. Between 64 and 68 A.D. Diameter 11/16 inch (19 mm.). Weight 7.3350 gm.

Unpublished. Cf. *CAH*, IV, pl. 205g. H. Mattingly, *Coins of the Roman Empire in the British Museum* Vol. I, 1923 p. 208, # 56. For sculptured portraits, H. P. L'Orange *Apotheosis*, pp. 57 ff. For a recent survey, V. Poulsen 1, pp. 32–36.

74 Vespasian

After Nero's death Vespasian, Titus Flavius Vespasianus, won the four-cornered fight for the throne and founded the Flavian dynasty. Born in 9 A.D., from good Italian stock, raised on his grandmother's estate at Cosa (Figs. 3–4), he was by 69 A.D. a veteran general who had fought in the Balkans, Britain, Africa, and Palestine. Will power and habit of command give a Napoleonic appearance to his profile; but to establish a total contrast to Nero he made much of his peasant-like shrewdness, parsimoniousness, and earthy humor.

Here for once we see Roman portraitists struggle with a complex problem. From architecture, painting, and sculpture it is clear that the general style and taste under Vespasian (69–79 A.D.) were following a trend established under Nero toward magnificent extravagance, dynamism, and optic illusions which have given rise to the term 'Flavian baroque.' Yet the emperor and the court desired a return to Republican honesty and sobriety.

With the experience of three generations in portraying imperial rulers behind them, the best Flavian portraitists manage amazingly subtle compositions conveying at once intensity and aliveness yet skillfully 'citing' many individual features in a manner superficially similar to Republican portraits. A glance back to the 'Arringatore' (Fig. 63) reveals at once the similarities of registering observed traits and the totally different spirit in which these observations are synthesized.

Rome, Museo Nazionale delle Terme, inv. 330. From Ostia. Marble. Chin restored. Height 16 inches (0.40 m.). A. Hekler, pl. 218a. B. M. Felletti Maj, *Museo Nazionale Romano, I Ritratti*, 1953, p. 79, pl. 141, with literature. *

75 A Roman Businessman

Genio Lucii nostri, Felix libertus. 'To the *genius* of our Lucius—Felix, freedman.' This is the inscription on the marble shaft of the herm into which is set the remarkable bronze head found in Pompeii, in 1875. For once we can

see how those peculiar, short-necked busts were installed and displayed. As to *genius*, to the Roman every man had his *genius*, originally 'the begetter,' then more broadly the life-power of a personality. You could and did worship the *genius* of the head of the family, though not the man himself.

The Lucius portrayed has been traditionally identified as Lucius Caecilius Iucundus, 'the Pleasant One.' His was a peculiar genius, closer to what we call 'the genius of Wall Street.' Wax tablets from his office file were found in his house, mostly of auction sales.

Though he lived during Nero's luxurious reign (his office records stop with the earthquake which hit Pompeii in 62 A.D.) Iucundus was no Fancy Dan. He wears his hair cropped in old Roman style. The artist has brought out in profile the pushing, sharp-eyed sagacity of an elderly businessman; from the front Iucundus presents an appearance which has been described as 'shrewd, ugly, kindly' (MacKendrick). Petronius in his *Meal of Trimalchio* had magnificently satirized the new rich of this stamp but the sculpture is free of satire. A recognizable individual of a recognizable type, Iucundus has dignity and determination.

> Naples, Museo Nazionale Inv. 110663. From the House of Caecilius Iucundus, V: i : 26. Bronze bust, partly corroded, on marble herm. Height of bronze 14 inches (0.35 m.).
> A. Hekler, pl. 200, K. Kluge, K. Lehmann-Hartleben 2, pp. 23 f., 27 f., pl. 7. A. De Franciscis, *Il ritratto romano a Pompeii*, 1951, p. 31–34, figs. 17–20, denies identification of *Lucius* with the banker Lucius Caecilius Iucundus and dates the portrait to early Augustan Age. P. MacKendrick,
> * p. 213, fig. 8:11. Inscription: *CIL* X:860.

76 An Emperor Condemned

'*Damnatio memoriae* implied that the praenomen (first name) of the condemned man might not be perpetuated in his family, that images of him must be destroyed, his name erased from inscriptions and, in the case of emperors, their acts rescinded' (J. P. Balsdon). This was part of the punishment for crimes equivalent to high treason against the majesty of the Roman state; and Domitian (81–96 A.D.), brother of Titus (Fig. 54), shared with Nero this dubious distinction. Nevertheless, a number of portraits of Domitian are known.

'Tall of stature, with a modest expression, and a high color,... He was balding' (Suetonius, *Domitian*, 18). 'I bear with resignation the aging of my locks in youth,' wrote Domitian in his own book, 'On the Care of Hair.' Domitian *dominus* and *deus*, 'master and god'; Domitian the atrocious tyrant who in his last years killed and tortured on the slightest suspicion; Domitian who administered justice scrupulously; Domitian who spent hours in seclusion catching flies and stabbing them with a sharp pen; Domitian 'presiding at games and festivals clad in a purple toga in Greek fashion and wearing upon his head a golden crown' who had only statues of gold and silver set up in his honor on the capitol—a man embittered, suspicious, and insecure, who in the end was murdered in a palace plot upon the instigation of his own wife.

Given Domitian's temper it must have been a delicate task to make his portraits. Whether from philhellenism or from baldness, his tall locks are combed back—as are those of Nero and Titus. The turn of the head to express power is a Hellenistic tradition of royal portraits. The square head is a Flavian family trait; the long neck, the hanging nose, the pursed lips do not add up to that handsome countenance which even hostile criticism admitted. Suetonius says Domitian had large myopic eyes; here they are small and suspicious, the expression calculating rather than commanding. Probably with assists from the emperor, official sculpture displays a conscious calming classicism in the late years of Domitian. The lancet-like incisiveness of analysis working with fewer features is the more remarkable.

> Rome, Museo Nuovo Capitolino no. 1156. Found in Rome. Pentelic marble. Chin and right ear chipped, bust broken. Height 21¼ inches (0.53 m.).
> H. S. Jones, *Palazzo Conservatori*, 1926, p. 65, no. 3, pl. 16. The most recent discussion, literature, H. Jucker, *Das Bildnis im Blätterkelch*, 1961, pp. 54–56.

77 Trajan in Retrospect

The superlatively finished head of Trajan (ruled 98–117 A.D.) was found near the theater of Ostia. On stylistic grounds it appears to have been made under Hadrian after Trajan's death. Knowledge and sympathy for his age and experience rather than awe and respect for his mighty personality are the keynotes of this portrait of

Trajan. There is, to be sure, aquiline energy in the flight of the eyebrows, and concentration in the glance; but the brows are contracted as if in a struggle against illness and the mouth hints at an infirmity of the body overcome by will power. A portrayal more human, more complex, less monolithic than the heroic statue in Copenhagen (Fig. 55).

Where the skill of the artist and the new sensitive, sensuous Hadrianic style celebrate their triumphs is in the caressing differentiation of textures as between the eyebrows and forehead, the exquisite subtlety of skin over bone, the subdued, fluid, slightly nervous movement from feature to feature which results in a subdued unquietude of mood.

Ostia, Museo Ostiense 17(17). Marble. Over life-size. Height 14 inches (0.35 m.).
W. H. Gross, pp. 113 ff., 132, no. 74, pls. 33–35. R. Calza, E. Nash, p. 50, pl. 57. R. Calza, M. F. Squarciapino, *Museo Ostiense*, 1962, p. 58, no. 18.

78 A Flavian Beauty

'The Women of the Caesars' was a popular book in the beginning of this century. Through Roman history from Lucretia to Fausta, women hold their own in acts of glory and gore. European literature and theater have been much enriched by their dramatic fates and deeds. How well had Roman portraiture responded to these imposing personalities? Character rather than femininity seems to be their strong suit—it is not difficult to find the elderly housewife and the stern mother-in-law, but few Roman portrayals of women can be described as charming. Since the determined faces might as well be those of men, Roman sculptors paid close attention to hair fashions. In this field Roman ladies left little untried. The 'baroque' trend in taste resulted in quite extra-ordinary constructions under the Flavian dynasty (69–96 A.D.).

With her swanlike neck, feathery eyebrows, full lips, and fine aquiline nose, the unknown lady has poise and aristocratic bearing. If the paint of the eyes and on the lips had survived she (like Livia in Fig. 70) might have seemed more like flesh and blood. She inclines her head graciously rather than gracefully and her glance is coolly appraising. The artist had worked on the lively rhythm of that enormous enframing crown of hair, using the drill with virtuosity in the black and white accents of the

corkscrew curls. The eyebrows are masterpieces of texturing. The broad effect is to make the face stand out in sharp clarity against the artificial heaving and weaving of the coiffure. One would think the portrait a product of Domitianic classicism; but throughout the Flavian age women's faces are shown with much less detailed characterization than men's.

Rome, Palazzo Capitolino, Stanza degli Imperatori 23. Carrara marble. Tip of nose, some curls, bust restored, neck broken. Eyes, hair originally painted (traces in the eyes). High polish. Height 25 inches (0.63 m.), of head 15 inches (0.38 m.).
H. S. Jones, *Catalogue Museo Capitolino*, 1912, p. 193, no. 23, pl. 49. *CAH*, V, pl. 86c. L. Goldscheider, *Roman Portraits*, 1940, cover (very dramatic) and pl. 53. V. Mariani, L. von Matt, *L'Arte in Roma*, fig. 57. H. Kähler, *Rom*, pl. 230. *

79 Trajan's Sister

The small-faced head looks, from the front, rather doggedly sober. The side view unfolds an array of dramatic surprises. The four different ways of doing up hair gave the sculptor an opportunity for brilliant changes of pace and his workmanship is impeccable. Under this 'ship of state,' the elderly clear-eyed face with pursed lips and jutting chin is strikingly reminiscent of Trajan (cf. Figs. 55, 77).

Doubts have been expressed by M. Wegner about L. D. Caskey's identification of the portrait as Marciana (before 48 A.D.–113 A.D.), the sister of Trajan. The coins with portraits of Marciana (112–113 A.D.) show a somewhat different arrangement of locks in front, but this is a matter Marciana may have varied. The facial resemblance of the Boston head to the profile seen on coins is marked.

The fresh and delicate modeling of the lower part of the face has been rightly praised. From what little we know, Marciana was a remarkable woman, sufficiently influential with Trajan to receive the title of *Augusta* in life and to be deified after death.

Boston, Museum of Fine Arts 16. From Subiaco. Fine-grained marble. Tip of nose, ears, chin, lips chipped. Height 10½ inches (0.26 m.).
L. D. Caskey, Museum of Fine Arts, *Greek and Roman Sculpture*, 1925, pp. 211 f., no. 125. M. Wegner II:3, p. 121, cf. pp. 77 ff., for other portraits. C. C. Vermeule, *Greek and Roman Portraits*, Museum of Fine Arts, 1951, fig. 51. *

80 Hadrian

Hadrian is in fashion. We like our psyches complicated and he is the one Roman emperor who managed to baffle even his contemporaries. His haunting deathbed poem to his soul is an evasive clue to a mind which could face with sympathy, doubt, and detachment the great question mark of death.

As architect, Hadrian reveals himself as a playful, romantic experimenter never averse to *épater les bourgeois*. In his portraits we encounter Hadrian as seen by others —or as he wanted to be seen? It is improbable that an emperor so art-minded should have failed to intimate what he liked; although it might have taken the court artists a little while to grasp the predilections of one who was never unambiguous.

The over life-size head found in Ostia is thoughtful, restrained, classicistically bland. Certain things the artist knew. Instead of Trajan's Roman crewcut coiffure, Hadrian sports a beard. The crown of locks, too, would be considered something Greek; but unlike Nero's and Domitian's hair-dos (Figs. 73, 76), it is not an allusion to a specific divine or regal claim. The artist tried to retain something of Roman individuation—an irregular nose, the ambiguous, slightly vague glance. Other elements were to evoke memories of Greek classic—the rounded locks allude to early classic images, the slight bending of the head, the treatment of beard and mustache to the portraits of Pericles, the great statesman of Athens' Golden Age (495-429 B.C.). Later images of Hadrian were to do better justice to the sophisticated complexity of the emperor. The head from Ostia belongs to a propaganda campaign early in Hadrian's reign which was to establish him a legitimate successor to Trajan and a worthy majestic ruler in his own right.

Ostia, Museo Ostiense, No. 11(32). Found in the Baths together with a head of Trajan. Marble head and neck; for insertion in statue. Height: 16 inches (0.44 m.).

R. Calza and F. M. Squarciapino, *Museo Ostiense*, 1962 p. 55, no. 11. M. Wegner II:3, pp. 29 f., 103 f., pl. 30a and b. A literary evocation of Hadrian: M. Yourcenar, * *Hadrian's Memoirs*, 1954.

81 Antinous

Homosexual love for boys was officially disapproved in imperial Rome but the scandalous gossip about the emperors includes with monotonous regularity allegations of sexual activities of this kind. Normally the emperors kept such favorites in the background; Hadrian did not. For him the heavy-featured Bithynian boy, Antinous, was more than a plaything. When Antinous (born 110-112 A.D.) drowned in the Nile in 130 A.D. under circumstances which were supposed to suggest, in unknown ways, that he sacrificed his life for that of Hadrian, the emperor founded cities in his honor and treated him as a hero, a semidivine being. Cults of Antinous were established everywhere in Greek-speaking lands. That he was equated with Silvanus (Fig. 117) and other gods of nature intimates what Hadrian must have seen in him—a vegetative, god-given beauty. The best and most characteristic expressions of the sensuous romanticism of the Hadrianic age are found in Antinous' portraits.

The portrait in Kansas City shows the large bust which came into favor under Hadrian. Being a Greek, almost certainly Attic work, it harks back to certain minor divine figures such as Eubouleus, an Orphic earth deity worshiped in Eleusis, to provide the mood and elevation appropriate to a heroized being. For once the heavy crown of locks and the short face with large lips do not completely resist transformation into a recognizable human; and the work lacks the saccharine gloss which makes some of the Italian representations hard to take.

Kansas City, Nelson Gallery of Art—Atkins Museum 59.3. Head and bust made in one piece with profiled stand. Pentelic marble, brown sintering, nose broken. Height 27½ inches (0.70 m.). 130-138 A.D.

Handbook, 1959, p. 39. C. C. Vermeule, Nelson Gallery-Atkins Museum, *Bulletin* 3, October 1960, pp. 1-7. M. Milkovich in Worcester Art Museum, *Roman Portraits*, 1961, p. 42, no. 17.

82 Head of Septimius Severus

A comparison of the face of Lucius Verus (ca. 180-190 A.D., Fig. 83) with that of Septimius Severus is something of a shock. Put side by side with the refined, manneristic extravaganzas of the marble head, the face of the bronze (200-210 A.D.) looks suddenly compact, prosaic, even vulgar. Allowance must be made for the difference of technique; cast bronze could never be dissolved to the same degree as marble. Nevertheless, the style of the Severus portrait is clearly tending toward

the compact; the hair is much more closely integrated with the head. In the close-up view, Severus begins to look less like a god and more like a boxer or a butcher, an impression for which the crude mouth and scraggy hair are to a large degree responsible. Both the growing solidity of volume and the growing distrust in the emphatic, sidelong glance are traits which we shall encounter more markedly in later Severan portraits.

Nicosia, Cyprus Museum. Head of the bronze statue
* from Chytri reproduced in Fig. 56.

83 Lucius Verus—Playboy or Philosopher

At Aqua Traversa, probably on an imperial estate, were found two remarkable overlife-size portraits of Marcus Aurelius and Lucius Verus, who jointly held the rule of the empire for eight years (161–169 A.D.). Both heads are composed along the same lines, with fantastically dissolved masses of hair, sideburns, and beard forming a chiaroscuro frame for the marbled polish of the face. The type was intended to portray the philosophic ruler. In the portraits from Aqua Traversa, however, there is a heightening of personality which is not found in certifiably contemporary portraits of either emperor. Marcus, the older (born 121 A.D.), the deified, looks up to heaven with Jovian brow, his eyebrows arching. Lucius Verus, the younger (born 130 A.D.), handsomer, gazes from deep-lying eyes under firm forehead, a conquering Hercules. It has been justly surmised that these busts were created during the rule of Commodus (180–193 A.D.), son of Marcus Aurelius. As he did not hesitate to show himself as divine, he needed to elevate his father and adoptive uncle to superhuman stature.

Verus was handsome, probably athletic, and he liked hunting and gladiatorial games. Marcus made him co-ruler when Verus was thirty-one years old; three years later while at Eastern Headquarters at Antioch (164 A.D.) he married Lucilla, the daughter of Marcus. He lived it up at Antioch and let his generals fight the Parthians. In 166 he celebrated a triumph; three years later, in the midst of German wars, he died at the age of thirty-nine.

Artistically, the transformation of stone from a clearly defined solid form into a drilled, twisted, hollowed, foamy substance represents the maximum of optical effects attainable in marble sculpture. The virtuoso

refinement is carried to extremes in the hair-for-hair rendering of eyebrows. Optic elements are used again in the eyes with deepened pupils and hollowed irises. A century later, the beard was to win the day for apostles and saints; Verus is still of this world. The slightly distrustful glance is a markedly individual trait.

Paris, Louvre 1170. From Aqua Traversa. Marble. Bust and back of head restored. Height (crown to tip of beard) 22⅜ inches (0.57 m.). 180–190 A.D.
M. Wegner II:4, pp. 60, 240, pl. 44a (Marcus pl. 296). G. M. A. Hanfmann, *Latomus* Monograph 11, 1953, pp. 46 f. *

84 A Roman Master Sculptor

'*Le style c'est l'homme même.*' We speak of style, of phase, of advance; but with one exception we don't know the names of the sculptors who made the portraits reproduced in this book. What matters more—we do not even know their artistic *oeuvre*, we can rarely say, 'These two pieces are by the same man.' Artistic quality was a major consideration in making this selection but artistic quality may mean pioneering originality or perfecting the ideas originated by others.

For artistic originality, no Roman portrait of the later empire is more striking than this head of an unknown lady. The sculptor combines an almost modern feeling for large clear volumes with a poetic sensitivity for the beauty of linear patterns. Such sinuous delights art had not seen since archaic Greek *korai*. On the back of the head the intricacies of many tresses are transformed into a *perpetuum mobile* of circling geometric shapes, a marvel of abstract beauty.

The young oval face looks out from under the heavy roll of hair, a face made more fragile and moving by contrast with the weighty, stony mass out of which it emerges. Slightly bony cheeks give it character. The glance—the pupils now more markedly deepened—is attentive in a measuring, reserved way; the small mouth moves slightly, as if she might soon speak.

There are damages to the nose and mouth, and somebody has hacked at the hair on the (spectator's) right side. In spite of them, the piece bespeaks a master who changed not only the form but the spirit of art. For there is about this head a proud inwardness unknown to earlier Roman portraits, a first hint that soul and body are divided.

Cincinnati, Museum of Art 1946.5. Marble. Height 9⅝ inches (0.245 m.). The hairdo occurs in portraits of Manlia Scantilla and Didia Clara, wife and daughter, respectively, of Didius Iulianus (emperor March to June 193 A.D.); but the girl is neither of these, nor is she Julia Domna.

Guide to the Collections of the Cincinnati Art Museum, 1956, pp. 6–7. *Cincinnati Art Museum News* II:2, February, 1947. Coins: H. Mattingly, E. A. Sydenham, *Roman* * *Imperial Coinage* 4:1, 1936, p. 18, pl. 4:1–3.

85 A World of Distrust

Implicit reserve turns into explicit distrust in the eloquent head of an unknown man found during the excavations of Via dell'Impero. Here too the break with optic refinements of Antonine art is clear; geometric solidity is reasserted in over-all form. The introduction of a simpler short-cropped hairdo is one of those changes which illustrate Huizinga's contention that the tenor of an epoch is reflected in its fashions; the Antonine pretensions to theatrical beauty of locks and beards were abandoned. As thrones began to topple and emperors were raised and killed off by the soldiery, the mood of thoughtful deliberation yielded to worried suspicion. The glance is no longer sideways; it goes almost around the corner. The man tries to see not only who might be at his side but who might be behind his back. Worry deeply wrinkles his brow. The half-concealed eyes are made very emphatic by sharply outlining the pupils and deep semicircular drilling of the iris.

The over-all effect does no longer sharply contrast face and hair; such contrast as there is comes from the new way of portraying hair by quick, short, flat strokes. The appeal is to an over-all sense of 'hairiness,' almost to the sense of touch, not to an artistic convention for locks of hair, such as came with the Greek heritage into Roman sculpture.

This masterly sculpture is still realistic in the broad sense, still concerned with the appearance of a definite person at a definite time. Tensed motion relates the features to the glance; short curving patterns sweep like wavelets over the surface of the hair. As in form, so in spirit this work is typical of the beginning of the transition from the Roman to the late antique world.

Rome, Museo Nuovo Capitolino 2302. Found in excavations for Via dell'Impero. Pentelic marble. Height 8⅜ inches (0.21 m.). About 240 A.D.

D. Mustilli, *Il Museo Mussolini*, p. 112, no. 27, pl. 69:272. F. Poulsen, *From the Collections of the Ny Carlsberg Glyptotek* 3, 1942, pp. 112 f., figs. 24 f. *

86 Trebonianus Gallus?

During the time of 'Military Anarchy' it is rare to find many portraits of any emperor, rarer still to find portraits in bronze. Yet the unpopular Gaius Vibius Trebonianus Gallus (251–253 A.D.) seems to have been lucky. The bronze statue in the Metropolitan Museum (Fig. 58), a bronze head in the Vatican, and the battered but fine head in Florence shown here, have been claimed as his likenesses. H. von Heintze, however, would recognize in them the Emperor Decius, praised by pagan writers as 'affable in peace, most resolute in war,' and less favorably known for his persecution of Christians (249–251 A.D.).

For art history it matters little, since the portraits of both emperors must have been made within a period of four years. The Florence head does not quite show the grotesque emotionalism of the New York portrait; its artistic language grows logically from trends observed in the preceding decade (Fig. 85). The outline is simpler, the worry-folds more marked, the asymmetrical gaze more stationary. The short-stroked hair moves in even more rapid swirls. In its total impact, the head has dignity and force.

Florence, Museo Archeologico 14013. Bronze, probably from a statue, broken. Lower chin, back of head missing, nose reset. Height 10⅝ inches (0.27 m.).

A. Minto, *Critica d'Arte* 2, 1937, pp. 49 ff., pls. 40 ff. L. Goldschneider, *Roman Portraits*, 1940, pls. 98 f. H. von Heintze, *RM* 63, 1956, pl. 27. B. Felletti Maj, *Iconografia Romana Imperiale* 2, 1958, p. 204, no. 261. C. C. Vermeule, p. 6, fig. 9.

87 Philip the Arabian

Imperator Caesar Marcus Iulius Philippus Augustus, as the inscription on the coin names him, was born in Arabia and supposedly started his career as a successful captain of robbers. He culminated it by inciting the troops against Gordian III during a successful Roman campaign against the Persians in Mesopotamia. He ended his short imperial tenure (244–249 A.D.) when he was slain by his own soldiers. In between, several wars were fought but his reign is remembered for two contradictory matters—in the year 248, on April 21, Rome celebrated

her 1000th birthday; and the emperor supposedly was a Christian. What seems to be true is that this forerunner of the great Islamic conquerors from Arabia was indifferent to the official Roman religion. His coinage for the millennium celebrated Rome's eternity, promised that a new era would begin with his dynasty—and displayed the exotic animals shown in the Secular Games.

The brilliantly detailed portrait on the silver medallion is strikingly similar to the so-called Trebonianus Gallus bronze head in Florence (Fig. 86); but other portraits of Philip show that his head was much larger and elongated and give much prominence to the hooked Semitic nose. Indeed, the emphasis on the largeness of form combined with the dotlike stroking of hair is characteristic for the turn away from the late Severan style toward a style which is intentionally harsh, and which reintroduces some of the realistic detail of Republican portraiture. But these stylistic means serve to characterize the new aggressive, one might say 'barbarian' type of self-made 'Soldiers' Emperor.' In the medallion, presumably struck in tradition-conscious Rome, the artist labored to soft-pedal this superman complex and to produce some thoughtful dignity for the ruler to whom it fell to celebrate the millennium of the Eternal City.

Boston, Museum of Fine Arts 35.1463. Silver medallion. Diameter 1½ inches (38 mm.). Weight 30.378 gm. 244 A.D. C. C. Vermèule, p. 20, fig. 40. M. B. Comstock, C. C. Vermeule, *Roman Medallions*, M. F. A., Boston, 1962, pl. VI. C. C. Vermeule, *Greek and Roman Portraits*, Boston, * 1959, no. 65.

88 Gallienus

The Emperor Publius Licinius Egnatius Gallienus (253–268 A.D.) managed to stay alive and rule for fifteen years —a record for the stormy era of the third century A.D. There was, for a brief spell, a change of atmosphere at the court. Gallienus and his wife Salonina befriended the greatest mind of later antiquity, the Neoplatonist Plotinus (205–270 A.D.), and his circle revived the role of philosophy and Hellenism. Gallienus himself visited Athens and was initiated into the Eleusinian mysteries. At the same time he showed tolerance toward the Christians.

That these changes were sufficiently comprehensive to deserve the name of a 'Gallienic renaissance' as some

scholars propose, is doubtful. It is true, however, that artists working in the immediate entourage of the court did produce work which sought to revive a larger, monumental canon of figures; and intellectual conclaves became a leading theme for sarcophagi.

Perhaps the finest portrait of Gallienus, the head in the Museo delle Terme, demonstrates that an intentional effort was made to move away from the detailed, hard-stroked descriptiveness of the preceding military portraits. The long-locked coiffure and beard suffice to show the intent; and an attempt is made to return plasticity to locks and curls. This is, however, a far cry from the majesty of Zeus or portraits of Alexander the Great. The rigidity of the underlying form is unmitigated, the facial features glide on the surface and the shadowed, intent, upward glance gives a preponderance to the psychic element of a soul and mind which searches nervously, uneasily for some meaning beyond a world that lives by the sword.

Rome, Museo Nazionale delle Terme, inv. 644. From House of the Vestals, Forum Romanum. Carrara marble, for insertion into bust. Nose, locks chipped. Bit of cloak on right shoulder. Height 14 inches (0.38 m.). 262–268 A.D.

A. Hekler, pl. 298. H. P. L'Orange, *Studien*, pp. 5 ff., fig. 11, B. M. Felletti Maj, *I ritratti*, Museo Nazionale Romano, 1953, pp. 152 f., no. 304, literature. E. B. Dusenberry, *Marsyas* 4, 1948, pp. 1 ff. *

89 The Precursors of Byzantium

Asia Minor had suffered a shock when Persians (256 A.D.) and Germans (267 A.D.) suddenly invaded a country so long secure. Yet the solid prosperity built up under the Roman peace was not so quickly dissipated. As late Roman history unfolded, the strategic, rich subcontinent gained in power. Nicomedia and Nicaea preceded Constantinople as imperial capitals. At the same time the cultural and artistic liaison with Rome began to weaken. Local trends began to assert themselves within the Roman mold.

The very fine head of an unknown man found at Miletopolis in Mysia shows the long-locked hairdo, somewhat along the lines of the hair crown of Antinous (Fig. 81). Although the flesh is hardened by the same petrifying tendency as in contemporary Roman portraits, the slight rounding of the face and the swelling of the sturdy neck suggest a sense for structure still reminiscent

of Greek tradition. On the other hand, the semi-abstract rendering of arched eyebrows, mustache, and beard, and staring rigor of the eyes go far beyond the indubitably contemporary portrait of Gallienus (Fig. 88) to make a 'Proto-Byzantine' impression. It is not difficult to envisage a man with such eyes turning into a Byzantine saint.

Berlin (East), Staatliche Museen, Sk. 1639. From Miletopolis. Marble head for insertion into statue. Nose missing, part of neck restored. Height almost 13 inches (0.32 m.). 260–270 A.D.
C. Blümel, *Römische Bildnisse* (Katalog) Staatliche Museen, 1933, p. 47, no. R 113, pl. 73, with literature. C. C.
* Vermeule, pp. 11 f., pl. 26.

90 A 'Soul Portrait'

This striking head lay face down, packed into the road bed which Byzantine engineers had hastily built over the devastated 'Marble Avenue' of Sardis in western Asia Minor sometime after a raid of the Persian King Chosroes II (615 A.D.) left the city in ruins. It was discovered by the American excavators in 1961.

Justly hailed as a masterpiece, the head is an admirable exemplar of the intensive spiritualization of human personality during the transition from the Roman to the Byzantine Age. The fanatical, deeply shaded eyes, the speaking mouth impress the beholder as the hallmarks of a sage or a saint.

There are some 'late' traits. Behind the frontal wreath of hair, the back of the head is only sketchily finished, as is, to some extent, true of the head from Miletopolis (Fig. 89). The wrinkles which crease the brow are unplastic, incised lines. With these more abstract devices the artist combines a delicate sense for plastic values in treating the hanging flesh and grizzly hair.

The excavators had dated this head on the very borderline between Roman and Byzantine art on the theory that the head may have belonged to a statue which stood in the colonnade of the 'Marble Avenue'--a thoroughfare apparently laid out around 400 A.D. There is, however, no certainty. The head might have been brought from some other location. The 'shaded,' intensive glance, the combination of linear and plastic detail seem to occur in portraits between the time of Gallienus (260 A.D.) and the Tetrarchs (284 A.D.), Figs. 88, 89, especially 91.

If this theory is correct, we must acknowledge that 'soul portraits' began already in late Roman art and that the sculptural workshops of Asia Minor in the third century were capable of distinguished yet varied achievements in responding to the spiritual and emotional crisis of their age.

Manisa Museum, Sardis–S.61.18(3398). From Byzantine road over main east-west avenue of Sardis. Local marble. Probably from a statue. Nose, some locks, neck broken. Height 12 inches (0.30 m.).
G. M. A. Hanfmann, *BASOR* 166, April 1962, pp. 45 f., fig. 37. *Illustrated London News* April 7, 1962, p. 544, * fig. 18.

91 Carinus

This portrait and the one of Numerianus (Fig. 93) have important things in common. The head is treated as a big angular volume; it impresses by bulk. The sculptors are on their way toward 'Tetrarchic cubism.' The glance becomes larger and more distant; the details more stationary; the flesh stonier. Within this general movement toward abstraction there was still room for artistic individuality. There were still choices to be made—but these choices were determined less by the appearance and character of the sitter and more by a desire to evoke some emperor of the past. In the head of Carinus (283–285 A.D.) the sculptor had remembered the portraits of Gallienus of the kind shown in Fig. 88. His treatment of the flat, sharply stroked hair on the head harks back to even earlier portraits of the third century. More illuminating is the difference between Carinus and Trebonianus Gallus (Fig. 86). Both emperors faced similar problems and could be reasonably certain of the same violent end. Yet Trebonianus looks sharply at this world; Carinus seems to wait for a message from far away. Nobody would guess that he had nine wives and supposedly made the palace gay with actors, dancers, and singers. Not the individual emperors but the concept of the imperial personage had changed toward greater majesty and spirituality.

Rome, Palazzo dei Conservatori, Fasti Moderni II:5. Found in the region of Castro Pretorio in 1887. Marble. Height 16½ inches (0.415 m.). 282–285 A.D.
H. S. Jones, *Palazzo Conservatori*, p. 76, pl. 22. B. M. Felletti Maj, *Iconographia Romana Imperiale*, pp. 283 f., no. 379, fig. 203, literature. C. C. Vermeule, pp. 13 f., fig. 30.

92 A Priest of Dying Paganism

The great Phrygian goddess Cybele had been fetched to Rome by an official embassy to save the city from Hannibal (205–204 B.C.) but her cult with its self-mutilations, eunuch priests, and frenzied contrasts of joy and lamentation did not appeal to official Republican Rome, least of all her castrated lover-god Attis. Yet her popularity grew and under the later empire Cybele and Attis rose ever higher in the esteem of the Roman ruling class. Next to the glorification of the Sun, it was Cybele and Attis which were most elaborately allegorized and defended by Neoplatonic philosophers and their aristocratic friends.

Ostia had a large precinct with shrines of the great Idaean Mother of Gods, of Attis, and of Bellona, goddess of war, from the mid-second century A.D. on, if not earlier. There were guilds of *cannophori*, 'bearers of reeds,' who opened the great festival of Attis on March 15, and the *dendrophori* who carried pine trees symbolizing the castration and death of Attis on March 22. All joined in orgiastic rejoicing on the *Hilaria*, on March 25, when Attis was reborn. The cult was headed by an *archigallus Coloniae Ostiensis*. This high priest is here portrayed reclining on his deathbed which is covered with an ornamented mattress and cushions. Two smaller reliefs showed him officiating. Holding two torches, he approaches the pine tree and a statue of Attis, and offers a sacrifice to a statue of the Great Mother. He wears a kind of soft cap (miter), the long-sleeved tunic, the trousers of oriental priests, and high shoes. On his right wrist is the large bracelet, showing a shrine with three figures, the symbol of the highest office in the cult. In his hand the priest holds the pine branch of Attis. The round box was used to carry sacred objects in the mysteries; a snake winds around it. G. Calza suggested that the man was a eunuch but this is uncertain.

The emaciated body flattens angularly into the bed; if the goddess promised a happier afterlife, the face, a mask of pessimistic despair, gives no hint of such faith.

The date suggested by the angular expressionism of the portrait is between 280 and 300 A.D.

Ostia, Museo Ostiense 158(18). Found out of place, along Via Severiana. Lid of yellow marble with gray streaks in form of a couch from a sarcophagus (the latter lost). Front parts of back of couch, part of cap, nose missing.

7 ft., 4 inches (2.20 m.) by 3 ft. 7 inches (1.10 m.). Height 16 inches (0.40 m.).

G. Calza, *La necropoli del Porto di Roma nell'Isola Sacra*, 1940, pp. 205 ff., figs. 108–11. R. Calza, E. Nash, p. 96, pl. 135. R. Calza, M. F. Squarciapino, *Museo Ostiense*, 1962, pp. 22 f., no. 18 and 19–20, figs. 5–6 (cult reliefs). On the cult in Ostia, R. Meiggs, pp. 354 ff.

93 Numerianus?

Numerianus and his brother Carinus (Fig. 91) were sons of the Emperor Carus, who reigned a little over ten months and died in Mesopotamia in the midst of a successful campaign against the Persians. Carinus was to rule the West; Numerianus, who had accompanied his father, the East. He was secretly killed while returning from the campaign (284 A.D.), perhaps by his father-in-law. His avenger and successor, Diocletian, at long last restored the empire.

Numerianus was considered to be something of a literary figure. He declaimed in public, wrote verses, and so impressed the Senate by his eloquence that this august body set up a statue in the library of the Forum of Trajan 'To Caesar Numerian the most powerful orator of his times.'

A head acquired by the Boston Museum has been tentatively identified as a portrait of Numerianus on the basis of a moderate resemblance to his coins. The immediate model is the latest portrait type of Gallienus which brings to the fore insistence upon the cubic largeness of the head (so-called 'Torlonia type'). In its emphasis upon the solidity of form and majesty of bearing, the head resembles and exceeds the head of Carinus. It has been rightly observed by C. C. Vermeule that in the treatment of details of hair and beard the sculptor made an attempt to return to the drilled patterns of Antonine portraits (Fig. 83) with results which only emphasize the abstract, patterned character of his work. Perhaps a resemblance to Marcus Aurelius was intended. The family name of Numerianus was Marcus Aurelius; and the name of the philosopher on the throne was one to conjure with. If Numerianus, the portrait, purely Roman in style, may derive from the statue set up by the Senate.

Boston, Museum of Fine Arts 1958.1005, Marble of Asia Minor? Made for insertion into statue. Height 15½ inches (0.394 m.).

101

C. C. Vermeule, pp. 3 ff., figs. 1-6, and for the Gal-
* lienus-Torlonia, fig. 13.

94 Constantine—The Man

Naissus in Moesia (Niš in Yugoslavia) was the birthplace
of Constantine and was used by him as a summer
residence. There must have been many people at Naissus
who knew him from childhood. The excellent bronze
portrait in Belgrade conveys the feeling of a powerful
but distinctly individual personality. The mood of super-
human majesty is maintained in the frontal view. In
profile, the aquiline nose, the slight softening at the
corners of the mouth speak in accents more human
than those of the colossal *divinus vultus* (divine face) from
the Basilica (Fig. 96). Even the glance seems more
attentive than preternaturally remote. Constantine wears
the jeweled diadem which henceforth becomes a distinc-
tive *insigne* of the emperors. Its slight projection helps
to relieve the austere roundness of the skull.

The broad, rhythmic modeling of major features is
masterly. The penetrating work is by an outstanding
court sculptor who knew Constantine well.

Belgrade, Narodni Muzey. Found in 1900 on the right
bank of the Nišava River with coins of Constantine.
Bronze with traces of gilding, for insertion in statue.
Traces of lead solder. Height 12¼ inches (0.361 m.).
K. Kluge, K. Lehmann-Hartleben, pp. 52 f., 136, pl.
* XVI. D. T. Rice, M. Hirmer, p. 287, pls. 2-3.

95 Late Antique Majesty

'The emperor as he proceeded was saluted as Augustus
by voices of good omen, the mountains and shores re-
echoing the shouts of the people, amid which he pre-
served the same immovable countenance which he was
accustomed to display in his provinces. For though he
was very short, yet he bowed down when entering high
gates, and looking straight before him, as though he had
had his neck in a vise, he turned his eyes neither to the
right nor to the left, as if he had been a statue; nor when
the carriage shook him did he nod his head or spit, or
rub his face or his nose; nor was he ever seen even to
move a hand.' Thus does Ammianus Marcellinus, a

contemporary, describe the progress of the Emperor
Constantius II (337-361 A.D.).

This son of Constantine was a pious Christian equally
certain of the righteousness of his faith and the super-
human majesty of his position. His colossal bronze image,
consciously modeled on the colossus of Constantine
must have towered over 30 ft., an awe-inspiring symbol
of the supra-mundane ruler, who communicates with the
celestial realms.

In this head the late antique Constantinian classicism
reaches a more assured, less rigidly abstract phase. Nearly
for the last time, the Roman predilection for individual
traits is permitted some play in the very marked, aquiline
nose, pursed mouth, and jutting chin. The missing part
probably bore 'a crown of gold adight with jewels'
which medieval pilgrims still saw (*Graphia Urbis Romae*).

The statue may have stood in the vicinity of the
imperial palace in the Lateran, where the head was placed
on two columns next to the statue of Marcus Aurelius
during the Middle Ages. The work was transferred to
the Piazza Conservatori by Sixtus IV in 1471.

Rome, Palazzo dei Conservatori, Sala dei Bronzi No. 7.
Height 6 ft. 7/8 inch (1.85 m.).
H. S. Jones, *Catalogue Palazzo Conservatori*, Oxford,
1912, p. 173, no. 7, pl. 60. R. Kluge, K. Lehmann-Hart-
leben, 2, pp. 53, 56; 3, pl. 17. R. Delbrueck, *Kaiserporträts*,
p. 139, pls. 52-54, M. R. Scherer, pls. 5, 212, 214-216
(medieval and Renaissance representations). W. F. Volbach,
M. Hirmer, p. 316, pls. 18 f.

96 Constantine—Divinely Inspired Ruler

'*Isapostolos*,' equal to the apostles, the divinely appointed,
divinely inspired ruler of the Christian world, Con-
stantine brought the challenge of a totally new con-
cept of the emperor to Roman portraiture. His re-
presentations had to embody those elements of the
traditional imperial image which expressed his claim to
the traditional authority of *rector totius orbis*, ruler of the
entire world. At the same time they had to reflect the
charismatic quality of the Lord's Anointed, the New
Moses, Vicegerent of God on earth, privileged to
visionary revelation and communication with a change-
less world of immortal radiance which his soul will join.

The colossus from Constantine's Basilica is a majestic
statement of this coming Age of Faith. The dimension

of time is eliminated. The old oriental formula of arching brows helps emphasize the steady gaze directed into the distance. Detail is eliminated to convey perennial, monumental substance. The classical form is used symbolically; physical beauty is the outer clothing of the beauty and greatness of the soul.

> Rome, Palazzo dei Conservatori, Cortile 2 (Inv. 1692). The head and fragments of hand and legs, found in 1487, come from a seated statue, over 30 ft. high, erected on a huge base in the west apse of the Basilica of Constantine. Statue had a brick core, body of wood covered by bronze. Head and limbs, Pentelic marble. Height 8 ft. 6 inches (2.60 m.), weight 8–9 tons. Joined with plaster to neck. Groove for metal diadem behind curls. 324–330 A.D.
>
> H. S. Jones, *Catalogue Palazzo Conservatori*, 1926, pp. 5 f. (history), 11 f. (other fragments) pl. 2. A. Minoprio, *PBSR* 12, 1932, pp. 10–13, pl. 9 (reconstruction of statue). R. Delbrueck, *Kaiserporträts*, p. 121, pls. 37–39. A. Rumpf, *Stilphasen*, p. 55, literature; denies identification, * dates it 360 A.D.

97 Lady of the Constantinian Age

The late antique expressionistic revolution and the subsequent reintegration of style on a basis of abstraction brought to sculpture a sense of monumental strength which, in the best work done under the House of Constantine, rises to heights of spiritual dignity not attained by earlier ages.

Although no safe identification has been made of the portrait of the woman shown in the marble head at Fossombrone, its quality alone would indicate either a princess or a lady of high family.

There are traits here that are known from other portraits of the fourth century—the leather-like rendering of the crowning tress, and the icon-like emphasis on the enlarged glance. Within the time-bound type, the sculptor has given to this head the feeling of mystery and revelation of Sibylline prophecy rather than human pride.

In this lofty dignity the work resembles the late portraits of Constantine and those of Constantius and prophesies the unearthly majesty of Byzantine imperial portraits in the mosaics of Ravenna.

> Fossombrone, Museo Vernarecci 24. Marble. Nose missing. Height 11¾ inches (0.30 m.). Ca. 350 A.D.
> *BdA* 29, 1935–1936, pp. 306 f.

98 A Princess of the House of Constantine

Among the majestic, colossal and awe-inspiring images of Constantinian portraiture this small head stands out by its jeweled loveliness. One would hardly believe that it could be by a contemporary of the sculptors of the Arch of Constantine (Fig. 140). Certainly the artful wreath of tresses is a Constantinian fashion which lasted, however, into the later fourth century. As this photograph somewhat exaggeratedly indicates, the head is based on cubic abstract form and it displays that heavenward glance which spread by reflection from the emperor to the other members of *Divina Domus*.

The head has been identified as a portrait of Constantia, sister of Constantine and (310 A.D.) wife of his co-ruler Licinius. When Licinius was defeated (324 A.D., near Scutari) she saved his life by her entreaties with Constantine—but not for long.

This is a masterpiece by a sculptor, whose sensitive style and crystalline polish anticipate qualities of style not seen until the 'Theodosian Renaissance' some decades later. Nor is his mastery only formal; in other views the head discloses the moving solemnity of an adolescent girl who is aware of her high station.

> Chicago, Art Institute 1960.64. Greek island marble. Under life size, 8⅞ inches (0.225 m.).
> Identified as Athenian work (which seems doubtful) and as Constantia and dated 313–314 A.D. by C. C. Vermeule, *The Art Institute of Chicago Quarterly* 54:4, December 1960, pp. 6–10, ill. p. 8. M. Milkovich, *Roman Portraits*, 1961, p. 76, no. 34, ill. *

RELIEFS

99 Lustratio Exercitus

'A *lustrum* is a purificatory ceremony conducted every five years by the censors.... In this and other ceremonies of this kind a procession went around the object to be purified, whether a body of people, as the army (*lustratio exercitus*) or a piece of land.... In Cato Maior (*On Agriculture* 141) the victims are three, pig, sheep, heifer (*suovetaurilia*) and the prayer is to Mars to keep away all evil' (H. J. Rose).

In the reliefs reproduced, Greek-trained marble sculptors struggle to render the novel Roman subject matter. The Roman sacrifice takes up the center of the long frieze. The huge bull adorned with tasseled fillet and broad belt looms larger than the Roman official clad in toga who pours a libation at the altar and the warrior god Mars, who receives the sacrifice. Other people are much smaller—two servants behind the altar, one pouring wine from a jug; a flutist and a lyre player; a boy with incense box, behind the priestly official; another waving two laurel branches; a man with toga drawn over his head carrying a military flag; and kilt-clad servants, who will perform the sacrificial killing. One stops the bull, two push the sheep and the pig. The scene of sacrifice is enframed by groups of soldiers; and on the left, a man writes on tablets, another turns the 'pages' and brings more tablets. This has been interpreted as the taking of census, or as mustering out of the army, or as registering veterans at the foundation of a colony.

An elegantly carved mythological frieze with the marriage of Neptune (now in Munich) belongs to the same monument. The reliefs were from the seventeenth century on in Palazzo Santa Croce. A Temple of Neptune was discovered under the church of San Salvatore next door. A temple to Neptune was dedicated in 42 B.C. by Gnaeus Domitius Ahenobarbus for a naval victory in the civil war.

Did the reliefs come from the altar of the Neptune Temple? If so, they would show purification of Ahenobarbus' forces after victory. Other suggestions: foundation of colony of Narbo Martius in 118 B.C.; the census taken by an earlier Domitius Ahenobarbus in 115 B.C.

Paris, Louvre. *Cat. Somm.* 975. Length of frieze ca. 19 ft. (5.65 m.), height, 2 ft. 5 inches (0.82 m.). Much repaired.

T. S. Ryberg, pp. 27–34, pl. 8, thorough discussion, literature. E. Nash, 1, p. 120, figs. 831–835, Temple of Neptune.

IOO Actium

Even more strikingly than the 'Purification of the Army' (Fig. 99) this relief illustrates the uneven, experimental character of Roman reliefs before the formation of the Augustan style. Puppet-like figures of peculiar dis-

proportions are shown in an ambitious scene involving a great variety of postures and sophisticated foreshortenings. The relief may represent a translation into sculpture of one of the posterlike triumphal paintings which were displayed in and after victory parades.

The slab is a corner block. At left, around the corner, fragments of cavalry men indicate action on land. The battleship is perhaps a four-deck man-of-war. On the prow is a 'castle,' a tower used as gun platform for artillery. An officer in 'body cuirass' and a marine have climbed out for attack. Other marines crowd the deck. A large land crocodile, symbol of Libya, is carved on the prow. The crocodile appears on coins of Canidius Crassus, who commanded Mark Antony's land army at the battle of Actium (31 B.C.). A trident encircled by a snake held in a hand is seen on the shield of the second marine from right; this, too, is an ensign of Libya.

In the naval engagement at Actium off the northwest coast of Greece, Agrippa won the rule of the Roman world for Augustus, forcing the heavier units of Antony and Cleopatra to flee. At the same time, on land, 'Two thousand Gauls their horses wheeled, And wildly shouting Caesar's name, / deserted [Antony] on the field.... The foeman's broken fleet / Into the sheltering haven flee / In pitiful retreat...' Like the relief, Horace's victory song (*Epodes* 9), stresses cavalry and sea battle.

Vatican, Sala di Meleagro 22. Found in the Temple of Fortune, Praeneste. Gray marble. Height 2½ ft. (0.75 m.). Width 4 ft. (1.20 m.). Depth 2 ft. 2⅛ inches (0.66 m.).

W. Amelung, *Katalog der Skulpturen* 2, pp. 65–72, pl. 5. H. S. Jones, *Companion to Roman History*, 1912, p. 264 (ships at Actium). R. Heidenreich, *RM* 51, 1936, pp. 337 ff., fig. 1.

IOI Roman Mythology—Rape of the Sabine Women

An extraordinary discovery has given us the earliest sculptured representation of famous legends of the infancy of Rome. Fragments of a marble frieze discovered in the venerable Basilica Aemilia (Figs. 1, 2) are known to include the stories of the traitorous Tarpeia, the Rape of the Sabine Women reproduced here, and many other episodes—a marble chronicle inspired by the same systematic attempt to build up an epic tradition of

Rome's greatness as Livy's *History of Rome* and Vergil's *Aeneid*.

The agitated style of large-bodied, dramatic figures derives from the Hellenistic baroque tradition but seems to herald the firmer, more unified style of the Augustan Age. Of the many rebuildings of the Basilica Aemilia, those of 34 B.C., 14 B.C., and 22 A.D. offer suitable occasions for the creation of the reliefs. The style of sculpture would better suit the earlier date but architectural historians favor the later one which would place the frieze early in the rule of Tiberius.

On the left, two Romans carry off two struggling Sabine women. A third woman flees with Romans in pursuit; the scene ends with a seated figure, a goddess or a personification. Farther to the right, in another scene, women are about to lead a mule cart, probably intended for the seated goddess.

> Rome, Museo del Foro. From entablature of lower story of interior of Basilica Aemilia. Marble. Recomposed of many fragments. Height 2 ft. 6 inches (0.74 m.).
> E. Nash, 1, p. 179, figs. 197–199, with literature. G. Carettoni, *Rivista dell' Istituto Nazionale d' Archeologia e Storia dell'Arte* XIX, 1961, pp. 5–78, complete publication. H. Furuhagen, *Opuscula Romana* III, 1961, Acta Instituti Romani Regni Sueciae, Series 4, XXI, pp. 139–
> * 155.

ARA PACIS—THE AUGUSTAN VISION

'When I returned to Rome from Gaul and Spain after successfully settling the affairs in these provinces, in the consular year of Tiberius Nero and Publius Quintilius (13 B.C.), the Senate voted that an Altar of Augustan Peace should be consecrated for my return in the Field of Mars and ordered that magistrates, priests, and Vestal Virgins should bring an annual sacrifice to it' (Augustus, *Deeds* 12).

'Peace dwell with us! fair Peace and none before
Yoked to the curvèd plough the sturdy steer;
 Peace reared the vine— ...
Come bounteous Peace! still hold the wheaten ear
And from thy joyous lap rich fruits outpour.'
(Tibullus, *Elegies* I:10, 45 ff. (26 B.C.), translated by J. Cranstoun).

'May the descendants of Aeneas cast dread into the world, far and near... Add incense, priests, to the fires, which burn for Peace. Let the white victim fall under the blow so that the House (of Augustus) which gives us Peace, may last eternally in peace' (Ovid, *Fasti* I, 717 ff.).

No other monument of the Augustan Age known to us can rival the Altar of Augustan Peace in its harmonious translation of the ideological program of Augustus into aesthetically convincing form. Perhaps because peace had been so fervently desired by so many for so long, the monument escapes that frigidity which can so readily blight art which tries to illustrate 'a platform.' The Ara Pacis created the iconographic type for imperial processions of state and defined the Augustan style which became the basis of Roman imperial art.

The original altar was an enclosure which stood in the Field of Mars, west of the Via Flaminia. The foundation ceremonies took place on the dedication on January 30, 9 B.C.

The original location under Palazzo Fiano in Via in Lucina was discovered in 1568. Excavations in 1859, 1903, and 1937–1938 have established almost all major features of the structure and decoration. In 1938 the Ara Pacis was re-erected in a different location, at Via di Ripetta near the Tiber and turned 90 degrees (entrances on north and south, instead of east and west).

102 Rome's God-Given Greatness

The illustration shows the altar as reconstructed under a modern shelter from the entrance (originally west) side. The external architecture with florid Corinthian pilasters, dividing horizontal meander, richly profiled footing, has much in common with the Second Pompeian style (Pls. VII, XVI).

The delicate floral displays symbolize the flowering of nature in the new age of peace. Swans, birds of Apollo, allude to Augustus' special affinity for this god, who gave him victory at Actium. The two figured panels allude to the divine origin of Rome—Mars watching his sons, the twins Romulus and Remus—and to pious Aeneas, mythical prototype of Augustus, and ancestor of the Julian family. On the right (north side), representatives of the Senate and the people march to the ceremony. The illustration shows the stepped altar and the inner wall of the enclosure decorated with lattice work below, sacrificial bowls and garlands suspended from ox skulls above.

Foundations, platform and pavement of travertine. Superstructure of Luna (Carrara) marble. Many parts of reconstruction restored in marble and plaster. Exact shape of part above pilasters uncertain. Almost 39 ft. (11.63 m.) north-south; 35 ft. 5 inches (10.52 m.) east-west. Estimated height over 20 ft. (ca. 6.10 m.).

103 Ara Pacis—Part of the Altar

The altar rose on a platform of four steps. Two additional steps brought the ministrant to the table-shaped centerpiece. The tongues to left and right were crowned with boldly curving acanthus spirals in a symmetrical arrangement. Winged lions support the ends. This rich vegetative life continues the theme of nature's response to peace. The fierce lions, once symbols of Oriental kingship, are guardians against evil.

A small frieze went around the top of the altar. Six Vestal Virgins and three attendants, two preceding, one following, are seen on the left. On the outside, animals were led to sacrifice. The vertical, rounded figures clearly separated from each other differ from those of the frieze of the enclosure and are closer to Republican representations of sacrifices (Fig. 99), perhaps out of religious conservatism. The procession on the altar and the procession on the enclosure are envisaged as parts of one continuous ceremony.

Altar: marble on a core of tufa. Height of frieze: 1 ft. 4 inches (0.39 m.).

104 Aeneas at Sacrifice. Detail of Fig. 102

In its romantic view of rural simplicity and heroic piety this relief sustains a mood found in Vergil's descriptions of Italy in olden times. A simple altar made of earth stands under a gnarled tree; a garland of laurel is thrown over it; fruits lie on it. More are brought in by a laurel-crowned boy. Another youth leads a pig to sacrifice.

Aeneas, tall, bearded, beautiful, dignified like the gods and heroes of classic Greek art, his head crowned, his cloak drawn over his head, stretches out one arm (to pour a libation from a bowl which the acolyte must have filled from his jug—this part of the relief is lost); with the veiled left arm he loosely holds the spear which conquered Latium for his Trojans. Behind him is his faithful companion—*fidus Achates*. On the rocky hill in a carefully depicted small shrine, are two seated divinities (the Penates), brought by Aeneas from Troy. Their cult was restored by Augustus.

According to Vergil (*Aeneid* III, 383), Aeneas was to stop at a place where he would find a white sow with a litter of thirty piglets: 'There is the site for your city, the terminus of your travails.'

The sculptor was intimately conversant with Attic sculpture of the classical period (perhaps by copying) and had at the same time mastered the most advanced late Hellenistic rendering of landscape.

Originally two adjoining slabs. Height 5 ft. 2 inches (1.55 m.). Left and right sides missing. A head thought (not without dispute) to be that of Achates is used in the reconstruction, Fig. 102.

105 Augustus at Sacrifice. Detail of Fig. 102

On the north and south side of the enclosure, a procession in two parallel halves was moving westward toward the entrance. At the southwest corner the spectator saw before him Augustus, the new Aeneas, the bringer of peace, participating in the first sacrifice to Peace. On the left are lictors with *fasces*, symbols of *imperium*. Augustus was carved across the join of the two slabs. His veiled head and outstretched right arm are on one slab, half of the heavily draped figure on the other. The men to his left and right are two consuls, probably those of 13 B.C. On the right are two fire priests with peaked caps. Heads of spectators pass in the background. Only Augustus and the keen-featured man across from him pay heed to the business at hand. Most of the others look back at the procession.

There is dignity here and beauty in some of the figures but no solemn rhythm unites the procession. Augustus wanted to convince the men of his time; they were to note the correct observance of ritual and recognize the part played by Augustus and his family. The cast was determined in the year 13 B.C. The individuals were intended to be recognizable; but Augustus was not an historian and changes were made. The studied informality has a reason—the *princeps* and his family must appear as the First Family but not as a royal family.

The excellent Greek sculptors from Athens did what

they could with the contradictory assignment. They produced a 'classical' effect by making all of the imperial procession stand, all of the Senate and the people run in a uniform rhythm. The sculptors must have had training in portraiture; here they ranged successfully from near ideal to strongly characteristic.

CAH, IV, pp. 112–124a. E. Welin, Dragma M. P. Nilsson, 1939, pp. 500–513. G. Moretti, Ara Pacis Augustae, 1948. J. M. C. Toynbee, Ara Pacis Reconsidered, 1953. I. S. Ryberg, pp. 38–48, pls. 10–13. P. MacKendrick, pp. 156–171. E. Nash, 1, p. 63, figs. 60–74, literature. H. P. L'Orange, in Institutum Romanum Norvegiae, Acta. 1, 1962, pp. 7–16, literature. H. A. Thompson, Hesperia, 21, (1952) pp. 79 ff. H. T. Rowell, Rome in the Augustan Age, * 1962, pp. 213–222 (interpretation).

106 Julio-Claudian Refinement

Without the popular sentiment which associated the coming of peace and stability with the Deified Caesar Augustus, the Julians and Claudians would have had no claim to rule. The persistence of Augustan fashions in portraiture and the imitation of Augustan monuments in other arts had political as well as artistic reasons. Within this preset mode art was developing toward ever greater refinement and sophistication of form. The increase of optical devices, of oscillating use of light and shade to enliven details was the major trend in sculpture which was to transform it in the time of Nero and the Flavians.

The fragmentary relief of a suovetaurilia in the Louvre owes much to the Ara Pacis but its sculptors play superlative variants on the old theme. They group their figures in complex, overlapping, receding layers. They range from paper-thin to highly rounded relief. They carve the folds of garments in brittle patterns. Rhythmic animation, which gave pause to the sculptors of the Ara Pacis, is handled with greater assurance. The sacrificing official, who brings fruit and incense, moves with graceful step; the man leading the heifer picks up the motion and achieves a fluent transition to the last group. The exquisite laurel trees and garlands are a joy.

As the fragment of a second altar on the right indicates here were two processions. In 47 A.D. the Emperor Claudius closed the five-year term (lustrum) as censor; his colleague was Vitellius who, 22 years later, briefly occupied the imperial throne. The face of the sacrificant is restored; his tall stature would suit Claudius. The objection is that the emperor should be on the favored 'right' side; if so, the priest is Vitellius.

Paris, Louvre, Cat. Somm. 1096. The relief, certainly from an imperial altar in Rome, was already in the fifteenth century in the Palazzo Venezia. Marble. Face, right arm of priest, lower edge with feet, restored. A fragment of a second procession is also in the Louvre. Other identifications propose Tiberius or Caligula. Height 2 ft. 10 inches (86 m.). Length 6 ft. 4 inches (1.98 m.).
E. Michon, Mon. Piot 17, 1910, pp. 190–203 pl. XVIII. CAH IV, pl. 138, I. S. Ryberg, pp. 106 ff., fig. 54a. TEL, Encyclopédie Photographique de l'Art III, p. 279. *

107 Mythology—Decorative and Allegorical

The refinement reached by Roman reliefs around the middle of the first century A.D. is even more striking in the congenial medium of pliable, sculptured, white stucco than in the stately carving of official marble reliefs (Fig. 106). The detail shows the widely spaced decorative system from the vault of the Basilica under Porta Maggiore (Fig. 26). Unlike the later circular and segmental decoration of the vault of the Pancratii (Pl. xi), this is composed of oblongs and squares, rather like the lattice work of an arbor. Some of the units are thought of as framed pictures: the two scenes of divine abductions, at the top, a winged genius carrying off Ganymede and a Dioscurus carrying off a daughter of Leucippus, the two mythological scenes in the center (Medea bewitching the dragon so that Jason, kneeling on table, can snatch the Golden Fleece; Paris leading Helen away); and the pictures of centaurs and sileni surmounted by scrolls.

Other panels are friezes with genre scenes. Little boys with writing tablets and their schoolmaster, seated; little boys racing in armor; beggarly jugglers with pointed caps and women at a tripod; and pigmies. Isolated in individual panels are heads of Medusa, cupids, seated goddesses; and victories float through the air to sacrifice. All are swiftly sketched ethereal miniatures. The delicate suspension of reality is in the same taste as the Third Pompeian style (Pl. viii).

Rome, Basilica under Porta Maggiore. Part of central vault. Stucco. Width of vault ca. 10 ft. (3 m.).
E. L. Wadsworth, MAAR 4, 1924, pp. 65–85, pls.

38–44. E. Strong, *JHS* 44, 1924, pp. 65–111, plan of decoration, mystical interpretation. E. Nash, 1, p. 169, fig. * 186, literature.

108 The Arch of Titus—Jerusalem Taken

Senatus Populusque Romanus Divo Tito Divi Vespasiani Filio Vespasiano Augusto. 'The Roman Senate and People to Deified Titus, Vespasian Augustus, son of Deified Vespasian.'

Titus (Fig. 54), Vespasian (Fig. 74), Colosseum (Figs. 36, 37); the Arch of Titus in Summa *Sacra Via*, at the highest point of the Sacred Way in the Roman Forum (Figs. 1, 2) rounds out the story of the eventful years which followed the Jewish War of 66–70 A.D. Both Titus and Vespasian were dead when the arch of Pentelic marble was completed to recall for all eternity that fateful day when the Menorah, the Table of Shew Bread, the silver trumpets which called the people to Rosh Hashanah (Exodus 25:23–37, Numbers 10:2, 29:1, Leviticus 23:24) from the Temple in Jerusalem were carried in triumph past this spot at the foot of the Palatine.

The laurel-crowned procession sweeps out of the background, passes, and disappears under an arch. The placards which described the booty or named the conquered cities and the trumpets wave in the air. Eight men carry the stretcher with the seven-armed lamp holder. They bend under the weight; they have pillows on their shoulders. The base of the Menorah is decorated with eagles and sea monsters in Hellenistic style. The Table of Shew Bread stands on the next stretcher; the trumpets are fastened to its legs. A vase is on the table. The surface of the relief is broken but apparently the table was shown foreshortened at an angle. An even stronger sense of depth is suggested by the arch which fades into the background. A victory floats in its spandrel. The bronze statuary on top includes a quadriga, two human figures and five more horses.

Twenty massed figures standing for thousands reveal in a flash the highlight of the triumphal parade. Tumultuous life and motion is held forever. The master of the arch had this power—as did Rembrandt in his 'Nightwatch.'

The sacred implements were taken from Rome by Vandals (455 A.D.), recaptured by Belisarius (534 A.D.), and returned to Jerusalem by Justinian (before 565 A.D.).

Rome, Forum. Panel in south side of passage through the arch. Much damaged. The beam holes at top are from the chamber built in the Middle Ages into the vault of the passage by the Frangipani family who used the arch as a fortress. Height 78 3/4 inches (2 m.); width, 151 1/2 inches (3.85 m.). Original inscription on Colosseum side, *CIL VI*: 945.

109 Titus in Triumph

Clad in a toga, Titus stands in the richly decorated chariot. Holding the reins (now lost), he turns the horses. A Victory with mighty wings crowns him, the seminude Genius of the People and (probably) the togaed Senate escort the chariot, the helmeted Amazonian Valor leads the team—the divine powers protecting Rome have taken human form to celebrate Titus and his triumph. The only mortals are *lictors*, attendants of an imperator; their *fasces*, bundles of birch rods, wave solemnly in the background, awesome reminders of the power of life and death vested in an *imperium*.

The triumphal chariot came at the end of the triumphal procession; the motion is slower, more dignified than in the picture with the spoils. In both panels figures are massed in the lower part, air and depth are suggested by the space overhead.

The ornate pilasters and the coffers of the vault made the corridor-like panels stand out the more strongly. Their reliefs spring to life with the rays of the rising or sinking sun.

Never again had Roman art sought so clearly to hold the spectator to a brief moment of illusion, as he passed through the arch. If he proceeded in the direction of the procession, toward the Capitolium, he also experienced a moment of self-identification with the movement of the procession.

The originality of Roman art was rediscovered for the modern world when Franz Wickhoff, invoking Velazquez, saw that in the Arch of Titus 'sculpture tried to attain with its own means an effect like that to which painting could only aspire at a high stage of its development: the impression of a complete illusion. All is subordinated to the unique purpose of producing the feeling of uninterrupted motion.... Air, chiaroscuro, everything is used to obtain the sense of reality. To make natural light (and

real air) contribute to the perfection of the artistic effect was one of the most audacious innovations... (in the history of art).'

North panel in passage. Nearly all heads lost; beam holes in lower part. The arch was erected shortly after 81 A.D. Bust of Deified Titus, carried by an eagle at the top of passage vault. Entire arch rebuilt by G. Valadier, 1822.
F. Wickhoff, *Roman Art*, trans. E. Strong 1901, p. 78. C. D. Curtis, *Suppl. Papers Amer. School Rome* 2, 1908, pp. 47–49, architecture. E. Strong, *Scultura Romana* 1, 1923, 105–118. S. B. Platner, T. Ashby, pp. 45–47, literature. I. S. Ryberg, pp. 146 f., pls. 52–53. M. R. Scherer, pp. 75 f., pls. 6, 28, 31, 115, 120, 123, 125 (medieval, renaissance, baroque renderings). E. Nash, 1, p. 133, figs. 143–147, * literature.

THE 'CANCELLERIA RELIEFS'

Palazzo Cancelleria on Corso Vittorio Emanuele became famous in the annals of archaeology when in 1937 by unarchaeological excavation the tomb of the consul Aulus Hirtius (died in 43 B.C.) was located underneath the palace. Lying against and around it were a series of marble slabs which have added a new chapter to the history of Roman reliefs.

They are what few had hoped for—documents of state from the reign of Domitian whose portrait has survived in one (Fig. 110) of the two scenes, but was recut into a likeness of the Emperor Nerva (96–98 A.D.) in the other (Fig. 111) when Domitian's memory was condemned.

I I O Vespasian and Domitian

The first relief, composed of three slabs, shows a touching display of trust and affection between father and son. Vespasian (69–79 A.D., cf. Figs. 74, 76), dignified and majestic, approvingly lays his hand upon the shoulder of young Domitian. Two *lictors* approach from the right, a third stands on the left; the act involves imperial authority and is perhaps intended to signify the transfer of *imperium* to Domitian. In the background, the youthful Genius of the Roman People, foot on a rock, holds a horn of plenty and the bearded Genius of the Senate stands next to him.

Two figures hurry off to communicate the event to the Vestal Virgins; the one head preserved shows their characteristic head gear. The *lictor* on the left belongs to the Vestal Virgins. Behind him, on a podium, a voluptuous goddess Roma, one breast markedly exposed, sits on a throne and contemplates the event. Clearly, Vespasian expresses approval of what Domitian has done—perhaps during the first year of the Flavian dynasty, when Domitian emerged out of hiding to play the prince in Rome, until Vespasian returned from the east (70 A.D.).

I I I Domitian Is Pushed into War

On the left, a Victory, of whom only a wing remains, flies ahead, holding rods and iron ax. Mars marches forward, followed by Minerva, special protectress of Domitian. Both look back inviting the emperor to follow. He is loath to start and is given a push by a helmeted, ample-breasted personification of courage (Virtus or Roma?). He holds a scroll with writing in his left hand. Two lictors pass in the background. The Genius of the Senate, who holds a knotted stick crowned by a bust of Domitian and the Genius of the People with a horn of plenty wave good-bye. A bearded officer gives the marching order to three soldiers. 'Domitian's decision to take the field is portrayed as a result of divine pressure brought to bear against his will' (P. G. Hamberg).

Both reliefs are propaganda 'think-pieces.' The first seeks to counter rumors of Domitian's scandalous behavior during his father's absence and make clear that the imperial hero, Domitian, was his father's cherished trust and support from the beginning. Brother Titus, who actually succeeded Vespasian, is left out of the picture.

The second scene seeks to justify the unpopular war of 83 A.D. in Germany which Domitian was rumored to have started in the hope of a cheap triumph. Others (E. Simon) believe Domitian is arriving as a new Hercules to greet as an equal a (lost, seated) Jupiter on the left.

The parade of divinities and allegorical figures may not mean much to us; to a Roman this picture language was charged with emotional connotations.

The reliefs are elaborately allegorical in content, intentionally classicistic in design. This hard Domitianic classicism emphasizes a broad display of stationary figures and a coldly white polish of surface. Conscious repression of the preceding Flavian baroque is evident at every step. The high 'pictorial' space derives from that of the Arch of Titus (Figs. 108–109). Figures, frontal, diagonal or

even seen from behind, presuppose a much looser relation to background than those of the Ara Pacis (Figs. 103–105) or the Claudian relief (Fig. 106). Rich, pictorialized treatment of hair, garment folds, wings, and helmets survives from the baroque tradition. Fostered presumably by Domitian's personal taste in the last decade of his rule (85–96 A.D.), this is a classicism which draws on imperial reliefs from the time of Augustus more than on Greek classical sculpture. Apart from the general idea that flattened relief and vertical figures are 'classic,' the resemblances with Greek art are in the nature of individual 'quotations.'

I 12 Head of Mars. Detail of 111

The noble profile of the head of Mars owes something to a Greek original, directly or indirectly. The immediate model may well have been a famous Augustan image of Mars. The mastery of chiaroscuro treatment of marble, acquired during the 'Flavian baroque' is evident in the hair, beard, and the crest of the great helmet which is supported by a crouching griffin. Nervous life animates the features.

Holes along the lower rim of the helmet indicate that a piece was attached. A number of Roman parade helmets with this kind of relief decoration are known. (J. M. C. Toynbee and R. R. Clarke, *JRS* 38, 1948, pp. 20 ff.)

I 13 Head of Minerva. Detail of 111

'Minerva had him by the hand and was leading him into Rome' (painting described by Petronius, *Meal of Trimalchio* 29, before 66 A.D.). A composition showing Minerva leading a favorite by the hand, must have been known in Rome already under Nero and was utilized here for Domitian.

'He dreamed that Minerva, whom he worshipped with superstitious veneration, came forth from her shrine and declared that she could not longer protect him' (Suetonius, *Domitian*, 15).

We may be sure that the sculptors knew how important Minerva was for Domitian. Here everything counted. The high girt figure (Fig. 111), large for the small head, seems to be based on a Hellenistic type; such an Athena,

based in turn on Phidian inspiration, is seen on the famous Altar of Pergamon (180–160 B.C.). The head with the hair parted in the center, vertical locks, small deeply set eyes suggests Greek heads of the late classical era, though again a Hellenistic revision is possible. But the soft fleshliness of the face and the elusive smile with which she encourages Domitian are of the Flavian Roman style. This head is very much alive. One wonders whether a Roman lady of Domitian's court might not have lent this individual touch to the traditional type.

Minerva wears an Attic helmet decorated with rams' heads and jumping griffins. A puzzled-looking owl supports the crest.

Vatican. From excavations under Cancelleria Apostolica Palace, Rome. Marble. Height 7 ft. (2.10 m.). Seven slabs, two scenes. Length of each scene ca. 20 ft. (ca. 6 m.). Original monument uncertain but format (frame at end of Fig. 110) favors an arch (e.g., the four-faced *quadrifons* known from coins of Domitian). 85–96 A.D.

F. Magi, *I Rilievi Flavi del Palazzo della Cancelleria*, 1945. P. G. Hamberg, pp. 50 ff., H. Last, *JRS* 38, 1948, pp. 9–14, pl. 1. A. Rumpf, *BJb* 155–156, pp. 112 ff. J. M. C. Toynbee, *The Flavian Reliefs from the Palazzo della Cancelleria*, 1957. P. MacKendrick, pp. 236–241, fig. 9. E. Simon, *JdI* 75 (1960), pp. 134 ff., a survey of controversies about subject matter and dating (Rumpf, Hadrianic; Simon, 93–96 A.D.).

I 14 The Column of Trajan

A marvel of the ages, the marble column of Trajan still stands where Apollodorus of Damascus had placed it, between the Greek and Roman libraries in Trajan's Forum. The location confirms what the form of the column suggests. It is intended to be a huge, book-like picture scroll, the equivalent in stone of the *Commentaries*, lost to us, which Trajan wrote on his wars in the Balkans.

With its height of 100 ft. (for the shaft), its 2,500 figures, its frieze length of 625 ft. (over 200 m.), the column is the nearest antiquity came to a documentary war film. Its hero is the disciplined, resourceful, relentless Roman army; the emperor, slightly emphasized by larger size, receives constant attention as the ideal general who addresses the troops, leads them into battles, and shares all their hardships and perils. But he is a real human person, not an allegorical symbol of imperial omnipotence.

The engineering corps, led presumably by Apollodo-

rus, is constantly in evidence. In seeking to explain clearly the various problems faced by the engineers, the designer of the narrative has expanded, codified, in a measure created, a new way of portraying architectural environment.

Thus in the lowest windings of the column we see a careful description of the city and the Roman fortifications system and of the famous pontoon bridge which Apollodorus built across the Danube. The bearded river god looks on from a cave. The army in disciplined array is setting out for the campaign of 101-102 A.D. against the Dacians.

Above, earth is dug, bricks or stones and beams are carried as the Romans construct a camp. The emperor, on the right between two officers, supervises the construction. Here and in the two scenes above a sort of aerial perspective is used so that we can see what is going on within. Note the careful delineation of another type of bridge in the third winding where the army is setting out.

On top, Trajan is seen twice, once speaking from the official platform in front of legionary standards, to Romans and barbarians (Dacians?) on foot and horseback, then (on the right) in front of the camp conversing with another barbarian embassy. A mighty waterfall is on the left; the muscular river god(?) seen from the back raises a stone slab.

Although clearly composed in rather shallow relief, each scene takes careful reading as the interest is very evenly distributed among various groups and figures.

The second and fourth winding show the small windows to light the staircase within the column.

E. Strong, *La scultura romana* I, pp. 159-163.

115 The Pious Leader

Accompanied by a cavalry general, Trajan on horseback approaches an altar. A high officer and a boy ministrant with an incense box stand by. The sacrificing servant twists the head of a bull by pulling the ribbon on its horn. Standard bearers with their lion-head caps *(signiferi)* and soldiers crowd in from the right. Behind them rises a fortified town with a colonnade, a circular camp with tents lies on the right.

Second part of the second campaign, 105-106 A.D. E. Strong, *La scultura romana* I, p. 177. Cichorius, scene CII. In Fig. 115, top is the right, bottom the left part of the scene.

116 Romans Besieged by Dacians

The column of Trajan knows themes of intimidating terror (heads of Dacians put on display) and atrocity propaganda: Dacian women torture captive Romans by burning them with torches. Yet its over-all attitude is objectivity. Victory is not obtained cheaply. Here the wild and passionate barbarians assault a Roman fort with arrows and battering rams (right). A dying Dacian lies on the ground, a wounded one sits at the bottom of the city wall. The Romans, acting in unison, are swinging their spears (which were attached separately) to batter down anyone trying to scale the wall.

Barbarian horsemen with Germanic looking helmets approach from the left. Their horses wear scale armor and look almost like medieval dragons. An old formula of city siege already used in Egypt and Mesopotamia and later picked up for mythological epics by Hellenistic art, is here transformed out of military knowledge and actual observation. The different ensigns on the Roman shields would identify the units. The barbarians, too, show remarkable variants of facial types.

This scene is from the first campaign of 101-102 A.D. Cichorius, scene XXXII.

Mantegna, Raphael, Michelangelo, all admired the column of Trajan as a treasury of an enormous heritage of ancient figurative compositions. It remains so to this day. Whether or not such a design was based on Greek book illustration, it was composed and refashioned to convey an authentically Roman experience. With the great number of executing sculptors the quality must have varied; but the designer who composed an epic involving five times the number of figures in the Parthenon frieze was one of the great artists of all times. That the scenes of battles, departures, embassies, sacrifices repeat themselves does not mean that the narrative was not based upon reality. Modern documentary war films show the same repetitive typology. War can only be symbolized; it cannot be represented.

Within the range of typical events the master shows drama, suffering, dignity, submission, humor; but it is the even and sustained tenor of narration which distin-

guishes this Trajanic war from later interpretations. Trajan's approach is to let the spectator understand that only by discipline, cooperation, ingenuity, and endurance did the Roman legions and their auxiliaries overcome the wild nature of the country and the fierce courage of the Dacians.

The Dacian kingdom of Decebalus on the plateau of Transylvania included gold and silver mines in the Carpathian Mountains. Two wars are shown on the column (101–102, 105–106 A.D.). The Dacian capital Sarmizegethusa was captured in 106; Decebalus committed suicide.

> Rome, Forum of Trajan. The column is of Parian marble. Erected in 113 A.D., perhaps after designs by Apollodorus of Damascus (cf. Fig. 23). After Trajan's death in 117 A.D., his ashes were placed in a golden urn and deposited in the base of the column. His statue stood on top, was lost in the Middle Ages, was replaced in 1588 by statue of St. Peter. Pedestal 18 ft. 4 inches (5.5 m.) square, contained vestibule, hallway, funerary chamber for urn. Inscription over southeast door, *CIL* VI:960. Height of entire monument over 128 ft. (38 m.), of column 100 Roman feet (29.77 m.). Height of frieze increases from 3 ft. (0.90 m.) at bottom to 4 ft. 2 inches (1.25 m.) at top, for visibility.
>
> S. B. Platner, T. Ashby, pp. 240–242. C. Cichorius, *Die Reliefs der Trajanssäule*, 1896–1900. E. Strong, *La scultura romana*, 2, pp. 153–189. K. Lehmann-Hartleben, *Die Trajanssäule*, 1926. P. Romanelli, *La colonna traiana*, 1942. M. R. Scherer, pp. 105 f., pls. 6 ff., 19, 110, 171–173. P. MacKendrick, pp. 266 f., 269–272. E. Nash, 1, p. 283, figs. 335–
> * 337, literature. G. Becatti, *La colonna coclide*, 1960, pp.25–31.

I I 7 Antinous Silvanus

This charming relief is Hadrianic sculpture at its best. The signature, *Antonianos Aphrodisieus epoiei*, nicely engraved on the altar indicates that the master belonged to the flourishing school of sculptors from Aphrodisias in Caria (Asia Minor), whose work was much favored by Hadrian.

Antinous is shown in the guise of the Roman rustic god Silvanus. For the figure type the artist took as a model one of the beautiful high classical Greek reliefs. Hadrianic, however, is the dainty lightness of setting, the thinly etched relief of the altar and of the tendrils and grapes overhead. The figures build up in fine gradation to reach emphatic roundness in the pensive profile of the

youth and the head of the dog thrusting up to the (lost) object which Antinous held in his left hand.

Clad in the short, girt tunic of the country man, Antinous holds the vintager's knife in his right hand; a wreath of olives crowns his head. A pine cone, two pomegranates, and some fruit lie on the altar. Because altar, vine, and dog are only partly seen, we seem to be looking through a window but the fine rhythm and tactful placing of the figure against the neutral clarity of the background suggests an ideal sphere in which the beautiful youth will dwell forever in thoughtful solitude.

Silvanus, who usually is accompanied by a dog, originally the god of uncultivated land, but is here associated with the theme of pious rustic sacrifice in a vineyard.

> Rome, private collection. From Padiglione del Torre near Lanuvium. 130–138 A.D. For another portrait of Antinous, cf. Fig. 81. Pentelic marble. Height 4 ft. 9 inches (1.42 m.). Width 2 ft. 2 5/8 inches (.66 m.). Upper part of Antinous' cap missing.
>
> E. Strong, *La scultura romana* 2, 1926, pp. 203 f., pl. 43. G. M. A. Richter, *Three Critical Periods*, 1951, p. 54, pl. 110. M. F. Squarciapino, *La scuola d'Afrodisia*, 1943, pp. 29–31, frontis., with other attributions to Antonianos.

I I 8 Marcus Aurelius Sacrificing on the Capitol

The ancient ritual of triumph appears here in a different format. If the column of Trajan had made all action visually continuous, the three slabs preserved from an arch of Marcus Aurelius subdivide the triumphal procession into a series of upright 'panel pictures,' each a segment of a larger entity to be continued by the imagination. The effect of air and overhead space is very marked against the relatively low wall of massed figures. They are, as yet, clearly legible but their motion is ponderous, almost inert, and a restless effect results from the concentration of so much drilled detail at mid-height.

The sculptor introduced an architectural background which, because of its determined frontality and the jump in scale, fails to awaken a spatial illusion comparable to that of the Arch of Titus (Figs. 108, 109). Despite this incipient flattening and the lack of differentiating emphasis among the figures, the relief exhibits a style of very high competence in rendering realistic figure and

architectural detail—a far cry from the dramatic and simplifying emotionalism of the column of Marcus Aurelius begun several years later.

The unrestored head of Marcus is a sympathetic study of a ruler worn down by age and war. The furrowed head behind him is thought to represent *praefectus praetorio* M. Bassaeus Rufus; the Jupiter-like bearded man is the Genius of the Senate. Above the small boy is the head of the Chief Fire Priest *(Flamen Dialis)*. Two hundred years before, Augustus at sacrifice had been youthful and confident (Fig. 105); now the Roman world was getting worried and old.

The Temple of Jupiter Capitolinus is short two columns but displays its pedimental sculptures including the Capitoline triad of Jupiter, Juno, and Minerva; Sun and Moon on chariots; Vulcan and Cyclops forging thunderbolts in the corners. The enclosure of the temple area is crowned by lion and bull hunts (of bronze?).

Rome, Palazzo dei Conservatori, Scala 11:4, formerly Church of S. Martina *(Secretarium Senatus)*, Forum. Transferred by Leo X, 1515, restored heavily 1595. Luna (Carrara) marble. Height 10 1/2 ft. (3.14 m.), width 7 ft. (2.10 m.).
H. S. Jones, *Catalogue Palazzo Conservatori*, 1926, pp. 22–f., fig. 1 (before restoration). M. Wegner 11:4, pp. 44 f., 195 f., literature, pl. 286. *CAH* V, p. 104a. I. S. * Ryberg, pp. 156 ff., fig. 86.

119 Murder over the Grave

Would you like to see a man murder his mother, a wife burned to death, a flock of children slaughtered—as a nice ornament for your grave? Yet this is precisely what highly placed Romans in the time of Hadrian did like to have carved on their marble caskets—the legends of Orestes, Medea, and the children of Niobe, all subjects of particularly horrible happenings.

For reasons not adequately explained, the Romans shifted from the traditional ritual of cremation to the deposition of the dead in marble sarcophagi. That 'the change could be a natural product of the growth of individualism… entailing greater reverence for the relics of the individual human body, a greater interest in the fate of the individual soul' (J. M. C. Toynbee) would be convincing, were it not all so sudden.

Somebody at Hadrian's court set the style and propagated the idea that certain myths were suitable symbols—for the sudden violence of death? Death struck the dead as suddenly as Clytemnestra, Creusa, the Niobids? One should like to blame Hadrian himself for these erudite fancies, even though he was cremated.

The change created an entirely new task for sculpture in relief which, in Rome, was solved in a peculiar way The front of the casket shows the main story without any tectonic frame at the ends; the short sides have either supplementary or unconnected subjects; the back is neglected. A tall lid, sometimes with an additional story makes for a tall façade.

Three scenes are shown: Furies asleep (at the cairn of Agamemnon) on the left; in the center, Orestes with the help of Pylades has just slain his mother Clytemnestra and her lover Aegisthus; the old nurse flees in terror; from behind a curtain two Furies advance to begin their pursuit of Orestes; on the right, Orestes steps over a sleeping Fury as he leaves Delphi to be acquitted by Athena in Athens.

The style is, in this example, more classically Hadrianic than in a related sarcophagus in the Lateran, dated by brick stamps of 134 A.D.

Cleveland, Museum of Art, 1016.28. Sarcophagus with lid showing two masks at corner, and Seasons personified by reclining women and flying *putti*. Greek marble. Height of sarcophagus 1 ft. 11 inches (0.58 m.). Length 6 ft. 11 inches (2.11 m.). Height of lid 8 3/4 inches (0.22 m.). Lid restored.
The Cleveland Museum of Art. *Handbook*, 1958, no 43. *Bulletin*, 15:4, April 1928, pp. 90–91, illus. pp. 85, 86. Cf. J. M. C. Toynbee, *Hadrianic*, pp. 183 ff. and for the lid G. M. A. Hanfmann 2, p. 170, no. 385, fig. 107. For the controversial subject of the meaning of such myths cf. A. D. Nock, 'Sarcophagi and Symbolism,' *AJA* 50, 1946, pp. 166 ff. K. Schefold, *RA* 1961:2, pp. 177–209.

120 Mythological Portraits

'To the Divine Shades, Caius Iunius Euhodus, President for Five Years of the College of Builders of Ostia during the twenty-first *lustrum* had this sarcophagus made for himself and for Metilia Acte, Priestess of the Great Mother of Gods [Cybele] of the Colony of Ostia, Most Saintly Wife,' states the inscription borne by two flying Victories (*CIL* XIV:371).

A priestess of the Mother of the Gods was an impor-

taut personage among the freedmen of Ostia. The Phrygian-capped heads of Attis, the torches, the cymbals, tympanon, and flute on the lid refer to Metilia Acte's sacred calling.

Euhodus wanted all the world to know how wonderful his wife was—and what she looked like. She is shown as Alcestis, the wife so faithful that she was willing to die instead of her husband—even though this cast Euhodus in the unmanly part of the cowardly husband Admetus. The story had a happy ending, as Hercules brought Alcestis back from the dead. For recognizability Euhodus had portraits of himself and his elderly wife put on the bodies of Admetus and Alcestis. The forcible insertion of unadulterated self into a half-understood mythological frame may reflect the pretensions of the newly rich, half-educated business class; their immortal prototype, Trimalchio, satyrized by Petronius, would have approved (*Meal of Trimalchio* 51).

On the left, Hercules enters as the house mourns. Alcestis, on a couch, is taking leave of husband and children. On the right, Hercules accepts Admetus' thanks; the hell-hound Cerberus at his feet. Alcestis is still veiled, as befits one returned from the ghosts. On the right, the rulers of Hades, Proserpina and Pluto, engage in a show of affection touched off by admiration of Alcestis. The story accords with Euripides' play *Herakles*.

The twenty-first *lustrum* of the college can be dated between 161 and 170 A.D. Thus this relief illustrates the mid-Antonine style on sarcophagi. The frieze is elongated, the space is deepened, and architectural elements are introduced. Figures are squat, gestures somewhat automatic. Shadows cling to figures and there is much drill work in detail.

Vatican, Museo Chiaramonti 179. Found in 1826, Scavi Cardoni, Ostia. Marble. Height of sarcophagus 2 ft. 8 in. (0.795 m.). Length 7 ft. (2.10 m.). Width 3 ft. 1 inch (0.92 m.).

C. Robert, *Sarkophagreliefs* III, pp. 311 ff., pl. 7, no. 26. W. Amelung, *Die Sculpturen des Vatikanischen Museums* 1, 1903, pp. 429 f., no 179, pl. 45. J. M. C. Toynbee, *Hadri-* * *anic*, pp. 182 f., 198 ff., pl. 42:1. R. Meiggs, pp. 319 ff., 362.

I 2 I The Chaos of Battle

From time to time there emerge in Roman art new forms and motifs of great power and originality which reflect revolutionary changes of style. Such a work is the great battle sarcophagus found near Portonaccio. Instead of the frieze-like composition relying on a long band with figures of uniform height (Figs. 119–120), the sarcophagus rises like a mighty wall; the function of the frieze is now allocated to the lid, devoted to scenes from the life of the Roman general and his wife. On the right, events in the field, a trophy, and barbarians offering submission perhaps as a result of the great battle shown below; in the center, the general in toga joining hands with his wife in marriage; on the left, at home, the lady is shown amidst her children and ladies in waiting. The events are not arranged as an historic sequence but rather to show the high points of the two lives in the manner in which they are conjoined. The scenes shown symbolize the *virtus* and *clementia* (courage and mercy) of the husband and the domestic virtues of the wife and mother.

The battle scene is contained at both sides by a pair of mourning barbarian captives above whom there rise trophies—an empty helmet and a face-mask helmet staring like ghosts. Between them in light and dark, is a heaving and weaving mass of bodies. The general is emphasized by his central position and by the sweeping line of his raised arm and sword as he rides into the thick of battle. The rest of the composition cannot be seen at a glance but must be read; if that is done, the apparent confusion turns out to be a reasonable simplification of a definite tactical maneuver characterized by extreme documentary exactitude in details of uniforms, military ensigns, and equipment of the Roman troops and of their German enemies 'reproduced with complete accuracy of technical military knowledge' (Hamberg).

In principles of composition this 'over-all pattern' represents a complete break with earlier tenets of classical sculpture; in psychology and mood it reflects an emphasis on chaos and cruelty of war grown out of the desperate struggles waged by the Romans during the reign of Marcus Aurelius.

Rome, Museo Nazionale delle Terme 112327. From the Via delle Cave di Pietralata near Portonaccio. Marble. Height with lid, 4 ft. 11 in. (1.50 m.). 190–200 A.D.

P. G. Hamberg, pp. 176–179, pl. 40, with analysis of battle situation in a drawing. B. Andreae, *Motivgeschichtliche Untersuchungen zu den römischen Schlachtsarkophagen*, 1956, p. 15, no. 13. F. Matz, pp. 157 f., 166, 188 ff., pl. 38.

122 The Column of Marcus Aurelius

Modern Romans take the Piazza Colonna for granted as one of the liveliest squares of the city. Its tall structures box in the column from three sides. This was not the ancient effect. Coming down the Via Flaminia (also Via Lata, now Via del Corso) the visitor, after passing the Ara Pacis would have before him on the right an open area with the simple column of Antoninus Pius and the cremation precincts for the family of the Antonines. Behind them the Marcus column 'rose free and bold above the imperial edifices of the Campus Martius [farther south] some 150 feet against the sky' (G. Gatti).

Raised ten feet above the level of neighboring streets the precinct and Temple of the Deified Marcus was the first monumental complex on the right (west) side followed by a phalanx of imperial monuments from the time of Trajan and Hadrian. The colonnaded forecourt opened on the Via Flaminia and was closed on the opposite (east) side by the temple, with the column placed on the temple axis some 100 ft. from the street. The intention was to provide an architectural setting analogous to that of the column of Trajan which, throughout, served as model.

It is not known whether the colonnades of the precinct provided any facilities for viewing the column. Its eastern face, the major side in the arrangement of the reliefs, was turned toward Via Flaminia and could probably best be studied by dwellers in the apartment houses on the opposite side of the street. Considerable traces of these houses have been discovered under the modern Palazzo della Galleria.

Curiously, only the Regional Catalogues of the fourth century A.D. list 'Temple of Antoninus and the spiral column 175 feet high, 203 steps inside, 56 windows.' The column must have been complete in 193 A.D. when its official custodian, a freedman by the name of Adrastus, achieved immortality because his petition to build a guardhouse behind the column and three official endorsements, all dated, happen to survive in an inscription.

Named officially *columna centenaria Divorum Marci et Faustinae*, the monument of Luna marble must have included the bronze statue (or statues, if Faustina Junior, wife of Marcus, was shown) and perhaps the leveling course of travertine in the total height of 175 Roman ft. (51.95 m.). The column proper measured 100 Roman ft.

(29.6 m.). It rose on a pedestal which is now two-thirds hidden below the level of the Piazza. Drastic changes to the pedestal were made by Domenico Fontana when in 1589 he repaired the column for Pope Sixtus V, who 'having expurgated this column of all impiety' installed a statue of St. Paul on top.

Rome, Piazza Colonna. Modern level almost 9 ft. (2.65 m.) above threshold of entrance into pedestal from west. Oak-leaf torus base, Doric egg-and-dart capital. Internal spiral staircase. Ancient and Renaissance repairs, also in reliefs. Twenty-one relief 'windings.' 180–193 A.D.

E. Petersen, A. von Domaszowski, G. Calderini, *Die Marcussäule*, 1896. S. B. Platner, T. Ashby, pp. 132 f. G. Caprino, A. M. Colini, G. Gatti, M. Palottino, *La colonna di Marco Aurelio*, 1955, literature, topography, history, art, restorations. G. Becatti, *Colonna di Marco Aurelio*, 1957. E. Nash, 2, p. 276, figs. 327–328.

123 Anguish and Agony. Detail of 124

'Beat, club, drag, burn, kill!' This is the sermon of the Marcus column. The disciplined technology and superior coordination of the legions which Trajan extolled is here transformed into mobs running amuck when they give battle.

That this, too, is art, that there is in the reliefs of the Marcus column a power of expressive, aggressive emotions whipped up to a point where raw experience breaks into the traditional forms of Roman narration, was first recognized and documented visually by M. Wegner in a remarkable study published in 1931. A generation which had lived through the First World War and saw its own traditional art break down was receptive to the messages of the sculptors who had to rid themselves of the horrors they had felt.

It is possible that these sculptors had traveled with the army. What makes their work remarkable is that they feel the anguish and suffering of the enemy as keenly as if they were going through it. These barbarians are not the wild but noble savages of Hellenistic art; they are human beings going through a crushing, degrading, disastrous experience and responding with outbursts of emotion *de profundis*.

Of such figures none is more terrifying than that of a barbarian twisting in an agony of panic as he sees his comrades put to the sword.

Detail of Fig. 124. M. Wegner, *JdI* 46 (1931), p. 147, fig. 40.

124 Execution of Rebels. Detail of 122

Germans are executing Germans while the Roman cavalry rides watch in the background. Two contorted corpses, two frowning heads lie on the ground. The executioner swings his sword over the next victim. Three others await their fate, arms tied in the back. Who is friend, who is foe? German bodyguards protect the Roman emperor. And heads roll before the stoic eyes of the 'Philosopher on the Throne.'

Over the reliefs of the column of Trajan there is still cast the last glow of the heroic spirit of Greek battles—and the objective assurance which a confident empire can afford. In the column of Marcus Aurelius war is hell. The grim brutality of a scarred and terrified nation comes to the fore; and whether the artists meant it or not, their work is a scathing commentary on man's inhumanity to man.

The style is disjointed, dramatic; figures with faces of demons emerge out of darkness. Whether these artists rose up from 'folk art' or not, this is a totally different aspect of Roman art from the heavy stateliness of the triumphal reliefs celebrating the conclusion of the same war, made but a few years earlier (Fig. 118).

After the end of the first campaign Marcus Aurelius was on his way home (173 A.D.) when under a new king one part of the German Quadi rose in rebellion. They were overpowered by those who kept faith with Rome and, as the scene indicates, were surrendered to the Romans and executed by their own people.

The figures on the right belong to the next scene in which some Germans beg the emperor for mercy.

E. Petersen, scenes LXI and LXII. Part of the 'Second War,' 173–175 A.D.
W. Zwikker, *Studien zur Marcussäule*, 1941, pp. 258 f., on the historical events. C. Caprino, pp. 102 f., pl. 38.

125 The Rain Miracle. Detail of 122

The Age of Miracles begins here. Christian soldiers claimed that their God brought about the tremendous thunderstorm and flash floods which saved the Roman army fighting the Quadi in Moravia. The sculptor was assuredly not a Christian but neither did he attribute the miracle to Rome's traditional Thundering Jupiter. The winged rain spirit floats in sheets of rain. His outspread arms are Michelangelesque in power, his head resembles that of a Byzantine Pantocrator, his body engulfs an entire army of marching Romans as well as barbarians and horses dying in the mountain torrents.

The beginning of the scene, not visible here, shows the Romans marching from camp, praying for rain; then protecting themselves with their shields against the downpour. Grapes of wrath—the Romans fierce, pushing forward in a heap, the barbarians pathetically broken.

The scene has provoked great controversies because of the contradictory dates in literary sources and because of the Christian claims to the miracle. On the evidence of the column the miracle must have taken place in 172 or 173 A.D. during the 'German War' shown in the first half of the narrative.

Height of frieze 50 1/2 to 52 1/2 inches, (130–135 cm.)
Petersen, scene XVI.
E. Strong, *La scultura romana*, 1926, pp. 270 f., fig. 171. *CAH* V, pl. 106a, and text volume XI, pp. 795 ff. P. G. Hamberg, pp. 107, 152 ff. C. Caprino, pp. 88f ., pl. 12, with literature, and M. Pallottino pp. 52, 54 f. on the 'Master of the Rain Miracle.' E. Renan, *Marc Aurèle*, 1882, pp. 273 ff.

126 Panorama of War

In the year 203 A.D. the great triple arch was dedicated in honor of the Emperor Septimius Severus and his sons Caracalla and Geta at the northwestern end of the Roman Forum.

The detail at the northern gate of the side toward the Capitolium shows the composite columns with composite pilasters, the profiled vault with an allegorical figure on the bracket, two river gods reclining against a rough landscape background, and within the vaulted entrance an inner gate communicating with the main passage.

Deeply recessed and framed, the triumphal frieze depicts three carts with booty, then Roman soldiers forcing barbarians to do obeisance to the goddess Roma at the right. It is the sequel to the large picture divided by a 'ground line' into two scenes. In the lower scene, a river comes from the left streaming into two 'boxes,' perhaps water reservoirs of the city which appears in the center. Its city wall of masonry is provided with towers; tall buildings, two and three stories high are seen inside

where the defenders throng. On slanting ground lines two (left) and four (right) horsemen flee from the city and, at lower left, defenders on foot withdraw. On the lower right, Roman soldiers (chain mail cuirasses) prepare for the assault in the shelter of a fort.

In the upper picture, the same city with the same attached 'boxes' surrenders. Severus (headless) stands on the right flanked by two companions, his retinue rising like a wall behind him; one group of Roman soldiers is at his feet, another in the opposite corner. The surrendering barbarians are in the center. On the upper left Romans enter the city; the building within now appears more clearly as a fortified palace with vaulted gate and towers. The spotted background signifies rocks. The campaign shown is probably that of 198 A.D. against the Parthians and the city may be Seleucia on the Tigris, or Babylon. The narrative panoramic panels are new in the decoration of triumphal arches.

The division by 'ground lines' and the 'explanatory' views of the city from above have been elaborated beyond the column of Marcus Aurelius. In its large format, inclusion of two successive events, explanatory portrayal of mass actions, the panel may be directly inspired by triumphal paintings of the wars of Severus in Mesopotamia. The style derives from the tradition of the column of Marcus but the figures are squatter and sketchier.

Rome, Forum (cf. plan, Fig. 1, northwest gate). Pentelic marble. Height of panel 29 ft. 2 inches (8.78 m.). Inscription: *CIL* VI:1033.
For the contemporary arch at Lepcis cf. Fig. 127; Severus and family, Pl. XLVIII, figs. 56, 82.
E. Strong, *La Scultura romana* 2, 1926, pp. 301 ff. S. B. Platner, T. Ashby, pp. 43 f. G. M. A. Hanfmann, pp. 174, 217 f. P. G. Hamberg, pp. 145–149, pls. 28–30. M. R. Scherer, pp. 69 f., pls. 11, 33, 55, 100–102, 108, 111 f., 116.
* E. Nash, 1, p. 126, figs. 133–139.

127 A Triumph of Severus

Septimius Severus, a native of Lepcis Magna in North Africa (Tripolitania), personally conducted a campaign in 203 A.D. to make the city safe from the attacks of African desert tribes. His success was celebrated by a great tetrapylon, a triumphal arch with four gates liberally decorated on the internal and external faces. The detail shown is from one of the four very long exterior friezes;

two of them described the triumph, two the unity of the imperial family and the divine protection they enjoyed.

The chariot panel is perhaps the most remarkable. A system of vertical accents emerges; the background reasserts the stone. The frontal display of the figures on the chariot, the flattened horses, the closed frontal phalanx of spectators in military dress above the horses, the 'zoning' of horsemen in two tiers—all these are first signs of the break between classical and 'late antique' abstract style. Bodies of horses are stonier, the folds of garments become slashing accents of shadows rather than molded hollows.

Standing in the center the emperor steers the team, his head crowned with laurel, ribbons streaming behind; triumphantly his sons push against their father, Caracalla on the right, Geta on the left. The artist has tried to vary the arrangements of togas and the positions of the hands —Caracalla grasps a fold, Geta veils the right arm. Geta's face is chopped off; his memory was officially condemned after Caracalla had murdered him.

The chariot is shown in a peculiar view, part profile and part head-on. Its reliefs, to be envisaged in bronze, show a victory with wreath and palm branch flying toward three local gods; Liber (God of Wine) and the city goddess of Lepcis about to be crowned by Hercules. There is some fine flat work on the horses' 'breast-belts,' another new trend.

The artist has subtly shifted the traditional imagery; the triumphant emperor no longer goes to Rome and Jupiter on the Capitol. He is at once the general and Jupiter, and presumably the procession shown took place in Lepcis itself.

Lepcis Magna Hybia. Height 5 ft. 6 in. (1.72 m.). Nearly 25 ft. (7.20 m.) of this frieze panel are preserved. Marble. Attributed by J. B. Ward-Perkins and others to a workshop of sculptors from Asia Minor (Aphrodisias). 203 A.D.
R. Bartoccini, *Africa Italiana* 4, 1931, pp. 32–152, fig. 73. P. Townsend, *AJA* 42, 1938, pp. 512–524. J. B. Ward-Perkins *JRS* 38, 1948, pp. 72–80. I. S. Ryberg, pp. 134–136, 160 f., figs. 73 A-B, 88–89. *

128 Escapism under the Severi

It is a far cry from the icon-like imagery of the imperial triumph to the classicistic imagery of the triumphant Bacchus, from the woodcut rigidity of carving at Lepcis

to a caressing *morbidezza* of Sèvres and Meissen polish in the tub-shaped Season sarcophagus made in Rome. We are in a different world, a world where the private individual strives to insure his immortality in a sphere which combines the ideality of traditional mythology with a cosmic framework suggestive of continuity in the life of nature.

The luxurious marble casket in New York develops the figure-packed designs of late Antonine art (Fig. 121) but seeks to combine with it something of the sense of the abstract order which we saw emphasized by the vertical arrangement of figures on the arch of Lepcis. Bacchus on the tiger and the flanking pairs of Seasons are much larger in scale and more strongly stressed by light, while small groups of seasonal animals and *amorini* mill around in the semi-darkness of the deep curving space. Whether the dead person was an initiate into the Bacchic mysteries, whether he identified himself with the god Liber who brings liberation and bliss we cannot say.

The tenor of the work is sensuous and sentimental, untouched by the brutality of Severan times. It is an art of escape.

New York, Metropolitan Museum of Art 55.11.5. From Collections of Cardinal Alberoni (1664–1752) Rome, and Duke of Beaufort, Badminton House. Greek marble. Height 3 ft. (0.90 m.), length, top 7 ft. 4 inches (2.205 m.), width, top 3 ft. 1 1/5 inches (0.93 m.). Ca. 220 A.D.

C. C. Vermeule, *AJA* 59, 1955, p. 130, pl. 41:1, 60, 1956, pp. 323. F. Matz, esp. pp. 1–13, 141 ff., pls. A-H and 1. G. M. A. Hanfmann, *Gnomon* 31, 1959, pp. 533–539. K. Schefold, *RA* 1961, II, pp. 206–208.

129 A Mixed Metaphor. Detail of Fig.128

'Give to the earth the fruit so that the earth may give it back'; 'Happy times (Seasons) closed the period of your life.' 'Do you not see the year assuming four aspects in imitation of your lifetime?' 'May Spring contribute flowers… Summer adorn thee with wheat… Autumn will always bring presents of Bacchus..' These and other sentiments dwell on Seasons as symbols of the eternal cycle of life, as bringers of pleasant things to the grave, or as companions of the fruit-bearing god Bacchus. On the New York sarcophagus the imagery continues around the casket with Ocean (seen in this picture) and Earth (on the other side). A *putto* crowned with

flowers, clad in the panther skin of Bacchic satyrs, brings a young kid and a milk bowl, symbols of spring, two small *amorini* carry a horn of plenty, and a winged *putto* with a pine branch and basket of olives, proper to winter, concludes the assembly.

Are all of them companions of Dionysus; is this a never-never land of bliss when all seasons bring good things at all times; or is this 'the great cosmos' of other funerary inscriptions in which Ocean and Earth symbolize the entire world?

Much can be said about the earlier works of art from which the designer copied his motifs but he seems to have wished to pile up images suggesting a pleasant and relaxed ambient even if their meanings did not fit any unified explanation.

The detail shows the gleaming white carving of extreme dexterity, soft in detail, hardening in over-all conjunction of the various parts of the body.

Detail of right end of the sarcophagus shown in Fig. 128. Height 3 ft. (0.90 m.). Ca. 220 A.D.

F. Matz, pp. 10 f., 138 f., pl. C. On the combination and meaning of the different themes, G. M. A. Hanfmann, 1 pp. 185 ff. and 2, pp. 17–20, Ocean and Earth.

130 Hunt—Heroic or Oriental

Iconium is known from the Acts of the Apostles (13–14) and as Konya for the flowering of Seljuk arts. It became a Roman colony under Hadrian. It is proof of the technical and artistic capabilities of the Roman empire that a workshop producing huge marble caskets flourished in this remote region during the third century A.D. Granting that sculptors often went to execute the order on the spot, even the local transport of these giants was no mean achievement. Rough bosses for lifting, one seen in this picture, others in Fig. 131, show how this was done.

The sarcophagus from the ancient city of Sidamara has given its name to a group distinguished by their emphasis on tall elongated figures, and by reduction of architecture the details of which are submerged in coloristic dissolution. On the front, Dioscuri flank a seated sage (the deceased), and Artemis and Hera, mythological disguises for wife and daughter. Husband and wife appear again in life size, reclining on the couch-shaped lid. On the back five mounted hunters rise in dance-like symmetry over

their prey; and this scene is carried around the corner to the right end shown here. Arching high, the muscular hunter and slender horse pursue a stag which sails away through the air. Below, a dog fells another stag. High on a piece of rock is another dog. A wilderness of drilled foliage surrounds the arched shells above. The frieze on the foot end of the couch shows *amorini* fighting bears and lions; the frieze on the pedestal, a starting gate and racing chariots. The Roman horseman (Fig. 134) enmeshed in the wild melee of battle contrasts with the Sidamara sculptor's strongly plastic figures clearly outlined against the deep, dark space. Some compositional details such as the positioning of animals in the air and the coloristic treatment of ornament owe a debt to Persian art; but in the figure of the huntsman there flashes up the spirit of the heroes of Hellenistic hunts, of Alexander and his successors.

Istanbul, Archaeological Museum, Mendel no. 112. From Ambar Arasï (Sidamara), Vilayet Konya. Marble. Height 10 ft. 5 inches (3.135 m.). Length 12 ft. 8 2/5 inches (3.81 m.), Width 6 ft. 5 inches (1.93 m.). Right end with lid. 240–250 A.D.

T. Reinach, *Mon. Piot* 9, 1902, pp. 189–228, pls. 17–19. C. R. Morey, *Sardis* V : 1, 1924, pp. 40–43, figs. 65–67. *CAH*, V, pl. 192b. M. Schede, *Meisterwerke der Türkischen Museen* 1, 1928, pp. 19–20, pl. 38–41. G. Rodenwaldt, *JHS* 53, 1933, pp. 181 ft.

131 Eternal House, Eternal Sleep—An 'Asiatic' Sarcophagus

'Roman' sarcophagi—made in Rome and Italy—are primarily 'picture carriers,' intended to be seen from three sides, their back placed against the wall. The 'Asiatic' sarcophagi made by workshops active in western Asia Minor are clearly intended to be free-standing structures to be seen from all four sides, 'eternal dwellings' but not ordinary houses. In these colonnaded palaces the dead well in the company of statuesque gods and heroes. Somewhat illogically, the dead are also asleep on rich beds of ivory and silver which are imitated in the lids of the caskets.

The sarcophagus of Melfi is one of the earliest known examples of this rich type. The architecture includes prouse, drilled ornament, spirally fluted columns, projecting and receding entablatures, arcades, triangular pediments and shell-shaped half-domes, dolphins, and animal acroteria; the style derives from the ornate and picturesque façades which developed during the second century A.D. in the eastern provinces of the Roman empire.

At the head end, a door with reliefs of two mourning cupids and two worshipping cupids opens into the tomb. A statuesque woman and a heroic man (Hermes?) flank the door.

On the front are a seated Apollo, a warrior, a goddess, perhaps Kore, a youthful god with flowing hair, a seated majestic god (Hades); a sword hangs next to him. Among the figures on the back is Aphrodite and at the foot end are Odysseus, Helen, and Diomede. All follow famous Greek statuary types.

On the lid, the lady sleeps peacefully; another cupid, his torch down, mourns the breaking of the love that united the woman, as beautiful as Aphrodite and Helen, and her husband. A little dog, now lost, lay at her feet.

The finely turned couch displays horse heads at the foot rest, vines in the ornamental stripes of the mattress and a frieze of sea monsters and griffins runs along the side.

This aesthetic, literary, consciously Hellenic mood expresses the attitude of the leading families of the Greek cities of Asia Minor who fostered pride in Greek culture and in the legendary past of their cities.

Melfi, Palazzo Pubblico. Marble. Height with lid 5½ ft. (1.66 m.). Width 4 ft. 1½ inches (1.24 m.). From a brick mausoleum at Via Appia, Melfi, 9 miles (13 km.) from Venosa. 170 A.D.

R. Delbrueck, *JdI* 28, 1913, pp. 278–308, figs. 2–8, pl. 23 and *Antike Denkmäler* III:2, 1912–1913, pls. 22–24. C. R. Morey, *Sardis* V:I, 1924, pp. 34–35, figs. 39–41. G. Rodenwaldt, pls. 661 f. *CAH*, *V*, pl. 116b and text vol. XI, p. 801.

132 A Christian Martyrdom

Among the outstanding accomplishments of archaeology in the thirties of this century was the reconstruction by Margarete Gütschow of a number of marble sarcophagi and marble slabs found in the Christian catacomb of Praetextatus. None of these has excited more interest and

controversy than the fragmentary marble slab used to close a burial niche in the wall *(loculus)*.

A fragment to the right of the scene shown here displays an incomplete inscription; another the unfinished portrait bust of a woman. The inscription states that Aelia Afanasia (A-thanasios—'immortal') put up the sarcophagus 'lest my domestics Elpidius Nidus Ruf(us?)...' and then breaks off.

The style with the globular heads, dotted drill, primitive but lively action is well known from the work of the cheap, mass production, 'popular' workshops in the second half of the third century A.D. But the subject shown is unique. In all pagan sarcophagi the dead is magnified and immortalized by association with the world of myth or extolled for his heroic, intellectual, or domestic virtues. Here, a woman, bound hand and foot, undergoes humiliating punishment. She is being whipped by a masked hangman and may yet be tortured by burning with candles which two older men bring from the left. The presence of a standard of state *(vexillum)* held by a man on the right may have signified that Aelia Afanasia is being punished by the state.

Other explanations have been tried (ritual flagellation in a pagan cult), but only one creed extolled torture and humiliation as the glorious attainment of victory and life everlasting, Christianity in the time of the persecutions. Humble as the art may be, it is astonishingly bold in its defiance of traditional Roman ideals—and its naïve liveliness expresses emotions and beliefs which were to transform the Roman world and its art.

Rome, Museum of the Catacomb of Praetextatus. Greek island marble with traces of paint. Height 15 1/5 inches (0.38 m.). Martyrdom may have occurred under Valerian, 258 A.D. Date of relief 270–280 A.D.

M. Gütschow, *Atti Pontif. Accademia Romana di Archeologia*, Serie III, *Memorie* IV:2, 1938, pp. 181–187, and H. Fuhrmann, pp. 187–207, with interpretation of individual figures as participants in punishment by whipping often inflicted by Roman magistrates. G. M. A. Hanfmann, p. * 44, no. 86.

I33 School in the Rhineland

How Roman art spread into western Europe and what effects it had upon the arts of the indigenous population is a fascinating and complex subject of great importance for the history of medieval art. We have seen Trier in its proudest hour as a rival of Rome in architecture (Fig. 34); but even earlier, in the second and third centuries A.D., Trier was a major center of one of the regional schools of sculpture which arose as the local aristocracy and its tastes entered into the Roman pattern of urban living.

Preserved by chance in the foundations of a Constantinian fortress of Neumagen *(Noviomagus)*, these reliefs from funerary monuments owe their basic language to Roman art; but the spirit and the style are sufficiently distinctive to make this an art *sui generis*. A delightful directness and informality pervade the school scene. In the absence of detailed Roman models the artist had to fall back on what he saw. The figures are large and soft, the garments heavy, the eyes and gestures expressive in an unclassical way, even though the teacher is ultimately a descendant of dramatic Hellenistic philosophers. A real schoolboy, not a disguised cupid, comes in with his schoolbook of wax tablets in his hand and salutes awkwardly. The schoolteacher looks up; he seems angry. The two industrious boys exchange glances behind their big scrolls. The sculptor is interested in the high-backed chairs and the carefully laced shoes. The soft nature of the stone, different from ennobling marble, helps to achieve the feeling of homespun, unposed intimacy.

Trier, Rheinisches Landesmuseum, inv. 9921. Fragment from the right side of a funerary monument from Neumagen. Sandstone with traces of white underpaint. Length ca. 6 ft. 5 inches (1.93 m.). Height 2 ft. (0.60 m.). Late second century A.D.

W. von Massow, *Die Grabmäler von Neumagen*, 1932, pp. 132 ff., no. 180, pl. 27, figs. 86 f., with partial reconstruction of the pillar-like monument. It included, in superimposed friezes, other scenes from the life on a country estate. G. Rodenwaldt, pl. 623, *CAH* V, pl. 122 and text vol. X, p. 805. H. Schoppa, p. 54, pl 70.

I34–I35 The Battle Sarcophagus 'Ludovisi'

One of the strangest and most spectacular of all Roman sarcophagi is the 'battle sarcophagus' which had been in the Ludovisi Collection since 1621. It was found outside Porta San Lorenzo, Rome, and hence must have held the mortal remains of an emperor or general who was buried in Rome. The marble lid which originally covered the casket wandered off from the Ludovisi Collection and is in the Museum at Mainz.

The Roman commander is shown in such a way that his head appears exactly at top center. A snake rises behind his head. His identity has been much debated and the mystery is heightened by an oblique cross (X) incised on his forehead. This may be a 'seal' of the Persian god Mithras much worshipped in the Roman army. The owner of the sarcophagus has been variously identified as the praetorian prefect C. Furius Timesitheus (died 243 A.D.), the Emperors Hostilianus (died 251 A.D.), Volusianus (died 253 A.D.), and Claudius II Gothicus (died 70 A.D.). There is no agreement about the battle shown; expressive as they are, these long-maned trouser-clad barbarians have been viewed as Oriental Persians or Occidental Germans. Their inroads from east and west shook the empire simultaneously. Perhaps the general is envisaged as triumphant against all barbarians at all times.

At first the eye takes in only a confused welter of heaving heads, limbs and garments, a restless, unquiet pattern of diffused lights and shadows which leaves our an inch of the background exposed. The gilding of many details originally added to the play of light. As the effort to 'read' the scenes is made, one picks out types made familiar on the imperial columns and earlier battle sarcophagi—the victorious horsemen galloping in from one side, the tuba trumpeter (on the upper left), the mortally wounded warrior gliding from the collapsing horse. But all of these figures and groups give up their separate interest and existence. Neither the beautiful group nor the beautiful individual figure matters—and there are crying disproportions of size and of limbs. Most of the Romans have small heads with puffed-up cheeks. Exaggerated emotional effects are achieved by brutal undercutting of eyelids. The quality and technical competence of carving is fantastic, carrying off triumphantly the innumerable overlaps and undercuttings. There is a certain classicism; the figures are still plastic, not flattened; and the mighty barbarian seen from the back strides and swings with the vigor of an Hellenistic statue. There is much precision of detail—the chain mail cuirass of the *signifer* on the right, the distinctive helmets of lions and griffins denoting a special officers' guard, 'the protectors.' The truly original contribution of the master lies in the tortured heads of the barbarians, punctuating the composition in the lower part of the relief, a region of the damned from which there rises a roar of rage and pain. By contrast with these emotionally charged enemies, the would-be calm Roman victors appear vacuous.

The head of the emperor—very different in style—was carved by a portrait specialist.

Rome, Museo Nazionale delle Terme 330 (8574). Found in 1621 in Vigna Bernusconi outside Porta San Lorenzo and purchased by Cardinal Ludovisi. Italian marble. Traces of gold and purple (violet) underpaint for hair, beards, horses' manes, armor, horse trappings. Continuation of battle scene and trophies on the ends. Height 5 ft. (1.53 m.). Length ca. 9 ft. (2.73 m.). Width ca. 4 ft. (1.37 m.). Fig. 135; height of head 6 inches (0.15 m.). After 250 A.D.

T. Schreiber, *Die antiken Bildwerke der Villa Ludovisi*, 1880, pp. 189–94, no. 186. G. Rodenwaldt, *Antike Denkmäler* IV: 3, 4, 1929, pp. 61 ff., pl. 41, figs. 1–18. *CAH* V, pl. 188, text vol. X, p. 553. P. G. Hamberg, *Studies*, pp. 181 ff., pl. 41. S. Aurigemma, *The Baths of Diocletian*, 3rd ed. 1955, pp. 28 ff, no. 330. B. Andreae, *Untersuchungen zu den römischen Schlachtsarkophagen*, p. 16. H. von Heintze, *Röm. Mitt.* 64, 1957, pp. 69–91 with detailed literature. The lid: F. von Duhn, *Mainzer Zeitschrift* 12, 1917, pp. 1 ff., pl. 1. G. Rodenwaldt, *op. cit.*, figs. 1, 16–18. Details: G. Rodenwaldt, *Die Kunst der Antike*, pl. 621. *

136 Head of a Boy. Detail of 137

This detail shows the striking difference of technique in treating the portrait; shallowly incised, lancet-like hair on the head of the boy, instead of the majestic beards and ample, drilled locks of the by-standers. The turn of the head and expression resemble the head of the philosopher on a famous sarcophagus in the Lateran.

Detail of Fig. 137. Height of head 7½ inches (0.19 m.). R. Bianchi-Bandinelli, *loc. cit.*, Gordian III (238–244 A.D.). C. C. Vermeule, *loc. cit.*, fig. 35, Hostilianus or Saloninus (died 259 A.D.). For the Lateran sarcophagus cf. *CAH* V, pl. 200 and G. Rodenwaldt in text vol. XII, p. 557, tentatively suggesting the great Neoplatonist, Plotinus, himself as the person represented, and Vermeule, fig. 39.

137 Statesmen or Philosophers

Mousikos anér, a man of the Muses, began to dominate the imagery of Roman sarcophagi beginning with the reign of Gallienus (Fig. 89). Seeking a reality purer and more intellectual than that offered by traditional mythology, many educated pagans comforted themselves with the vision of an afterlife in which they might be united with

the great philosophers who had cultivated the undying truths of the mind. Others, even without the hope of an afterlife, wanted to be remembered as devotees of poetry, philosophy, and culture. Next to routinely produced sarcophagi with philosophers and Muses, some specially ordered luxury caskets present traditional scenes of Roman life such as the handshake at marriage in the midst of stately figures whose tenor and aspect is 'philosophic,' even though the traditional garment of state may, as in this case, define them as senators or other official personages.

Being so clearly a product of the highest skill available in Rome, the sarcophagus from Acilia has attracted much speculation concerning the identity of the boy (Fig. 136), presumably the son of the couple who appeared in the center of the composition. If the bundle of scrolls at his left belongs to him, these scrolls characterize him as *anér mousikos*, one given to things of the mind. The style with the portrait-like heads and conscientiously magnificent Roman garments is very like that of a famous philosopher sarcophagus in the Lateran which has been thought to represent one of the Neoplatonists close to Gallienus. Such nearly individual efforts at classicism were still possible in Rome at the time of crisis. The desire to achieve a convincing representation of intensive thought and spiritual dignity was genuine; and the images of these bearded, dignified thinkers were remembered long enough to provide the visual mold for the portrayal of prophets and apostles.

Rome, Museo Nazionale delle Terme 126.372. Sarcophagus from Acilia. Marble, much missing. Height ca. 5 ft. (1.49 m.). 260–270 A.D.

R. Bianchi-Bandinelli, *Bd'A* 34 (1954) pp. 200–220. S. Aurigemma, *The Baths of Diocletian*, 3rd ed., 1955, pp. 128 f., no. 330 pls. 81 f. C. C. Vermeule, pp. 16 f., figs. 34–36, with account of other dates and identifications, dates 270–280 A.D. On philosophic immortality, H. Marrou, *Mousikos Anér*, 1937. G. M. A. Hanfmann, 'Socrates * and Christ' *HSCP* 60 (1951), pp. 218 f.

I 38 The Gay Helmsman

Who would not be gay when transporting good Moselle wine over the Moselle? Obviously it is pride in the product that has driven the sculptors—or their patrons—to show the best produce of their estate over their graves.

Then, also, the journey into the thereafter is often show as a journey by boat and perhaps the wine-lovers hope the journey might turn out to be one of familiar gaiet

Such glorification of trades and crafts was not un known in Roman art. The baker Eurysaces built a pyr mid and showed his entire bakery in a frieze and in P tronius' *Satyricon* 71, the new-rich, Trimalchio wants have ships and large jars of wine shown on his tomb— but nothing as adventurous artistically has survived Rome as the pyramid of wine kegs flanked by two ship laden with more wine kegs.

One might discern a slight hesitation in the school sce (Fig. 133), as if the artist was not quite sure of h ground. But when it came to wine and bibulous types, Moselle sculptor knew no hesitation. With a master use of light and shade he has sketched, rather than carve the twinkling eye, the grin which just begins to sprea over the full-cheeked, bearded countenance with bulbo nose, the face of one who knows how to make merry. puts his ear to the wine keg and with eager anticipatio listens to the wine gurgling. The head is unmistakab Germanic in appearance and Falstaffian in spirit.

Trier, Rheinisches Landesmuseum, inv. 768. Funera monument from Neumagen. Head of the helmsman on t inner side of the incomplete ship. Sandstone. Heig 7 3/5 inches (0.19 m.). Early third century A.D.

W. von Massow, *Die Grabmäler von Neumagen*, 1932, p 203 ff., no. 287b, figs. 128, 130 reconstruction of top funerary monument, pl. 55. G. Rodenwaldt, pl. 625. Schoppa, p. 54, pl. 75. M. Pobé, J. Roubier, p. 73, pl. 2

I 39 Christus Regnat

'Junius Bassus, *Vir Clarissimus*, lived 42 years and months; during his tenure as Prefect to the City as neophyte he went to God on the 24th of August, in t Consulate of Eusebius and Hypatius' (359 A.D.). So words of this remarkable inscription appear in t picture: (PRAEF)ECTVRA VRBI NEOFITVS IIT A DEVM. Its date makes the sarcophagus a milestone the history of early Christian art.

Born in 317 A.D. Junius Bassus was *praefectus urbis*, highest position in Rome after the emperor. Althou like Constantine he was baptized only on his deathb the elaborate, essentially Christian sarcophagus sho that he had prepared himself to die a Christian. Set in t

stories within the heavily ornate palatial architecture are scenes from the Old and New Testament: Daniel, the Martyrdom of St. Paul in the lower story; Abraham and Isaac, the Arrest of St. Peter, Christ giving the Law to two Apostles (shown here), Christ brought to Pilate, Christ before Pilate. Entirely traditional scenes of seasonal *putti* are shown on the ends of the sarcophagus.

The sumptuous architectural framework heightens the concept realized in the 'Asiatic' sarcophagi (Fig. 131). It reflects contemporary palatial buildings such as were going up in 'New Rome,' Constantinople. During this early phase of the new capital, court sculptors may well have traveled back and forth between the metropolis of the east and that of the west.

A new style, softer than that under Constantine and consciously beautiful diffuses its charm over the sculpture. This style developed in Italy and Asia Minor but is flowering in the so-called Theodosian Renaissance took place in Constantinople.

Christ is an emperor more exalted than any earthly ruler. The sky, who held a protective cloak over the empire of Augustus (Fig. 50) is under the feet of the Lord. Jesus is still a beautiful youth as on the Christ-Peter sarcophagus (Fig. 142), but mightier and more determined. His right hand was extended in blessing, with his left he gives the New Law which will save mankind.

Vatican, Crypt of St. Peter. Found 1595 in the Confessio of Old St. Peter's. Marble. Height of sarcophagus 3 ft. 11 inches (1.17 m.). Length 8 ft. (2.41 m.). Height of detail shown 18 3/4 inches (0.475 m.). Right hand of Christ restored. The remarkable vine spirals on the columns contain quite pagan *putti* and satyrs. Christian symbols are represented by lambs in the spandrels.
F. Gerke, *Der Sarkophag des Junius Bassus*, 1936. C. R. Morey, *Early Christian Art*, 1942, pp. 134 f., 271, fig. 141. W. Lowrie, *Art in the Early Church*, 1947, pp. 88–90, pl. 28. W. F. Volbach, M. Hirmer, pp. 22, 320, pls. 41–43.

40 The Arch of Constantine

The last great triumphal arch preserved in Rome stands on the border between the pagan and Christian Roman empire. Henceforth triumphal arches were erected in the interior of churches, not on the 'Sacred Way' leading to Jupiter on the Capitolium.

As an architectural monument, the Arch of Constantine is worthy of the age which built the Basilica of Constantine (Figs. 32, 33). Copied in all major features after the great triple Arch of Septimius Severus in the Forum (Fig. 2), the Arch of Constantine rises with even greater effect in its open location. The lower part is carefully proportioned; the two lateral arches reach exactly to the line whence the central arch springs. The result is a triadic stepped arcade. The motion of the semicircular arches is picked up by the circular medallions above the frieze. The vertical effect of the four detached columns is echoed in the pilasters of the façade and continued in the upper story, the attic, by the plain piers and the pedestals with the statues of barbarians. The effect of the over-all design is, however, impaired by the restless motion of sculptures which overload the two lateral parts of the façade.

The inscription states that the Roman Senate and the Roman People have vowed this arch 'famed by triumphs' to Constantine who 'by divine inspiration and greatness of mind revenged the Republic and (liberated it) at once from the tyrant and his entire faction.'

The Senate, conservative and pagan, knew that Constantine ascribed his victory over Maxentius to the Vision of the Cross which had appeared to Constantine before the battle. It was not yet known how far the emperor would go in supporting Christianity. Making haste, the Senate ordered only units of sculpture traditionally indispensable to a new triumph—victories and barbarians on column pedestals; the river gods, victories, and seasons in the spandrels; the cosmic powers of Sun and Moon in medallions on the short sides. The real cause of the triumph, the battles and benefactions of Constantine were portrayed in a small inconspicuous frieze. Instead, Constantine was offered a sermon in stone—be like the 'model emperors,' Trajan, Hadrian, and Marcus Aurelius! From Trajan's monuments come two reliefs in the central passage, two at the ends of the attic, and the statues of barbarians, from Hadrian's, the eight medallions on the façades, and from those of Marcus Aurelius, the relief panels on the long sides of attic. Hadrian's medallions include sacrifices to pagan gods.

Rome, Arch of Constantine, north façade. White marble, yellow marble for columns, brickwork in attic, porphyry around medallions and in main cornice. Height 70 ft. (21 m.). Length 85 2/3 ft. (25.7 m.). Width almost 15 ft.

(7.4 m.). Heads of barbarians and heads of emperors in the Aurelian reliefs of the attic restored and replaced in 1732. Arch dedicated 312 A.D., completed by 315 A.D. (inscriptions in side arches refer to tenth anniversary of Constantine).

S. B. Platner, T. Ashby, pp. 36–38, older literature. H. P. L'Orange and A. von Gerkan, *Der spätantike Bildschmuck des Konstantinsbogens*, 1939. M. R. Scherer, p. 76, color plate, pls. 19, 31, 53, 74, 79, 124–127, 132 (condition in later times). E. Nash, 1, p. 104, figs. 108–116, literature.

I4I The Imperial Bounty. Detail of Fig. 140

The small frieze with the deeds of Constantine is squeezed awkwardly between the large river gods in the spandrels and the nobly classicistic medallions from a hunting monument to Hadrian in which some of the heads are changed to represent Constantine and his co-ruler in the east, Licinius.

In the center Constantine, enthroned, his frontal, lofty position a symbol of the omnipotence of the emperor who though immovable yet generates all action. In the upper background, officials distribute and record the imperial bounty. The architecture with curtains in the background has been explained by some scholars as representing the interior of a basilica, the emperor enthroned on the tribunal, with the officials doing their work in the galleries of the second story. Others think of a portico in an imperial forum. The prosaic immediacy of the scenes is in the spirit of the 'folk art' of Trier, whence the sculptors might have come with the emperor. On the other hand, there is eloquence in the puppet-like figures of the people, throwing back their heads, stretching out urgent hands as they strive to catch coins which are shaken out of special coin containers.

These friezes, carved in a primitive 'woodcut style,' have been assailed as the lowest ebb of Roman art and praised as the revolutionary creation of late antique expressionism. Certain it is that the same sculptors made Christian sarcophagi with the drowning of the Egyptians in the Red Sea, the very deed celebrated by church fathers as the Biblical analogy to the drowning of the defeated host of Maxentius in the Tiber after Constantine won the Battle of the Milvian Bridge near Rome.

Arch of Constantine. North façade, relief of the imperial largesse (*congiarium, liberalitas*) over the right lateral arch.

Height of frieze ca. 40 inches (1.02 m.). Length 17½ ft. (5.38 m.).

A. Riegl, *Spätrömische Kunstindustrie*, reprint 1927, pp. 84ff., fig. 14. H. P. L'Orange, A. von Gerkan, *op. cit.*, pp. 90 ff., pl. 17, fig. 12. G. Rodenwaldt, *CAH*, text vol. XII, p. 566. C. R. Morey, *Early Christian Art*, 1942, p. 54 (negative judgment). E. Nash 1, p. 104, fig. 110, literature.

I42 Let Us Praise the Miracles of the Lord

Released from persecution and bondage, Christian art emerged under Constantine out of the secretive darkness of the catacombs to proclaim its triumph and to glorify the miracles of the Lord. This overflowing desire to tell the world in word and image of Christ's great deeds led in the very first stage to the densely packed representations of many scenes in friezes in which formal order is secondary.

Thus on the so-called Christ-Peter sarcophagi there appear in crowded array as in a procession the Fall of Man and Expulsion of Adam and Eve; Christ changing water into wine at the Marriage of Cana; the Healing of the Blind; the Resurrection of Lazarus (or Ezra's vision?) Christ Prophesying the Denial of Peter; the Healing of the Paralytic; Abraham preparing to sacrifice Isaac; Peter led by two soldiers (out of prison?); and Peter, again, like Moses, striking water from the rock to baptize two soldiers (?).

The themes of Fall—its counterpart, the Denial—and the miraculous power of the Lord are strongly emphasized, while the theme of salvation is implied allegorically in the miracles and in the book roll with the New Law held by Christ.

Christ is a beautiful 'Apollonian' youth. Peter, strongly characterized, resembles both Adam and Moses, to whom he is linked theologically—by his fall to one and by his leadership to the other. There are resemblances of detail to the Arch of Constantine, such as the caps of the soldiers. The cutting, graphic rendering of folds now becomes an important stylistic feature. But despite the instability of stance caused perhaps by the novelty of subject and design, the style and proportions are much more classical. They suggest that Christians were now employing sculptors whose previous training was in the making of mythological sarcophagi. We witness here the first step toward a Christian classicism in sculpture,

event of momentous significance for a creed which on the basis of the Mosaic injunction against images might well have completely refused anthropomorphic art.

Rome, Lateran, Museo Christiano 135. Marble. Height 27½ inches. (.70 m.). Length 88½ inches (2.23 m.). Width, 25½ inches (.65 m.). 320–330 A.D.
C. R. Morey, *Early Christian Art*, 1942, pp. 56 f., 257 f., fig. 57, assumes that three scenes are from some apocryphal *Acts of St. Peter*, although two scenes on the right may equally well refer to the Denial and to Moses. G. M.
* A. Hanfmann, pp. 59, 67 ff., fig. 78. and no. 66, literature.

143 The First Angels

The sarcophagus of Junius Bassus enlarged the range of Christian themes. Its sculptors strove for a classic effect but the total composition seems crowded even though the fully rounded figures are carefully combined in groups of twos or threes. In the clear and simple design of the so-called 'Prince's Sarcophagus' the art of Constantinople reaches its first classical moment. Were it not for the monogram of Christ (I and X), one might doubt the Christian character of the casket which is, however, assured by the representation on the ends where two apostles stand at the sides of a cross.

The two angels on the front are victories Christianized; the Roman wreath of victory has become the Christian Crown of Life.

A monumental rhythmic quality reminiscent of late classical sculpture is conjoined to the lyricism of the 'soft style.' Technical tradition and the plastic sense of the Greek 'Asiatic' workshops live on in the carving. The surprising 'naturalism' of the ribbon flung out from the wreath calls to mind Hellenistic delicacies in the ornament of the Ara Pacis.

The art of Constantinople, forcibly brought into being by an imperial act, took time to mature. In the first century of its existence (ca. 330–430 A.D.) the few scattered examples of Constantinopolitan sculpture display a great variety of stylistic currents and artistic competence. Made for the child of someone close to the imperial court, this harmonious relief came as a revelation. As a spectacular achievement in the Christianization of classic art, it parallels the creation of a Christian philosophy and a Christian *paideia* in the realms of thought.

Istanbul, Archaeological Museum 4508. Discovered in 1933 at Sarigöl (Lycus Valley) with coins of Arcadius (395–408 A.D.). Asian marble. Height 18 3/4 inches (0.475 m.). Width 19¼ inches (0.49 m.). Length 4 ft. 5½ inches (1.36 m.). Intended for a child. Ca. 390–400 A.D.
A. M. Mansel, *Ein Prinzensarkophag aus Istanbul*, 1934. J. Kollwitz, *Oströmische Plastik der Theodosianischen Zeit*, 1941, p. 132, pls. 45, 47. J. Beckwith, *The Art of Constantinople*, 1961, pp. 20–23, pls. 23–26. D. T. Rice, M. Hirmer, *The Art of Byzantium*, 1959, p. 288, pl. 9. N. H. Baynes, H. St. L. B. Moss, *Byzantium*, 1961. pl. 35. *

144 The Cosmic Triumph of Cybele and Attis

Under the later Roman empire sculpture in marble began to decline in Italy and in most of the provinces of the empire. Portable objects of the luxury arts took the place of marble statues and reliefs. The masterpiece of Roman goldsmith work known as 'the Patera of Parabiago' had, in its last use, served as the cover of a funerary urn for a cremation burial in a Roman cemetery, though this was hardly its original purpose. Cast of almost pure silver with details of relief and rim gilded, this libation bowl *(patera)* may well have belonged to a highly placed priest of Cybele (cf. Fig. 92), for the late Roman aristocracy valiantly sought to allegorize Cybele and Attis in a Neoplatonic sense and to support their cult. Thus the Emperor Julian (361–363 A.D.) and his friend Sallustius extolled Cybele and Attis in their writings.

The Great Idaean Mother and Attis ride on a chariot drawn by roaring lions while three armed *Curetes* dance around them. Above, on smaller chariots, the Sun (horses) and the Moon (bulls) dash across the sky preceded by the morning and the evening stars. An athletic figure emerging from the ground holds the circle of the zodiac. Within it stands the god of Time (Aion) grasping the zodiac between the signs of Aries and Taurus to show the spring equinox. The snake winding around the obelisk is another symbol of eternal time. The Earth with cornucopia reclines below. Her two children point excitedly to the miraculous arrival of Cybele and Attis. A snake eats grapes out of the horn of plenty while a cricket and a lizard are signs that the warm season has come. Four Seasons run across a meadow toward Earth whose figure is counterbalanced by two water gods; at the very bot-

125

tom, Ocean and Thetis emerge from a sea indicated by thin lines and fishes. The composition may allude to festivals of Cybele and Attis which took place close to the spring equinox.

Milan, Brera. Found at Parabiago near Milan. Silver, cast, chased, gilded. Diameter 15 3/5 inches (0.39 m.). Weight almost 8 lbs. (3.555 kg.). The dates proposed range from the late second to the late fourth century A.D. 360–390 A.D.

A. Levi, *La patera d'argento di Parabiago*, 1935. D. Levi, *Hesperia* 13, 1944, pp. 287 ff. G. M. A. Hanfmann, pp. 227 ff., no. 449. W. F. Volbach, M. Hirmer, pp. 28, 331, * pl. 107.

I45 The Byzantine Emperor

When does Roman art end and Byzantine art begin? There is no clear break, but during the second half of the fourth century A.D., the soft, beautiful style becomes more and more the property of eastern Roman workshops, sometimes in a more classical and monumental aspect, as in the 'Prince's Sarcophagus' sometimes in jeweled and abstract beauty which is to play its part in the transcendental edifice of Byzantine art.

'Our Lord Theodosius Perpetual Augustus on the Occasion (because of) the Most Happy Day—X,' for the tenth anniversary of the accession which the Emperor Theodosius I celebrated at Thessalonike in 388 A.D. This inscription is graven on the upper left of the great silver dish which was part of a Sacred Largesse, made by a divine or nearly divine ruler, to a deserving subject. 'When the emperor himself assumed the consulate, several hundred Senators received a silver dish filled with gold coins' (R. MacMullen).

The universe is divided in two parts. Of these, much the larger is the Sacred Palace floating on an empty background like a celestial vision. The enthroned emperor is the spiritual center of the Palace and the empire. Below, the Earth and her fruit-bearing children suffice to indicate the geographical range and the happy condition of the world. The motif of nature's blessing is repeated in the flower-bringing cupids which fly above the emperor. The two sons of Theodosius, Valentinian II, right, Arcadius, left, smaller in scale are yet both *kosmo-krators* each holding scepter and world orb. Subdued but important acknowledgement is given to the German imperial guards. To protect the Sacred Majesty, rather than combat barbarians, is now the first function of the army. An official, draped in a heavy cloak receives from the imperial hand a folded tablet (diptych) which contains a benefaction.

The slender figures bear a general resemblance to human beings but seem weightless. Curious vestiges of three-dimensional space survive in the foreshortened footstools. This vision of abstract hierarchical order displays itself in ceremonial ornamental splendor. There is nothing Christian in this representation but art here anticipates the essence of the Byzantine view that the east Roman empire was an unchangeable, universal reality and that the emperor 'was God's own choice, manifestation, and vice-regent' (R. Jenkins, *Byzantium and Byzantinism*, 1963).

Madrid, Real Academia de la Historia. Found in 1847 Almendralejo, province of Badajoz, Spain. Pure silver, cast, raised and engraved. Traces of gilding in inscription. Diameter 2 ft. 5 1/8 inches (0.74 m.). Weight 50 Roman pounds (36.05 lbs.) indicated by inscription on back.

H. Pierce and R. Tyler, *L'Art Byzantin* 1, 1932, pp. 46 f. pls. 35–37. R. Delbrueck, *Kaiserporträts*, p. 200, pls. 94–98. A. Grabar, *L'empereur dans l'art byzantin*, 1936, pp. 89, 126, 149, 157, 202, pl. XVI. W. F. Volbach, M. Hirmer, pp. 24, 322, pl. 53. For the Sacred Largesses cf. R. Mac-Mullen, *Latomus* 21, 1962, pp. 159–166.

PLATES

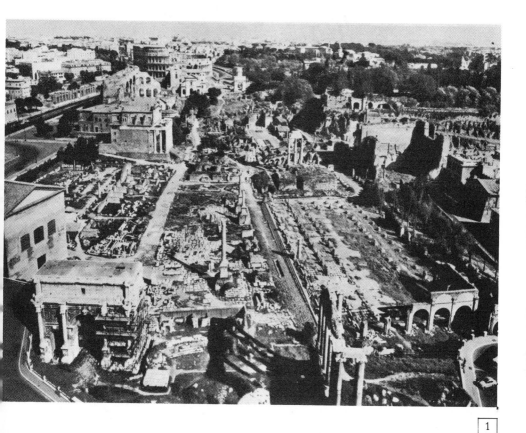

1

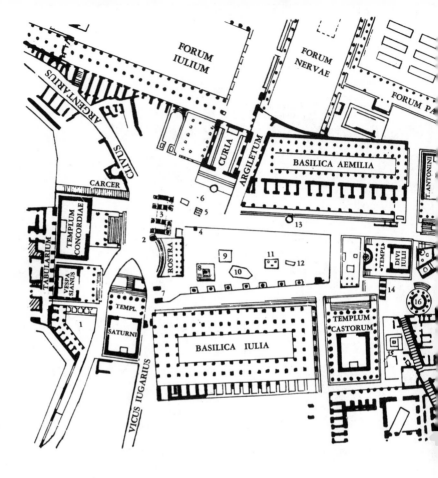

ROMAN FORUM

1. Portico
2. *Umbilicus Urbis Romae*
3. Arch of Septimius Severus
4. Decennalia Basis
5. *Lapis Niger* (The Blach Stone)

6. Comitium
7. Arch of Tiberius
8. Column of Phocas
9. Marsyas, Fig tree, Olive, and Vine
10. 'Lake' of Curtius

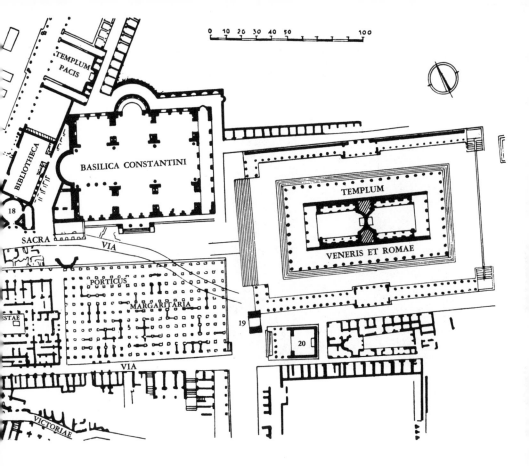

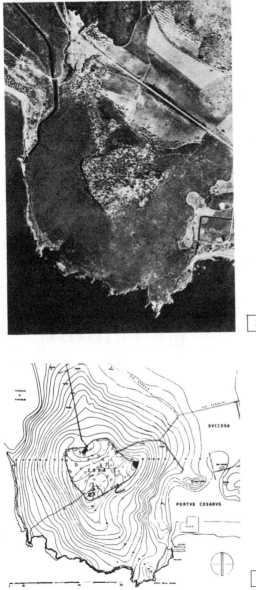

3

4

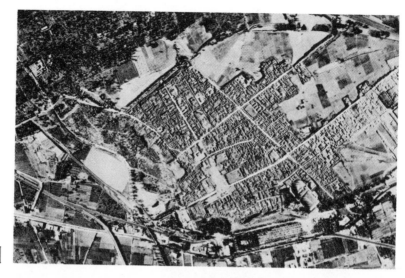

5

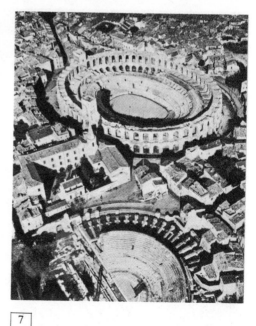

7

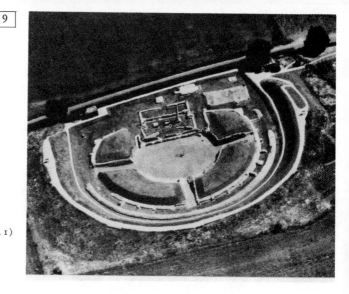

9

10

Key to Plan
(*Antiquaries Journal* 40, 1960, p. 3, fig. 1)
VI, above Triangular Temple
XI Theater
XII Forum
XVI Temple

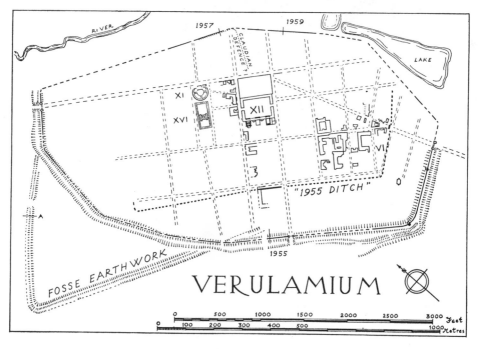

VERULAMIUM

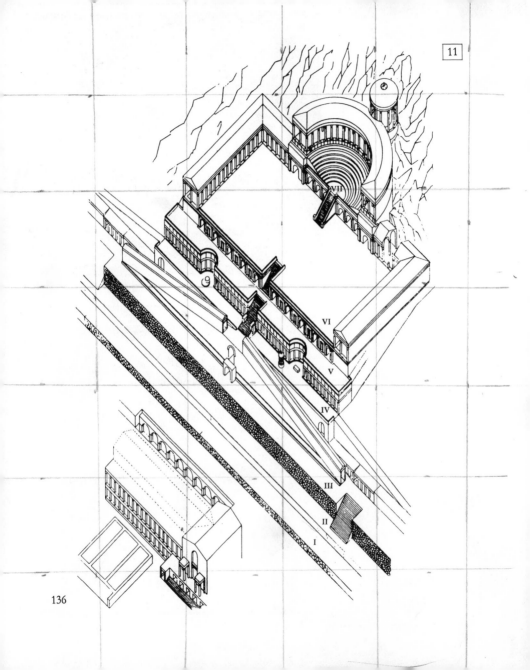

VII

9

VI

V

IV

III

II

I

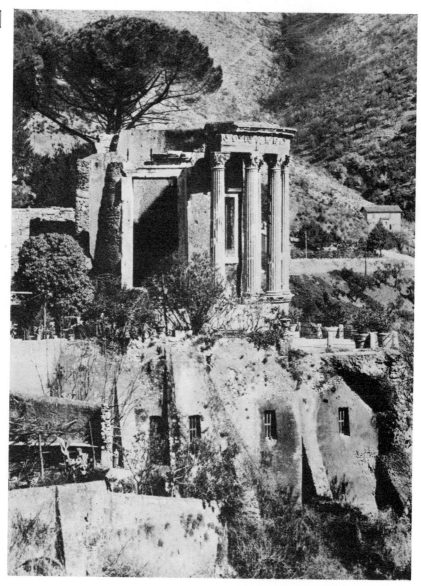

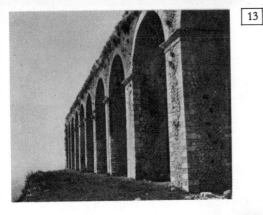

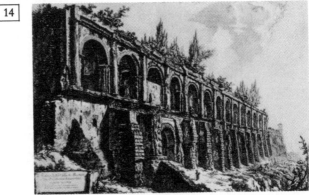

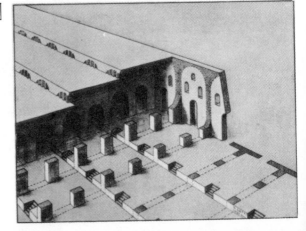

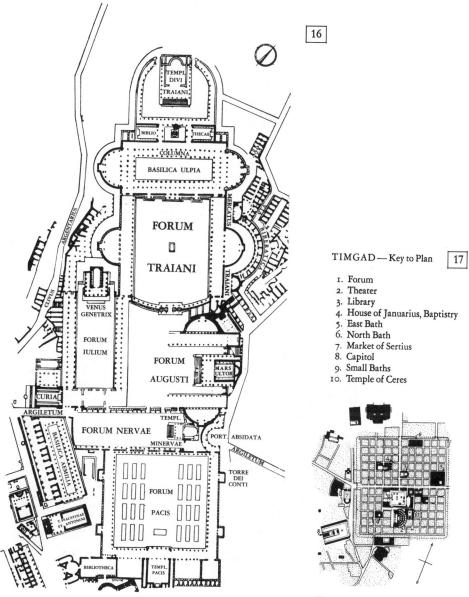

TEMPL
DIVI
TRAIANI

BIBLIO THECAE

COLUMNA

BASILICA ULPIA

ARGENTARIUS

FORUM

□

TRAIANI

MERCATUS

LITERATICA

TRAIANI

CLIVUS

VENUS
GENETRIX

FORUM
IULIUM

FORUM

AUGUSTI

MARS
ULTOR

CURIA

ARGILETUM

TEMPL.

PORT. ABSIDATA

FORUM NERVAE

MINERVAE

ARGILETUM

BASILICA AEMILIA

TORRE
DEI
CONTI

FORUM

PACIS

T. FAUSTINAE
ET. ANTONINI

BIBLIOTHECA

TEMPL.
PACIS

TIMGAD — Key to Plan 17

1. Forum
2. Theater
3. Library
4. House of Januarius, Baptistry
5. East Bath
6. North Bath
7. Market of Sertius
8. Capitol
9. Small Baths
10. Temple of Ceres

100 0 100 200 300 M.

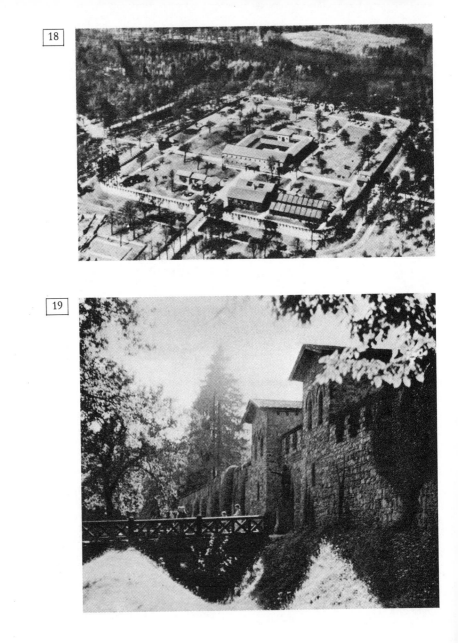

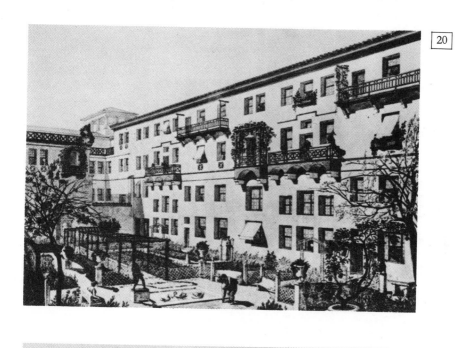

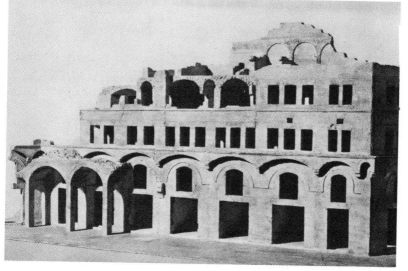

22

23

24

25

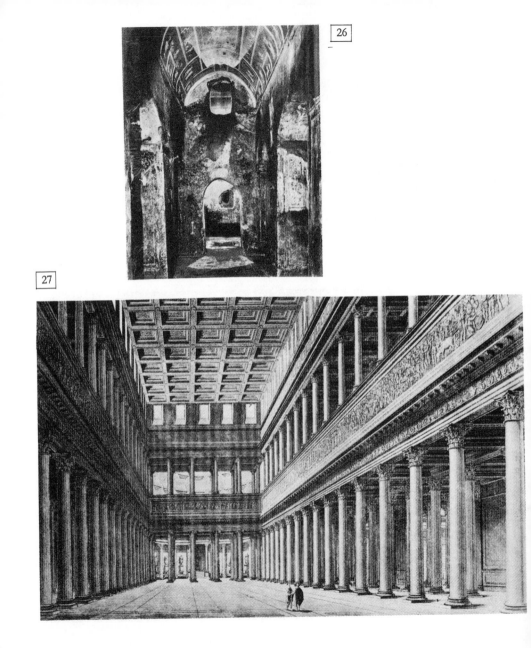

26

27

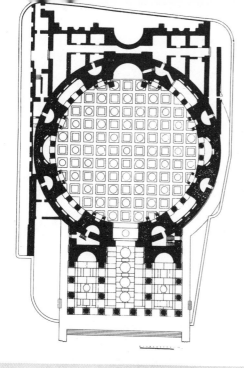

28

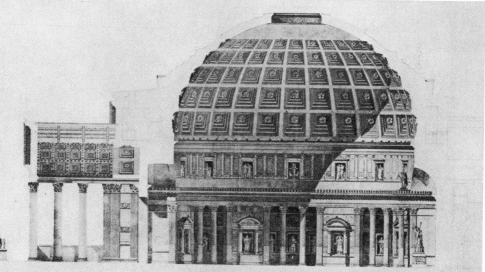

29

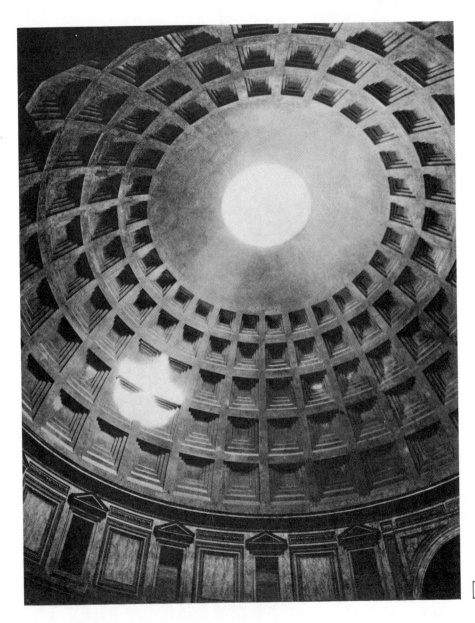

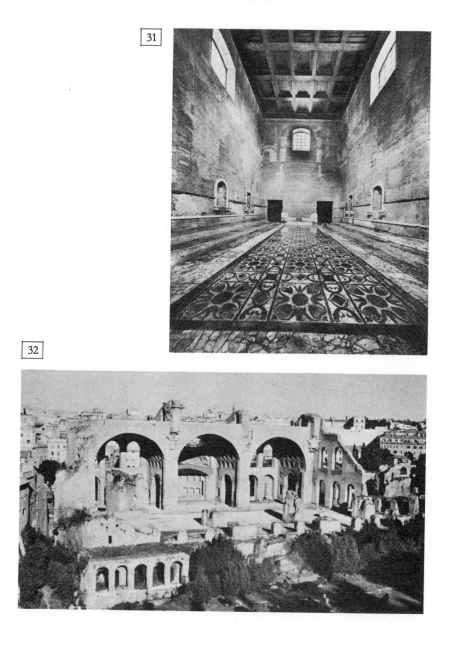

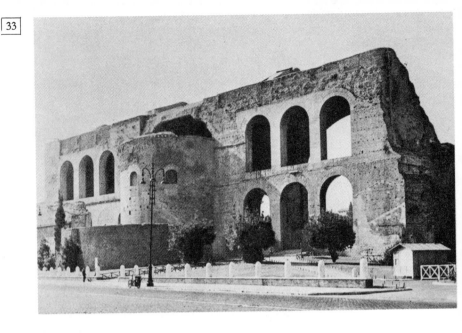

33

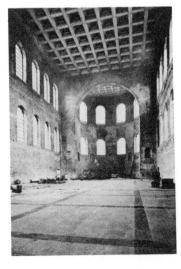

34

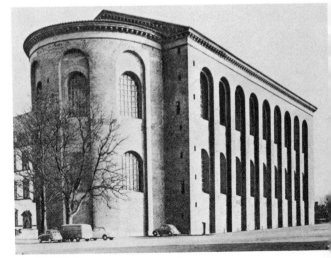

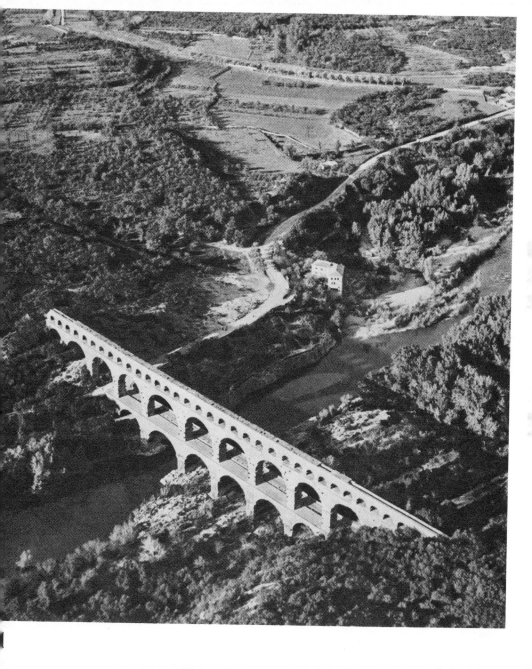

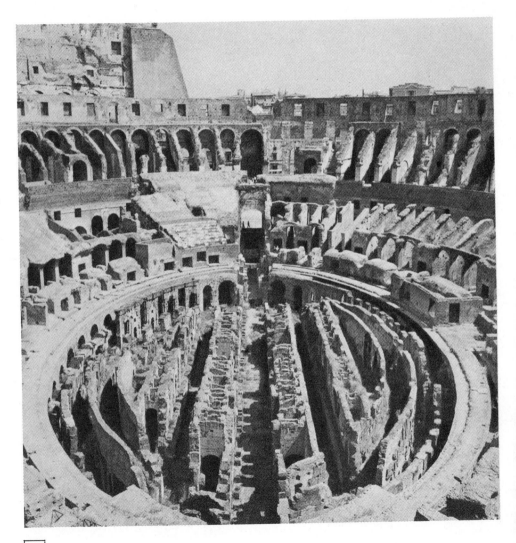

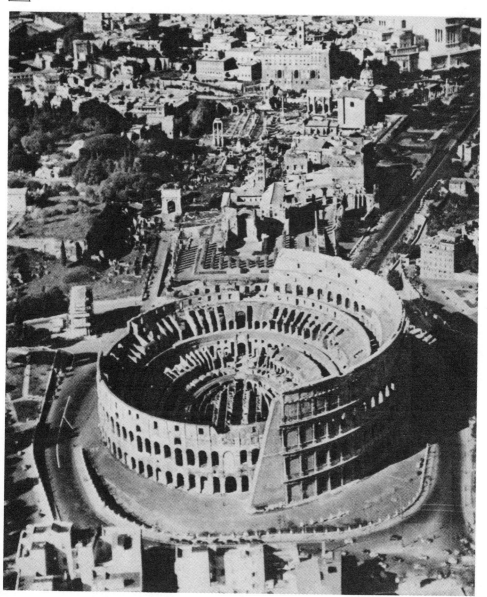

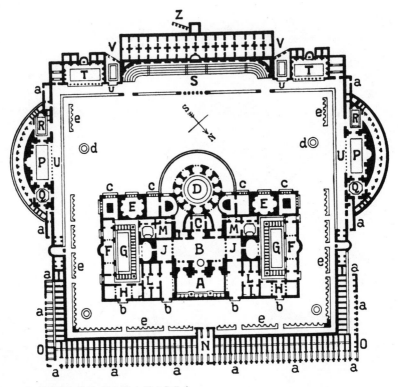

BATHS OF CARACALLA

A.	Frigidarium (Swimming Pool)	QQ.	Nymphaea
B.	Great Hall	RR.	Study Rooms
C.	Nymphaeum	S.	Steps to Portico
D.	Calidarium	TT.	Libraries
EE.	Lounges	UU.	Promenades
FF.	Lecture Halls	VV.	Cisterns
GG.	Palaestra	Z.	Aqueduct and Reservoir
HH.	Vestibules		
JJ.	Courts		
LL.	Dressing Rooms	aa.	Façade of External Enclosure
MM.	Steam Baths	bb.	Entrance to the Baths
N.	Main Entrance	cc.	Game and Sport Rooms
OO.	Shops	dd.	Fountains
PP.	Gymnasia	ee.	Podia of Colonnades

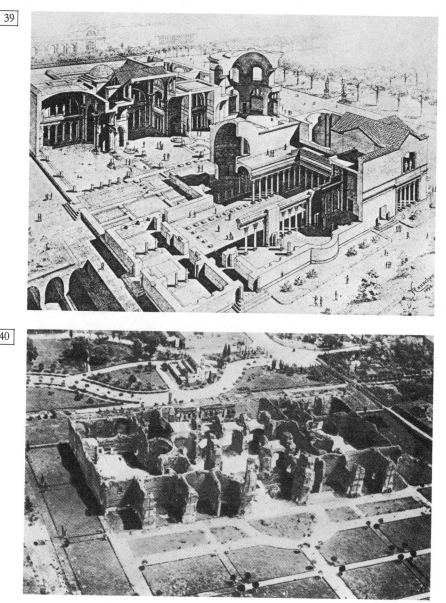

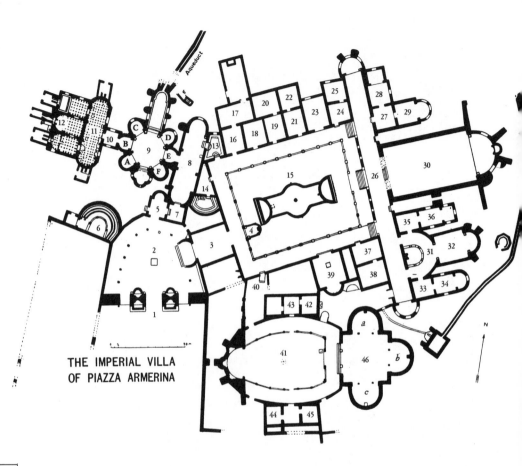

THE IMPERIAL VILLA
OF PIAZZA ARMERINA

1. Entrance
2. Atrium
3. Tablinum
4. Imperial shrine
5. Latrine
7–12. Baths
13. Vestibule with Portrait Mosaic
15. Peristyle court
17. Fountain

23. Mosaic of the Small Hunt
26. Ambulacrum with African Hunt Mosaic
30. Throne Hall?
31–36. Apartment of emperor?
33. Circus Mosaic
38. 'Bikini' Mosaic
39. Hall of Orpheus Mosaic
41–46. Court and Triconch Hall (Hercules Mosaic)

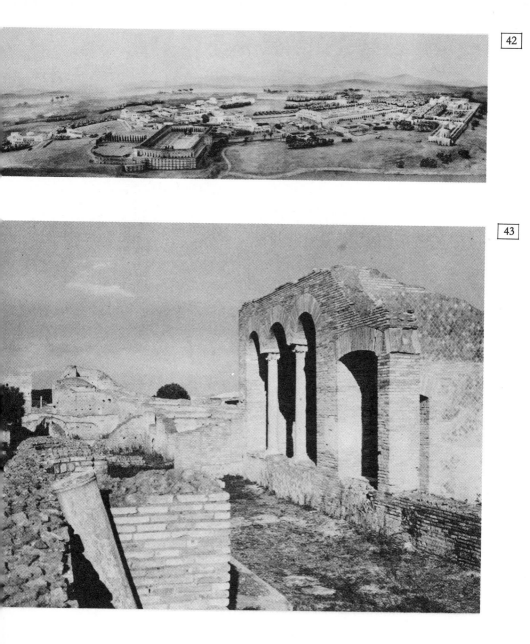

42

43

44

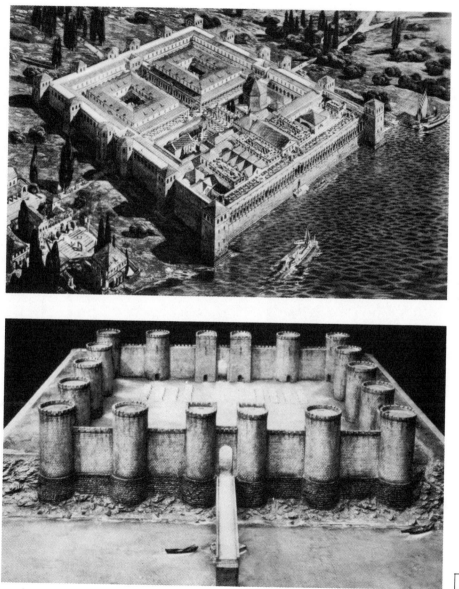

45

46

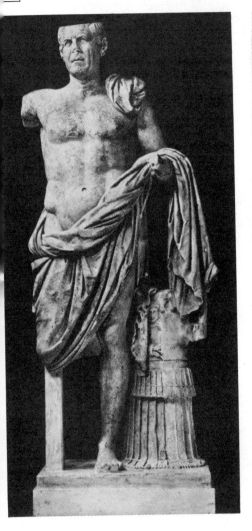

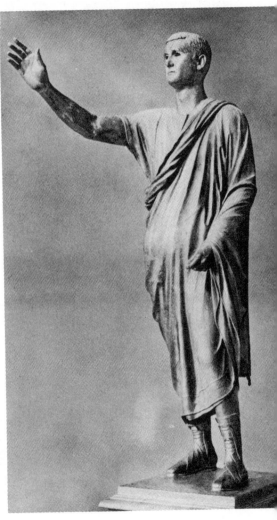

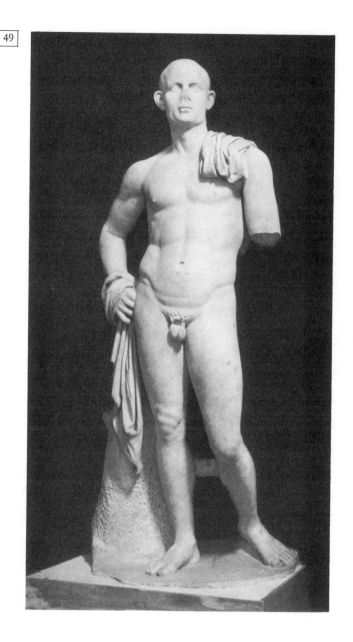

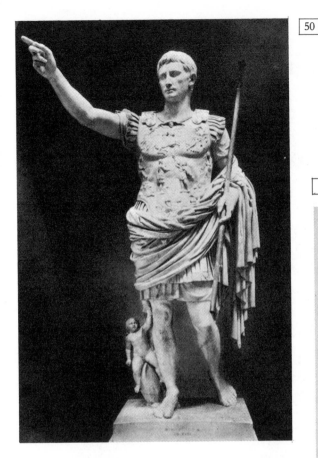

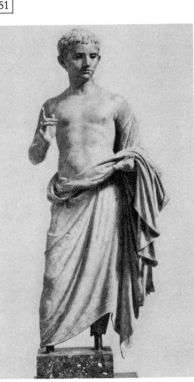

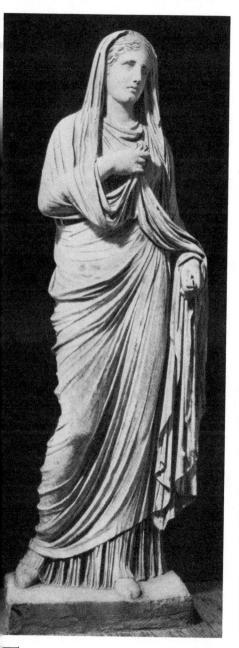

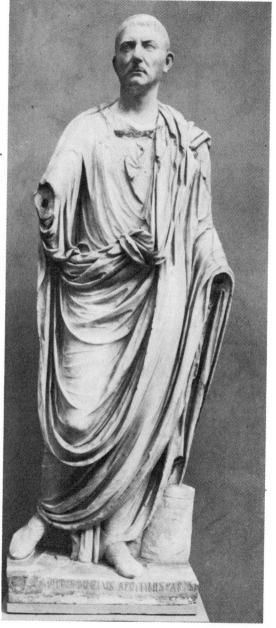

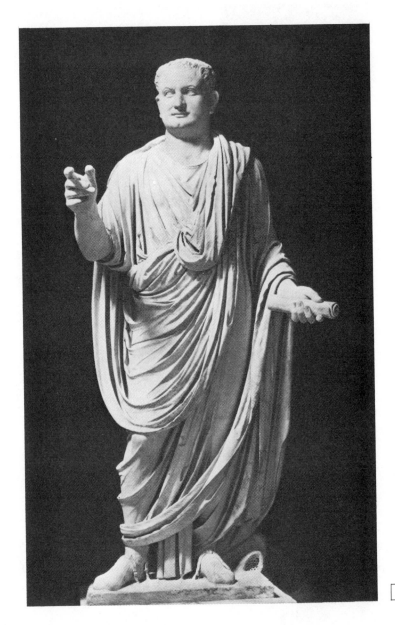

55

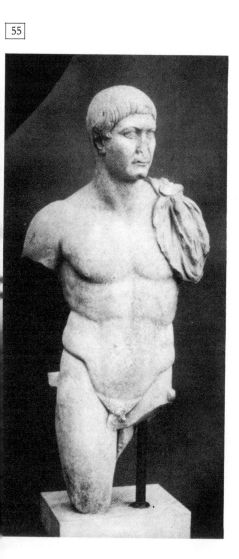

56

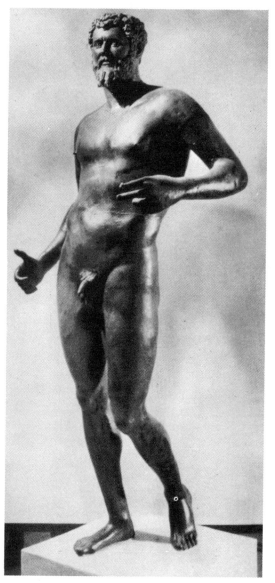

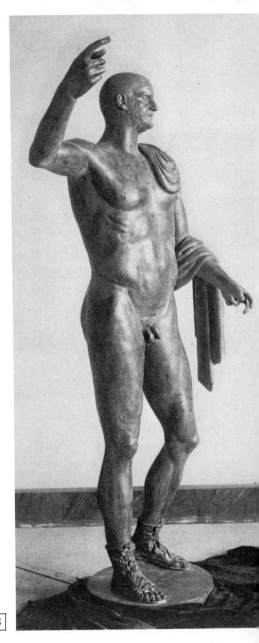

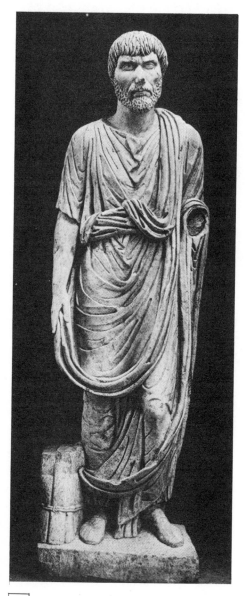

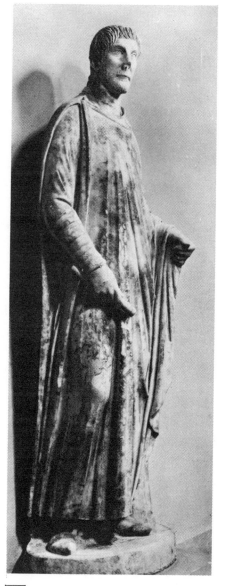

59 60

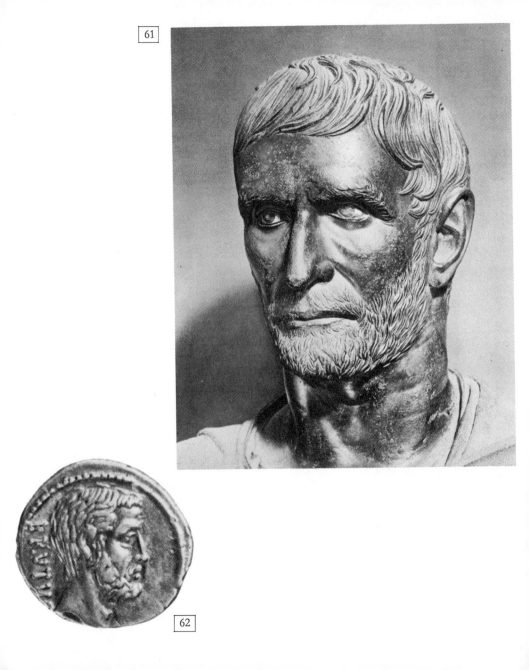

61

62

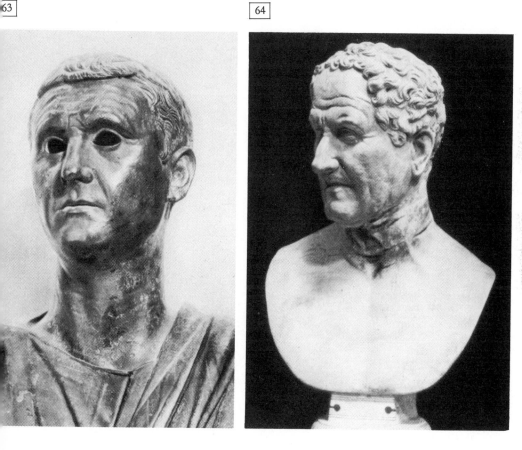

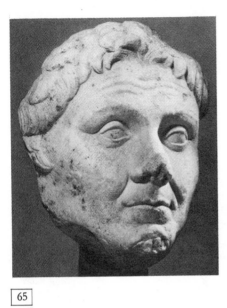

65

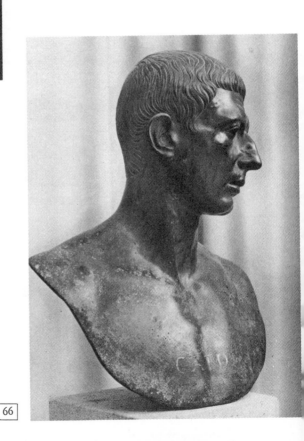

66

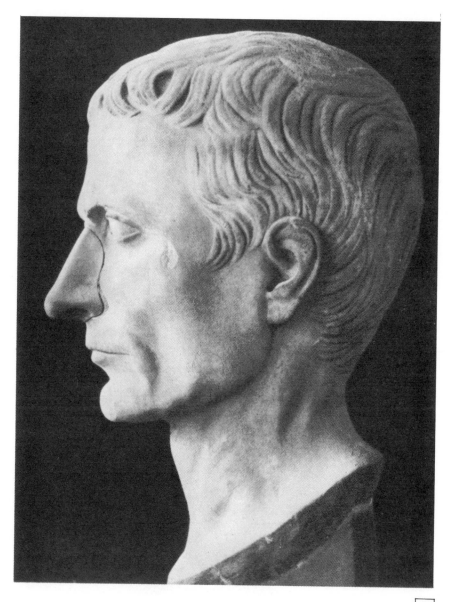

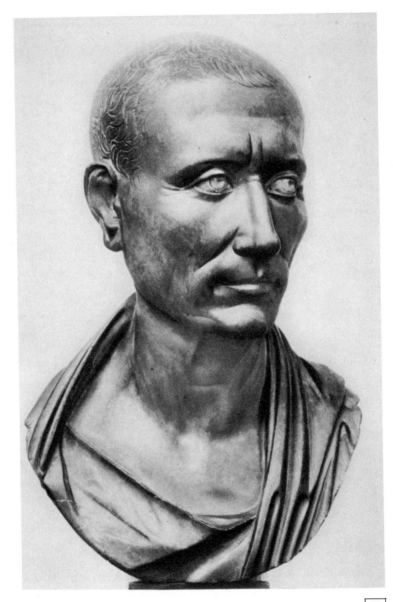

170

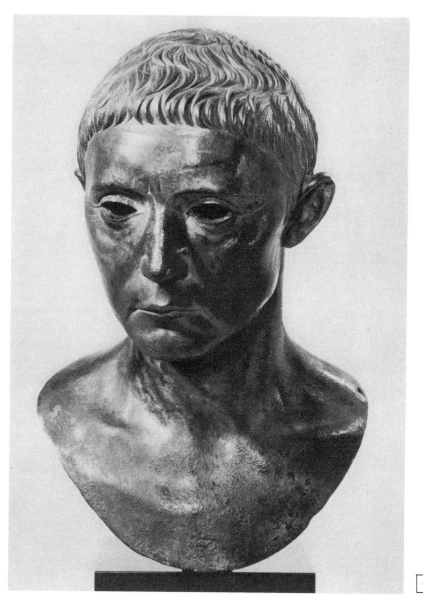

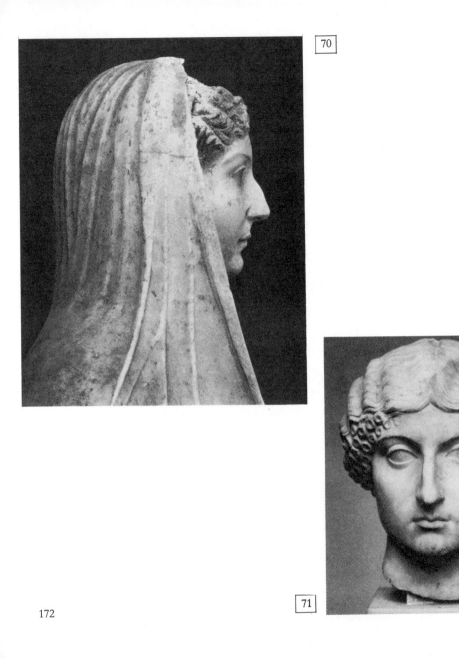

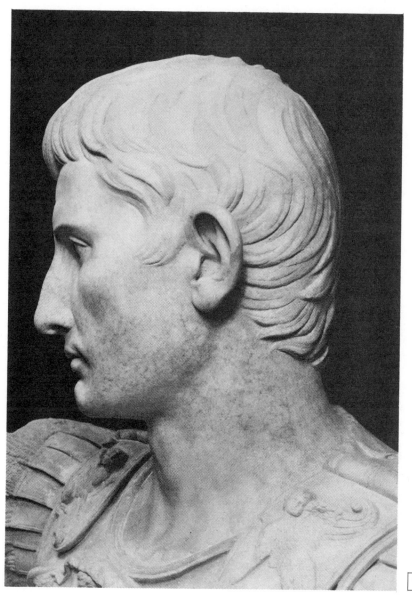

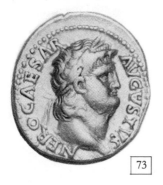

73

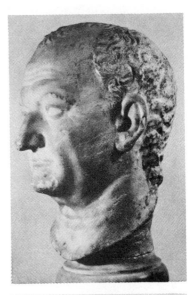

74

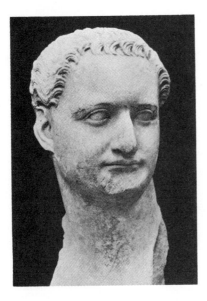

76

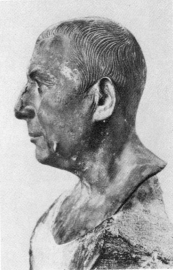

75

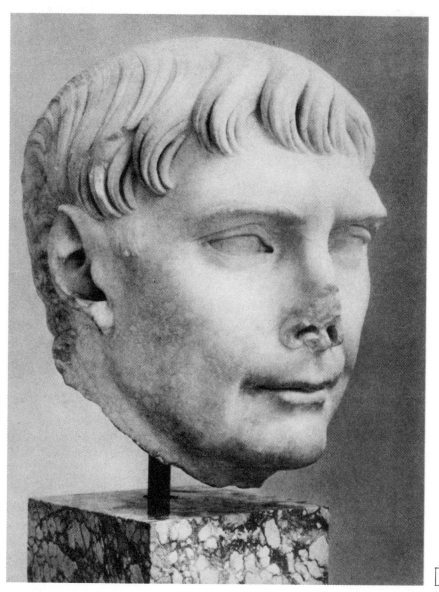

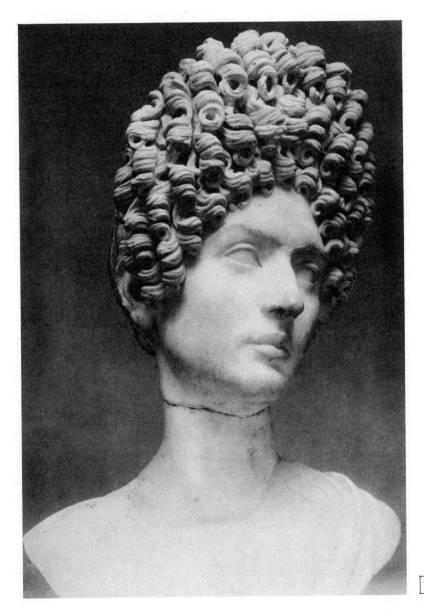

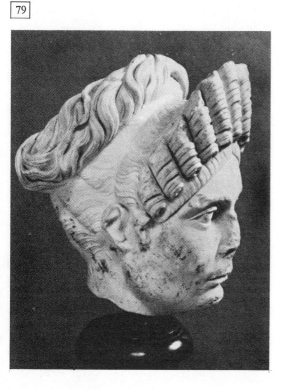

79

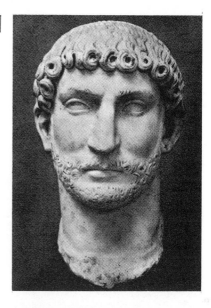

80

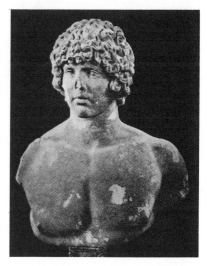

81

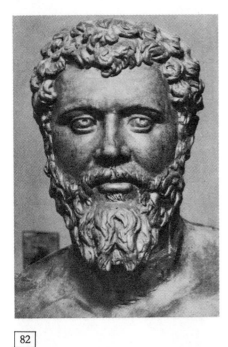

82

83

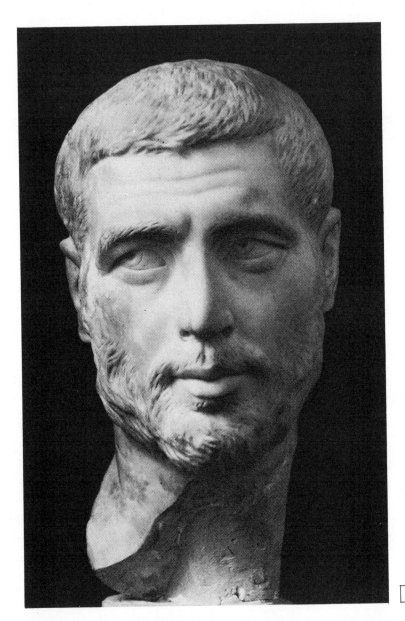

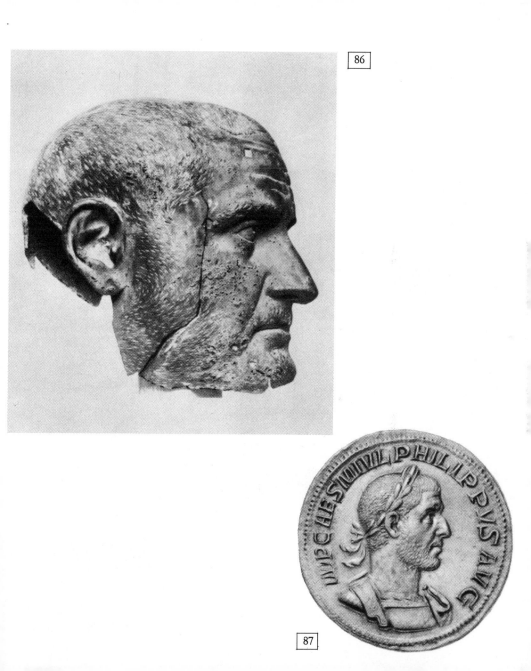

86

87

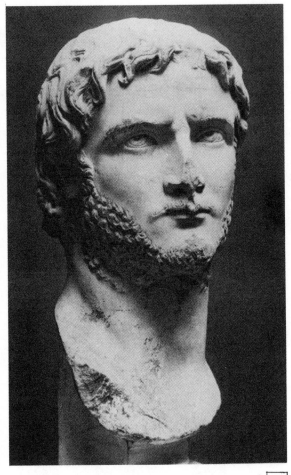

89

88

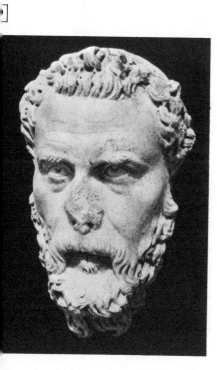

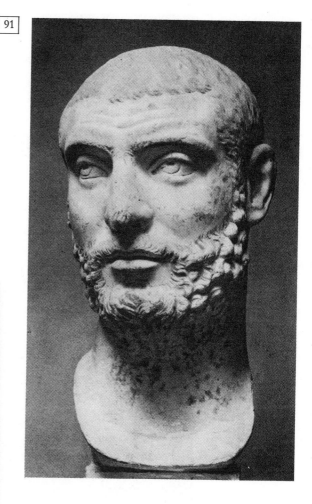

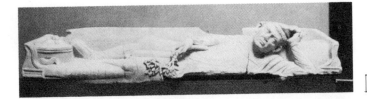

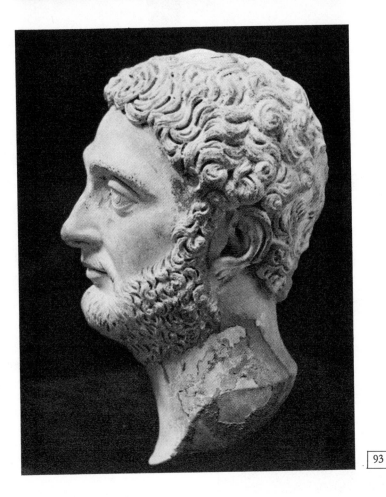

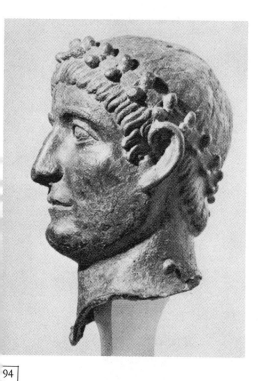

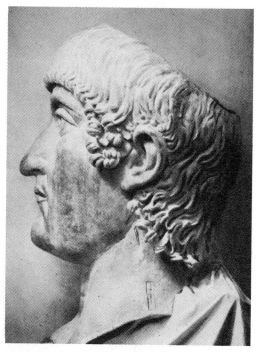

94

95

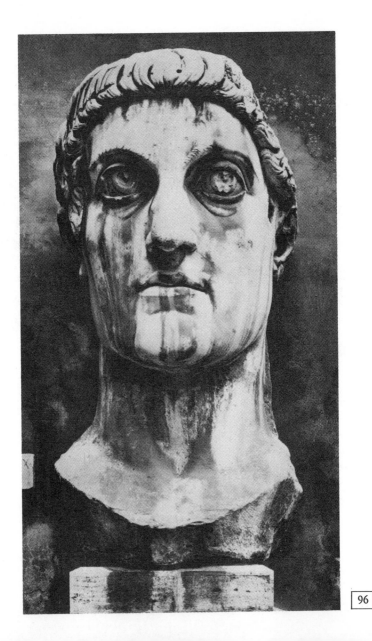

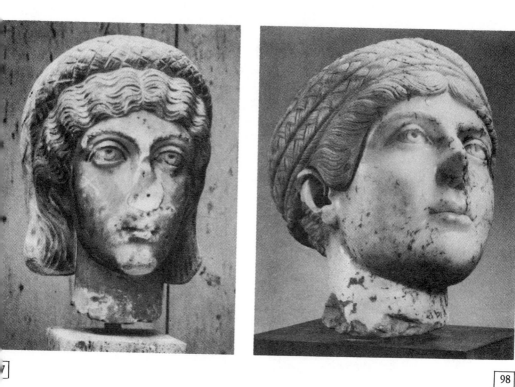

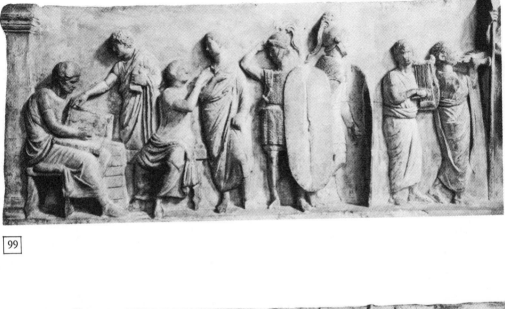

99

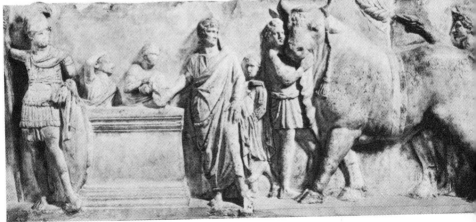

99

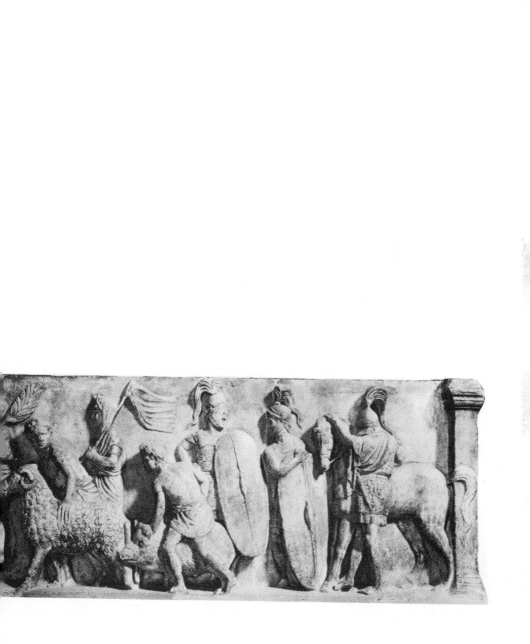

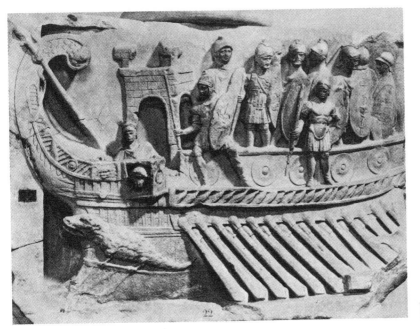

100

101

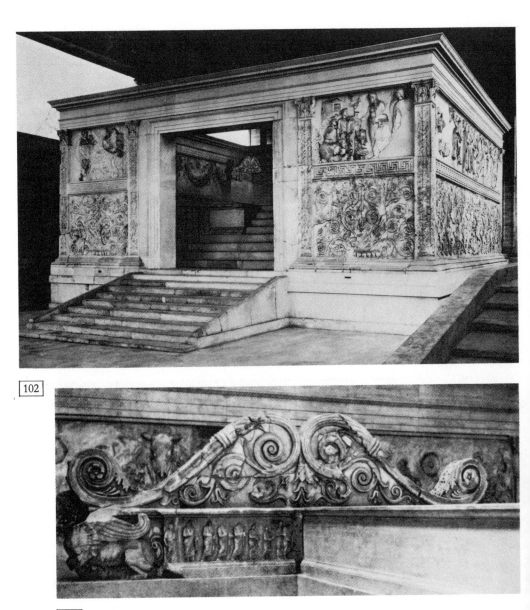

102

103

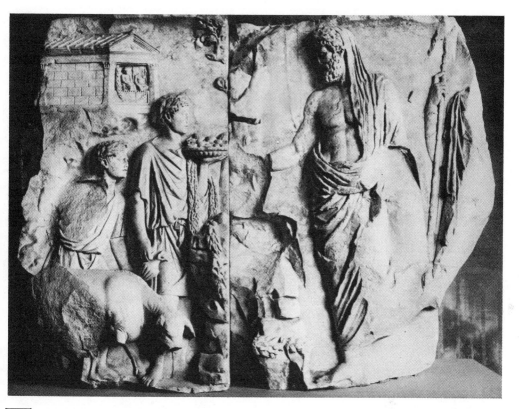

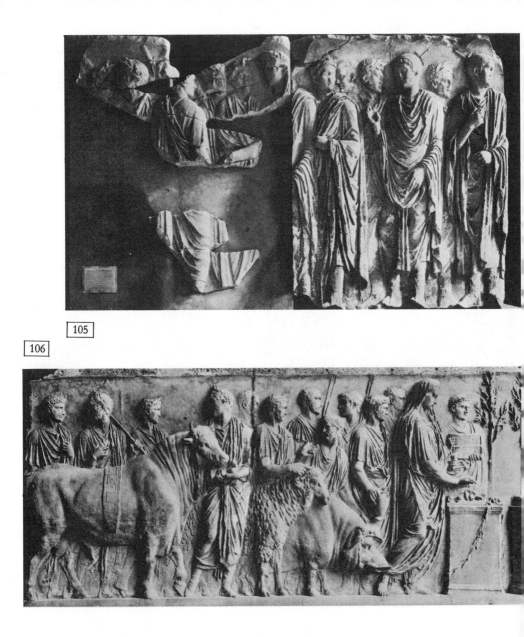

105

106

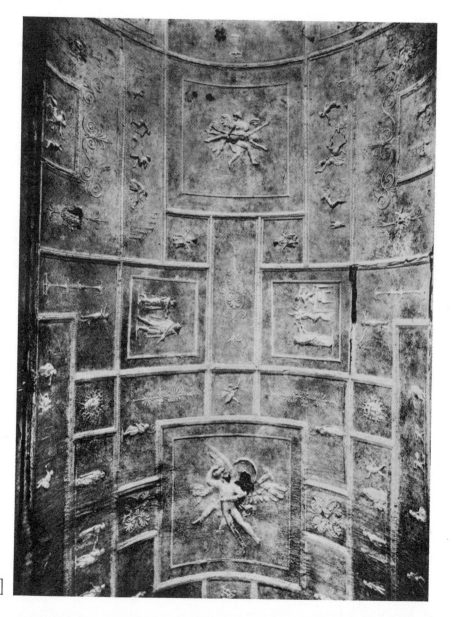

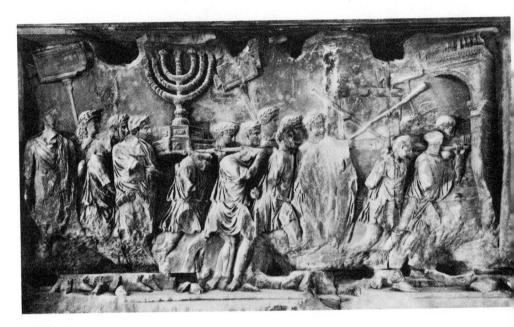

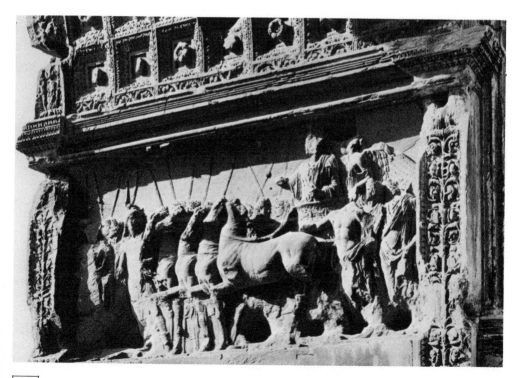

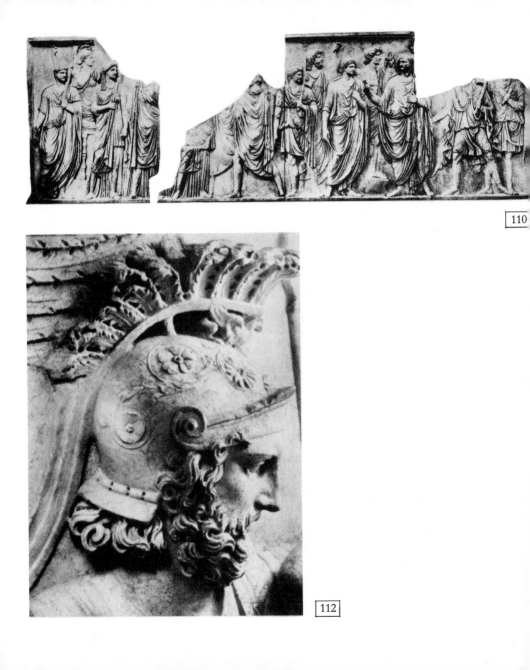

110

112

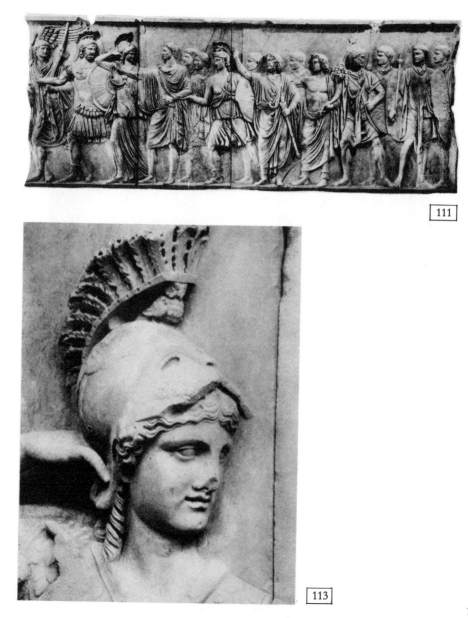

111

113

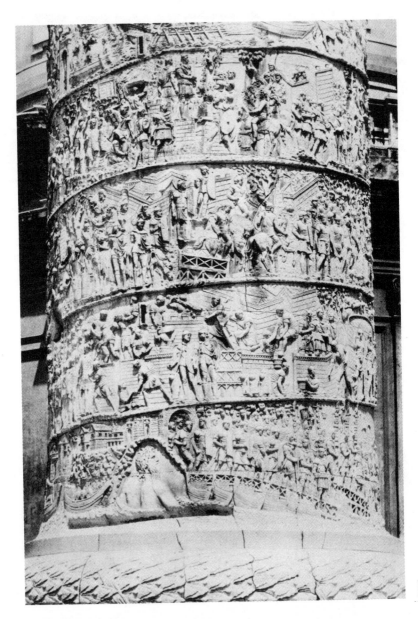

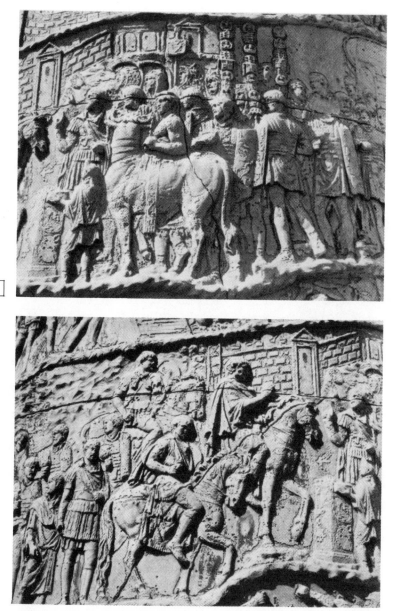

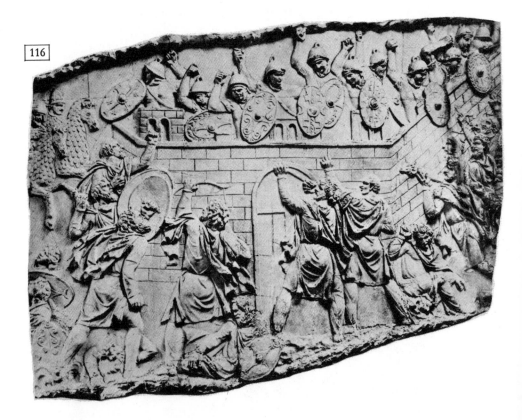

116

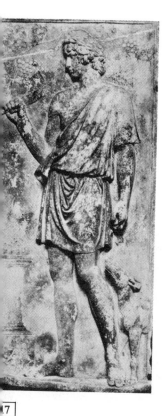

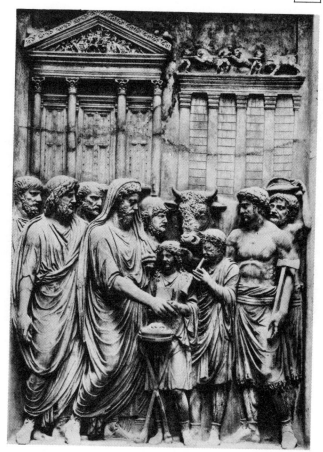

117

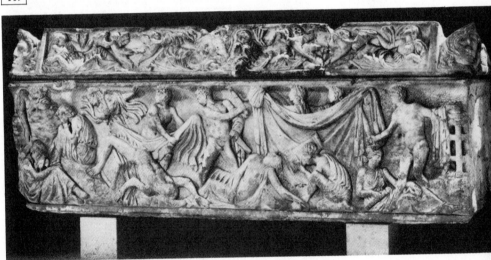

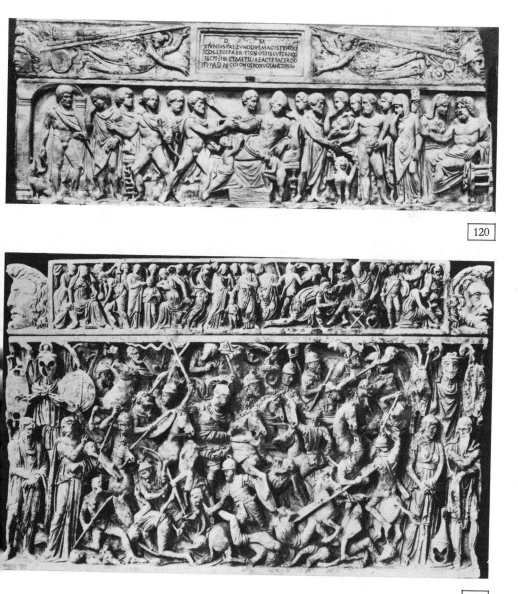

120

121

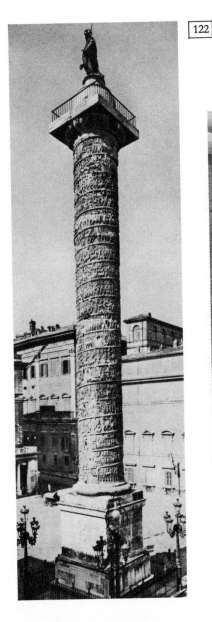

122

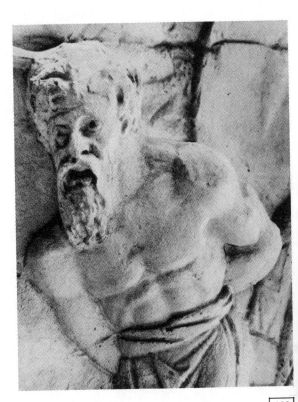

123

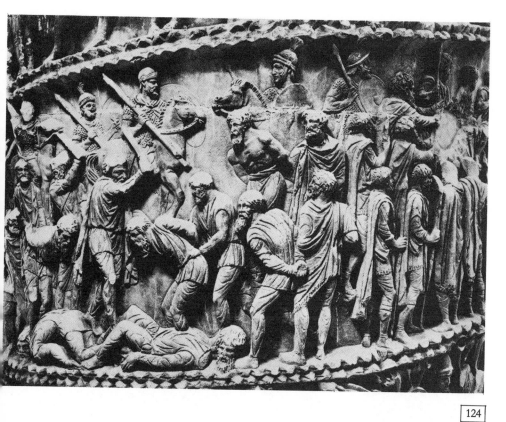

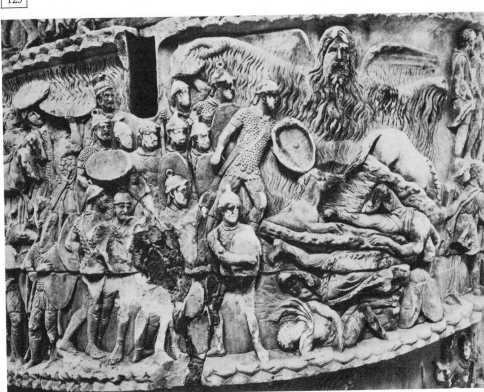

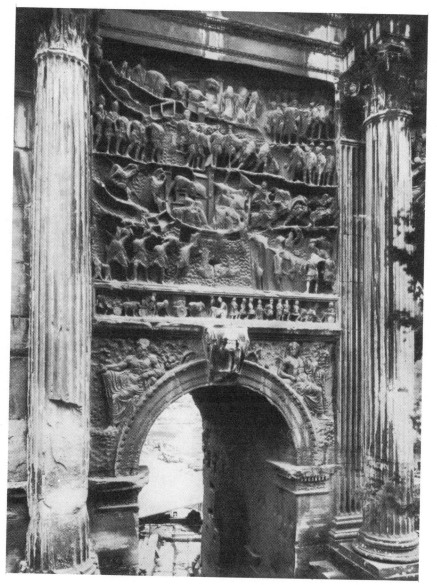

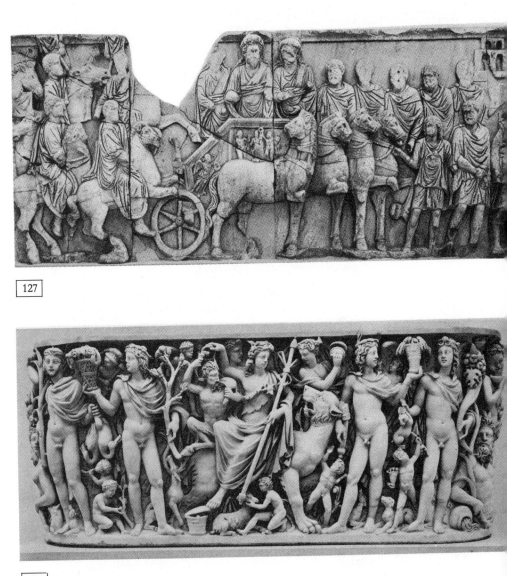

127

128

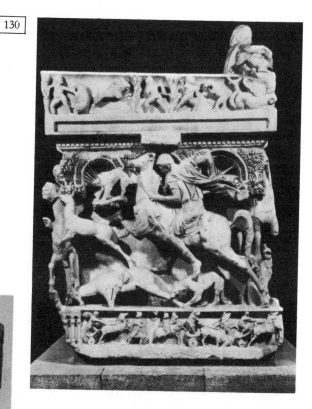

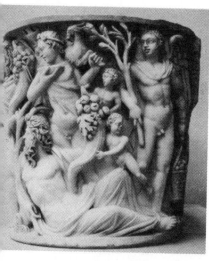

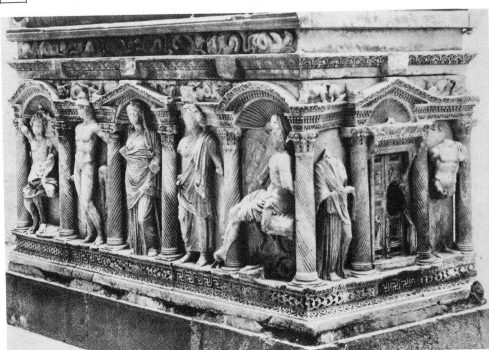

131

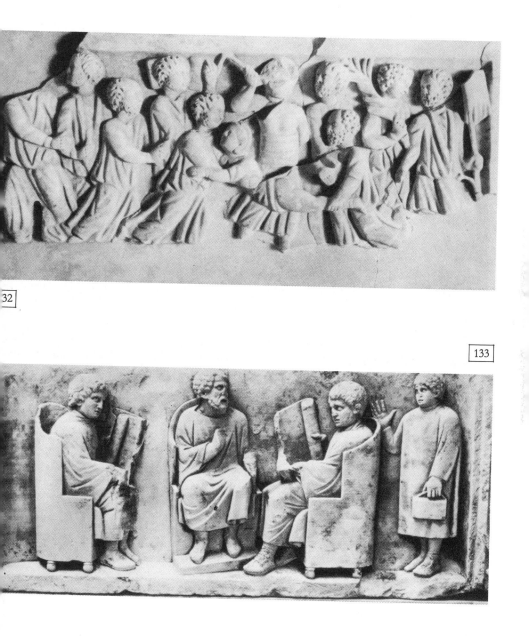

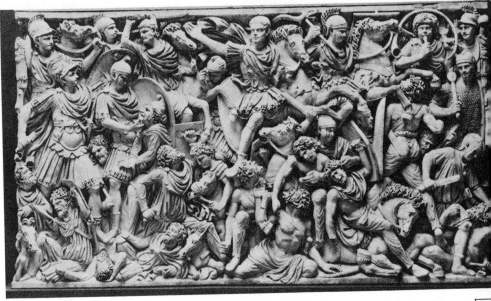

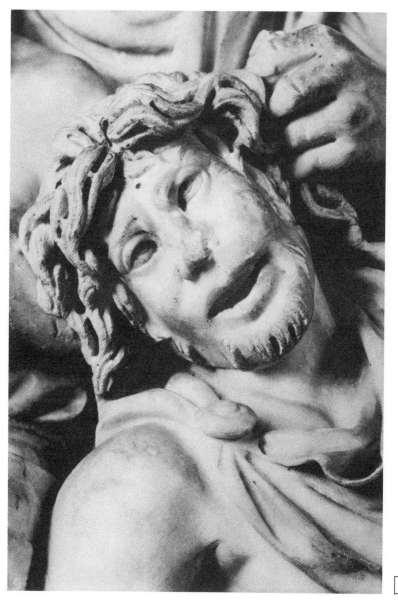

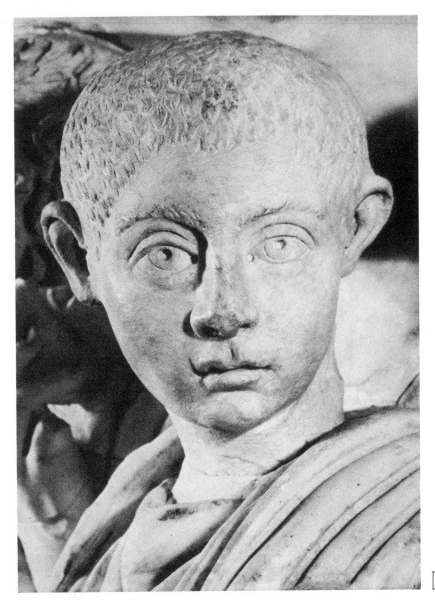

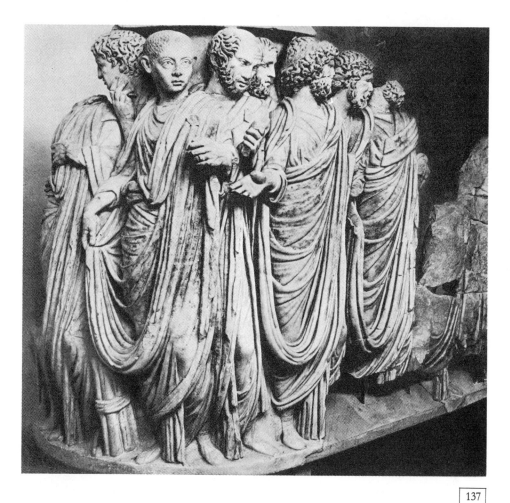

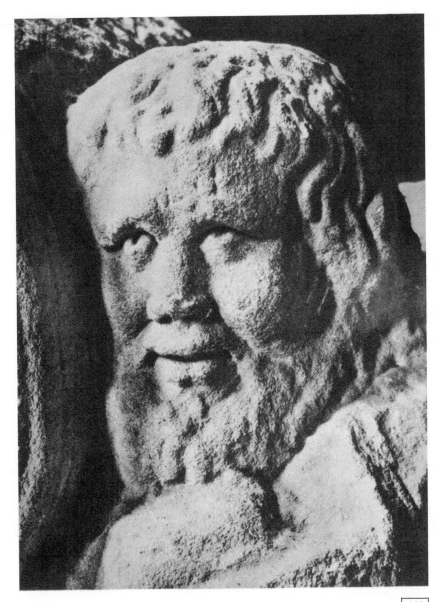

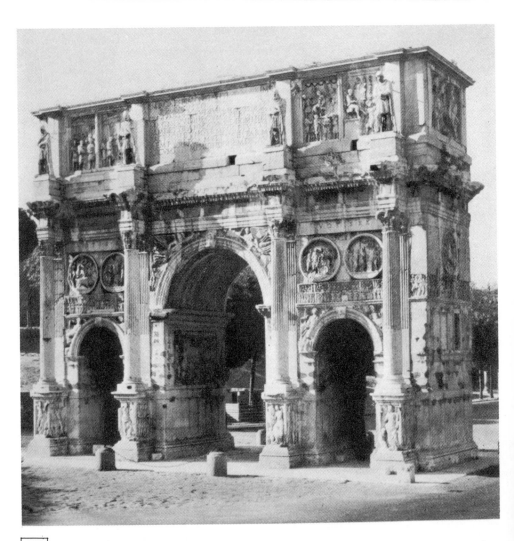

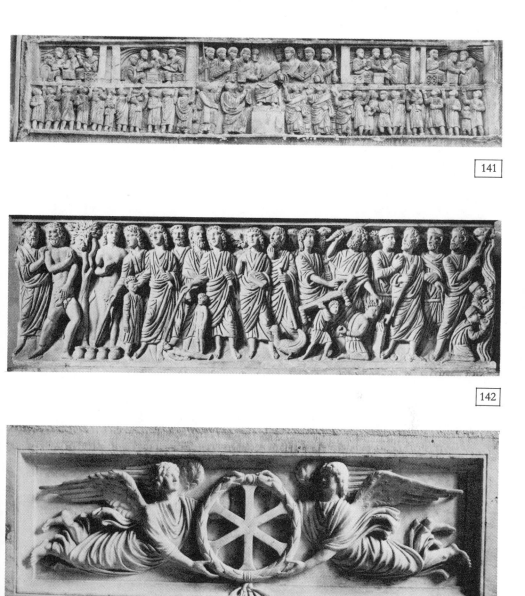

141

142

143

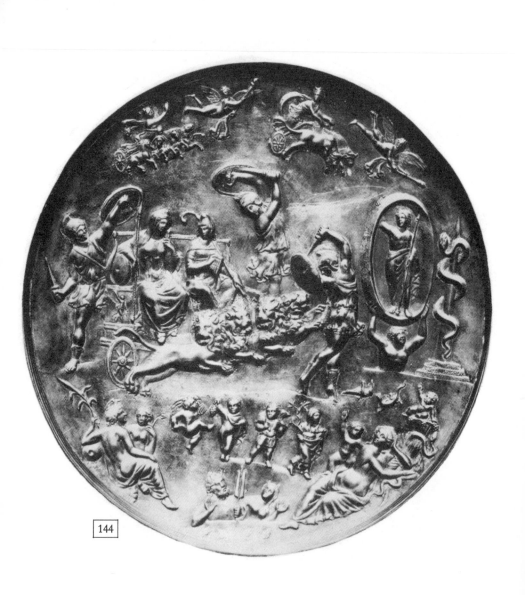

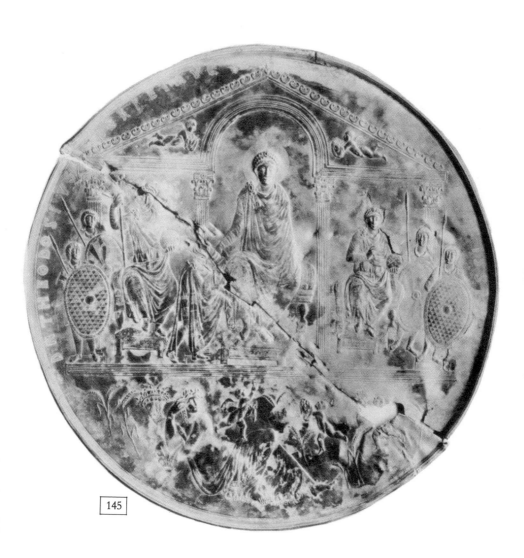

145

V

This rich house of the late Republic, known as the House of the Griffins, shows how Cicero and other notables lived on the venerable Palatine hill of Rome. The residential complex was preserved under the imperial palace, the foundations of which cut through the Republican house. It is of the highest importance for our knowledge of the development of Roman wall painting and mosaic; its decoration proves that the capital set fashions which were closely and faithfully followed in the seaside resorts of Herculanum, Stabiae, and Pompeii. The so-called 'Large *Cubiculum*' (bedroom), competently vaulted and colorfully painted, marks the very beginning of illusionistic architecture. The treetrunk columns, not real but painted, seem to step forth into the room on projecting pedestals; behind them are panels of Pompeian red alternating with veined slabs almost Chinese in their effect— and a long green frieze imitating marble. The wall behind the columns is still envisaged as solid and unbroken. The columns carry a shallow roof seen from below, its coffers and the pedestals arranged symmetrically to an optical axis which would bisect the short end wall.

The artist was obviously carried away by the lure of optical illusion. He used the *trompe d'oeil* motif of red and white cubes not only in the center of the floor mosaic—where it was used traditionally to startle people by the feeling that they were walking over a tumbling pile—but with little logic, in the lower part of the wall, which thus seems to tumble forward around the column base.

Because the element of architectural illusion is present, the wall paintings of the House of the Griffins are usually considered to stand at the very beginning of the so-called 'Second Pompeian style' of wall decoration.

Rome, Antiquario del Palatino. The wall paintings of this room were transferred to the museum in 1960; the mosaic floor remains in the house. The preserved part of the room is only 24 ft. 7 inches by 9 ft. 10 inches (7.5 by 3 m.). Internal height to top of vault ca. 13 ft. (nearly 4 m.). Walls of *incertum* (irregular-shaped stones set in concrete), floor mosaic in *tesserae* with central *emblema* $21\frac{1}{2}$ by 20 inches (0.55 by 0.51 m.). Excavated by Giacomo Boni in 1912. Structural characteristics show that the house was built before mid-first century B.C. A number of scholars advocate a date of ca. 100 B.C. Its decoration is, in any case, representative of the times of the great dictator Sulla (d. 78 B.C.) before the full development of the rich and luxurious style associated with the era of Caesar and Pompey.

A. Bartoli and G. E. Rizzo, *Monumenti della pittura antica scoperti in Italia*, sez. III fasc. I *La pittura della Casa dei Grifi* (Palatino), Rome 1936. P. Ducati, pp. 72–74, pls. 35 (great hall or *cubiculum*), 36 (part of room with griffin stucco). *CAH*, IV, p. 84 f., fig. a. M. E. Blake, *Ancient Roman Construction*, 1947, p. 26. H. G. Beyen, pp. 47–52, pls. 7–9.

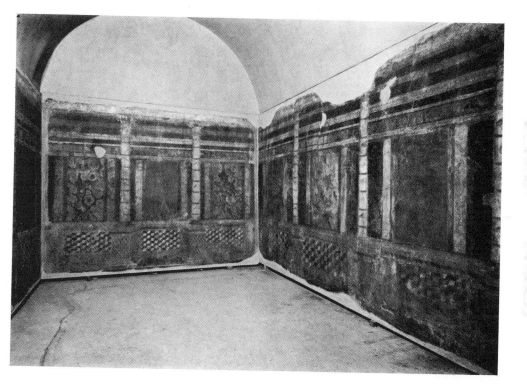

V A Bedroom in a Late Republican House

VI

In 1900 some of the most impressive paintings of the ancient world were discovered in the ruins of a villa near the hamlet of Boscoreale, about a mile from Pompeii. The name of one Publius Fannius Sinistor was written on a bronze vessel found in one of the rooms. He may have owned the villa shortly before it was destroyed by the eruption of Vesuvius in 79 A.D. We do not know who built the villa and commissioned its decoration more than a century earlier (ca. 50 B.C.).

The little bedroom lay at the northwest corner of a colonnaded court. Paintings of illusionistic architecture covered the side and back walls. The two symmetrical long walls displayed, in the part nearer the entrance, sacred precincts with images of Diana-Lucina, goddess of moon and birth, and three-bodied Hecate who rules the night. Flanking these rustic sanctuaries are picturesque cities rising in precipitous, terraced formations. Toward the rear of the room, where the sleeping couch had stood, the side walls display luminous vistas of temples and colonnades. That of the right-hand wall (northwest corner) is shown in the picture. (Top cornice and the plain vertical pilasters are modern.)

The amazing display of architectural riches repays close study of every detail. Over a footing of gray marble, the lower wall builds up in course of purple (porphyry?) masonry with drafted edges. The wall is crowned with yellow and gray marble profiles envisaged as coming forward. On this stage-like platform rises a majestic portal set on a low green base. Four columns of yellow marble stand on porphyry bases. Their capitals are of white marble and 'composite' order (Corinthian acanthus chalice and Ionic volutes); human heads peer from the top part. Over a purple frieze white brackets support a cornice with bead-and-reel which projects powerfully above the columns. Again the marble is golden; so is the shallow pediment with Doric features (plates with drops, the *mutuli* and *guttae*) flung boldly across the central opening. It is crowned by a delicate, symmetrical plant; pointed antefixes stand on the sloping

edges. This triangular roof reads ambiguously—does it crown the columns or is it an opening in the red masonry wall above?

The wall on either side of the entrance shows red, stuccoed and painted panels familiar from Pompeian houses. It is crowned by a white profile, a blue frieze, and a projecting roof; golden coffers of the ceiling are seen from below.

Two red piers (or altars?) flank the entrance which seems barred by a lavender balustrade. Presumably one may go around it. Pears and pomegranates brought as offerings lie on the piers; a laurel twig is tied to the balustrade. A round-topped incense burner stands in front of the entrance. Its openwork lid has a red edge. Two handles for carrying hang down from the plate.

In a manner not clearly explicable, black curtains sag down above the red panels and across the entrance.

We are looking at a sacred precinct, axially planned. Its center is occupied by a round temple. The red columns are overgrown with spiraling plants perhaps envisaged as being of bronze. The capitals are of white marble. Above are red stone parts, a purple frieze in between, a green rain gutter (*sima*) decorated with white lion-head spouts. A pagoda-shaped roof rises to carry a Corinthian capital from which a gleaming sacred object springs out of a leaf chalice.

The flanking colonnades march along with heavy unfluted Tuscan columns which carry a purple frieze with sea monsters.

Making the second-largest color area of the picture, green-blue sky spreads above and continues behind the temple and the rear colonnade.

Within each panel, the eye is enticed back, step by step. This progress is achieved by axial perspective, in which all foreshortened lines of the buildings will meet on a central vertical axis (but not in one point). Greek geometricians and painters had developed this system of 'architectural perspective' and used it in stage backgrounds. To apply this type of painting to residential

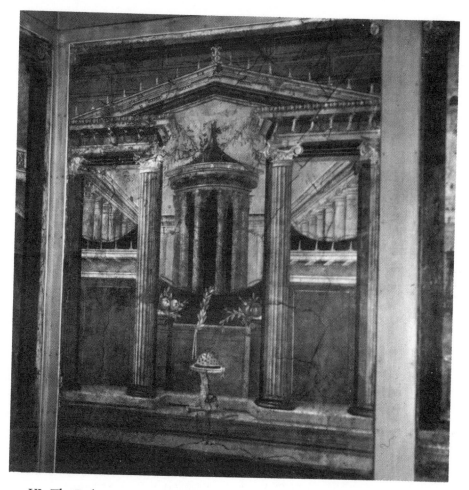

VI The Bedroom at Boscoreale

teriors was a Roman idea. Waking from his dreams,
e owner of the Boscoreale bedroom would be greeted
the sight of vistas of regal splendor, of villas, temples,
laces, dominions of which he could dream, but which
could not afford to build.

New York, Metropolitan Museum, 03.14.13 C.
Dimensions of the room: 13 ft. 4 inches (43.6 m.) by 20
ft. (65.6 m.).

A very thorough and careful description of the entire
villa and of the bedroom, P. W. Lehmann, pp. 89, 118 ff.,
201 ff., fig. 51, pl. 19, with earlier literature. K. Schefold,
p. 35, pl. 5. *

VII

In 33 B.C. the Emperor Augustus bought the house of the family of Hortensii on the Palatine; it is described by the ancient authors as modest (Suetonius, *Augustus* 72); the location was, to be sure, most residential, comparable in status to Beacon Hill of nineteenth-century Boston. In 1869 a house was discovered under the later Imperial Palace; it had been piously preserved throughout antiquity. The house was nicknamed the 'House of Livia,' wife of Augustus (58 B.C.–29 A.D.) but most scholars believe that this is the residence of the founder of the Roman empire. Augustus seems to have exercised a definite influence in formulating the Augustan style in official architecture and sculpture; we may surmise that his choice of interior decoration would have set the style for fashionable Rome.

The paintings in most rooms are in the late, rather bizarre character of the Late Second Pompeian style. It is clear that Augustus did not heed the strictures against an architecture 'which cannot exist' made by the architect Vitruvius in a book dedicated to Augustus. The 'Room of the Garlands,' more classicistic in taste, with its chaste, flat wall and its cool color scheme, already points the way to the diminished architectural illusion and playful classicism of the so-called Third style.

Our illustration shows only the lower part of the wall and does not quite reach to the floor. Adventurous bases with white sea monsters jumping out of spreading leaves supported the columns from below. The column is faceted in the lower part, grooved in its upper part. It continues out of another floral chalice way up the picture to support a painted ceiling which is envisaged as being outside the room. All columns are shaded in light purple on the side away from the entrance.

The basic division of the wall is in three parts; the tall white panels in red frames hung with garlands; the miniaturistic 'Yellow Frieze'; not appearing in this picture is the upper zone of white panels. They are decorated with female heads growing out of plants on the leaves of which griffins, victories, and sileni are precariously balanced. A fantastic architecture, but one that might be envisaged as a portico in a sanctuary.

The garlands are laden with apples, plums, and grapes. A basket with fruit and branches is suspended from the garland on the left, a mask of Pan from that on the right. These objects are interpreted by some scholars as symbols of religious festivals.

It was customary to hang garlands in sanctuaries; something of this kind, the display of the good things harvested, has maintained itself in many agricultural countries, and in the American Thanksgiving.

Is there any special meaning to this array in the house of the first Roman emperor? The garlands are as similar to those on the altar of Augustan Peace (Fig. 102) as painted and sculptured garlands can be expected to be. They stand for blessings of peace and fertility, the 'Yellow Frieze' for happy life in the countryside; the symbols of Apollo and of Victory at the top of the wall allude to the personal god and protector of Augustus and to the victory he gave. Even in the privacy of his home the First Citizen did not object to reminders of the blessings which his rule had brought to the world.

The chaste white of panels, the subdued grays of frames and columns, the greens playing over toward a cool blue, are characteristic of Augustan classicism.

Rome, Palatine, 'House of Livia.' Right-hand room (*ala dextra*) in a complex opening on a court, ca. 27⅓ ft by 12⅜ ft. (8.3 by 3.75 m.), height of wall ca. 13⅔ ft. (4.2 m.) The building is dated, on structural grounds, to the first half of the first century B.C. Augustan repairs are placed by G. Lugli, *La tecnica edilizia romana*, 1957, pp. 424, 430, to the years 33–29 B.C. However, if the house is that o Augustus, the paintings and repairs should go back to A.D. when the house was hit by lightning. The house i identified with the house of Augustus because the nam of Julia Augusta (Livia) was found on the water pipes.

G. E. Rizzo, *Monumenti della pittura antica*, sez. III, fasc 3, *La casa di Livia*, 1936, pp. 41 ff., fig. 30, pls. 4 and (color). For Garland Room, L. Curtius, *Wandmalere* p. 90. fig. 54. Reconstruction of entire wall repeated i *CAH*, IV, pl. 84 b. and E. Strong in Vol. IX (text), pr 827 f. H. G. Beyen, I, p. 22, II, p. 21, n. 7, fig. 232 garlan wall, figs. 228–236 other paintings.

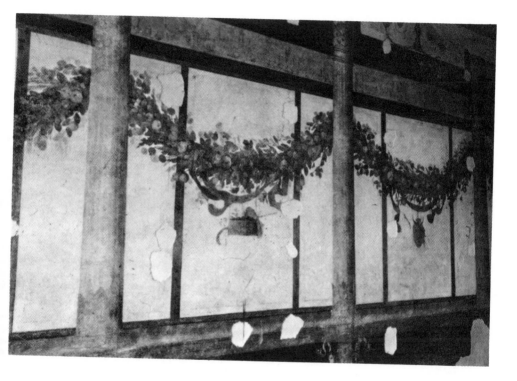

VII Wall with Garlands from the 'House of Livia'

VIII

'Excavations were made among the ruins of the Palace of Titus with the hope of findings statues, when certain subterranean chambers were discovered, and these were decorated all over with minute *grottesche*, some figures, stories, and ornaments, executed in stucco in very low relief. These discoveries Raphael was taken to see, and Giovanni (Udine) accompanied his master, when they were both seized with astonishment at the freshness, beauty, and excellent manner of these works.' Thus does G. Vasari in his *Lives of the Most Eminent Painters*, 1550, record the excitement which the foremost painters of the Renaissance felt at the sight of real ancient paintings about which they had been reading in the venerated classical authors. Scribbles left by distinguished visitors show that another assistant of Raphael, Polidoro da Caravaggio, had studied in the 'caves' (*grotte*). Shortly, these 'grotesques' started a new fashion in the decorative vocabulary of the late renaissance. What impressed the Renaissance artists was the richness of naturalistic vocabulary used so casually, and that fantastic play of imagination in which masks are at once decorative and real, plants are ornament and vegetable, and truth and fancy are boldly and inextricably mixed. They were less impressed by the delicate assurance of compositional schemes which essentially belongs to the so-called Third Pompeian style.

Executed in feverish haste under the supervision of a court painter who supposedly was so solemn-minded as to paint clad in a toga (the equivalent of painting while wearing a tuxedo or tail coat), these paintings of the colossal imperial villa should show the style of Roman painting in the years 64–68 A.D. The note of exquisite daintiness is even more strongly emphasized by the white background, the resemblance to jewelry by the orange-yellow of the matchlike structures and ornaments.

The section shown is the upper part of a wall in which these thin frameworks rose in zones; a similar delicate pattern continued over the barrel vault. One discerns on the right a tall pavilion, a bird floating within, a dolphin above. Thin sticks point downward and help suspend a slender green garland of leaves. In a spatially ambiguous trick the pavilion is linked by golden 'shelves' to a golden tripod on which an eagle perches. Metal (?) vases with plants and plants alone manage to stand on this band. A horizontal series of leafy arcs, palmettes pointing downward, goes in wirelike precision from 'pavilion' to tripod to the next unit.

After the fire of Rome in 64 A.D., there were acres of such ornamental walls to be painted in the colossal villa which Nero tried to construct in the very center of the city.

The architects Severus and Celer had planned much that was new and revolutionary; but the interior decoration did not keep up, except for some particularly luxurious units. In certain parts the House shone with gold, sparkled with gems, pearls, and shells, and had dining rooms, where ivory panels in the ceiling turned and perfume was automatically sprinkled. Some paintings were more ambitious than the sample shown—for instance the 'Golden Ceiling' much copied by Renaissance painters; but the poorly preserved figure work not particularly distinguished.

The haunting name of 'Golden House' arose from the façade of the vestibule which was gilded (Pliny, 36:

Rome, 'Golden House' of Nero, so-called 'Hall of Birds.' For location cf. E. Nash, plan p. 339, no. 5. Room 57 in Weege's plan.

M. R. Scherer, pl. 144, E. Nash, p. 344, fig. 414. On the Golden House in general, F. Weege, 'Das Goldene Haus des Nero,' *JdI* 28, 1913, pp. 127–244, pls. 4–22. S. Platner, T. Ashby, pp. 166 ff., figs. 21 f. A. Boëthi Chapter 3. P. McKendrick, pp. 189–195.

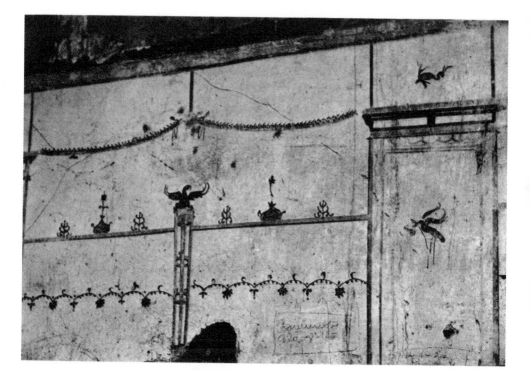

VIII Painting from the 'Golden House' of Nero

IX

There are times in the history of art when painters feel their imagination challenged by visions of colossal architectural prospects, by the desire to imagine a fusion of various arts blending into a symphony of architecture, sculpture, and painting. Stage designers of the baroque felt this intoxication. The sympathetic eye of Ludwig Curtius has discovered for art history a remarkable Roman forerunner in the most glorious example of the so-called Fourth Pompeian style.

The fragment from an unknown building in Herculanum is but the upper left part of a painted wall. A taller, lower part must be imagined underneath. This, the left part of the wall, in which the lines of architecture slant from left to center was surely counterbalanced by a mirror image on the right. The Roman compositional scheme, amounting practically to a law, called for a tripartite division with a frontal structure occupying the center. The total effect must have been breath-taking. For once, the term 'baroque' is not misplaced. The colors, however, are light in tone; the blue-gray of the curtain and the beige-pink and white of the background determine the impression as much as the gold and crimson splendor of architecture and ornament in the foreground.

To tell us that this is a world of illusion, a curtain drops from a tensile golden arch topped by a bearded mask. In the foreground is a mighty pavilion with broken pediment and two projecting brackets. The egg-and-dart profile seems to indicate a curving roof or ceiling in front. Plants climb up and down the sturdy columns, wreaths are suspended from golden shields under the brackets. Winged horses dash up the roof, two sea horses speed forward on the brackets. In the left wall of the pavilion we see a closed window, and an open triptych, at a curious angle. In the center of the roof, a tragic mask turns a reproachful gaze. In the upper part, a colonnade is broken in two, and majestic colonnaded palaces recede into the distance.

The Fourth style, which flourished from ca. 70–100 A.D., resumed the task of turning the walls into architectural illusions but imbued them with the surrealistic ambivalence of the Third style—with the sense that the ornaments and even architecture live and move. It owed something to stage painting (hence the masks). The manipulation of space, the desire for colossality, the use of broken and distorted forms were being translated at the same time into architectural reality by such architects as Rabirius who designed the Flavian Palace on the Palatine. No real architecture, however, could reach the imaginative fusion of reality and irreality which the best painters accomplished.

The unknown master of Herculanum went as far as any painter of antiquity in using the imperfect vehicle of central axial perspective to produce a feeling of almost infinite recession. The darkness of foreground colors against the gradually lightening background serves as a means to this end.

Naples, Museo Nazionale, 9731. 76½ inches (1.95 m.) high and 51½ inches (1.31 m.) wide.

L. Curtius, *Wandmalerei*, p. 174 ff., fig. 111. H. G. Beyen, fig. 152. A. Maiuri, *RP*, p. 48, (color).

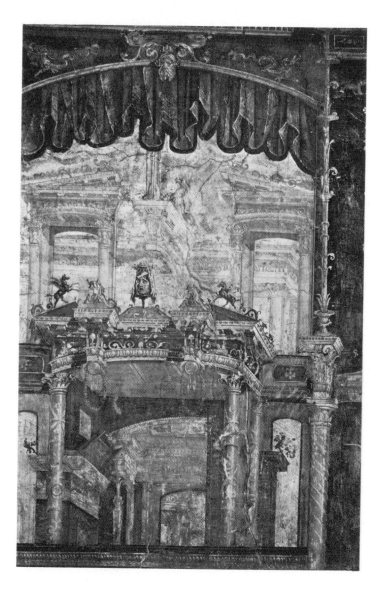

IX A Baroque Vision — The Wall Fragment from Herculanum

The design of that fabulous and fascinating building the Pantheon is discussed in the comments on the black and white illustrations (Figs. 28–30). Here part of the interior of the Pantheon is shown as an example of the coloristic effects of marble revetments, a luxurious, decorative art developed by the Romans to the highest pitch. Initial steps toward this type of revetment were presumably taken in Hellenistic palaces; at least, stones of varied colors seem to be imitated in the so-called 'First Pompeian'—actually Greek Hellenistic—architectural wall painting. With the possession of diversified marble quarries and the necessity of concealing the unostentatious texture of brick and concrete walls, the Romans used the increasingly gleaming, yet subdued coloristic effects of colored polished stones.

The pavement underwent a considerable restoration in 1872; its pattern consists of alternate squares of yellow marble and circles of porphyry or granite on a field of yellow marble.

The central, largest niche of the seven niches is occupied by the altar of the church. A picture of the Virgin of the thirteenth century is set into the wall; the altar and chandeliers were designed by A. Specchi (consecrated 1724) and the mosaic in the apsis belongs to the same restoration. The choir stalls date from 1840. Otherwise, the decorative system of the lower part is here seen nearly intact. The decoration above the cornice was altered by Paolo Tosi in 1747.

The spatial effects are typical of Hadrian, but as yet more restrained than in Tivoli; seven niches hollowed deeply into the wall, projecting forward with columns and entablatures, and, as may be discerned on the right, a screen of columns thrown across the niches. In the Pantheon, this back-and-forth is disciplined by emphasis on verticals and horizontals—the entablature, the horizontal band over the arch of the central niche, the metopal zone of porphyry and marble at the height of the column capitals. The vertical ascent is less emphatic, but there is fine gradation in the use of the spatially effective three-quarter pilasters of the side niches, the fully rounded columns which stand free of the wall flanking the central

niche, the pair of shallow pilasters in the background of the niche itself. Less happy, perhaps, are the little projecting portals on pedestals; even though tied by a band of color to the pattern of the wall, their triangular pediments disrupt the strong simplicity of its pattern.

The lower part up to and including the entablature is based on the color scheme of yellow and purple, interrupted by the white Parian marble of the base course and of the stepped part (epistyle) of the cornice.

The large fluted Corinthian columns (29 ft.–8.9 m.) have shafts of yellow marble, the so-called *giallo antico* the same material is used for the pilasters and panels. The small unfluted columns of the little shrines are of the purple-veined Phrygian marble brought from the quarries at Synnada (*pavonazzetto*); the purple panels (oblong in the lowest, circular in the second, and square in the third zone) are of porphyry. Over a frieze of porphyry, the top of the cornice of warmer-toned Parian marble is finely decorated with egg-and-dart and acanthus brackets.

The system above the cornice was radically altered in 1747; neither the false windows with triangular pediments nor the profiled panels are ancient. An attempt to restore the ancient effect has been made by A. Terenzio over the first niche to the right of the central apsis. On a pedestal stood delicate porphyry piers; between them three oblong panels were followed by nearly square false windows with grills.

Above this so-called 'attic' a second cornice (entablature) of Parian marble decorated with egg-and-dart serves as a base for the ascent in five tiers of the twenty-eight radial series of stepped coffers of the dome.

To the right of the main altar is a statue of the martyr St. Rasius by B. Cametti; the rectangular niche serves as a chapel of the Virgin of Clemency and has frescoes of the fifteenth century (Madonna with Sts. Francis and John the Baptist); to the left of the main altar the martyr St. Anastasius by F. Moderati (1717); behind the next two columns under the altar are the tombs of Raphael (1483–1520) and Lorenzetto (1490–1541). The Madonna del Sasso, for which Raphael had been commissioned, is flanked by commemorative stones for the painter Anni-

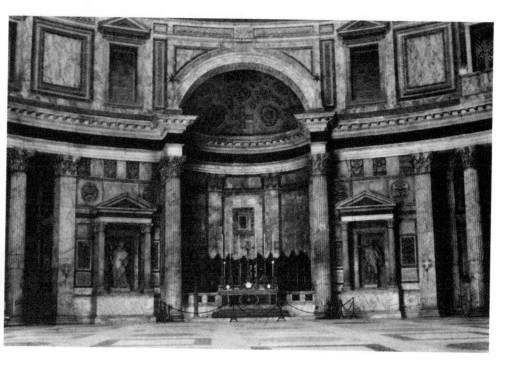

X The Interior of the Pantheon

bale Caracci and Raphael's fiancée Maria Bibbiena. Raphael was custodian of the Pantheon and left a legacy for Masses to be read for his soul, which are still being read by the clergy. The bust of Raphael is by Fabris (1833).

The apsidal chapel, and that on the opposite wall, contain the tombs of the kings of Italy Umberto I and Vittorio Emmanuele II. The first chapel on the right of the entrance has an Annunciation by Melozzo da Forlì (1438–1494).

L. Beltrami, *Il Pantheon*, 1898. A. J. Durm, *Baukunst der Römer* (2nd. ed.), 1905, pp. 550–572. F. W. Shipley, *Agrippa*, pp. 55–65. K. Ziegler, *RE* (1949), s.v. *Pantheon*, 43 (1953). R. Vighi, *Il Pantheon*, 1959. V. Bartocetti, *Santa Maria ad Martyres*, 1960 (careful description of present state), pp. 11 ff., 53 ff.

*

In 1857 F. Fortunati discovered a sepulchral complex which has become known as the 'Tomb of the Pancratii.' The mausoleum had two stories, one largely destroyed, above ground; the other, with two chambers, below. The Pancratii were a burial college who used the outer of the two subterranean chambers some time after the construction of the building. They need not have been the original owners.

The stucco decoration is particularly well preserved on the groined vault and upper walls of the inner subterranean chamber. In earlier Roman examples (Figs. 26, 107, stucco was treated primarily as a sculptural medium. In the vault of the Pancratii there is an interplay of plastic and pictorial effects. The large reliefs (of which one is seen in this picture) are done in white stucco relief on white background; smaller panels show white figures against red, blue, violet, and yellow backgrounds; and other panels are done in painting only.

The compositional principles of painted interior decoration after the end of the Fourth Pompeian style (79 A.D.) are still imperfectly known. There was apparently a return to the concept of a flattened wall and to the thin architectural decoration of the Third style, but the attitude toward decorative design had changed. Instead of optic illusion, which pretends to open walls and ceiling, the over-all composition aims at an abstract, geometric plan. Hand in hand with this schematization of form goes schematization of content. Instead of lively narrative sequences, the scenes and figures are arranged in accordance to conceptualized allegorical schemes. If Jupiter, who is being borne to heaven by an eagle in the center of the ceiling, is a symbol of immortality, if the Dionysiac beings of other panels stand for the happiness awaiting the dead, then presumably some allegorical meaning also attaches to the mythological scenes. The rape of the Palladium by Diomed, the sufferings of Philoctetes may be allegories for acquisition of wisdom through trials and suffering. Other myths shown may allude to virtues of the deceased—Achilles releasing the body of Hector to Priam may symbolize clemency; the Judgment of Paris love of beauty; and Hercules in company of the Olympians, virtuous strength.

The 'Tomb of the Pancratii' stands at the very beginning of this process of conceptualization and abstraction. However ambiguously, something still remains of architectural illusionism. Thus in the lunette shown in our picture we can see the triple façade with projecting wings, so familiar in Pompeian wall painting (Pls. VIII–IX). The central structure is covered by a shell, the side wings are very slender porches. A painting stands on the shell. It represents a mask of Ocean carried by two sea horses. Two cupids fling themselves on their knees. One holds a sword, the other a shield. Under the shell and the porches a peculiar architectural profile crosses the width of the structures; a cow and a calf, two panthers jumping at a vase, and a goat and a ram manage to do tightrope acts on this precarious perch. A young hero (center), perhaps Achilles, and two warriors occupy the main fields.

At the top of the ceiling, an oblong stucco panel shows an Apollonian youth ushering into the presence of a divine or royal couple a young huntress, who drives a chariot pulled by a lion and a boar. Admetus, husband of Alcestis, was supposed to accomplish such a feat. Two L-shaped panels display centaurs wrestling with panthers. The painted panels strike an idyllic-romantic key. They contain little landscapes, birds, baskets pleasant things which the dead would like to have about them. A generation later, Christians will paint them in the catacombs as allusions to Paradise.

Rome, Via Latina, at 'Cessati Spiriti.' Tomb of th Pancratii, inner chamber; right-hand (from entrance) wall Entire chamber 18 ft. 2 inches (5.45 m.) by 14 ft. 3 inche (4.28 m.). Dated by brickstamps 159 A.D.

E. Wadsworth, *MAAR* 4, 1924, pp. 75, 77, pls. 29 35:1, a basic discussion of stucco decoration. F. Wirth p. 83, figs. 41 f., pls. 14b, 16. M. Borda, pp. 96, 102, 27 (color).

XI Classicistic Romanticism — Stucco Decoration in the 'Tomb of the Pancratii'

XII

After the catastrophe which overwhelmed Pompeii, Herculanum, and Stabiae in 79 A.D., the development of Roman painting becomes difficult to trace. The first serious effort to bring the material from Rome and Italy into a stylistic sequence was undertaken by F. Wirth only thirty years ago; the first attempt to include some of the remains of wall paintings scattered through Roman provinces in a general history of Roman painting was made by M. Borda quite recently (1958).

Large areas of painted walls of the second and third century A.D. have been uncovered in the houses and mausolea of Ostia, the harbor of Rome (see Figs. 20, 22, 43; Pl. xv). Because these paintings were buried in loose sand they have suffered more than the hermetically sealed paintings of the buried cities of Vesuvius. But even after allowance has been made for their poor state of preservation, the Ostian paintings appear more limited in the range of subject matter and composition and less skilled in execution than the majority of Pompeian wall paintings.

If we study the wall decorations of the Roman provinces, we are left with the impression that this reduction in the range of wall paintings was a general phenomenon in later Roman art. Whether large figurative decorations became less frequent because easel paintings and mosaics increasingly took over these themes, is a question we can pose but cannot answer with assurance. That large figurative compositions were to be seen in Roman picture galleries appears to be the case from the description of such a gallery by Philostratus, early in the third century

A.D. As late as the sixth century A.D. the church father Procopius described large mythological wall paintings which he saw in a bath at Gaza.

Ostian wall painting is at its best when it attempts modest decorative tasks. In the chaste, ivory-white panel illustrated here, an effect of delicate elegance is attained by using a thin red frame, a slight, projecting porch (on the left), and by dwelling on the minute quality of the green garlands and floral 'candelabra.' A swiftly sketched central motif—a yellow-red bird falling head down—provides a touch of coloristic excitement for this rarefied decorative scheme, so much flatter and simpler than the Third Pompeian style (Pl. viii) to which it owes its basic inspiration. This simplified delicacy may, on the strength of other examples (Pl. xi) be taken as representative of the style of interior decoration which prevailed during the Antonine Age.

Ostia, Museo Ostiense 19c(1006). From Regio III, Insula x, 'Insula of the Charioteers.' One of a sequence of three wall panels. Height of part shown ca. 6 ft. 7 inches (1.98 m.). 150–160 A.D.

R. Calza, M. F. Squarciapino, *Museo Ostiense*, 1962, p. 111. B. Felletti Maj, *Monumenti della pittura antica*, sez. III, 'fasc. 1–2, *Le Case della Volta Dipinta e della Parete Gialla, Ostia*, 1961, pp. 32 ff. Closely related to decorations in the 'House of Diana,' F. Wirth, pp. 121 f., figs. 58 f. On interior decoration of the second century A.D., M. Borda, pp. 96 ff. On Ostian paintings in general R. Meiggs, pp. 436–446, who cites an inscription showing that the painters were organized in a guild of *collegae pingentes*.

XII Wall Decoration from Ostia

XIII

Isola Sacra, first described as 'Sacred Island' by the Byzantine writer Procopius (537 A.D.), was an area separated from the town of Ostia by the Tiber and from the port of Ostia by the canal built by Trajan. The cemeteries on the island belonged to the harbor community of Portus, and were used chiefly by middle-class people. In nicely built, vaulted tombs of brick the dead rested in peace amidst green plants and little gardens. Neither the inscriptions nor the decoration of these mausolea indicate feverish dread of death or exuberant hopes for an afterlife. The motifs chosen are those very common in Roman funerary decoration. Their significance lies more in the setting of a mood than in the expression of a credo.

The small tomb, the vault of which is illustrated here, was admirably preserved when it was first discovered by chance. Apart from a figure in the white, gabled pavilion at the back of the tomb chamber, the painted walls featured dolphins, birds, and flowers—each set in a separate panel. Thus, visually, the red medallion and the golden lozenge of the ceiling became the most emphatic part. Within two floral wreaths, Mercury with his magic wand and his purse floats in the center. Mercury, in traditions derived from Greece, conducted the dead to the lower world. Here, however, he guides them not under the earth but skyward; and the god himself has become an amiable child. What sphere is symbolized by the red medallion we do not know, but it is some pleasant place to which the four Seasons bring their presents.

The curious winged masks (flask-shaped?) and the gleaming vases placed radially in the yellow lozenge-shaped panel may allude to Bacchic pleasures.

Green bands outline the 'lozenge' and the triangular panels with the winged Seasons. Three of these are preserved. The amorino who brings grapes, his scanty garment billowing, is probably Autumn. The sun-tanned, aggressive boy swinging a shepherd's crook and holding a tray with a cup is Spring who often brings pails with milk. Winter is readily recognized by his heavy clothing.

In its position on top of the vault, the medallion corresponds to the 'eye' in the dome of Hadrian's Pantheon (Fig. 30). The concept of the vault as the 'Dome of Heaven' which had a long history before the Romans and was bequeathed by them to Early Christian art is thus illustrated in a modest way in this tomb.

The large red bands which frame the vault are continued in a series of arches and bands in the design on the walls below. The traditional architectural illusion of receding and projecting colonnades and pavilions is thus replaced; the arrangement of bands foreshadows the 'cobweb' system of the Roman catacombs in which red and green lines accompany the major architectural forms.

Ostia, Museo Ostiense 47 (10 113). From Isola Sacra Tomb 143, a vault with niches for ashes of the dead. Only the vault has been transferred to the museum. Diameter of the vault 4 ft. 10 inches (1.45 m.). 160 A.D.

G. Calza, *La necropoli del Porto di Roma nell' Isola Sacra* 1940, pp. 377 f., pl. vii, color of entire tomb. G. M. A Hanfmann, *CW* 35 (1941), pp. 90 f., development o Ostian painting.

XII! A Painted Ceiling from Isola Sacra

XIV

'And Christ the Lord will enlighten thee, the Sun of Resurrection.' Rarely can the transition from pagan to Christian imagery be grasped so vividly as in this mosaic of the only Christian mausoleum in the pagan cemetery excavated in the forties under St. Peter's Cathedral. As a young hero with flying cloak taming his rearing steeds enframed by circling vines, the Sun God charioteer would not be recognized as Christ were it not that the other subjects on the walls of the small burial chamber are unmistakably those which appear again and again in Christian catacombs during the time of persecution: a fisherman and fish, Jonah being thrown to the whale, and the Good Shepherd. But once the truth is known, every detail becomes significant—the arrangement of sun rays suggesting a cross, the intense upward glance, and above all the yellow background intended for gold, symbol of Light Everlasting which, after Resurrection, will shine on those who are saved. Here, in form and meaning, is the precedent for the golden domes of Byzantine churches.

As in other works of the 'time of crisis,' corporality is reduced, light and shade are simplified, fluency of drapery reduced to pattern. But the spiritual and emotional intensity is a positive charge, not a negative, as in so many brutal or dejected faces of pagan art. However imperfectly it may be expressed by the traditional pathetic formula of Hellenistic art, we sense that in the head of the charioteer the artist strives to convey some lofty concept exceeding his power.

Many instances can be cited from literature for the ease with which early Christians associated Sun Day and Resurrection with the image of the sun. Nor should we forget that perhaps at the very time when this mosaic was created, unter the Emperor Aurelian (270–275 A.D.) and again under Constantine, 'Invincible Sun' (*Sol Invictus*) was a strong competitor of Christ for men's souls.

Vatican. Mosaic on the ceiling vault of the mausoleum ('M') of the Julii under gate of main altar, St. Peter's. Yellow, green, light blue, black, white mosaic *tesserae* Christ's right (raised?) arm and two horses (?) lost. He is beardless, wears a girt tunic and cloak, and holds a bluish-gray world orb in the left hand. Sepulcher 6 ft. 6 inches (1.97 m.) by 5 ft. 5 inches (1.63 m.) Pagan mausoleum 150–175 A.D., redecorated with Christian subjects 250–275 A.D.

B. M. Apollonji Ghetti, A. Ferrua, *Esplorazioni sotto la confessione di San Pietro in Vaticano I*, 1951, pp. 29–53, pls. B.C. J.M.C. Toynbee and J. B. Ward-Perkins, *The Shrine of St. Peter and the Vatican Excavations*, 1956, pl. 32. Kirschbaum, pp. 37, 40–42, pl. III. M. Lawrence, in *De Artibus Opuscula XL, Essays in Honor of E. Panofsky*, 1961, pp. 333 f., fig. 26 (pagan chariot 'ascensions'). For St. Augustine on Sun worship, cf. G. M. A. Hanfmann, pp. 200 ff.

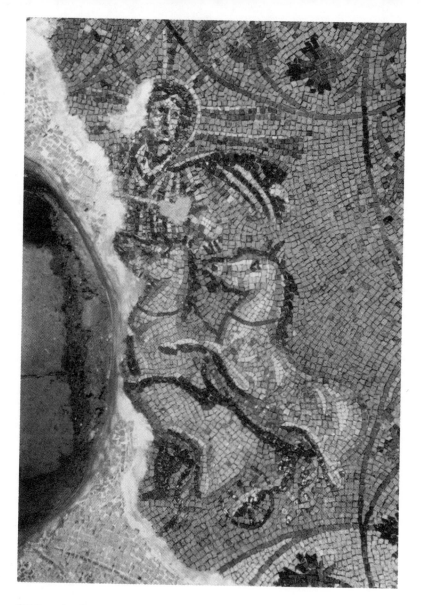

XIV Sol Salutis — Christ as Sun

XV

Marble had been suspect in Republican Rome; it is a remarkable fact that the beautiful marble of Carrara, a mainstay of modern sculpture, was not worked until Augustan times. The Elder Pliny (ca. 77 A.D.) lists it as a recent discovery. On the other hand, Augustus' boast that he left Rome a city of marble need not be taken literally, as most of the marble structures were public buildings. What is certain is that an art of interior decoration with marble slabs developed and flourished in the Roman Empire from the time of Augustus on. The technique calls for slabs to be fastened on a bedding of cement with iron pegs or hooks.

This art reached perhaps its greatest popularity in the late Roman period when the owners of rich houses aimed at the effect of subdued but shining splendor as it had been hitherto displayed in public buildings like the Pantheon (Pl. x). In its heyday, Ostia was an important point for transshipment of marble from Africa, Greece, and Italy to Rome; in the fourth century, spoiling of earlier structures provided sufficient material. In Asia Minor this tradition of *skoutlosis* or *opus sectile* continued unbroken into the early Byzantine age, for which Santa Sophia provides sufficient proof.

The charming *cubiculum* or bedroom 'E' in the House of Amor and Psyche is exceptional in having preserved not only the floor but also the wall decoration, at least in its lower part. The floor is arranged in patterns squares and triangles. The central motif is a rosette w the short rays set into a square. The frames of squa and rosette are done in a pink and yellow on dark speck green, an effect much like later intarsia work. The ou frame features a bead-and-reel pattern.

Over a purplish-gray socle there rise in a simple a chaste pattern vertical panels of veined marble, alt nately wider and narrower. Some of them are made fr a sepulchral slab of the second century A.D. They framed by strips of purple-gray *portasanta*. The effe somewhat startling in the narrow and intimate room one of a light, rather classicistic interior.

Ostia, House of Amor and Psyche, *cubiculum* 'E' from (entrance). Becatti lists *giallo antico*, porphyry, serpenti *portasanta*, *rosso antico*, gray, and red marbles as used the house. All of these had to be imported; large bl of African marble, of green *cipollino* from Euboea, anc white marble from Carrara have been found in a 'mar dump' on the canal from the port of Trajan to the Ti Floor ca. 10 ft. (3.0 m.) by 12½ ft. (3.75 m.). A copy of Amor and Psyche group has been placed on the orig columnar support of marble. According to Meiggs, fourth century A.D.

G. Becatti *Bda* 33 (1948), pp. 106 f., 198 f., figs. 6, G. Calza, G. Becatti, *O·'ie* (guide), 1956, p. 33, fig. 39. the marble decoration and date, R. Meiggs, pp. 72, 259 ff., 452 ff., 552.

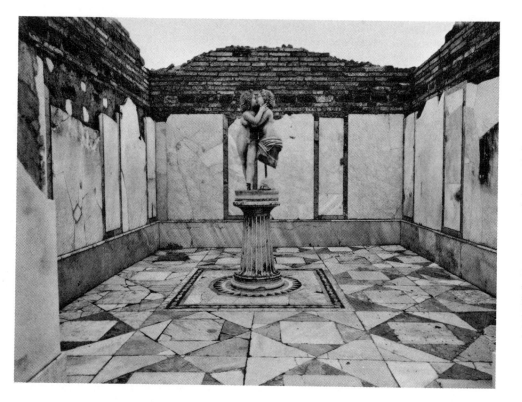

XV A Late Roman Interior — Cubiculum in the 'House of Amor and Psyche'

There is in all of ancient painting no scene which has provoked more comment, controversy, and mystification than the Flagellation Scene in the 'Villa of Mysteries.' A powerful winged woman, her nude upper body outlined against the dark purple wings, raises her arm high over her head. In a moment she will bring down a switch on the bare back of the cowering girl who kneels, seeking refuge, at the knees of a fine-featured seated woman. The winged demon or deity has bent her left arm; her fingers are spread out as if to ward off some unseen power. A purple-fringed yellow garment billows around her hips as she is about to pivot. Her feet are shod in the high boots of a huntress. The young girl is undergoing an ordeal; the woman with whom she seeks refuge draws the cloak from her back to let the blow fall—and how gorgeously and expressively is this nude young body described against the deep purple of the flying cloak! Her 'protectress' looks up with apprehension and anxiety toward the winged demoness, waiting for the blow.

Set off from the two are two other women of strikingly contrasting appearance. The one in the background, clad in a heavy purple-violet dress, with fine neck and delicate features, looks almost like an Elizabethan lady. Overlapping her whirls a dancing girl banging the cymbals, naked except for the flying yellow, metallically hard cloak which somehow manages to cling to her shoulder and knees. A wand of the bacchantes, the *thyrsus*, projects diagonally between the two, as if by a miracle of levitation. We know from other ancient works of art that the nude dancer is a maenad, a woman inspired by Bacchus to frenzy.

Many other mysterious scenes precede and follow the flagellation: A small boy reads from a book roll, a servant maiden brings fruit; a hidden object, probably a phallus, is being revealed in a winnowing basket by a kneeling woman. Nature, at least Bacchic nature, comes into the room. A young Pan and a Pan girl are seated on a rock. A satyr looks into a cup (Pl. XL), an old silenus enthusiastically plays the lyre. In the center of the composition the god of wine himself reclines in the lap of Ariadne whom Theseus abandoned on the island of Naxos and whom Bacchus then married and made immortal.

There are mortal women involved in this ritual, but no grown-up mortal men. The proceedings are being watched by a majestic lady (Pl. XXXIX), while in a separate scene a girl is being groomed with two little cupids in attendance. Surely this is a ritual in which one or several girls are being initiated into a mystery presided over by Bacchus and his bride. It has been suggested that the painting shows the initiation of a bride prior to her marriage. Whipping with branches is known in various cultures as a rite designed to insure fertility.

The artistic merits of the grouping, of the depiction of individual figures and of coloristic refinement, make the frieze the finest painting with large figures which has survived from antiquity, and yet there are also some weak passages and imperfections.

Is this a painting by a great master and his assistant which was designed specifically for this particular room of this villa, or is this strange frieze a copy or an adaptation of an earlier monumental Greek painting, perhaps seen originally in a temple of Bacchus in Hellenistic Asia Minor? An enormous amount of learning and ingenuity has been expended on these questions, but we cannot be sure of the answers. The pictures can, in any case, be taken as evidence for the pictorial quality which Roman painters were capable of attaining in the time of Caesar.

Pompeii, Villa of Mysteries, Room of the Great Fresco (no. 5). Ca. 29½ by 19⅔ ft. (9 by 6 m.), total height of fresco, 10 ft. 10 inches (3.31 m.), of figures ca. 4½–5 ft. (1.41–1.55 m.). Tempera technique, the 'Second style' background painted first, then the figures. Discovered in 1909.

P. B. M. Cooke, *JRS* 3 (1913), pp. 157 ff. M. H. Swindler, pp. 330 ff., figs. 532–536. L. Curtius, *Wandmalerei*, pp. 343 ff., figs. 186–197. A. Maiuri, *Misteri* I and II, pp. 121–174. fig. 60, pls. 10–12 (color), and *RP*, pls. 50–63 with color plates. M. Bieber, *Review of Religions* (1937), pp. 3 ff. H. G. Beyen, I, pp. 61–88, figs. 11, 14–21.

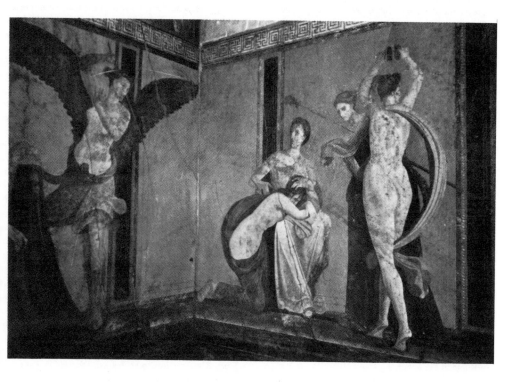

XVI Ritual Flagellation — Villa of Mysteries

for the decorative system and date. M. P. Nilsson, *The Dionysiac Mysteries of the Hellenistic and Roman Age*, 1957, pp. 66–76, 123 f. K. Lehmann, *JHS* 52 (1962), pp. 62–68. R. Herbig, *Neue Beobachtungen am Fries der Mysterien-Villa* (Deutsche Beiträge zur Altertumswissenschaft 10, 1958), for list of literature, pp. 70 ff. E. Simon, *JdI* 76 (1961) pp. 111 ff., figs. 3, 16 f. The date of the paintings has been placed by some at 60 B.C., by others ca. 40 B.C. Unresolved questions: An original design for a noble Roman family (M. Bieber), or a copy of a Hellenistic temple painting (Cooke, recently E. Simon)? Portrayal of actual ritual of Bacchic mysteries and/or initiation of brides, or a painting copied only for its æsthetic merit? *

With the rise of a taste for luxury, the Romans developed a great interest in gems. Julius Caesar gave six collections of gems to the temple of Venus Genetrix in his Forum: Augustus employed the great Greek gem-cutter Dioscurides to carve his signet ring. It is perhaps to Dioscurides that we owe the splendid masterpiece of cameo-cutting known as the Gemma Augustea.

The history of the Gemma Augustea resounds with famous names. Made at the court of Augustus, it must have wandered in antiquity or in the early Middle Ages—perhaps to Byzantium. In 1246 it was in the treasury of the Abbey of St. Sernin in Toulouse. It was described by Filarete *(Trattato del Architettura*, 24). King Francis I appropriated it (1533). It disappeared from Paris (ca. 1590) to be sold to Rudolph II of Hapsburg for 12,000 gold pieces.

The cameo is an Arabian onyx with one white and one bluish-brown layer. Even with its imposing size, nearly 10 inches (0.23 m.) in width, it is incomplete on the upper left, where at least one more figure appeared.

The ideology is akin to that enunciated on the statue of Primaporta (Fig. 50), celebrating the triumph of Roman arms. As in the reliefs of Primaporta, the world is divided into zones—the upper, a fusion of Rome, Olympus, and the world, of *urbs* and *orbis terrarum*, the lower showing the northern frontiers. The triumph on the battlefield in the lower zone precedes the triumph in Rome in the upper.

That Augustus is openly shown as a new Jupiter worshiped together with the goddess Roma, calls for an explanation. Although Augustus permitted this joint cult in some provinces (Dio Cassius, 51:20), he steadily resisted any attempt to introduce it in Rome. Either the cameo was made after Augustus was dead and deified, or the gem was destined for a recipient in the provinces or client kingdoms.

In the larger upper zone, attention is centered on the divine couple; in the lower zone, the action moves frieze-like toward the left. Displaying a radiantly heroic body Augustus holds the scepter in his left hand, the crooked staff of the *augur*, the Roman priest of prophecy in his right. The eagle, bird of Jupiter, sits under the throne. The zodiacal sign of Capricorn (sign of the month of conception, not birth) floats above. When Augustus was still a student at Apollonia, he visited the astrologer Theogenes, who flung himself at his feet, so impressed was he by Augustus' horoscope. A woman (*Oikoumene*, personifying the civilized inhabited world) with mural crown and veil places a *corona civica*, for saving lives of Roman citizens, on the head of Augustus. Roma looks admiringly at him. She, as well as Augustus, tramples on the armor of defeated enemies. On the right under Oikoumene, are the bearded Ocean and the Earth with the horn of plenty. One of her children peers over her arm, the other holding ears of corn, leans against her leg. Elsewhere they were called 'Fruits.' A youth in battle armor stands by Roma's side touching the pommel of a sword (?) with his left hand. Tiberius, a togaed, laureate triumphator steps from the chariot held by Victory.

The scene may refer to Tiberius' triumph in 12 A.D. over Germans and Pannonians, when, descending from his chariot, he did obeisance to Augustus. If so, the young man in armor is Germanicus, nephew of Tiberius (born 13 B.C.).

In the lower zone, two auxiliaries drag a kneeling man and a woman. Four warriors erect a trophy which includes a shield with scorpion device. Some see in this an allusion to the nativity sign of Tiberius. A second barbarian pair will be tied to it. The neck ring, worn by one barbarian, is the Celtic and Germanic torque; the strange-hatted allies might be Macedonian soldiers of King Rhoemetalces, who helped Tiberius in Pannonia.

The Gemma Augustea is based on dramatic Hellenistic compositions, probably paintings, known from other Roman copies. The coolly classicistic style of execution is very refined and favors a late Augustan or early Tiberian date (10–20 A.D.?). The skill of carving is breath-taking and defies reproduction.

Vienna, Kunsthistorisches Museum Inv. 79. Onyx, in German setting of the seventeenth century. Height 7 inches (0.19 m.). Width 9 inches (0.23 m.). Thickness ca. ½ inch (3.5–14 mm.). Some believe Roma a portrait of Livia. The image of Augustus Jupiter linked to (future) Roman triumphs already by Horace, *Odes* III, 5.

A. Furtwängler, I, pl. 56, II, pp. 257 f., III, p. 315. E. Eichler, E. Kris, *Die Kameen im Kunsthistorischen Museum Wien*, 1927, pp. 9, 52–56, no. 7, detailed literature and interpretation. *CAH*, *IV*, p. 156.

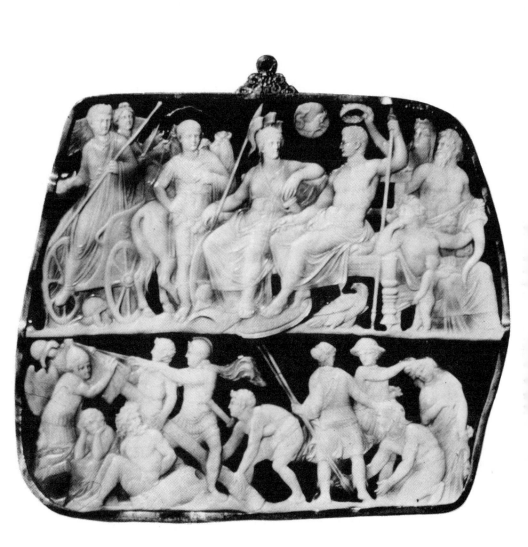

XVII The Gemma Augustea

XVIII

In the cross-vaulted room which now forms an ante-chamber to the famous room with the frieze of the mysteries (Pls. XVI, XXXIX, XL) there appears inserted into the architecture the likeness of a small easel painting. It is envisaged as standing on a shelf or architectural molding, rather high on the wall, directly above a large wall panel which shows an erotic scene between Bacchus and a satyr. The picture is a 'triptych.' Two black wings are shown open, as if hanging downward. Unlike medieval triptychs, these side panels have no figured pictures of their own. When closed, they served to protect the picture.

The central picture panel has a yellow frame. Rising on both sides, two groups of purple rocks open like a curtain to thrust into greater relief the main figure seen against a light purplish, vaporous background. On the left are tall reeds. On the right, tilted on a rude platform of stones is a phallic herm of Priapus, god of fertility and sexual strength. He wears a crown of yellow flowers. A large wreath of flowers hangs over his phallus, and yellow fruits lie at his feet.

Rushing forward with a mighty step, his head turned, a bearded man swings a flaming golden torch in his left hand. Even in front of the original, it is impossible to decide what he held in his right hand. His wild blond hair is crowned with reeds. A yellow necklace encircles his neck; a purple-gray kilt, probably an animal skin, girds his loins. A furry cloak flies off his shoulders.

In front and to the left of the man, a blond, pink-fleshed Amor with soft wings pricks a pig with a little goad. Amor seems to hold a wine-jar under his left arm. That the pig is being led to sacrifice is made certain by the bright red band *(dorsuale)* which is tied around the body of the animal. The right hind leg of the pig looks strangely like a human leg.

Amor's glance goes in the same direction as that of the

man, as if both were expecting assent or interruption of their nightly and sacred ritual. The deliberate placing over the Bacchus group suggests that this epidode is concerned with homosexual love among men.

This must be a definite story of someone driven by love to sacrifice to Priapus but the protagonist is difficult to identify. The reeds in his hair befit a river god but the rustic kilt and cloak would go better with a shepherd. The vigorous posture, the impassioned glance, and the wild flying hair of the main figure are familiar from such sculptures of the Hellenistic baroque as the altar of Pergamon and the Laocoon. The design is derived from an Hellenistic picture but not necessarily all details—although the pig's belt was known in Greek ritual it is far more common in Roman sacrifices.

The picture is swiftly stroked, in an 'impressionistic' technique, and a limited color range. As there is every reason to believe that the entire wall was painted simultaneously, it follows that already under the late Republic, this sketchy 'impressionistic' mode was deliberately employed side by side with the more finished, exactly detailed manner to be seen in the panel picture of Dionysus below and in the great frieze with the mysteries in the next room.

Pompeii, Villa of Mysteries. East side of 'Cubiculum with double alcove, no. 4,' Alcove B. Supposedly a bedroom attached to hall with mystery frieze. Height of picture without wings 9½ inches (0.24 m.). 60 40 B.C.

L. Curtius, *Wandmalerei*, pp. 372 f., an enthusiastic appreciation and inexact description of this 'ancient Magnasco.' A. Maiuri, *Mysteri*, pp. 55, 178 ff., fig. 68, and for Bacchus scene, fig. 67. P. Marconi, fig. 41. W. J. T. Peters, p. 9, pl. 1:2. For the Villa of Mysteries see also the literature with Pl. XVI, XXXIX, XL. On *dorsuale* cf. I. S. Ryberg, pp. 30 f. H. Herter, De Priapo. Giessen, 1932, pp. 26, 158. *

XVIII A Sacrifice to Priapus — Villa of Mysteries

XIX

Painted in big, bold, oblique strokes, this little picture makes one think of Flemish genre paintings but also of Daumier's dramatic impressionism. Its pictorial power stands up to such comparisons. There is immense skill in the way in which the figure of the man is blocked out against the subtly varied light of the door—or, to take a detail, in the dog sketched out in purple with gray and white highlights. Above and below the picture proper, a bright yellow-red egg and dart molding seems to belong to the architectural framework of the wall, not to the picture. Then we discover a long black-purple roof resting on a white pier—a stately building this. The blue sky is seen on the left of this pier and also on the right, behind the seated woman. Yet in front of this building stands a poor hut with a yellow thatched roof—the latter disappearing under the long roof of the stone building. The open entrance into the hut is light gray on top modeled downward into light yellow as if brightened from a light or fire within. Is the large building a stable or a palace?

A statuesque woman is seated on a strange gray round pedestal. She wears a pink-violet sun-hat like those of the Tanagra figurines. Her powerful forms are draped in a semi-transparent garment and a greenish-yellow cloak. A gray jar stands by the pedestal. In her left hand she holds a stick, in her right a cup. The man leans toward her, with one knee bent, a cup resting in his open hand. He is clothed in a tunic and short cloak and holds a long stick in his left hand. Fine highlights strike his garments from the right.

L. Curtius had ingeniously suggested that the woman is the goddess of harvests, Demeter, shown here during her wanderings when she had assumed the guise of an old woman. The 'peasant' then might be one of the kings who received her kindly. The strange conjunction of thatched hut and large stone building might be viewed as an allusion to a transformation of the poor hut into a palace. Others (B. Maiuri) have thought that the woman is a sorceress who hands a magic potion to the man.

The crux of the interpretation: does the woman give or does she receive the cup? In the original painting the former seems more probable; and if so, we have to revert to the non-committal title 'A Genre Scene.'

An early Hellenistic work may have served as model, but, for us, the picture is important evidence for the skill in pictorial impressionism reached by the best painters of the Fourth Pompeian style.

Naples, Museo Nazionale 9106. From Casa dei Dioscuri, VI:ix:6, tablinum. Cut from the center of the eastern frieze panel at the top of the south wall. Height 15 inches (0.385 m.). Left side damaged. According to a drawing made when the picture was *in situ*, Curtius, fig. 101, the oblong panel continued with landscape motifs on either side. 62–79 A.D.

Helbig, no. 1565, Curtius, *Wandmalerei*, pp. 160, 314 ff., fig. 181. Hermann, p. 170. L. Richardson, 'The Casa dei Dioscuri and its Painters,' *MAAR* 23, 1955, p. 126, pl. 23:2, 'Io Painter.' B. Maiuri, *Museo Nazionale di Napoli*. Novara, 1957, pl. 116. M. Brion, p. 197, pl. 3 (color detail).

XIX Woman and Wanderer?

XX

Those who have admired the unearthly beauty of the Byzantine wall mosaics of San Vitale or Sant'Apollinare Nuovo in Ravenna may well ask themselves, 'How and why did this artistic technique which covers the wall with a crinkly skin of tiny stones first begin?' The origins of mosaics lie in the Near East. When mosaics were introduced to Greece they remained for some time a floor decoration, a substitute for rugs. During the Hellenistic Age pictures were for the first time translated into especially fine mosaic technique. Such mosaic pictures were perhaps occasionally exhibited on the wall. A crucial step in the technique, the use of artificial glass pieces instead of natural stones, was the result of an expanding glass industry; they may have been made in Egypt, but our first examples of walls completely covered with mosaic come from Pompeii and Herculanum. The most striking of these is the fountain house and court of the 'House of Neptune and Amphitrite' excavated in Herculanum. Here a two-storied fountain façade with niches is completely covered with deep blue mosaic enframed by decorative pilasters, hung with garlands, and enlivened by charming hunting scenes.

The use of unrealistic sky- or water-blue revives the Near Eastern tradition of shining blue walls as seen in walls of glazed brick in Assyrian and Babylonian palaces —and anticipates the magnificent tiled mosques of the Middle Ages. These brilliant effects are attained by use of artificial glass *tesserae*. Because of the association of blue with water, such mosaics were favored for fountains and baths which even boasted vaulted ceilings covered with glass mosaics, *camerae vitreae* (Pliny, Natural History, 36:64) and the play of light on water must have enhanced the brilliance.

Something of the gorgeous ornamental effect of such mosaics is seen in our illustration. The entire panel is framed by a scalloped pattern of sea shells set in red paste. A symphony in blue of various hues sets the main tone. Displayed most effectively against it are the pale blue pilasters which, like the columns of the Second Pompeian style, grow out of lively and living chalices of leaves. In a wonderfully fantastic way a shell builds itself up on two vertical floral piers crowned by horns of plenty. Here the effects of geometrically designed, naturalistically executed ornaments gain from the contrasting colors.

The ancestors of these floral stems may be seen on the Ara Pacis (Fig. 102). A series of horizontal yellow leaves serves as base for the sharp radial ribs with golden sticks projecting from them at the top. The shell must be envisaged as a canopy spread out umbrella-fashion; the purple 'running dog' pattern and the golden zones of the canopy bring to mind luxurious fabrics of Tyrian purple woven with gold which are mentioned by Roman writers.

Within and under this canopy is a pentagonal panel. Poseidon or Neptune, ruler of the sea, a blue cloak draped over his arms and shoulders, holds his golden trident; his hair is white like that of an ancient mariner, but his brown body, strong and youthful, almost metallic with its sharp highlights. His consort Amphitrite leans on a pillar as she displays her body and moves her hips and arms, in a contrapuntal curve. She raises the cloak with one hand, holds lightly a scepter in the other hand. Both renderings are inspired by famous Greek works, that of Poseidon by a Poseidon statue, that of Amphitrite by a famous representation of Venus. They were probably translated into pictures before being retranslated into mosaics.

Compared to the triumphantly successful framework, the figures are slightly hard and simplified, but they hold their place within the decorative scheme.

Herculanum, V:7, Right-hand (side) wall of the Nymphaeum (fountain) room, part of the internal courtyard of Casa del mosaico di Nettuno e Anfitrite. Height of entire panel ca. 5 ft. (1.50 m.), surface buckled (head of Neptune); feet of figures lost. Date post-Augustan, fourth style.

L. Crema, 150, fig. 148 (with wrong caption) shows the wall in relation to the fountain placed at the back of the room. M. E. Blake, *MAAR* 8 (1930), pp. 11 ff. A. Tschira, *RM* 55 (1940), pp. 27 ff., A. Maiuri, *Herculanum* (Guide Books to the Museums and Monuments of Italy, no. 53, 1956), pp. 42 f., fig. 35, and *Ercolano*, vol. I, pp. 393–403, figs. 330 (plan), 332 (view through atrium straight on the mosaic), 333 (corner with mosaic and fountain), 336 f. (Neptune and Amphitrite, entire wall and detail). M. Brion, pl. 1.

XX A Roman Wall Mosaic — Neptune and Amphitrite, Herculanum

XXI

A large body, gleaming against dark shadows, an empty cup triumphantly lifted to the apex and center of the picture; soft light spreading mysteriously from the majestic figure of Dionysos, god of wine—these struck the eyes of the guests as they were about to step across the threshold into the dining room, the *triclinium* in a rich man's house of the great metropolis of Antioch in Syria.

Reclining easily on soft cushions, as ancient diners were wont to do, the god encourages the visitors to rival his deed. His magic ivy wand, the *thyrsus*, rests lightly in his fingers like a scepter. Without effort, Dionysos 'drinks under the table' the strongest hero of Greek legend. Herakles, muscular and bronzed, makes an unhappy face as he strains to empty his cup. His club and his robe are falling to the ground. A flute player pipes wild music into his ears. Meanwhile, Dionysos' little son Ampelos (the Vine) rushes in to applaud the winner. Bald, goat-faced Silenus, boon companion of the god, raises his hand like an umpire announcing the decision of an athletic contest. The soft-limbed god is victor, the athlete Herakles is 'down and out.' Emptied cups lie on the floor. The golden mixing bowl casts a mighty shadow.

Composed of many thousands of small, cut stones, the delicately tinted work translates a famous Greek painting into a mosaic. In simplified form the composition is repeated in a later mosaic at Antioch and in the Pompeiian wall paintings of Italy. To the Greek original, probably painted in the second century B.C., we may credit the skillfully intertwined chain of garments and figures which forms a large diagonal across the panel and creates the feeling that the picture becomes deeper toward the upper right corner.

The Worcester mosaic is one of the most advanced renderings of light and shadow that have come down to us from antiquity. Anticipating the chiaroscuro effects of baroque painters the artist contrasts a larger, light-filled area with a smaller section of deepening darkness. But no real light source could conceivably cause the individual objects—the club of Herakles, the staff of Dionysos, the overthrown cup, the mixing jar—to cast shadows so different in size and direction. And none of the figures casts a really well-defined shadow. The use of light is dramatic rather than realistic—it emphasizes the divine radiance of the god, and reveals the plasticity and texture of the individual bodies and objects.

The brilliant stylistic effects of the mosaic are those of the 'Flavian baroque' best known in Italy from Pompeian pictures of the so-called Fourth style.

Worcester, Mass., U.S.A., Worcester Art Museum. Floor mosaic from the entrance to the dining room of the 'Atrium House,' Island Quarter, Antioch-on-the-Orontes, ca. 50–100 A.D. Total area with border 72 $\frac{3}{16}$ by 73 $\frac{9}{16}$ inches (1.835 m. by 1.866 m.); without border, 32 by 59 inches (8.12 m. by 1.498 m.).

Antioch pp. 1, 13, 32, D. Levi, pp. 15, 21, pls. 1a, 146a. C. R. Morey *The Mosaics of Antioch*, p. 27, pl. 2.

XXI Drinking Contest of Dionysos and Herakles

XXII

'Wine, women, and song' is today's toast to the joys of life. For the Romans it was: 'Baths, wine, and women,' in this order. *Balnea, vina, Venus, corpora nostra corrumpunt sed vitam faciunt* ('baths, wine, Venus corrupt our bodies but make life worth while'), scribbled an honest Roman *bon vivant* on a wall at Pompeii. Venus is both the goddess and love; Dionysos or Bacchus, both the god and the wine. Hence the many representations of Venus and Bacchus in Roman bedrooms and dining rooms. The two strikingly similar compositions, that of Venus in a wall painting in Rome illustrated here and that of Bacchus in a mosaic of Antioch (Pl. XXI), reflect a kind of Olympian beauty and ease and retain enough of the traditional mythological framework to make the beholder feel that these divine figures are of another, higher, more heroic world.

This painting is one of the rare extensive mythological compositions from the period after the destruction of Pompeii (79 A.D.). The Cyprian goddess is shown in the midst of the sea, from which she originally arose at her birth. The breeze billows her garment in a triumphant arc. Her nude body is made to appear more voluptuous by the red, blue and purple garment thrown across her lap and by the necklace with its medallion falling on her breast. A handsome youth fills a cup with wine—or with nectar, traditional drink of the gods. His upright posture, with foot set on a rock, is known from a famous work by Lysippos, the court sculptor of Alexander the Great, and the main group is suggestive of late classic Greek painting.

Reclining on the rock behind Venus is another goddess, quite fully clothed, who may be Thetis, goddess of the sea. In the upper left corner, on a Roman arcaded pier lies another figure, personifying a harbor god.

The youth is probably Adonis, originally an Oriental god of vegetation (from the Semitic *Adon*—'The Lord'), but in Greek legend the son of a king of Cyprus and the beloved of Venus. His death was lamented by women in special rituals which, at Alexandria, involved a pageant portraying the wedding of Adonis and Venus and later a procession to the seashore. This may be the reason for the sea imagery of the Roman picture. Little cupids, children of Venus, are shown getting into boats and rowing away, perhaps to the island of Cythera.

The same youth and goddesses are shown on a Roman sarcophagus against the bustle of a busy port; there the youth is clearly Bacchus.

Only a small part (4.5 m. 1.7 m.) survives of what was originally a painted frieze nearly 100 ft. long. Appropriately, this marine picture decorated the fountain room *(nymphaeum)* of a Roman house of the time of Hadrian (117–138 A.D.). It well illustrates the sensuous romanticism of the period. In Christian times (fourth century A.D.) the room was redecorated, hence the damages to the frieze, such as the curved cut and the niche. The church of Sts. John and Paul was built over the early Christian building which was re-excavated in 1909.

Rome, 'Aula dell'Orante' under the nave of S. Giovanni e Paolo.

F. Wirth, pp. 80 ff., pl. 13. M. Borda, pp. 320 ff. and pl. E. Nash, I, p. 361, fig. 436. W. Amelung, *Dissert. Pontif. Accad. d'archeologia* 10, 1910, pp. 204 ff., pl. 16, sarcophagus.

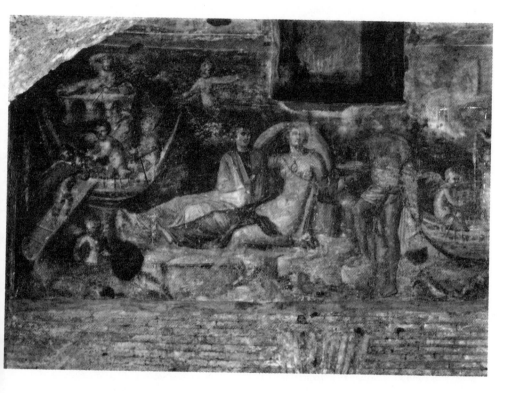

XXII Venus and Adonis in a Seascape

XXIII

Via Livenza 4 and Via Livenza 4a are two tall apartment houses of a non-committal style built in the 1920s. The concrete driveway of number 4 inclines, the driveway of number 4a is level. Enter a small iron gate in the slanting ramp and you are in Constantinian Rome, as you descend a steep Roman staircase under Roman vaults to come face-to-face with the Diana of the Springs.

What one sees today is only the northern end of a large hall which even in antiquity was concealed underground. It is a curious fountain structure with a central niche for an image. Below the niche, water cascaded into a deep basin. Marble railings separate this place of cult from the nave of the hall.

Fragmentary paintings imitating marble revetments and even more fragmentary mosaics on a blue background decorated the arch and vault above the fountain. The monogram of Constantine is imprinted on tiles in the bottom of the basin. As Christians emerged from the catacombs and Christian emperors assailed pagan cults, the pagans, in turn, went underground.

Above the cascades of real water, the worshippers saw a painted fountain at the top of the niche (only partly visible in our illustration). Jets of water fall from the red top into a golden vase and spill over into a rectangular pool. Four doves, one perched, another alighting on the edge of the vase, two feeding in a meadow of red and yellow flowers, complete the idyllic picture. Below, the niche is divided into black squares painted to imitate colored marble.

On both sides of the niche are mountain landscapes in gray and red frames. The sky glows with the sunset. Diana rushes forward through the woods. She holds the bow in her left hand and as she draws an arrow from her quiver, a stag and a deer gallop away in heraldic symmetry. Diana wears a laurel wreath surmounted by a small golden diadem. Over her sun-tanned body is a low-girt red tunic tied under her breast. Her cloak billows behind her. Her high hunter's boots are tied with red laces. Sharp highlights flicker in her glinting eyes, and in the folds of the cloak. She casts a vague shadow on the ground.

The sunset sky continues above the niche and carries over to a smaller, asymmetrical picture on the right (not shown). Here a young huntress, somewhat differently dressed, leans against a tree caressing a goat. She has been thought to be a nymph. Yet the left hand picture might show Diana of the Chase, ranging among the wild life of the mountains, the other could be Diana after the chase relaxing with the animals.

For late Roman painting the pictures are surprisingly delicate in coloring and lighting. Diana's red hair has real softness. There is a fine play of light on the rippling water of the fountain. The bodies are still well rounded. The landscape, though simplified, is continuous, not broken up into strips. Nevertheless, the lame posture of Diana, her lanky proportions, and the metallic quality of her garment fit in with the style known as Constantinian classicism, of which the sarcophagus of Junius Bassus presents a later, Christian example in sculpture (Fig. 13).

Rome, under Via Livenza 4a, east of Roman Via Salaria. Left-hand picture and part of central niche of fountain, north end of a large (70 ft. (21 m.) by 23⅓ ft. (7 m.), apsidal hall. Height of niche 6 ft. (1.80 m.), of Diana 3 ft. inches (1.17 m.). Dated by Constantinian brickstamp CIL XV, 1563 b., 330–350 A.D.

R. Paribeni, *NSc* 1923, pp. 386 ff., and Pontificia Accademia Romana di Archeologia, *Rendiconti* Serie II 3 (1923–4), pp. 45 ff., figs. 1–4. G. Wilpert, *ibid.*, pp. 57– interpretation as a Christian monument. P. Marconi, *pittura dei Romani*, 1929, p. 112, fig. 153. M. Borda, pp. 137, 353, pl. 23, dates 354–361 A.D.

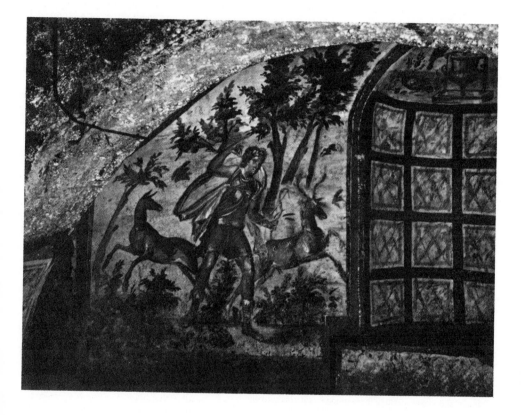

XXIII Diana of the Springs

There are acres of mosaics in the villa at Piazza Armerina. As the visitor climbs up the stairs and promenades on cat-walks in the modern glass and light metal cages designed to protect the ancient floors, he may be impressed by this huge output. Some of the mosaics can hardly be seen as units—the enormous 'Great Hunt' (Pl. L) can only be 'read' piece by piece as the spectator walks by. The so-called 'Little Hunt,' from which our illustration is taken, is better planned; at least it can be taken in at a glance as a large picture panel. Presumably, the artist depicts hunts which actually took place around the villa. Although he uses a number of stock motifs known from North African and other mosaics, his originality lies in the over-all plan of the composition, which is delightfully vague as to time and place. In the center, he set the thing hunters most enjoy—the colorful picnic scene after the hunt. On top, he shows the hunters departing and the fox being run to ground. Around the picnic are other episodes—hare hunt, bird hunt with falcons, stags driven into the net, and, in the lower right corner, the fierce boar being killed just as he attacks a fallen huntsman.

Above the picnic, the artist has portrayed a religious ritual such as proper huntsmen should observe. Flanked by two young men holding prancing horses, the chief huntsman sacrifices to the image of Diana. On the right is a boy with a dog, and a hunter holding a dead hare. It is toward this sacrifice that the two beaters (or slaves?), shown in the illustration, stride from the left. The boar is the major trophy, a proper offering to the goddess of the hunt. Whether or not this is the same boar being killed in another part of the mosaic, quite far away, the artist does not make clear—perhaps he assumed that this patrons knew.

The late Roman style related to that of the reliefs of the Arch of Constantine (Fig. 140) features big heads, squat flattened bodies, angular motion, unmotivated, 'formulaic' glances. While this style disintegrates the visual coherence of the setting and is careless of the sequence of time, it does not preclude lively narration and precision of factual detailing within individual groups. Thus the artist makes it quite clear that the dead boar has been put into a net and is carried on a bent pole. He has nicely observed the dog which cannot get over the excitement of the chase and which is trying to jump at the head of the boar. The costumes, too, are carefully explained: short, girt tunics with bands and shoulder patches, and leggings wrapped around the legs.

Here, as in other mosaics from Piazza Armerina, comparison with the reliefs of the Arch of Constantine makes one feel that painting or at least the coloristic arts began to lead the way. Color helps to avoid that slashing discontinuity which resulted when such motifs as the simplified black lines of garment folds were translated into stone, and the underlying schematization of the body is less obtrusive when covered by even slight modulations such as may be seen in the garments of the two hunters. The reduction of space to 'ground-lines' has not gone quite as far as in the mosaic of El Djem (Pl. XXXVIII) and the artist handles this device with greater freedom using it to create two continuous zones in the top part of his picture but reducing it to make the lower, more important part of the mosaic panel appear almost like a landscape seen from on high.

Villa near Piazza Armerina, *diaeta* (living room) 23 in Fig. 42. Mosaic. Dimensions of entire panel ca. 20 ft (6.00 m.) by 23½ ft. (8.00 m.). 300–330 A.D.

Gentili dates the mosaics 298–306 A.D. and identifies the three major hunters as the Emperors Constantius Chlorus and the Caesars Maximian and Constantine.

B. Pace, *I mosaici di Piazza Armerina*, p. 96, fig. 30. L. Bernabo-Brea, *Musei e monumenti in Sicilia*, 1958, pp. 148 f., black and white of entire mosaic, color detail. MacKendrick, p. 336, fig. 13:4, entire mosaic. G. V. Gentili, *The Imperial Villa of Piazza Armerina*, Guide 2nd ed., pp. 8, 29–31, description and fig. 14. G. V. Gentili, *Mosaici di Piazza Armerina, Le scene di caccia*, 1962, pl. iii, color, and text (no pagination). *Archäologischer Kalender 1964* (Philipp von Zabern Verlag), under *October*, color.

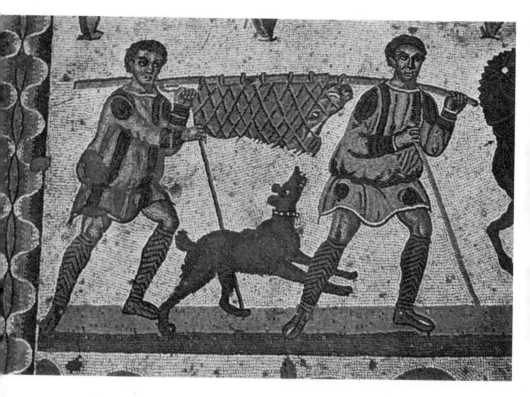

XIV Piazza Armerina — The Boar Has Been Killed

Their costumes have made them famous. Even people to whom Roman art meant very little were impressed when the mosaic found in a small room of the villa at Piazza Armerina revealed ten beauties dressed in a fashion seen on our beaches. Everybody realized how modern the ancients were.

Learned commentators recalled that the girls wear precisely what the famous Theodora wore when she appeared as an actress before her charms captured the Emperor Justinian (527–565 A.D.) and raised her upon the throne of Byzantium (Procopius, *Secret History* IX:298:42).

The mosaic panel is divided into two zones, one above the other. Each register shows five girls but only six are seen in our illustration. In the upper zone, the running legs of a girl survive on the left. The first girl shown here is about to take a long jump with weights in her hands. Then comes a disk thrower, and a runner; her competitor was farther on the right. All events shown were parts of the Olympic pentathelon.

Below, prizes are awarded. A girl acting as umpire bestowed a crown of roses on a smaller girl. The 'victor'-first figure on the left—extends her right hand to accept the prize; with her left she twirls a golden wheel.

Emphatically installed in the center of the composition—the first prize?—the next girl plants the heavy rose crown on her red hair; she holds the palm of victory in the crook of her bent arm. Her round-cheeked face is coyly turned as she looks down—into the audience? She wears red bathing trunks and a gray-blue brassière. The poses of the two victors imitate famous athletic statues. On the right, two girls (of whom only one is in the picture) play with a multi-colored ball.

Who are the girls and what is the occasion? Invoking Red Skelton and Esther Williams, Professor B. Pace has argued with much learning that the girls are professional performers in an aquacade: he considers that the lower bluish-gray band under their feet is the edge of a swimming pool.

That the girls are professional performers is probable though not provable. The track events they engage in, however, are suitable only for *terra firma*, not for a swimming pool. The prizes they receive are standard prizes for athletic performances which usually took place at the feasts of pagan gods. Because of the flower crowns one might think of some festival of flowers similar to the 'Festival of Roses' (*Rosalia*) celebrated in Roman Italy. If these are not real athletic events, then this must be a skit in which real games were parodied—the Olympic games, for instance, which were still celebrated in Antioch in the fifth century A.D.—and from which women were excluded! A 'take-off' by women would then be even more amusing.

In front of the original, one feels that this is not a copy of a stock motif. The artist knew the girls, sympathized with them, and carried hints of their individualities into his portrayals of hairdos and expressions. The style of his epoch, however, permitted only a limited appreciation of the 'Eternal Nude.' A glance back at the whirling maenad of the Villa of Mysteries (Pl. XVI), that hymn to the poetry of flesh, shows up the Bikini girls as hard and inert. Their heavy outlines, flattened pink flesh, and crude stylizations such as a yellow ring to outline the belly, a hook to depict the navel, become only too apparent.

Compared, on the other hand, to the squat proportions of the earlier Constantinian mosaics of the same villa (Pl. XXIV), the style of the 'Bikini Master' is elegant and his canon classicistic. Clearly, he belongs to that more balanced phase of art which extending over the later fourth and early fifth centuries A.D., culminated in the so-called 'Theodosian renaissance.'

Villa at Piazza Armerina, the inner of the two rooms (dressing room for performers?) at southeast corner of peristyle, No. 38 in Fig. 42. The mosaic is laid over earlier originally geometric floor. A nude silver Venus, well dated to ca. 350 A.D., is similar in style. R. Laur-Belart *Der spätrömische Silberschatz von Kaiseraugst*, 1963, p. 33 fig. 22. 350–400 A.D.

B. Pace, pp. 77 ff.; pls. XIV–XVI, color, P. MacKendrick p. 340, fig. 13:1. M. Bieber, *Theater*, pp. 237, 253, fig. 784 literature. G. V. Gentili, *The Imperial Villa of Piazza Armerina* (Guide) 2nd ed., 1961, pp. 38 f., fig. 74.

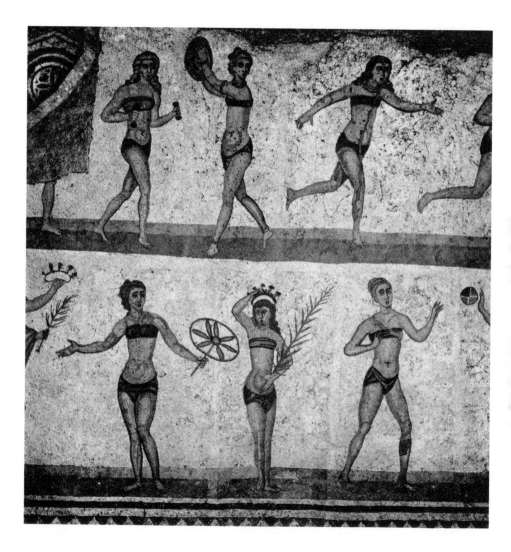

XXV Piazza Armerina — 'Bikini Girls'

One of the most remarkable finds made in the great sanctuary of Fortune at Praeneste (Fig. 11) was the discovery early in the seventeenth century of a mosaic with a bold, comprehensive view of the Nile valley as it was in the time of the Greek rule. The mosaic was discovered in the apse of the eastern hall. The Roman naturalist Pliny states in his encyclopedia of *Natural History* that ruglike mosaics, *lithostrata*, were introduced to Italy by the dictator Sulla, who 'caused one of them to be made of small marble *tesserae* (*crusta*) in the shrine of Fortune at Praeneste.' Recent research has tended to confirm the assumption that this mosaic, though perhaps made on the spot, was the work of a famous Greek mosaicist.

In 1625 the mosaic traveled for the first time to Rome; it was shaken up and completely reset in 1640 after designs for the baroque antiquary Cassiano dal Pozzo, who had the mosaic drawn after it had been lifted in pieces. Another restoration occurred in 1853 as the mosaic wandered back and forth from Praeneste to Rome and from Rome to Praeneste, the last time in 1953. A careful study by G. Gullini made during the last resetting has revealed that about half of the mosaic is restored in large patches. Enough is preserved, however, to prove the vast panoramic scale and give an inkling of the individual scenes. Our illustration omits the top part, which is largely restored, and some elements on the right and left.

The general subject was the Nile in flood, a phenomenon which excited great curiosity among the ancients; and the strange, exotic life, human and animal, which at this time teemed through the valley to the edge of the desert. The view taken resembles somewhat the view from a low-flying airplane. Such lively, objective observation is very characteristic of that phase of Greek civilization when natural sciences flourished and when natural history and geography received great impetus from the discoveries of strange lands, people, and animals. That the picture was to be studied not only for its artistic merit but also for its exotic curiosities was made clear by names ascribed to the various strange animals.

In the lower right corner is a colonnaded structure with a big awning to provide shade; behind it a tower house such as were to be found in Egypt. A group of soldiers, Greek or Roman, are gathering for a feast. Only those on the left are original. All around, Egyptian boatmen pole their canoes. A larger boat with a pleasure cabin (*dahabia*) is speeding along on the lower left, another sailing along on the upper right. The first casts a shadow which dances on the water. The engaging picnic scene in the submerged arbor is entirely restored. In the lower left corner, are two crocodiles and a hippopotamus on an islet; another hippo bellows, his head out of the water. A shelf-and-reed structure to the left is probably a shepherd's stable; oxen are driven to water and ibis birds fly about. In the upper part are sacred structures, on the left a Graeco-Egyptian sacred shrine with curious rounded pediment; priests and worshippers in white garments are moving in and around it; the wall to the left is restored. The next complex has an enclosure with two Egyptian towers, but a temple of Greek type. Two decrepit round structures are prefaced on the right by a typical Egyptian temple gate with *two* pylons. Various animals have climbed on the rocks in the water; from left to right, according to inscriptions, rhinoceros, 'monkey-pig' (*choiropithekos*), boar (*ephalos*), lizard, lioness, and lynx; those seen are largely ancient.

Palestrina, Museo Archeologico. Sanctuary of Fortune in Praeneste, 'Apsidal Hall.' Set in cement, ca. 20 ft. (6.56 m) wide by 16 ft. (5.25 m) high as restored. Mosaic cubes of marble set by hand in plaster, interstices filled with cement mixed with pounded terra cotta (*cocciopesto*). Set during the great rebuilding initiated by Sulla, and completed by his lieutenant Varro Lucullus ca. 80–75 B.C. Now reset on cement backing (1952); repairs of the seventeenth and nineteenth centuries in larger mosaic stones without the characteristic ancient cement in interstices.

M. H. Swindler, p. 318, fig. 509. M. I. Rostovtzeff, p. 254, pl. 254. F. Fasolo and G. Gullini, pp. 311 ff., figs. 433 f. (color details). G. Gullini, pls. 1, 13–28 (color), the only up-to-date account with exact indication of restorations. A. Rumpf, *Archäologie* p. 193, literature. O. Marucchi, *Bolletino della Commissione Archeologica Communale di Roma* 37 (1909), pp. 66–74, pl. 3, and *Dissertazioni della Pontificia Accademia Romana di Archeologia* 10 (1910) pp. 149–190, history and interpretations. E. Schmidt, *Studien zum Barberinischen Mosaik in Palestrina*, 1929.

*

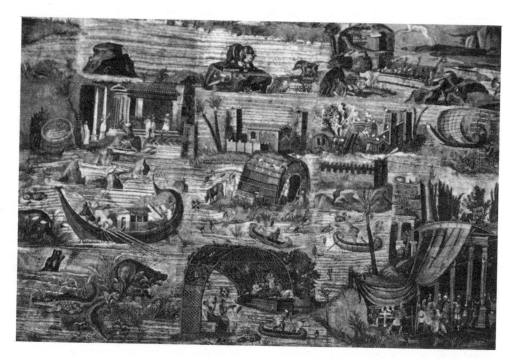

XXVI A Bird's Eye View of Egypt — Mosaic from the Sanctuary of Fortune at Praeneste

Since their discovery, the Odyssey landscapes have been the delight and the puzzlement of lovers of ancient painting. No other pictures of classical antiquity go as far in atmospheric effects, no others celebrate heroic nature as eloquently. Various theories have been proposed to explain these marvelous pictures. Some would see in them copies of a frieze-like Hellenistic wall-painting, giving the Roman copyist credit only for the architectural framework (P.H. von Blanckenhagen). Others believe that an illustrated Greek manuscript of the *Odyssey* was copied; hence the Greek names adscribed to the figures (K. Weitzmann). Others, yet, contend that while figures, groups, and parts of the setting were borrowed from earlier Greek models, the feeling for all-encompassing landscape is Italian, and allege that the Circe picture was chosen as the center of the series because of Circe's association with Mount Circaeus on the west coast of Italy and with early tribes and heroes of Italy in certain legends (K. Schefold). Another view is that these landscapes reflect, in art, that enlarged conception of nature which Stoics like a Poseidonios had popularized. 'Nature still receives its final animation from men; but the heroic mood is Nature's not man's. The perennial life of the universe will go on even when the Odyssey has ended' (G. M. A. Hanfmann).

The paintings were probably created by Hellenistic artists resident in Rome in the time of the late Republic. Writing around 25 B.C., the architect Vitruvius (VII:5,2) credits 'the ancients' with pictures of 'the wanderings of Odysseus through the countryside.'

Originally there were eight pictures in the sequence painted on the wall of a Roman house on the Esquiline for a total length of 48 feet (14 m.). The pictures were high up, ten feet above the floor, opening like windows onto a legendary world (Pl. xxviii). Pilasters with golden Corinthian capitals separate the scenes. In the recessed panels of the pilasters tiny cupids are painted in white. Adjoining the red pilasters, a row of dark purple piers suggest an external order surmounted by an entablature with masks and palmettes. The red pilasters carry a dainty gold and white Ionic entablature.

Odysseus has reached the land of the Laestrygonians, but the inhospitable natives attack the fleet (*Odyssey* x, 118–132). This picture, the second in the sequence, shows the Laestrygonians arming themselves with trees and rocks and attacking the ships which, however, are shown in the next panel.

The quiet, idyllic mood in the left part of the picture provides an effective contrast for the vigorous action on the right. At the lower left, a goat, reflected in the water, drinks from a light blue pool. Two white sheep graze at the feet of a pensive nymph who reclines on a rock. Seated next to her is a sunburned youth with the horns of a river god or a Pan, but the high boots of a hunter. He is clad in a red tunic and a purple cloak. The inscription above says: NOMAI, 'pastures.' High on the left, a shepherd drives his flock through the gray gate where another Laestrygonian stands guard. The city wall with its towers is seen on a ridge to the right. Painted only in silhouette from the back, a shepherd with a pointed cap turns toward the tumult.

In the center, a magnificently muscled Laestrygonian strives to break the trunk of a tree; a branch has already broken off. Past him, another Laestrygonian runs toward the shore carrying two spears. Another yet stoops to dislodge a rock. Along the beach, a native drags one-half of a dismembered Greek, hoists the other half on his shoulder. A fifth barbarian wades into the water pushing down a Greek of whom only an arm and part of the head are seen. At the upper end of the beach the king (inscribed ANTIPHATES) with an exclamatory gesture, 'utters a mighty shout' as he summons his people. In the hills above, three more Laestrygonians break and hurl rocks.

Rising diagonals of rocks and gorges, trees swaying in the wind, repeat the pattern of violent dynamic figures.

Vatican Museum, Library. From a house excavated in 1840 and 1849 in Via Graziosa (now Via Cavour) between Via Sforza and Quattro Cantoni. Fresco secco. Much damaged and restored. Height preserved 5 ft. (1.50 m.). Sequence preserved: Land of the Laestrygonians (*Odyssey* X, 9–110); Laestrygonians attack; try to destroy fleet (*Odyssey* X, 122–125); Sailing to Circe (*Odyssey* X, 126–141).

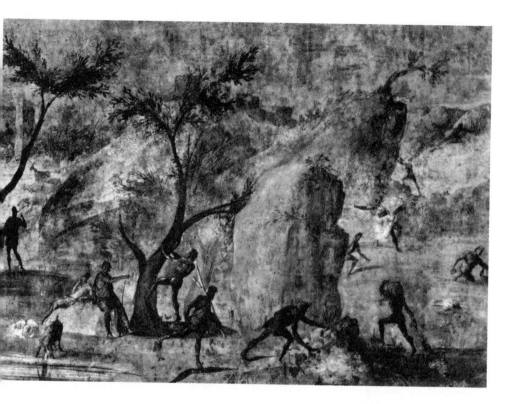

XVII Odyssey Landscapes: The Laestrygonians Attack

alace of Circe (center of wall) (*Odyssey* X, 308–324);
ntrance to Hades, Plate 71 (*Odyssey* X, 12–50); Punish-
ents in Hades, Plate 72 (*Odyssey* XI); a new fragment,
rens (*Odyssey* XII) 39–54, 158–200.

 B. Nogara, pp. 39, 42 f., pls. 9, 15, 16 (color). M. H.

Swindler, pp. 328, 338 f., fig. 529, 542. A. Maiuri, *R. P.
P*, 33. L. Vald Borrelli, 'Un Nuovo Frammento dei "Pae-
saggi del' Odissea"', Bd'a XLI: iv, 1956, pp. 289–300, pl.
IV color, Siren fragment, p. 299. figs. 14f., technique
(fresco plus tempera).

XXVIII

Two scenes are shown. At left, Odysseus at the entrance to Hades evokes the shades; in the extant half of the next panel are seen the punishments inflicted in Hades upon those who offended the gods.

'When you have crossed by ship the Ocean-stream to where the shore is rough and the grave of Persephone stands—tall poplars and seed shedding willows, go to the mouldering house of Hades. There is a spot where into Acharon run Pyriphlegethon and Cocytus... a rock here forms the meeting point of the two roaring rivers... and dig a pit... and round its edges pour an offering to all the dead *(Odyssey* X, 512 ff).

'So when with prayers and vows I had implored the peoples of the dead, I took the sheep and cut their throats and forth the dark blood flowed. Then gathered there spirits from out of Erebus... brides, unwedded youths and worn old men, delicate maids with hearts but new to sorrow; and many pierced with brazen spears, men slain in fight... In crowds around the pit they flocked from every side, with awful wail.' *(Odyssey* XI, 34 ff.).

Odysseus' ship lies offshore, sail billowing, oars lowered for departure. The green sea rises to a horizon lit by lightning rather than by the sunset. In an extraordinary chiaroscuro effect light pours through the bridged rocks upon Odysseus, his two companions, and the shades of the dead.

Two figures recline on the dark rocks; the lower personifying the infernal river, the upper a mountain deity. Fringed by swaying reeds, the still waters of the Styx lie at their feet. Sorrowing alone on the far rock is Elpenor, named by inscription, a companion who had died just before Odysseus set out for Hades. Standing broad-legged, Odysseus faces the tall figure of the seer Teiresias, who stoops to drink the blood of the sacrifice. Behind Odysseus are his agitated companions, Eurylochus and Perimedes. All are identified by inscriptions. Behind Teiresias, among the pallid dead, Phaedra, Ariadne, and Leda have their names adscribed *(Odyssey* XI, 90, 225 ff., 298, 320). The illusionistic strokes of color reach an apogee in the passage where the pale multitude of ghosts begins to materialize behind the far rock.

At first, one hardly perceives that there is a break in the landscape between the entrance to Hades and the rock over which Orion forever hunts the animals *(Odyssey* V, 121–124, XI, 309–310). Another figure, crouching, pushes a stone slab away from the precipice. This is Sisyphus condemned eternally to push a rock *(Odyssey* XI, 309). In the foreground, four blond daughters of Danaus pursue their endless task of filling a bottomless tub. A fifth Danaid sits mournfully under the rock, leaning on her jar. The name DANAIDES was inscribed over the girl in the center. The story of the fifty daughters of Danaus who had murdered their husbands does not occur in the *Odyssey*; it does appear in the 'pictures' of Hades by two Roman poets (Tibullus III, 79; Ovid, *Metamorphoses* IV, 463).

An eerie light suffuses the purple rocks and the meadows of varying greens.

Vatican Museum, Library. For details see Pl. XXVI.

B. Nogara, pp. 46 ff., plates after water colors. M. H Swindler, p. 339, fig. 541. P. H. von Blanckenhagen, *AJA* 61, 1957, pp. 79 ff., figs. 3–5. G. M. A. Hanfmann, *Dumbarton Oaks Papers* 17, 1963, p. 87, fig. 21. W. J. T Peters, pp. 27–32, figs. 15–21.

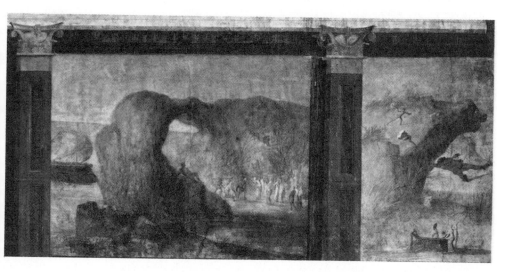

XXVIII Odyssey Landscapes — Odysseus at the Entrance to Hades — The Punishments
in Hades

Our time makes much of 'myth.' Yet it is difficult for us to envisage a highly civilized society in which myths were the known and customary vehicle of imagery and the drama and excitement of the present a secondary form of expression. In the times of the Late Republic, the old Olympian mythology in the grand epic manner had been battered by philosophy, science, and fatalism. A new mythology of state was presently reconstituted by Augustus in an allegorical-historic mode; but next to this grand official synthesis of myth, poets and painters were conjuring a little world of private mythology in which they vented the subjective emotions of the individual. The scandal chronicle of Rome records an intoxication with the arts of love which explains the popularity of erotic legends. Enchantresses celebrated by poets as Lesbias, Cynthias, and Lydias gained inspiration from mythological prototypes. As H. Gregory notes, within the framework of the mythology of the poet Ovid, even 'the incestuous girls of the *Metamorphoses* could argue their case with inspired anarchistic ardour.'

Mythological painting of the Augustan Age had much in common with Ovid's use of myth as the pathology of love. The very story of Polyphemus and Galatea depicted in this painting is the subject of one of Ovid's most engaging romances; and one of Rome's most notorious adventuresses in love, Julia, daughter of the Emperor Augustus, was mistress of the villa where this painting was found. Her daughter, the Younger Julia, cause of Ovid's banishment from Rome, may have looked at this picture; it is only fair to say, however, that the same erotic legend adorned a wall in the house of the stern Emperor Augustus himself.

Somewhat darkened and discolored, the picture shows in the foreground a statue of a goddess standing on a column. She holds a horn of plenty. A large slab of gray stone is thrown down to serve as bridge from shore to a pile of rocks in the sea. Here a tall column of porphyry rises; shields are tied to it at mid-height and it is topped by a gleaming bronze vase. Behind the column, a tree spreads its gnarly branches. Goats, black and white, pasture on the rocks.

Taking the center of the stage, large but not gigantic, sits the one-eyed Cyclops Polyphemus. A shepherd's crook is at his knee, a skin is thrown over his loins. He is trying to charm fair Galatea with rustic piping and song. The sea nymph Galatea, on the left, is borne off through the sea by a dolphin. Her slender legs shine through a transparent yellow garment; her body stands out nude and white against a purple cloak arching in the wind.

On the left and in the background is land, a small shrine, then wild cliffs. Diminished in scale but powerful in stride, Polyphemus appears once more as he heaves a rock at the fleeing ship of Ulysses. This scene is from the Homeric Odyssey; Polyphemus has been blinded and vainly seeks to take revenge.

The two scenes within one painting are from two different legends. In the poems of Theocritus (11:19ff) and Ovid (*Metamorphoses* 13:738 ff.) the Calibanesque but bucolic Cyclops woos in vain the dair.ty Galatea; in Homer he is a gigantic man-eating ogre. The same 'double exposure' is used by Ovid; in midst of the Galatea romance the seer Telemus prophesies to the Cyclops that Ulysses will unhook his eye. Painter and poet strive to unify and synthesize two divergent portrayals into one pathetic image.

In Ovid's account, Polyphemus' love illustrates the tenet that 'all is moved by Mother Venus.' In the painting the erotic element is sophisticated and allusive. The emphasis shifts to the setting, the fairy-tale land, picturesque, pastoral but not devoid of rustic sanctity. This is the never-never land urban sophisticates were dreaming of. P. H. von Blanckenhagen has well shown how the floating, discontinuous composition contributes to the feeling of irreality. He sees in the 'Painter of Boscoreale' the creator of an entirely new kind of both the 'sacral-idyllic' (Pl. xxx) and mythological landscape and the discoverer in the landscape of 'the intangible air in which and through which life exists.'

New York, Metropolitan Museum 20.192.17. From the west wall of 'Cubiculum 19,' Villa at Boscotrecase. Dimensions of room 10 ft. 6 inches (3.2 m.) by 17 ft. 8 inches (5.4 m.), of picture panel, height 6 ft. 1½ inches (1.875 m.), width 6 ft. 3½ inches (1.93 m.). Plan in *NSC* 1922, p. 459, fig. 1 and von Blanckenhagen, p. 12. Fresco secco. Surface damaged and partly missing.

P. H. von Blanckenhagen and C. Alexander, p. 38 ff., pls. 23, 40–43, D (color); appendix on technique by G. Papadopulos. For ownership and date see pl. xxx.

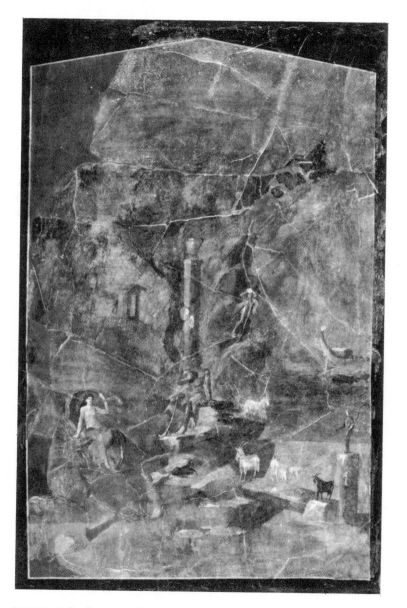

XXIX Polyphemus and Galatea — A Mythological Landscape

XXX

The charming, fleeting vision of a 'Sacred Island' is one of three landscapes which decorated the three walls of a small room, the 'Red Room' of the same villa which also yielded the mythological picture of Polyphemus and Galatea (Pl. xxix),

Among thin and elegant architectural motifs the picture panels are set against the rich red expanse of the wall and executed in swift strokes and pastel-like colors. The color contrast makes them stand out like windows opening onto a world of shepherds, gentle animals, and gracious divine and semidivine presences.

The painted landscapes are curiously bound to the realities of the room by the fact that the light in the paintings is envisaged as coming from the open, south side of the room (from which a view of the real and splendid landscape of the Gulf of Naples opened to the beholder).

'A rocky island with one large tree is characterized as a sacred place by the statue of a seated deity. Next to it stands a tall column decorated with shields. A bronze vase stands on top. To the left, on a square base, is a cylindrical monument covered by a red-tiled dome, decorated with sacred bowls or shields and garlands. A painted panel is propped against the base. To the left of the monument, a shepherd at ease leans against the sturdy square base of a short column, which again carries a vase. Three goats pasture on the rocky ground.

'On the right, a slightly curved bridge over grayish-blue water connects the island with the shore in the foreground. Two women and a child walk across this bridge. The first woman holds a branch or torch in one hand, while the other hand is stretched out in a gesture of veneration. The shore, too, is sacred; there is an altar, and on a pedestal next to a tree an ithyphallic herm.

'Behind the island, separate and distant, there is a grove protected by an enclosure with windows. There are two temples, the larger and nearer with a red roof on which stands a statue. It has a porch with columns. To the right, farther away, is a smaller temple. A shepherd, holding a staff, sits on the steps of the larger temple. Two men stand by the smaller structure' (paraphrased after von Blanckenhagen).

The island belongs to the goddess whose statue takes the central place. She holds a scepter in her left hand and wears a crown. She must be a goddess of nature, but whether it is Ceres or Persephone or Cybele remains uncertain. Phallic herms and phallic images of the fertility god Priapus were often set up in the Greek countryside. Von Blanckenhagen aptly recalls the shepherds of Theocritus (1:21, 310–245 B.C.) who sit 'beneath the elm facing Priapus and the spring.'

'The Boscotrecase painter... did not invent sacrodyllic landscape... but he discovered its potentialities and thus its essence. For us he is the founder of a species of Roman art that is perhaps more pleasant, more immediately accessible, and more rewarding than any other' (von Blanckenhagen).

Naples, Museo Nazionale, 147 501. From north wall of the 'Red Room,' Cubiculum 16, Boscotrecase; a rustic villa discovered and excavated 1902–1905. Height of the part shown ca. 2 ft. 2 in. (0.65 m.), cracked and mended. 'Uniformly colored backgrounds were painted with a lime medium over a highly polished lime and marble dust foundation, which was kept moist. The design details were executed with the same medium over the uniformly colored background' (L. Pitkin in P. H. von Blanckenhagen, pp. 65 f.).

The paintings belong to the very beginning of the Third Pompeian style. M. I. Rostovtzeff, pl. p. 552 f., pointed out that inscriptions incised on a column, on two jars, and on a tile prove that the house belonged to Marcus Vipsanius Agrippa (died 12 B.C.), the great admiral, statesman, and ablest helper of Emperor Augustus and then to his son Agrippa Postumus (12 B.C.–14 A.D.). The paintings may have been executed after an interruption. Possible dates for the landscape paintings are ca. 10 B.C. (von Blanckenhagen) or 3–7 A.D. (K. Schefold, *Die Wände Pompejis*, 1957, pp. 2, 356), depending on the view one takes of the beginning of the so-called Third style.

M. Della Corte, *NS* 19, 1922, pp. 459 ff. C. Alexander, *Metropolitan Museum Studies* 1, 1928–9, pp. 176 ff. K. Schefold, *Vergessenes Pompeji*, 1962, pp. 11, 59, 61 ff. pls. 38–42, 8 (entire panel in color). Exemplary publication by P. H. von Blanckenhagen and C. Alexander, pp. 15 f., 22 ff., pls. 10 f., 13, 32–34, Color pl. C. Technical appendix by G. Papadopulos and L. Pitkin.

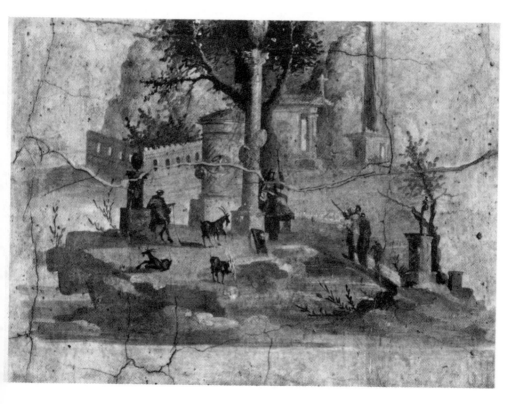

XXX A 'Sacral Idyllic Landscape'

XXXI

This celebrated 'sacral-idyllic' landscape from Pompeii is here for the first time reproduced in color. Its tonality may come as a surprise. Dominated by purple-gray suggestive of dusk, it also features stronger red-browns in the rocks, in the small building, in the statue of Priapus, in the reclining mountain god and the pasturing goats. Paris is clothed in a whitish-gray long-sleeved, long-legged garment. He wears a red-brown cap, cloak and boots. The mood is more important than the story. Were it not for his Phrygian cap, we might never know that the shepherd is Paris. Peace and solitude, the happy solitude which Paris was to lose, are the themes. The statue of Priapus, the arch crowned by a vase, the mountain god of Ida, who reclines in the distance express that sense for the divine in nature, which antiquity never quite lost. Those who know the rugged life of the shepherds in the Mediterranean, can appreciate the extraordinary idealization which led first the urban dwellers of Hellenistic cities and later the Romans to select the bucolic existence as a vehicle for their yearnings.

Although central to the composition, the figure of Paris is small, almost insignificant, a sophisticated allusion to myth, designed to heighten the poignancy of this *Abendstimmung*.

The landscape, as often in sacral-idyllic landscapes, is rugged, noble, and summary, a symbolic nature having no resemblance to the exhilarating pine-scented freshness of the real Mount Ida. The way in which animate beings are scattered through it, the emphatic accent on the living, growing tree, even the movement of the brush strokes are used to 'animate,' in a very literal sense and to suggest that nature is the mold and source of life.

Naples, Museo Nazionale 9508. From Pompeii. Height 17-⅜ inches (0.69 m.). Upper and lower right corners restored; cracked and buckled. Lower left corner disfigured by repainting. There are traces of bluish-gray water from a pool in the foreground.

C. R. Morey used the picture to exemplify a hypothetical 'Alexandrian' style of painting, but no proof for existence of such pictures in Alexandria has been found. Probably 60–70 A.D.

A brilliant analysis of this picture and the 'idyllic' landscape generally by L. Curtius, *Wandmalerei*, pp. 385–390, fig. 208. W. Helbig, *Wandgemälde Campaniens*, 1868, no. 1279. Herrmann-Bruckmann, pl. 8. M. H. Swindler, p. 373, fig. 581. C. M. Dawson, pp. 88, 126 f., no. 18, pl. 6. C.R. Morey, *Early Christian Art*, Princeton, 1942, pp. 37 f. fig. 34.

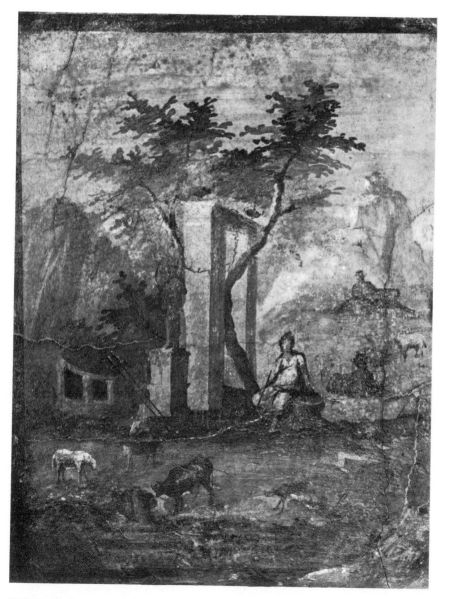

XXXI Paris on Mount Ida

XXXII

The title is a misnomer but gives something of the mood of this remarkable picture. Within its dark red frame, the painting is sketched with ephemeral lightness. Its dominant colors are white-gray and light purple; but in the foreground there is a matt yellow-brown tone.

A mountain wall rises in the background crowned by a high plateau and cleft by two gorges, one of which descends obliquely amidst cubistic purple rocks to reach a dark green glen (at lower left). A white goat grazes, at the edge of the abyss. On the other side of the gorge, silhouetted in purple, stands an image with hat or helmet, quiver and lance. Drawn faintly in white, a worshipper (?) stands in a posture which practically duplicates that of the statue. Loosely balancing this group, a sheep and a shepherd holding a cross-barred staff are seen on the rocky platform on the right. Another sheep grazes below. These figures, too, are faint, evanescent, ghostlike.

Placed firmly in the center of the composition is a sacred precinct. It stands on a marble platform. The low shrine is covered by a roof with red tiles which is topped by a floral finial. The garlanded door is open. Two elegant monuments flank the sanctuary. Their entablatures are crowned with palmettes and voluted acroteria. A sun-tanned brown shepherd pushes a dark, large-horned ram toward the sanctuary.

The image on the other bank of the gorge may be that of Diana, goddess of the wild. Others have suggested two images of Silvanus (B. Maiuri) or two herms (L. Curtius). The ram is hardly a lost ram retrieved by a good shepherd but rather a recalcitrant victim led to be sacrificed at the shrine.

There is a fine modulation of color in the rocks of the background which start in dark gray, turn purple-white, and finally gleam in purple-pink, as if the last rays of the sun were striking the mountain wall.

A glance at the landscape with Paris (Pl. xxxi) suffices to show that the painters operated with a certain stock repertory of 'bucolic' motifs—the grazing herd, the sacred shrine, the lonely tree; but such a comparison also shows the subtle variation of mood and accent attained within the framework of tradition by changes of scale—human figures and architecture are smaller, the mountains are larger in the 'Lost Ram.' In the exploration of nature as an entity superior to man, antiquity has never gone beyond these schematic, dreamlike landscapes.

Naples, Museo Nazionale 9418. From Pompeii. Height 3½ inches (0.44 m.). Cracked. Upper right corner restored W. Helbig, *Wandgemälde Campaniens* 1868, no. 1564 L. Curtius, *Wandmalerei*, p. 393, fig. 213. B. Maiuri, *Museo Nazionale di Napoli*, 1957, pp. 108 f., color detail.

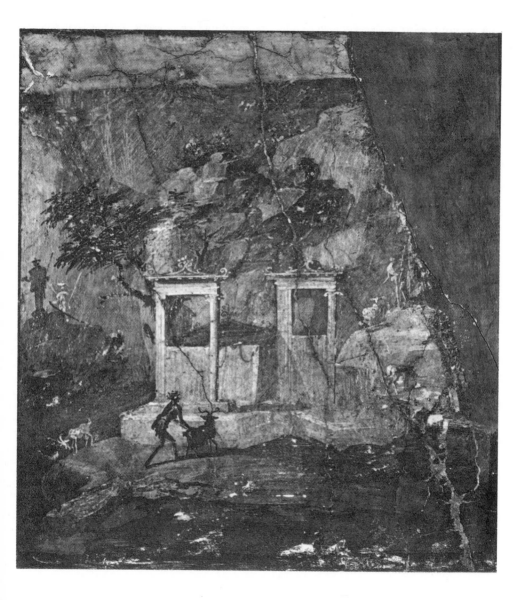

XXXII 'The Lost Ram'

'The essential character of illusionist painting is that it demands of the spectator to concentrate into spatial unity, by means of his complementary experience, color tones which are disconnectedly juxtaposed.' Thus commented F. Wickhoff on the extraordinary painting which he saw as 'the only historical illusionist painting at Pompeii.' Whether we call such pictures the last phase of Hellenistic Greek art or the high point of Roman 'Flavian baroque,' it is clear that the attitude of the artist was totally different from that of the classical Greek tradition with its firm delineation of monumental human figures and precise statement of setting.

The Trojan Horse, bearing in its belly the destroyers of Troy, enters creakingly the sanctuary of Athena. Strong white light strikes a group of Trojans; leaning back as one man, they pull at the ropes. Painted in yellow with a red mane, the forepart of the horse emerges behind from a towering, Roman-looking, many-storied structure. In the lower right are solemn, columnar figures of praying women and children. Light skims over another phalanx of women with torches; behind them 'an almost formless mass of hooded men, vague shapes, distinguishable only by halberds' (A. Maiuri) as soldiers.

Three frenzied figures of terrifying eloquence bring madhouse into the scene. One dashes out of the picture, terror personified, like E. Munch's 'Shriek.' Another, arms thrown into the air, implores or curses in front of the horse. The third, a whirl of draperies and limbs, flies forward as if to whip the horse—isolated with uncanny effect against the emptiness of the ground. We know from another painting of the Trojan Horse in Pompeii that in the composition which served as model these figures were three dancers aligned in the foreground—their insensate joy a bitter comment on the tragic deception but only a subordinate part of the design. To make them into key figures was a stroke of genius.

A tree, a pillar, a quiescent figure in heavy robes seated at its foot; a temple, dimly outlined, shut off the area of mass action on the right from the left part of the painting where four individual figures cry out portents of catastrophe. In bronze-red glow the statue of Athena in armor rises against vague hill and arch. Her pedestal is wound with garlands of supplication but she will abandon Ilion. The diagonal of her lance is echoed by the flaming torch of the woman above who rushes away —Ate, who blinds mortals to divine wrath, who will fling her torch into Troy. With desperate imprecation a woman in heavy cloak sinks to her knees before the statue. Cassandra, who knows the danger but cannot make others believe her, swoops in from the left, black hair flying, torch in hand. Ghostly walls and towers of Troy float in the half-gloom above. Mt. Ida looms up on the left.

The story of the Trojan Horse, first told in the *Odyssey*, became of special interest to Romans after the claim that Romans descended from the Trojans gained currency. Plays about the *Equus Troianus* were given in Rome already in the third and second century B.C. Books illustrating this and other epic stories were undoubtedly current in Rome and Pompeii but their illustrations were essentially linear drawings. Another Pompeian painting, wider in space, less intense in effect, and pictures of the Trojan Horse in small reliefs prove that major components are derived from such Late Hellenistic illustrations—the components, not the whole. Slashing light, faceless masses, and frenzied leaders— the visionary irreality of this dance of doom is an inspired creation of a Roman painter—and his alone.

Naples, Museo Nazionale 9010. Painting from Pompeii. 1 ft. 4 inches (0.39 m.) by 2 ft. 1 in. (0.62 m.). Surface much darkened and cracked.

F. Wickhoff, *Roman Art*, 1900, pp. 149, 180, pl. 12. C. M. Dawson, pp. 86 (no. 13), 129, 155 ff., pl. 5, with discussion of other representations and legend. A. Rumpf, *Archäologie.*, p. 180, pl. 63:4, literature, A. Maiuri, *RP*, pp. 75 f.

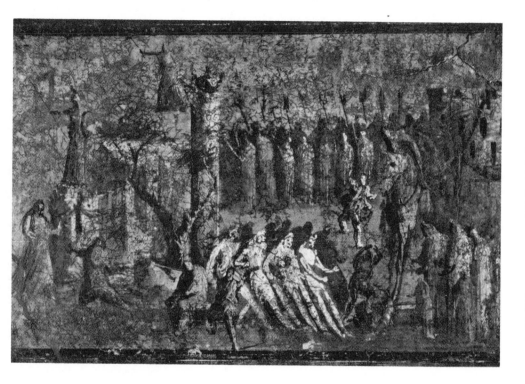

XXXIII The Night of Doom — The Trojan Horse

'…Remember
To fly midway, for if you dip too low
The waves will weight your wings with thick salt water,
And if you fly too high the flames of heaven
Will burn them from your sides. Then take your flight
Between the two.'

Thus did the mythical inventor Daedalus instruct his
son Icarus when they took off for the first man-powered
flight.

'Far off, below them, some stray fisherman,
Attention startled from his bending rod,
Or a bland shepherd resting on his crook,
Or a dazed farmer leaning on his plough,
Glanced up to see the pair float through the sky,
And, taking them for gods, stood still in wonder.'
Then came the crash. Icarus '…steered toward heaven.
Meanwhile the heat of sun struck at his back
And where his wings were joined, sweet-smelling fluid
Ran hot that once was wax. His naked arms
Whirled into wind; his lips, still calling out
His father's name, were gulfed in the dark sea.'

(Ovid, *Metamorphoses* 8, trans. Horace Gregory.)

With its rapid flashes of drama, its panoramic view of
earth and cities, its realistic portrayal of commonplace
spectators, the swift telling of the catastrophe, the boy
now falling, now drowning, Ovid's story of the age-long
wish-dream of humanity—to fly— has much in common
with the rendering of the flight of Daedalus and Icarus
in the Pompeian wall painting.

In the upper left corner, the Sun God, unwitting cause
of Icarus' fall, steers his chariot through the sky.
Sprawling head down, Icarus begins his fall, his arms
flung out, his legs bent, the wings detaching themselves
from the shoulders. Under the vast expanse of the skies a
promontory or an island city is seen from above, its
turreted walls and arched gates of masonry giving it a
medieval appearance. The town, lit up by glowing light as
if in a storm, is brilliantly detailed. Within the town, a
temple in a sacred precinct is seen frontally as in Roman
fora. The city wall continues upward on a causeway
perhaps linking the city to the mainland.

Fishermen in two boats have dropped their oars and
manifest their astonishment and terror, hands and heads
raised to the sky. In the foreground is a little segment of
shore. Two majestic women stand next to a 'sacred
pillar' topped by a gleaming bronze vase. Their gestures,
large and elaborate, comment on the tragedy; but they
may be nymphs rather than mortals, their restraint
contrasting with the agitation of the lowly fisherfolk.

They are unaware of the broken body of Icarus who
is seen drowned, under water, almost at their feet.
Wading into water, a fisherman approaches the prostrate
form.

A gap in the center of the picture deprives us of the
figure of Daedalus; only his wing tips survive. Other
Pompeian paintings show the father planing through the
sky, powerless to prevent the sudden death of his son.

As a representation of a seascape, the painting from
the House Sacerdos (priest?) Amandus is one of the most
ambitious ventures of antiquity. The mythical tragedy
is here subordinated to the concept of the *oikoumene*, the
inhabited world, the larger universe in which all
happenings take place. In this compositional mode the
interest is dispersed over several focal points, each
varying the theme. The emotional and psychological
reaction of the two women, the explosive figure of
Icarus, and the unconcerned, unknowing city receive
the major emphases.

Pompeii, 1:vii:7, House of Sacerdos Amandus, triclinium, at northwest corner of atrium, east wall. Ca. 54 by 35 inches (1.38 by 0.89 m.). Third style (ca. 40–70 A.D.) The inspiration comes from a lost Greek painting. A copy in the 'Villa Imperiale,' Pompeii, has Greek inscriptions to identify the figures. P. H. von Blanckenhagen suggests that a combination of normal and bird's-eye views and the inclusion of two moments of action characterize Roman reworking of the composition. Whether through illustrated manuscripts or otherwise, such paintings influenced Byzantine illustrators of the Old Testament.

A. Maiuri, *Monumenti della pittura antica*, 3:2, 1938, pp. 10 f., fig. 7. pl. 1. C. M. Dawson, pp. 99, 121, 140 ff., pl. 14. P. H. von Blanckenhagen, *AJA* 61 (1957), p. 82, fig. 11. G. M. A. Hanfmann, *Dumbarton Oaks Papers* 17, 1963, p. 88, fig. 24.

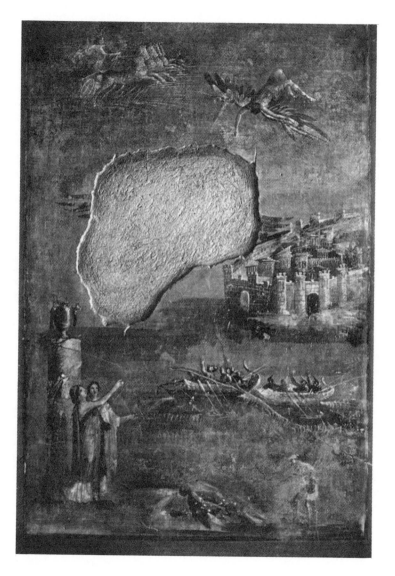

XXXIV The Fall of Icarus

XXXV

Apart from the greenish-blue water, the picture is painted almost entirely in white flashing over purple. This gem of ancient topographical painting resembles, in its bird's eye view perspective, an aerial photograph. The painter was amazingly sure in his reduction of a multitude of structures and figures to a miniature scale. The design is arranged in diagonals receding and converging toward the upper right.

One has to peruse the entire painting to realize how many things are crammed into a small compass. In the foreground is a little white landing with a rock shaped like a bridge behind it. Atop the rock is a pointed structure, perhaps a lighthouse. Two fishermen are fishing from the rock. Three small boats paddle past from the right while another approaches from the left. This, presumably, is the entrance to the harbor.

At the center, a pier is carried on arches into the water. The pier has a railing on the far side. It carries an arch surmounted on the left by a triton blowing a trumpet, and an octopus(?) on the right. Two statues are raised on tall columns; and two dark figures stand against the rail.

The pier forms the foot of a reversed L. Adjacent to it is the waterfront. Along the left ascends a series of pedimented structures, concluded at the top by two crenellated towers. A second series of smaller towers protects a colonnaded street which is framed on the right by a third wall with small turrets. An arched gate leads into the street which turns right and out of the picture at the top. A series of yellow dots in the street is perhaps intended to suggest crowds of people.

Jutting forward from the left to form the other side of the entrance to the inner harbor, a building with a red roof and white and pink walls rises out of the water. The lowest and the top story were colonnaded; the second story has only a door.

At the far left various buildings rise above the corner of the inner harbor. Lower down a short pier projects into the water. It is entered from shore through a triumphal arch with a chariot on top. Along the pink shore are four statues, each on a column. Behind them we see a temple front, in the center, and off to the right a colonnaded precinct. Two men busy themselves with small boats at the shore.

Four large boats lie in the harbor: that to the left has lowered its sails so that they seem to form a canopy over the deck. A dragon's head is carved on its bow. The boat behind it and that to the right have tied their sails to the mast, again as protection against the sun. That nearest the spectator seems to move as white oars dip into the water. Three of the vessels can be identified as heavy cargo boats. At the very top of the picture a small strip of blue is intended for the sky.

The identification by Dubois of the port as Puteoli (now Pozzuoli), the harbor vital for the grain supply of Rome under the Republic, has not found much support.

Naples, Museo Nazionale 9514. From Stabiae. Height $11\frac{1}{8}$ inches (0.245 m.).

C. Dubois, *Pozzoules Antiques*, 1907. K. Lehmann-Hartleben, *Die antiken Hafenanlagen des Mittelmeeres* (*Klio*, Suppl. 14), 1923, pp. 224 ff., fig. 11. M. I. Rostovtzeff pl. XII:1. A. Maiuri, *RP*, pp. 122 f., color plate. B. Maiuri, *Il Museo Nazionale di Napoli*, 1957, p. 111.

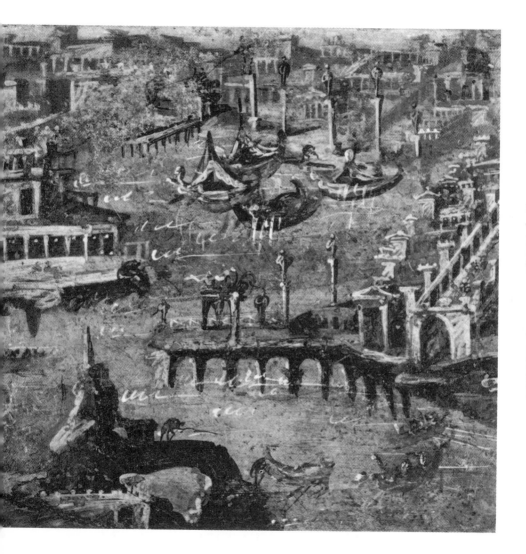

XXV A Campanian Harbor

XXXVI

In 1779 Italian excavators discovered in a colonnaded hall of the Villa of Hadrian at Tivoli (Fig. 42) five of the finest mosaics known from Roman antiquity. These were 'picture panels' inserted into a floor of colorful lozenge patterns. Despite some disfiguring restorations, they testify to Hadrian's refined taste. Two are idyllic scenes of shepherds pasturing peaceful flocks; two portray the cruel side of nature—a lion attacking two bulls, lion and tigers attacking centaurs. There is a curious twist to the theme—the half-human, half-animal centaurs were for early Greek art the bestial enemies of civilized Greeks. Here they themselves are attacked by wild beasts. The famous Greek painter Zeuxis (ca. 450–390 B.C.) was apparently the first one to project human sentiments into the centauric world; he had shown a centaur woman suckling a baby centaur, while papa centaur teased the babies with a lion cub (Lucian, *Zeuxis* 3–8). In the Tivoli mosaic, tragedy strikes, as the lion takes revenge for the abduction of the cub. A tiger digs his claws into the tender body of the centauress. The muscular, powerful centaur has smashed the head of a lion and rears high to bring the rock crashing down on the tiger. On a rock to the left, another tiger makes ready to spring.

The contrast of sensuous white woman and brown-tanned man is a heritage of Hellenistic art. The appeal to pathos, to physical empathy for torn flesh and streaming blood are effects well known from the famous sculptured frieze of the altar of Zeus in Pergamon (ca. 180–160 B.C.), a masterpiece of 'Hellenistic baroque.' Here the figures are freely spaced in a large expanse of mountain landscape which breaks off in jagged edges of cliffs on the side toward the spectator. This spaciousness is perhaps a Roman addition to the original composition.

Berlin (East), Antiquarium, T. C. 4949. Found by Marefoschi in 1779 in the hall of 'Peristilio di Palazzo,' cf. Aurigemma, p. 169, with color plates of the other mosaics. Upper width 35¾ in. (0.91 m.), height 23½ in. (0.59 m.). Mosaic, much of background, head of tiger in foreground restored. Some scholars consider the mosaic a late Hellenistic original (E. Pfuhl) after an earlier Greek painting of ca. 300 B.C.; others believe it a masterpiece of Hadrianic romantic art.

E. Pfuhl, *MuZ* 2, p. 858, fig. 692; original head of tiger fig. 693. E. Pfuhl, *Masterpieces of Greek Drawing and Painting*, 1955, pp. 134–136, pls. 153, 153a. A. Rumpf, *Archaeologie*, p. 183, pl. 65:3, literature. For the theory that this composition is intended as a tragic 'sequel' to the idyllic story of Zeuxis, M. H. Swindler, pp. 229 f.

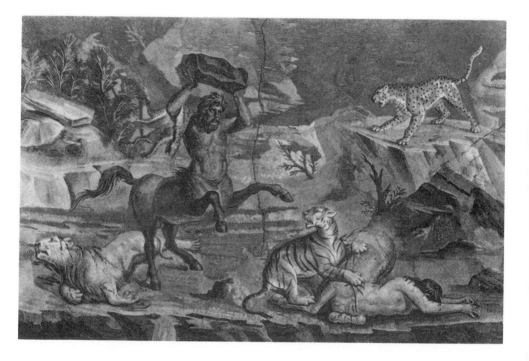

XXXVI Centaur and Centauress Attacked by Lion and Tigers

XXXVII

Leaning back for better purchase a naked fisherman hauls in his net (lower left corner). Two others, not seen in our illustration, were helping him. Beyond a rocky islet a boy, up to his chest in water, brings up a net rimmed with floats of red cork. On a rock nearer to shore another fisherman kneels in an angular, ungainly posture, his body glistening, his muscles bulging. His rod bends in a tense arc as he tries to land a big fish (hog fish) which he lures with bait in his scooplike basket. The young fisherman wears a wide-rimmed, yellow 'sun helmet.' A white cloth with black stripes is draped around his loins. In contrast to this tense, strained figure, an old fisherman sits quietly on the rock; he is white-haired, white-bearded, straight out of Hemingway's *The Old Man and the Sea*. He is putting the bait on the hook and squints the better to perform this delicate operation. The bait is in a copper jar placed carefully on the rock. The old man, too, wears the striped loincloth. Seven fishes fly over the white water as gray wavelets spread in their wake.

The left part of the mosaic is much damaged and not reproduced here. It showed two women seated on the rock, a third bathing—being discovered by spectators male and female, who paddle leisurely past in two boats.

Continuous landscape setting and keen observation of the life of fishing folk make this a remarkable composition. As the villa in which the mosaic was found is at the water's edge, the owner could see scenes like these almost every day. Yet it is doubtful that the artist drew from life; the other three panels of the same mosaic are copies of famous Greek Hellenistic compositions and so probably is this one.

Technically, the mosaic represents a transition from the close imitation of paintings in tiny mosaic stones (*opus vermiculatum*) confined to inset panels, to the use of the same polychromy, in larger stones (*tesserae*) for the entire mosaic floor (*opus tessellatum*).

The color scheme is based on the contrast of the white-gray sea (without a horizon line) and the rich browns and reds of sun-burned men and rocks. The masterly use of highlights for modeling of the figures must derive from the original painting. In view of the scarcity of large figurative compositions that have survived in post-Pompeian painting, (after 79 A.D.) this mosaic is of great value in assessing the coloristic trends in Roman art of the second century A.D.

Leptis Magna (Homs Lybia), Archaeological Museum. Excavated 1930, 'Villa of the Nile,' on the waterfront (between Roman harbor and circus) at Leptis Magna, in a hall (tepid bath? tepidarium) between two pool units. Original dimensions 12 ft. 1 inch (3.78 m.) by 3½ ft. (1.20 m.). *Tesserae* of blue, pink, and red glass, white and green marble, red, yellow, gray-green limestone, black basalt.

M. I. Rostovtzeff had suggested that the four panels (other subjects: Nile on crocodile; cupids in a sea port; Pegasus at the spring Hippocrene) may illustrate Hellenistic epigrams. For the style of the figures compare the Odyssey landscape (Pl. XXVII), for the composition the seascape in Pl. XXII. Dated correctly by G. Guidi to the second century A.D.

G. Guidi, 'La villa del Nilo,' *Africa Italiana* 5, 1933, pp. 26 ff., 56, figs. 17–19. M. I. Rostovtzeff, 'Karpoi,' *REA* 42, 1940, pp. 508–513, Pl. I:2.

*

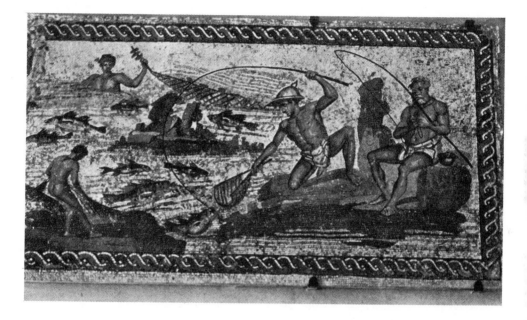

XXXVII Fishermen at the Sea Shore

XXXVIII

Next to war, in classical antiquity hunting was the great pastime of landholding nobility. Beginning with Xenophon's treatises it was celebrated in literature as a manly pursuit; it flourished no less under the Roman empire. A very interesting poem *On Hunting with Dogs*, by a native of Apamea in Syria known as 'Pseudo-Oppian,' was written in the time of Caracalla (212–217 A.D.), and was probably illustrated with pictures; the subject remained of absorbing interest as life shifted to the countryside in late antiquity. Indeed, much of secular art during the transition from the Roman to the Byzantine age consists of hunters and hunting scenes. In the fifth century A.D., church fathers had to protest against the use of hunting scenes in the decoration of churches. Mosaics of North Africa, though lacking the artistic sophistication of mosaics from Constantinople and Antioch, have a certain naïve forthright quality, and include much contemporary observation.

In typical late antique fashion this mosaic combines a visual and an explanatory space. The arrangement of figures, rocks, and trees seen from above may be understood as a unified scene; though trees and rocks are floating on 'islands' against the whole background, the diagonal foreshortening of rocks and the diminution in size of the trees reinforces this scattered illusion. The abstract quality lies in the very existence of this white background instead of a continuous portrayal of the 'ground' in terms of a landscape. The 'ground-lines' supporting the figures show that the artist felt his figures would not be intelligible if they floated on the background. Indeed, the placement of the ground-lines awakens a suspicion that they have been merged with shadows now no longer understood. They divide the composition into zones. The even distribution of figures and landscape features makes an even pattern which may be viewed as spaceless, flat tapestry.

The mosaicist intended to show within the same panel not one but three different moments of the hunt. In the upper zone, the owner of the estate, clad in a short tunic with purple stripes, (*clavi*) is setting out for the hunt together with his young blond son. The figure with a cleft stick striding mightily between them is a beater who will beat the bushes. The same (?) beater or his twin brother is trying to hold back two leashed greyhounds (sloughi's) while two bloodhounds are baying as they approach a neatly circular thicket in which the hare is hiding. His ears are flat on this back.

Below, the estate owner, hallooing, lifts his arm, and his son gallops along; the hare with ears now upright, has been raised and their hounds are in hot pursuit.

Bodies are flattened, flying garments immobilized; trees, rocks, and figures are flat color areas of almost equivalent weight; but much of Hellenistic heritage survives in the modeling and highlighting of faces of men and occasionally in the bodies of animals.

Tunis, Musée Bardo (Alaoui), no. A 288. Central panel of a floor found in the ruins of a rich house ca. 100 m. south of the hippodrome at El Djem (Thysdrus). Dimensions: ca. 12 by 10¾ ft. (3.72 by 3.28 m.). Date: third century A.D., according to catalogue; but more probably fourth.

P. Gauckler et al., *Inventaire des mosaïques de la Gàule et de l'Afrique*, Academie des Inscriptions et Belles Lettres, 1909–1915, text vol. 2, 26, plate vol. 2:1, no. 64 (color plate), M. I. Rostovtzeff, pl. 56. J. Aymard, *Essai sur les chasses romaines*. Bibl. Ecoles Françaises d'Athenes et de Rome 171 (1951), pp. 387 f., pl. 25b. For a hunting scene from the closely related hunting mosaics of Piazza Armerina see Pl. XXIV.

*

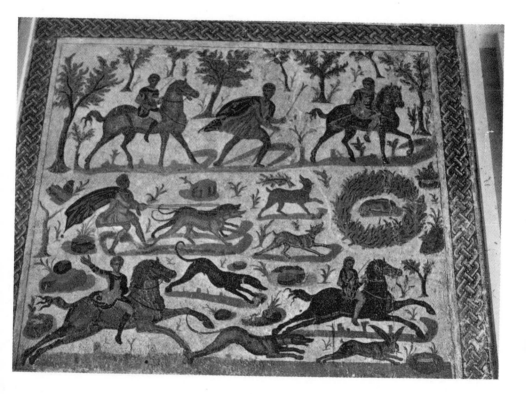

XXXVIII A Hare Hunt as Seen by a Late Roman Artist — The Hunting Mosaic from El Djem

The Romans are famous for their portraits; but when we say 'Roman portraits' we are apt to think of those sculptured busts (Figs. 61–98) which fascinated posterity from Frederick *Stupor Mundi* in the thirteenth century to Houdon in the eighteenth. Painted effigies must have been almost as common in Roman antiquity, but few have survived.

The '*Domina,*' the lady of the house in the Villa dei Misteri, is painted on a separate piece of wall in such a way that she is isolated from the frieze with the mysterious proceedings. She seems to contemplate the ritual with thoughtful detachment—an oval young face, white soft hands, fingers holding loosely the purple and yellow cloak which is drawn over her hair, sign of a married woman. Under the cloak she wears a fine, thin, sheer gown, a golden necklace, and a bracelet. The haughty face with a pouting mouth is lightly modeled. The arms are curiously rubbery and lifeless, especially at the wrists. The white chair, foreshortened downward, must be imagined as inlaid with ivory and purple; a blue cushion is on the seat, a blue and purple one to rest the elbow on. Some scholars argue that the seat is one-half of a bridal couch, of which the other half should be imagined as standing in the small adjacent bedroom; the bridal bed of the goddess Thetis is described by the poet Catullus (64:47) as polished Indian ivory covered with purple cloth.

The portrait is neither loudly emotional as the portraits of Hellenistic baroque, nor yet self-consciously calm as in official renderings of Augustan court art; rather the classic ideal of reserved understatement and permanence is for once happily blended with tactful individuation and aristocratic refinement.

There is a striking contrast between this refined, reticent woman and the large, 'cow-eyed' heads of women that we find in so many Pompeian paintings; the latter probably derive from emotional Hellenistic portrayals of goddesses and heroines. In the 'Queen' of the Boscoreale frieze (Lehmann's 'Aphrodite') and in the 'Arcadia' of the Telephos picture the same 'thinker' pose was used to depict such women of superhuman limbs and prophetic, sibylline mood. The painter of the Villa of Mysteries has successfully adapted the type to a new situation, and has given it the characteristics of a real noble woman in a thoughtful mood.

Many of the interpreters of the mysterious frieze (Pl. XVI) see in this lady the mother of the bride. It has been suggested that figures in the frieze with the ritual, too, have portrait-like features. At the time when the pictures in the 'Mysteries' room were painted, the villa may have belonged to the rich Pompeian family of the Istacidii.

As in the frieze itself large and statuesque figures deriving from Hellenistic art of the second century B.C. are set against a more 'classical' and neutral background, so there is in the interpretation of expression an intentional turn toward a more classical reserve and dignity. But just as the would-be classical backgrounds glow and sparkle with an unclassical richness of color, so the portrayal of personality betrays an interest in the individual features and differentiated moods which are part of the Roman contribution to European portraiture.

Pompeii, Villa of the Mysteries, west wall of Room of the Great Fresco, north of door to covered loggia. 60–40 B.C.

A. Maiuri, *Misteri* I (text) pp. 121–174, figs. 44–62 (62 Domina) II, pp. 33 f., pl. 15 (color), *RP*, pp. 53 f., color plates pp. 52, 54. E. Simon, *JdI* 76 (1961), p. 118, fig. 6. Herbig, *Neue Beobachtungen am Fries der Mysterien-Villa* (Deutsche Beiträge zur Altertumswissenschaft 10, 1958) pp. 39 f., figs. 23–24. J. C. M. Toynbee, *JRS* 19 (1929) pp. 67 ff.

XXXIX 'Domina' — The Lady of the Villa of Mysteries

XL

Among the riddles of the frieze of the Villa of Mysteries is a scene in which one young satyr holds up a mask while another looks eagerly into a silver cup which the ancient, dignified Silenus presents to him. The best guess is that they practiced a form of prophecy known as *lekanomanteia* by which images of future events are observed in a vessel containing a liquid. In this detail the mask and the head of the real Silenus appear one above the other. The artist has contrasted the lustful, grotesque Silenus of the Dionysiac plays represented by the mask with the restrained sage Silenus with whom Plato compared Socrates and who sang songs of wisdom for the shepherds of Vergil.

Against the rich purple of a pilaster framed with gold and green, the sun-tanned, bald-headed mask stands out in forceful vigor. The 'old sinner' with shaggy white eyebrows, white hair at the temples, a long gray-white moustache, a beard in screw locks, looks so alive that we forget that the head is supposed to function as a mask. Only the unnatural make-up of red circles around the eyes and on the mouth refers to the conventions of the theater. His brow is wrinkled. He pops his dark eyes like a vaudeville comedian making a joke and his red nose shines, a beacon of drunkenness.

The beard of the mask almost touches the pinkish-white, bald head of the real Silenus. His skin is pale, the pallor of the scholar. The swing of the eyebrows is the same as in the mask but they are lighter, whiter. Beard and moustache are of soft, streaming thin white hair. He is crowned with the Dionysiac wreath of ivy His right ear, tipped forward, is the only slight hint of the animal component of the Silenic nature. His small, full-lipped mouth is open. There is a resemblance to the portraits of Socrates in the proportions of the head and in the flattened but not ignoble nose.

Although Silenus is seated at the feet of Bacchus, he turns away from the god he serves. Nor does he himself look at the cup which he holds and in which the future is being read. Rather, his glance goes toward the ceremonies which take place on his right. His interest is with the present stages of the ritual.

Raised aloft like a symbol of triumph, the glance of the Silenic mask goes to the right where, after the completed divine initiation, the bride is being groomed for the actual earthly wedding.

Pompeii, Villa of Mysteries, east wall of the Room of the Great Fresco. Height of detail ca. 15 inches (0.38 m.).

A. Maiuri, *Misteri*, pp. 144 f., figs. 44, 56, 57, detail of heads, pls. N, VII (color). A. Maiuri, *RP*, pp. 51, 59 f., M. I. Rostovtzeff, *Mystic Italy*, 1927, pp. 51 f, 67, fig. iv: 2. M. Cooke, *JRS* 3, 1913, pp. 167 ff., first identified the scene as that of *lekanomanteia*. Alternate interpretation: sacred wine being drunk by the satyr. L. Curtius, *Wandmalerei*, pp. 352 ff., figs. 187, 194.

XL Silenus — As Mask and as Sage

XLI

A gentle, hazel-eyed beauty—with the seriousness of the young. The highlights in her eyes turn her gaze toward us, she communicates her question. A romantic age answered, 'Poetry,' and called her Sappho; but her dress and coiffure show that she is a Roman girl of the time of Claudius or Nero. A sober-minded critic went to the other extreme: 'A young Roman matron about to write up her accounts.' Yet when Roman artists show documents, they usually mean important documents, not daily accounts. Another picture (Pl. XLIII) shows a very different woman in the same posture—perhaps the marriage contract is meant.

The cool tonality is in the classicistic taste of the Third style, but already at the stage when the increased play of light introduces increased animation of form, an oscillation still subdued which will rise to vibrant chiaroscuro in the Fourth style. Whatever it is that the girl is doing, the painter makes us feel that she is both fine and refined. The ideal of aristocratic restraint had been set by the portraits of Augustus and his family. Within this set psychological mood the girl's portrait implies a more complex situation and hints at inner tension, however slight. The portrait of the empress Livia in her old age—perhaps set up after death (Fig. 71)—shows the same formal and psychological refinement and a similar displacement from the assured normative dignity of the Augustan Age.

Naples, Museo Nazionale 9084. Diameter of medallion 11.4 inches (0.29 m.). Found in Pompeii. Ca. 40–50 A.D.

O. Elia, *Pitture murali e mosaici nel Museo Nazionale di Napoli*, 1932, p. 112, fig. 41. B. Maiuri, *Il Museo Nazionale di Napoli*, 1957, p. 129. L. Curtius, *Wandmalerei*, p. 362, pl. 11 (color). A. Maiuri, *RP*, p. 100. M. Borda, p. 264. M. Brion, pl. 9. *

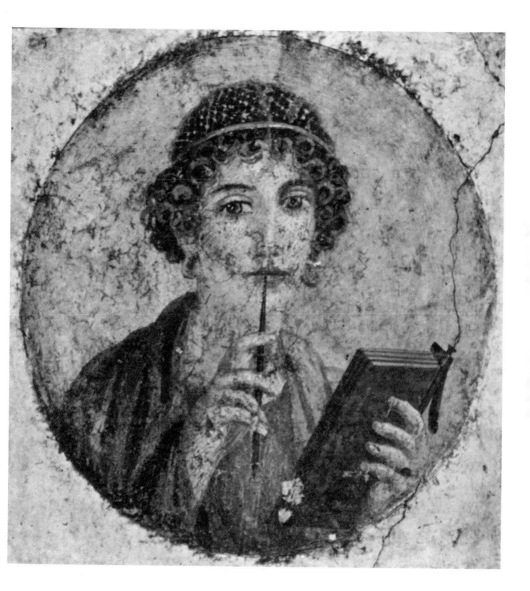

XLI Portrait of a Young Girl of the Claudian Era

XLII

Love of literature led Roman patrons to commission and Roman painters to paint portraits of illustrious poets, of whom this is one. His identity has not been safely established. Sophocles, the famous Greek dramatist, has been suggested, but the expression seems to fit someone more worldly—someone like Anacreon, poet of wine and love.

The aged man sits broad-legged on a rectangular, purple-gray stone. His right hand rests on his right knee, his left, slightly bent, held an object no longer recognizable. His lined head and obese chest, boxed in by the tight, somewhat schematic folds of a white cloak, stand out like a bronze bust struck by highlights. Our 'poet' wears a crown of blue-green ivy leaves. Under a gray moustache, his small mouth opens in speech or song. His brown eyes move upward and sideways but do not seem aware that the mouth is speaking—as if he were singing in intoxication.

The general tonality with the white background is classicistic. The ungainly position of the diagonally placed seat would fit a design of the 'strained' style of Early Hellenistic (third century B.C.) art. A loose, short-stroked, impressionistic technique was employed to conjure up an aura of poetry and classic purity.

When Vesuvius erupted in 79 A.D., Stabiae, the city from which the picture comes, was destroyed along with Pompeii and Herculanum.

Naples, Museo Nazionale 9078. Mid and lower part rubbed. Height 20 inches (0.51 m.). Width 15 inches (0.38 m.). 63–79 A.D.

L. Curtius, *Wandmalerei*, pp. 383 f., fig. 207, in a dithyrambic passage suggests a late classical painting as model.

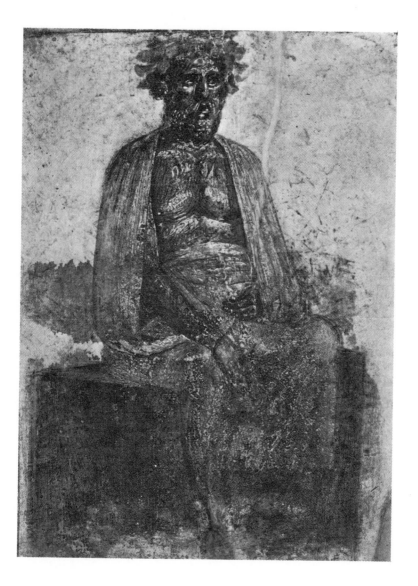

XLII Portrait of a Poet

XLIII

The mysterious girl (Pl. XLI) had enigmatic, oblique charm; this couple is very direct. They look at the spectator as people look when they are having their picture taken. Both are recognizable Neapolitans. The lady is pink-fleshed, quite pretty and young. Her chestnut hair is done up in playful curls which don't quite fit her face (and age?). She wears a red ribbon in her hair and a rich red dress, probably her best; she holds her writing implement to the lips, but the writing tablet is open, presumably to show what was written. There is no secret here. The husband is sturdy, large-featured, with short 'crew cut,' straggly beard and moustache, big ears, deep crease on forehead. The two pairs of big hazel eyes stare in unison under dark eyebrows, only her eyebrows are winged, feathery, meeting over her nose, and his are shorter, drawn up quizzically. He grips a scroll with a red seal which touches his chin; this, too, must be something official and legal. Like so many Mediterranean men, he may be younger than he looks.

The picture in its square red frame seems like an easel painting rolled off onto the wall. Is this the equivalent of our wedding picture preserved in permanence on the wall? Is he a small-town lawyer or baker?

Curiously, that is the controversy which hinges on who owned the house in which the painting was found.

The pictorial means used seem to be those of the early Fourth Pompeian style with its love of the browns and the reds—and there is an aura of provincial limner, as in early New England portraits.

Naples, Museo Nazionale 9058 (Sogliano 673). Lower left corner restored, several cracks. Height ca. 23 inches (0.58 m.). From Pompeii, VII:ii:60. The house was attributed to Pacuvius Proculus, a baker. In 1926 M. Della Corte, unsurpassed in Pompeian inscriptions, changed the identification of the house owner to Terentius Neo, *studiosus iuris*, hence, a lawyer. Date: L. Curtius argued that the hair styles are Late Republican, hence the picture should be dated 20 B.C.–10 A.D., but the lady has simply varied the curl coiffure of the girl seen in Pl. XLI. Short-cropped haircuts like that of the husband are known from portraits of the generals of Claudius and Nero (Corbulo). Probably 60–79 A.D.

O. Elia, *Pitture murali e mosaici nel Museo Nazionale di Napoli*, 1932, p. 109, fig. 38. A. Maiuri, *RP* p. 102. B. Maiuri, *Il Museo Nazionale di Napoli*, 1957, p. 126 (color plate). L. Curtius, *Wandmalerei*, pl. XII (color). M. Della Corte, *Case ed abitanti di Pompeii* (2nd. ed.), 1954, pp. 131 f. *JRS* 16 (1926), p. 151.

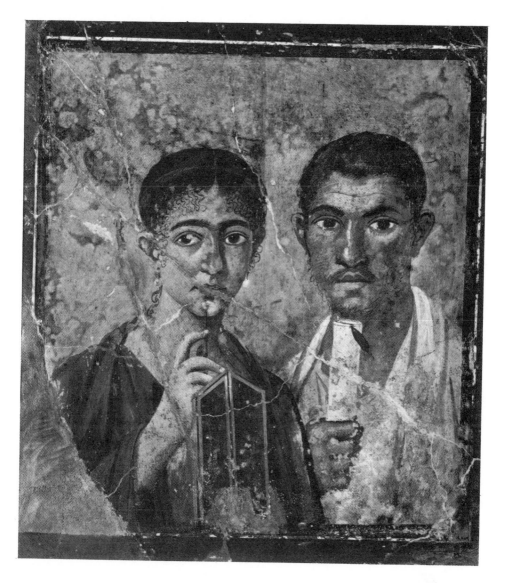

XLIII A Law Student and His Wife

XLIV

There is a striking difference between this broadly stroked, momentary sketch and the deliberate, posed, 'statue portrait' quality of Pl. XLIII. The long-locked youth and the full-faced girl with light blue cap turn their heads, look intently to their left. As he is nude, this is either a heroic and mythological couple or one from the semi-mythical, semi-ideal world of satyrs and maenads, or, again, from the idyllic-bucolic life of shepherds and farmers. The medallion frame of leaves, partly preserved on the right, would better suit one of the innumerable decorative motifs used with such inexhaustible richness on the walls of Pompeii. Nevertheless, there is an individual quality to these two heads with their slightly irregular features, a fleeting remembrance on the part of the artist of real young shepherds or farmers of the Campanian countryside. The warm flesh tones with brown-purple shadows carry the sensation of warm, pulsating life.

The 'impressionistic' brushwork is well employed to set off the highlighted sides of the faces exposed to light from a fairly well defined source and to suggest very boldly, as in the shadow under the man's eye, the dynamism of their gaze.

London, British Museum 37 (WT 1621), from Pompeii. Fragment of a painted medallion from a wall. Height 5⅝ inches (0.14 m.). Width 7 inches (0.175 m.). Fourth Pompeian style, ca. 60–79 A.D. The head of the youth with its energetic turn and upswept hair recalls portraits of Alexander the Great. Background partly restored. Many cracks; left eye of woman damaged. Incrustation on left shoulder of youth.

The pointed pink area at the right temple of the youth may be intended for a satyr's ear. On the other hand, the cap worn by the girl is unusual. One wonders whether it is not, after all, a royal headgear designed to characterize a barbarian princess; in the great frieze of Boscoreale one woman wears the Macedonian *Kausia*, another a Persian headgear. M. Robertson, *JRS* 45, 1955, p. 62, 11 12b. R. P. Hinks, *Catalogue of the Greek, Etruscan and Roman Paintings and Mosaics in the British Museum*, 1933, p. 20, no. 37, fig. 17.

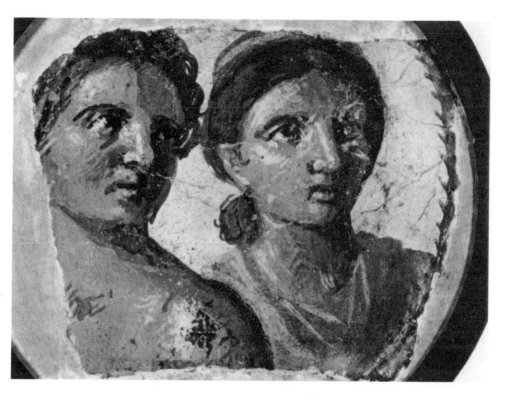

XLIV A Couple — Rustic or Royal

XLV

Some sixty miles south of Cairo lies the lake which the ancients called Moiris and the Oasis of Fayoum (from Coptic *Pha-Yom*, 'sea'). Linked by a canal to the Nile, it was a rich land exploited by Pharaohs, then by the Greeks, then by the Romans. The Greek King Ptolemy Philadelphos II favored and adorned the main city, Krokodilopolis, and renamed it Arsinoe after his sister-wife. Another Greek city, Philadelphia (El-Rubayat) has been partly excavated as was Antinoe, Antinoopolis, founded by Hadrian in 130 A.D. The teeming life of this province in Greek and Roman times has become known through great finds of thousands of documents written on papyri, in twelve different languages and dialects.

In 1887 the Viennese merchant Theodor Graf created a sensation when he secured some three hundred painted portraits of the kind which henceforth have become known as 'Fayoum Portraits.' These portraits come from cemeteries; they were painted on wooden tablets and were tied over the faces of mummies which at times were adorned with purely Egyptian religious representations. Some scholars think that following a Roman practice these mummies may have been displayed in the main room, the atrium, before being buried. The portraits were usually painted during the lifetime of the sitter. Originally they were identified by little wooden labels giving name, home town, and kind of burial. Some labels indicate that the dead from Philadelphia were to be buried in a place on the Nile (Kevke, in the region of Memphis). Some portraits are painted in encaustic, the technique of painting in heated wax with powdered colors; others in tempera, with egg white as a binding medium; others yet in a mixture of both.

The beginning of this extraordinary series of portraits is still controversial. It is probable that they span the first four centuries of the Christian Era. An edict of the Emperor Theodosius in the year 392 A.D. (*Codex Theodosianus* 16:10:12) against the cult of ancestors (and mummification—which, however, it does not say!) probably put an end to this painting industry. Similar paintings on linen cloth which was spread over the dead show the dead with Egyptian Anubis, who escorted the deceased, and Osiris who judged them and gave to the just life everlasting.

These painted portraits largely replaced the plaster masks used in Hellenistic Egypt. Zaloscer attempts to explain the change as a response to the prohibition of images in the Bible by the many Jews and Christians resident in the Fayoum, on the theory that this prohibition was understood to apply to sculpture. She sees in the Fayoum portraits images of people as they will be resurrected for eternity.

It remains unexplained why only this one region of Egypt has yielded some 600 images of this kind; scarcely any others have come from the many other regions with similar populations.

Copenhagen, Ny Carlsberg Glyptotek AEIN A 591. Found in Hawara in 1911. Tempera on linen. Measures 17 inches (0.256 m.) by 7½ inches (0.198 m.).

W. M. Flinders Petrie, *The Hawara Portfolio*, 1913, pl. XI. E. Pfuhl, fig. 143. H. Zaloscer, pl. 21 (color) with preceding literature.

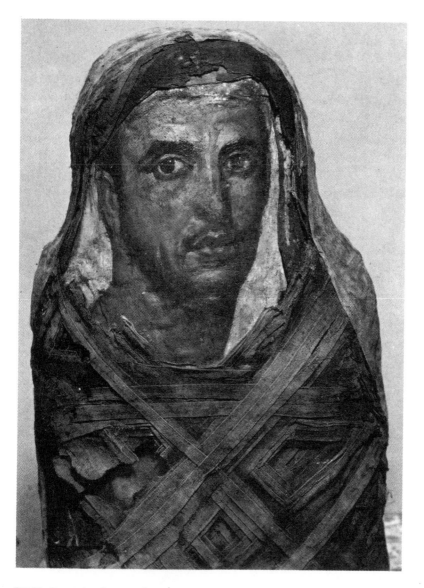

XLV Portrait of a Man from Fayoum

XLVI

The ancients were enthusiastic about wax painting. Pliny says that the method was practiced 'from the earliest times' (*Natural History* xxxiv:149), and Anacreon asks the painter to paint his beloved in wax. Only a long tradition could attain such skill in mixing powdered colors with pure beeswax and then manipulating them into the right position, as is seen in this painting with its very gradual transitions from one hue to another. The technique has been compared to impressionistic painting; both make individual strokes stand out, both make colors blend in the eye, though in ancient wax painting they are very small particles of pure colors.

In the case of the Fayoum portraits it is perhaps more to the point to think of plastic modeling. If one studies the original of this painting, or a black and white photograph which eliminates the colors, there is a striking resemblance between the surface of a Greek statue done in a constant continuous 'skin' of chisel strokes and the rough up-and-down surface of the wax painting. One has the feeling that such a head was 'built up,' modeled like a sculpture in the round. The hair is stroked back radially with the frontal row of locks raised in little plastic beads, the forehead and cheeks are done in waves of more or less horizontal hollows and ridges, and the

neck is circumscribed by downward sweeps. This is largely modeling with a pointed instrument. Body and background are flat and largely brushwork.

The attentive restraint befits a young woman of breeding and refinement. It is carried magnificently by a similar restraint and refinement of color. The costly, blue, purple and green garment acts as pedestal. An aristocratic touch, a hint of Vermeeresque enjoyment of the beauty of things, is added by the two earrings. They have a glow of their own; and there are two pinpoints of light in the eyes.

Even more successfully than in sculpture, the gliding, dispersed play of light helps to express the pensive questioning mood of the Age of Hadrian.

Cambridge, Mass., Fogg Art Museum of Harvard University 1923.60. Panel of hardwood, possibly fig tree. Thin ground of gesso type covered with glue. Wax paint in two major layers, local tones in lower, detailing in upper. Some loss in garment and background. Cleaned 1945, buckled paint reattached 1951. Height 14$\frac{1}{8}$ inches (0.35 m.). Width 11 inches (0.225 m.). 130–140 A.D.

D. B. Tanner, *Fogg Museum Bulletin*, 1932, pp. 6 f., fig. 5. H. Zaloscer, p. 60. On the wax technique cf. G. L. Stout, *Fogg Museum Technical Studies* 1:2, 1932, pp. 82–93. H. Zaloscer, pp. 19–23, 31–32.

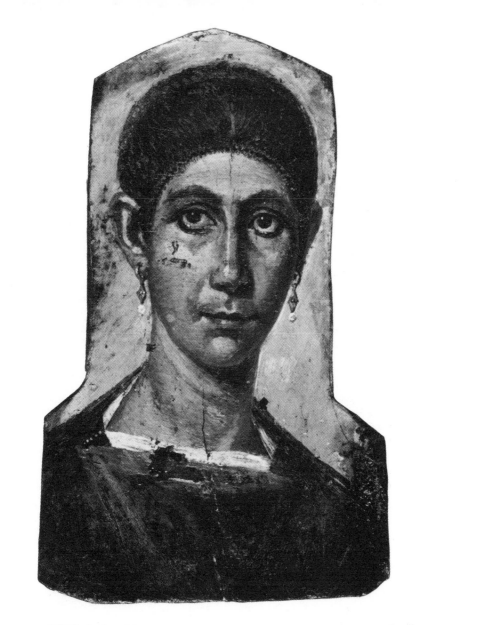

XLVI Lady with Earrings

XLVII

How far did ancient artists go in pictorial refinement? This is a question to which the wall paintings give only a partial answer. The ancients themselves regarded easel paintings by famous masters very highly; and the process of encaustic painting with wax had been used by such famous Greek artists as Polygnotus, Pausias, Aristeides, and Nikias. The unsung masters of the Fayoum, who apparently were little known outside their own province, display in general a high level of craftsmanship, higher, at least in the paintings of the heads than in most of the Roman wall paintings preserved. It is rare, however, that one has the feeling of real mastery. The head of a bearded man in the Albright Art Gallery is remarkable for a refinement of its brushwork and particularly fine quality in the over-all organization and in the expression of the person portrayed. The slender-faced man turns his head slightly, and the striking highlights in the eyes make the spectator feel that he is just fixing his gaze upon the beholder. Softly but deftly modelled, the flesh of the face is neither flat nor as yet dramatically lit as in some portraits of the Severan era. The large volume of black wavy hair, at first seen as a soft mass, upon closer view yields a moving rhythmic pattern of circular and curvilinear strokes. The eyebrows rise in sly, slightly asymmetrical arcs, adding to the quizzical impression. Oriental bearded faces like this are later seen as heads of Byzantine saints; but here the refined, subdued motion, the gentle, somewhat diffused light effects, with the only emphatic light reserved for the eyes, all illustrate the early phase of second century Roman baroque. The reflective, pensive mood is that of the portraits of the philosophic Emperor Marcus Aurelius. We know nothing about the sitter except that he looked at the world attentively and thoughtfully.

Buffalo, Albright-Knox Art Gallery, Acq. No. 38:2. Encaustic on wood, panel irregularly cut, 13⅞ inches by 8 inches (35 × 20.3 cm.). The date of 160–170 A.D. is confirmed by imitation of the hair style affected by the Emperors Marcus Aurelius and Lucius Verus.

D. B. Tanner, *Bulletin of the Fogg Art Museum* 2:1 (November 1932) p. 5, fig. 3. H. Drerup, *Die Datierung der Mumien-porträts*, 1933, II, pp. 39, 58, no. 18, ill. 11. Cambridge Mass., Fogg Museum of Art, *Style and Technique. Their Interrelation in Western European Painting*, May, 1936, p. 47, Cat. no. 5, ill. pl. I, no. 5. A. C. Ritchie, ed., *Catalogue of the Paintings and Sculpture in the Permanent Collection*, The Buffalo Fine Arts Academy, Albright Art Gallery, 1949, pp. 110, 111, 197, 198, ill., cat. no. 52.

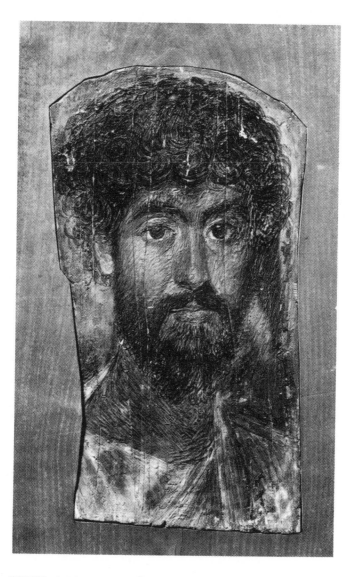

XLVII A Masterpiece of Fayoum Painting

It has been said that marble sculpture can never disclose a personality as intimately as painting (G. Rodenwaldt). It has also been suggested that the important task of communicating the official portraits of an emperor to the provinces was often solved by sending paintings rather than the weighty and breakable marble sculpture. The nearly total loss of painted imperial portraits makes a wooden disk in Berlin the only securely identified imperial portrait in painting.

Shown in a two row arrangement and in less than half life-size are the Emperor Septimius Severus (ruled 193–211 A.D.), his wife Julia Domna rising protectively over their two small sons, Geta—faceless—on the left, and the future Emperor Caracalla (ruled 211–217 A.D.) on the right. The medallion is said to have been found in Egypt. This is likely enough; only in Egypt or some other very dry climate could such a painting survive. Severus and his family visited Egypt in 199 A.D. after he had successfully concluded his war in Mesopotamia. He was then fifty-three years old, Caracalla eleven, Geta ten; we do not know the exact age of the empress.

Allowing for some damage to the painting, we still learn something we cannot learn from the representation of the same family in bronze and marble (Figs. 56, 127). The brown eyes are startling, vivid. The hair of Septimius Severus is gray, as the historical sources say it was, and his complexion florid. Julia Domna has chestnut hair, somewhat 'slit' eyes, and a rather full face; darling Caracalla is a fat Mediterranean boy with mischievous eyes and unruly hair. And the gorgeousness of crowns and costumes is very much more in evidence than in sculptured portraits. Thus far we may trust the painter, if we optimistically assume that he had at least caught a glimpse of the imperial family during some official function. Hardly more than that; there is an air of provincial-ism about the painting which is similar in style but not superior to the Fayoum portraits. It is not likely that the imperial family sat for this master.

In the survival of a certain pictorial fluency, the work fits into the Severan era. The painter still knows how to round flesh with strokes of light and shade, highlight the eyes and break down the colors—within limits. For bodies and garments he is satisfied with flat colors and almost spaceless effects, thus disintegrating the physical, organic unity. His attempts to give dignity already foreshadow an image-icon concept especially in Julia's face and relate his work to that sub-antique element on the arch at Lepcis (Fig. 127). His character drawing is of shallow draft—a benevolent father, a lively boy—a mother who poses frozen-faced. Looking at the best Severan portraiture (Fig. 85), one wonders what a great painter of the time might have done.

Berlin West, Ehemals Staatliche Museen. From Egypt. Tempera on wood. Diameter 14 inches (0.305 m.). Light blue-gray underpaint, various yellows including ocher for gold, red, crimson-purple, black, white pigments. Geta's face was erased after he was killed on Caracalla's orders in February 212 A.D.; hence the painting continued to be displayed thereafter. White togas (now seen in bluish underpaint) with yellow borders fringed with purple for men, embroidered gold wreaths on the chests of the boys. Purple borders fringed with yellow (gold) for Julia Domna. All three men hold white scepters with dark tips. 'Gold' laurel wreaths with two 'emeralds' and 'central ruby' for Septimius Severus and Caracalla. Crescent-shaped crown with white pearls, earrings and necklace of white pearls for Julia. Some repainting and losses of color. Probably 199 A.D.

K. A. Neugebauer, *Die Antike*, 12:3, 1936, pp. 156–172, pl. 10 (color). *CAH*, V, pl. 156a. On imperial portraits sent to the provinces, H. Kruse, *Studien zur offiziellen Geltung des Kaiserbildes*, 1934.

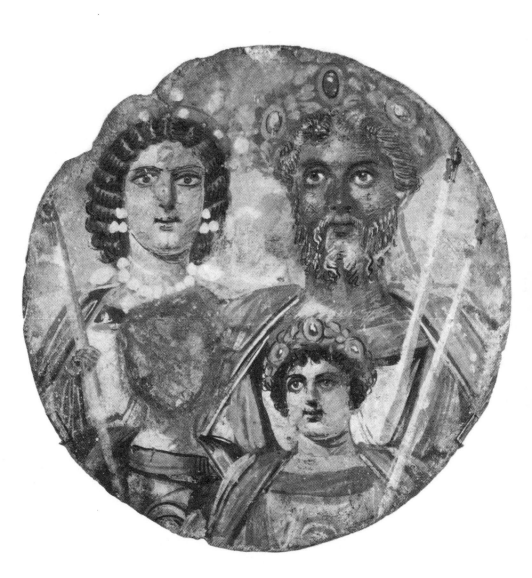

XLVIII Septimius Severus and His Family

XLIX

The two points of light in the eyes (cf. Pl. XLVI) now glow like two flashlights in the darkness. The tints are flat; but the head is flattened not only because of the different technique used. Three large forms are heavily combined: the hair, still the most rounded part, diversified by strokes of purple-brown and white; the broad oval of the face with the mouth set very low, stroked into semblance of relief by brown-red shading and hatching of simple, 'automatic' lines; the neck and bust, triangulated by long lines, and cut off from the white garment. The head does not pretend to belong to the body.

Formulaic outlines rule the eyes and nose, done in heavy strokes of crimson. A conventional pink rouges the cheeks. Black slits the mouth and twists its corners. The hanging lower lip is much smaller than the upper. The earrings with three pearls are in flat yellow and blue, outlined in purple—decorative patterns rather than glowing jewels. On the garment simple triangles do the duty of folds and a broad crimson band (*clavus*) descends from the left shoulder.

Even if one accepts Zaloscer's theory that all Fayoum portraits represent 'illumined spirits' ('*Verklärte*'), it is clear that the artists were not thereby released from time-conditioned changes in the portrayal of personality. The geometric dematerialization, the masklike formula for nose, eyebrow, eyes (with a nose worthy of Picasso) are late antique. The worry lines which split the forehead and the 'contemptuous' or doleful mouths are frequent in sculptured heads of the time just before and under the Tetrarchs (Fig. 91, Pl. IV), in the age of stony expressionism.

Cambridge, Mass., Fogg Art Museum of Harvard University 1939. III. Aqueous medium (not egg) on hardwood. Height 12¾ inches (0.32 m.). Width 7½ inches (0.19 m.). 270–300 A.D.

H. Drerup, *Die Datierung der Mumienporträts*, 1933, pp. 44, 62, pl. 17 A, attributed to 'Würzburg Painter.' Walters Art Gallery, *Early Christian and Byzantine Art*, 1947, no. 674. H. Zaloscer, p. 60, pl. 45, and for earrings, p. 26.

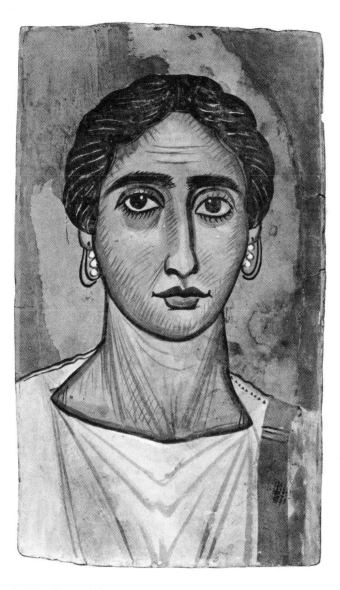

XLIX Toward the Late Antique

L

The 'Great Hunt' mosaic of Piazza Armerina unrolls its enormous length of nearly two hundred feet (59 m.) in an irreproducible band over the corridor just east and above the peristyle of the villa (no. 26, in Fig. 42). This hunting epic was obviously the pride and joy of the owner. We can see such extraordinary sights as panthers caught with an unfortunate crucified goat serving as bait; wild horses being lassoed, cowboy fashion; antelope, gazelles, and lions being hunted in the desert; and rhinoceros and hippopotamus being captured in a swamp. Then comes the transport of animals on land in carts and their subsequent embarcation. Two boys carry ostriches over the gangway. A bison and an elephant are already aboard ship; camel, tiger and antelope await their turn. Finally the beasts disembark to play their part at some animal games in a Roman amphitheater. That this great safari took place over many days and in many different areas is made clear by the personification of two provinces, Egypt(?) and Mauretania(?), at either end of the composition.

There can be do doubt that the owner of the villa went to Africa and took part in providing rare and precious animals for that beloved entertainment of the Romans. To afford such an homage he must have been of high rank. But who was he? A group, centrally located in the mosaic, but not emphasized in the over-all design shows an elderly man wearing the same cap as the four emperors, the Tetrarchs (Pl. IV). Two guards with large gray-green shields are at his side. Absorbed in thought, the elderly man leans on a tall staff which he holds in his right hand. His protector, on the right, points to the approaching cart with the captured animals.

The 'Lord' is clad in an ample, girt tunic with round embroidered purple ornaments, and long gray trousers. His cloak, to be imagined as woven with gold on the outside and purple on the inside, is fastened with a big round brooch on the shoulder.

Cap and beard are emphatically outlined in black. Short gray locks, beard, moustache; a furrowed brow; flying eyebrows—in facial type there is a resemblance to the porphyry Tetrarchs of San Marco.

Thus far, all are agreed. H. P. L'Orange and G. V. Gentili, the excavator of the villa go a step further. They identify the 'Lord' as the Emperor Maximian, one of the Tetrarchs and consider that the villa at Piazza Armerina was his hunting lodge built ca. 298–302 A.D. The contrary view is that the big game hunter was a high Roman official who undertook to provide animals for the games in Rome and happened to have a villa in Sicily.

It is instructive to have a painted portrait of the Tetrarchic era to compare with the sculptured ones. The head of Maximian is not shown in our illustration of the Venice Tetrarchs (Pl. IV); but as it happens, the bearded head in the Venice group which is really similar is that of the emperor identified by R. Delbrueck as Constantius Chlorus, father of Constantine. The system of rendering facial features, fairly lifelike in color, is revealed in its geometric bias when translated into stone by the linear strokes of the chisel. There is the same listening attitude rendered in both media but the homogeneous abstract quality of porphyry emphasizes the mask-like, otherworldly elements of expression.

Villa near Piazza Armerina, Room 26 in Fig. 41. Width of entire mosaic ca. 16⅔ ft. (5 m.), of the group, nearly 7 ft. (2 m.).

H. P. L'Orange, *Symbolae Osloenses* 29, 1952, pp. 114 ff. H. P. L'Orange and P. J. Nordhagen, pp. 20, 80, pl. 33. B. Pace, pp. 66 ff., 111 ff., pl. XI (color), basic criticism of identification as Maximian. P. MacKendrick, pp. 333–337. G. V. Gentili, *La Villa Erculia di Piazza Armerina, I mosaici figurati*, p. 44, pl. XXXI; *Mosaici di Piazza Armerina, Le Scene di Caccia*, 1962, pl. VII (color) with text; *The Imperial Villa of Piazza Armerina* (Guide) 2nd ed., pp. 13, 32 ff., fig. 39. L. Bernabò-Brea, *Musei e Monumenti in Sicilia*, 1958, pp. 154 f., black and white and color pls., best detail of head. On identification, cf. R. Delbrueck, *Antike Porphyrwerke*, 1932, p. 90, pls. 32–34. On animal hunts, cf. J.A. Jennison, *Animals for Show and Pleasure in Ancient Rome*, 1937.

*

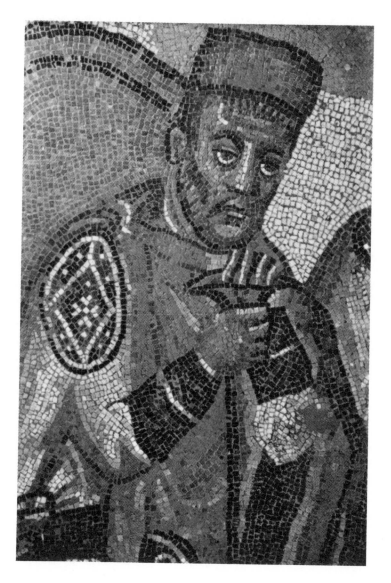

L Tetrarchic Ruler ?

The palace of the Byzantine emperors has long haunted the imagination of the Western world. Ceremonies which regulated the life of the emperor and his court were known from a firsthand witness, the Emperor Constantine Porphyrogenitus, but his account was written some five hundred years after the first buildings of the palace had gone up. Better knowledge of buildings was hoped for from the excavations of the Walker Trust which took place in Istanbul from 1935 to 1938, but few scholars were prepared for the discovery of the extraordinary floor mosaics, whose style, date, and meaning are still the subject of debate.

The mosaic formed the floor of the colonnades in a large peristyle. Its strange groups of hunters, shepherds, fishermen, children, and mythological figures float on the white background. Gorgons and expressive masks, some representing Ocean, others portraying the enigmatic moustachioed faces like that reproduced here, form part of a very luxuriant acanthus border. It is of the kind known as a 'peopled scroll' enlivened by rabbits, lion cubs, lizards, birds, fruits, roses, lilies, and sunflowers. The huge masks are turned inward toward the central panel. They have been called 'barbarians' but one wonders if perhaps a personification of wintry climes is intended as a counterpart to the Ocean.

The icy blues and refined browns are effectively contrasted with the red tips of the leaves. The face is startlingly alive; even if the large areas are set off somewhat harshly, there is evident a mastery of modeling with highlights and shadows. A very interesting, emphatic formula of crimson and black lines is used to circumscribe the eye; it serves admirably to produce the illusion of a piercing sideways glance.

Coming from the highest possible ambient of Byzantine life, the Imperial Palace, these mosaics should shed light on the crucial question of the sources and development of art in the Byzantine capital. Their technical brilliance is undeniable: the extraordinary range of figure types at the command of the designer is imposing yet baffling. Instead of resolving controversies, the mosaics have themselves become controversial. Part of the difficulty arises from the fact that, being floor pavements of a secular nature, they cannot be readily compared to either the church mosaics of Ravenna or to manuscript illustrations; and material from Constantinople is scanty.

The mosaicists of the Imperial Palace worked in the general tradition of Roman art as practiced in the Eastern provinces. Group after group of genre scenes can be paralleled on late Roman mosaics of Africa and Syria. Whatever date may be assigned to the mosaics of the Great Palace, they remain witnesses for the influence of Roman craft and Roman typology in 'New Rome.'

Istanbul, Museum of Mosaics (Torun Sokak). Imperial Palace. Detail of a border from the pavement in the colonnades of a peristyle. Mask much damaged. Width of entire border 5 ft. 6 inches (1.67 m.) of scroll 2 ft. 6½ inches (0.69 m.). Most of the mosaic stones are limestone; purple quartz with iron oxide; blue, green, yellow glass. Seven shades of red, three of blue, three of green, several yellows, two whites, gray. Tiny stones 1/12–1/8 inches (0.002–0.006 m.). Dates suggested have varied from Theodosius II (408–450 A.D.), to Justinian (527–565 A.D.), to Heraclius (610–641 A.D.).

G. Brett, *The Great Palace of the Byzantine Emperors, First Report*, 1947, pp. 65–67, pls. 40, 43, 49 (Ocean masks). D. T. Rice, *The Great Palace of the Byzantine Emperors, Second Report*, Edinburgh, 1958, pp. 130–131, pl. 49 C. Cf. also H. L. Thomas, *Archaeology* 12: 4, 1959, pp. 278 f. and cover. *

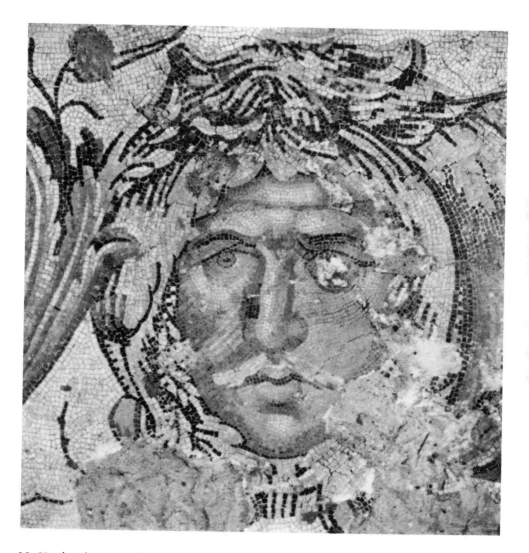

LI Head with Moustachè — Mosaic from the Imperial Palace of Constantinople

The luxury of private life had been a favorite target of Roman writers under the early empire. They criticized the use of precious materials as a deplorable departure from the homespun simplicity of the great Romans of the Republic; and the 'good' emperors took care to conform to these admonitions. Under the late Roman empire, however, the Imperial court adopted, for ceremonial purposes, a special kind of luxury, a luxury which relies on the inherent costliness of materials, on gold and silver, on purple and ivory. Ornateness became part of the style of life. The sudden popularity of the expensive gold-glass technique is a very characteristic expression of this trend. Gold had been used occasionally on glass vessels with mythological subjects from Hellenistic times on. Now gold-leafed medallions and cups came to be a common vehicle for portraiture, even more among the Christians than among the pagans. This is a meticulous technique in which gold leaf is placed over glass, the design is then incised into and through the leaf, and another layer of transparent glass is put on to protect the design. A masterpiece of this technique, possibly made in Alexandria, a well-known glass center, is mounted into an early medieval cross preserved at Brescia. The inscription BOUNNERI KERAMI, is perhaps best interpreted as (the family) of Vounnerius Ceramus. In style there is some connection with the wide-eyed severity of the latest female portraits from the Fayoum (Pl. XLIX), but formally and psychologically the Brescia medallion is of vastly superior caliber. It represents, on the highest level, the new, essentially Byzantine ideal of life—a lasting reserved mood, which by rigor of attitude and aristocratic splendor of attire, is made into a symbol of superior status and a superior state of life immune to change and flux. What is alive are the eyes, fixed intently in an almost accusing stare upon the spectator who dares to intrude upon such a lofty family.

It was originally thought that the glass medallion belonged to the Severan era but a glance at the family of Severus (Pl. XLVIII) will show how far their fat-fleshed bonhommie and vaporous forms are removed from the crystalline concord of the Brescia medallion. Heightened to colossal majesty, the same assertive glance is seen in portraits of Constantius II (337–361 A.D., cf. Fig. 95). The family represented in the Brescia medallion must have lived in his time or not long thereafter.

There is no way to identify the sitters, or, for that matter, to determine their relationship to each other. It is usually said that the haggard woman in the background is the mother, the boy her son and the other woman her daughter—but others have proposed the richly attired girl as the 'mother.' They may be sisters. The embroidered robe of the girl on the right may indicate that she had achieved a high rank or that she had just taken part in some special ceremony. The knot on the garment of the other woman has been thought to indicate that she took part in the worship of Isis which was vigorously supported by the late pagan aristocrats.

These people are no longer Romans portrayed in their specific historical moment; in their jewelled immobility and their unwavering attention they are already part of that unchangeable order decreed by Heaven which was to find its perfect embodiment in the Byzantine imperial images of Ravenna.

Brescia, Musei Civici, Monastero Santa Giulia. Mounted into the seventh century A.D. 'Cross of Desiderius.' 'Gold glass.' Diameter $2\frac{3}{8}$ inches (0.06 m.). 360–400 A.D. C. Albizzati, *RM* 29, 1914, pp. 247 ff., fig. 3. G. Rodenwaldt, *CAH*, V.p. 204, and text vol. XII, p. 560. P. Ducati, p. 309, pl. 212:2. C. R. Morey, *Early Christian Art*, 1942, pp. 127, 216, 269, fig. 132. G. Panazza, *I Civici Musei e la Pinacoteca di Brescia*, 1958, pp. 62 f., Pl. VIII-IX, color of entire cross. M. Borda, pp. 366 f., pl. 24 (color), late fourth century A.D. W. F. Volbach and M. Hirmer, pp. 25, 323 f., pl. 61 (color), with literature. M. H. Trowbridge, *Philological Studies in Ancient Glass*, University of Illinois, 1928, p. 116, translates the inscription: 'Bounnereus, the potter,' *i.e.* maker of the medallion; but H. C. Youtie (by letter) confirms Albizzati's translation, adopted above, and states: 'the lettering suits the third or fourth century, perhaps especially the third.' The dates proposed have ranged from 230 to 450 A.D. A traditional identification, now rejected: Galla Placidia (388/92-450/51 A.D.) with her son Valentinian III and daughter Justa Grata Honoria. *

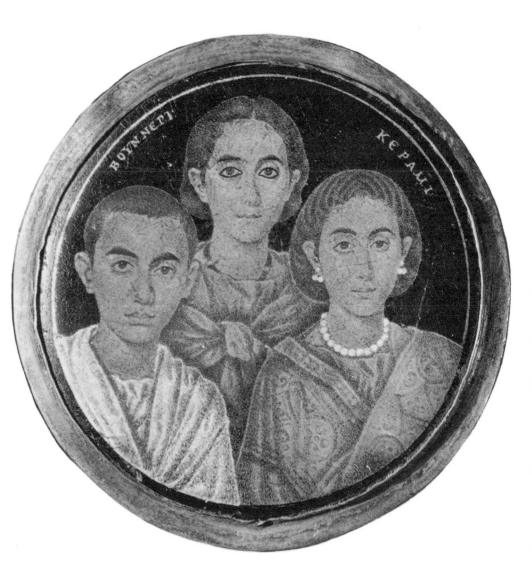

LII Proto–Byzantine Splendor

ADDENDA

Illustrations Identified by Arabic Numerals

1–2. Correction: E. Nash 1, p. 446, figs. 543–546.
D. R. Dudley, pp. 73–119. Fascinating archaic finds include temples under the Regia and Minotaur terracottas: E. Gjerstad, *Early Rome* 3, 1960. F. E. Brown, 'New Soundings in the Regia: The Evidence for the Early Republic,' *Entretièns sur l'antiquité classique* 13, 1967, pp. 47–64. M. Grant, *The Roman Forum*, 1970.

3–4. A. Boethius, J. B. Ward-Perkins, pp. 123, 151, figs. 65, 69 (temples, forum). V. J. Bruno, *Archaeology* 23, 1970, pp. 233–241 (houses). A. M. McCann, J. D. Lewis, *ibid.*, pp. 201–211 (port). *EAA*, 1970, Suppl., p. 264. J. B. Ward-Perkins, *Cities*, pp. 27, 120–121.

5–6. H. Eschebach, *Die städtebauliche Entwicklung des antiken Pompeii* (*RömMitt* Suppl. 17), 1970, pp. 17–57, pl. 11 (aerial photo), detailed regional plans 1–7, dividing city into three phases. A. Boethius, J. B. Ward-Perkins, p. 63, fig. 35, pls. 73, 99. J. B. Ward-Perkins, *Cities*, p. 24, figs. 40–41.

7. A. Boethius, J. B. Ward-Perkins, p. 353, pl. 186 (amphitheater). Architect: T. Crispius Reburrus. P. MacKendrick, *Roman France*, pp. 61–64, fig. 3.2.

8. P. Collart, *RendPontAcc* 35, 1962/63, pp. 147–159, on the Christian reuse of the sanctuary. P. Collart, J. Vicari, *Le sanctuaire de Baalshamîn à Palmyre*: I, II—*Topographie et architecture*, 1969.

9–10. Correction: The theater is "the only visible" but not "unique" in Roman Britain: for others, cf.: R. G. Collingwood

and I. Richmond, *The Archaeology of Roman Britain*, 1969, p. 115. S. S. Frere, *Antiquity* 38, 1964, pp. 103–112; *Verulamium Excavations I*, 1972, on the excavations 1954–1961, insula XIV (shops). J. M. C. Toynbee, *Art in Britain*, pp. 214–216, pls. 51–52. J. B. Ward-Perkins, *Cities*, pp. 29–30, 123, figs. 69–70.

11. A. Boethius, J. B. Ward-Perkins, pp. 140–143, figs. 78, 79. G. Iacopi, *Il santuario della Fortuna Primigenia e il Museo Archeologico Prenestino* (Guide), 1967. P. Romanelli, *Palestrina*, 1967, p. 39, fig. 51; on the sanctuary, pp. 33–55, figs. 43 f.

12. H. Kähler, *Tempel*, p. 36, pls. 26–27, fig. 18 (round temple).

13. H. Kähler, *Tempel*, pp. 16, 35, pls. 16–23, figs. 2 (axonometric reconstruction), 3 (plan).

14. A. Boethius, J. B. Ward-Perkins, p. 140, fig. 77. W. L. MacDonald 1, p. 7, pls. 4–5; pp. 3–19, Republican concrete and vaulting.

15. G. Rickman, *Roman Granaries and Store Buildings*, 1971, pp. 4, 106, 121, 149, 158.

16. J. B. Ward-Perkins, *Cities*, pp. 40–42, fig. 86. T. Hastrup, *Analecta Romana Instituti Danici* 2, 1962, pp. 45–61, on the Forum Iulium. P. Zanker, *Forum Augustum* (*Monumenta Artis Antiquae* 11), 1968. D. R. Dudley, pp. 118, 120–137. C. F. Leon, *Die Bauornamentik des Trajansforums*, 1971. M. E. Bertoldi, *Ricerche sulla decorazione architettonica del Foro Traiano* (*Studi Miscellanei* 3), 1962.

17. J. B. Ward-Perkins, *Cities*, p. 122, figs. 65, 66. M. Wheeler, *Roman Art in Africa*, 1966, pp. 120–125, pls. 40–42 (theater, arch). Th. Kraus, p. 165, fig. 30 (aerial view).

19. P. MacKendrick, *Rhine*, pp. 104–107, figs. 4.5–4.9.

20. J. E. Packer, *MAAR* 31, 1971, p. 134, fig. 51; pp. 138–139, figs. 35–45; plans 4–5, p. 95; *JRS* 57, 1967, pp. 80–95, estimating 100–300 persons per apartment block.

22. J. E. Packer, *MAAR* 31, 1971, pp. 127–134, fig. 22; general views and restoration, figs. 16–34; plans 2–3, p. 94; c. 150 A.D.

23. W. L. MacDonald, pp. 75–93, fig. 7, pls. 74–76, 78–95. G. Ch. Picard, *Living Architecture: Roman*, 1965, p. 46. A. Boethius, J. B. Ward-Perkins, p. 240, figs. 96 (axonometric), 97, pls. 127, 129.

24. Correction: E. Nash 2, figs. 734–735. A. Boethius, J. B. Ward-Perkins, p. 239, fig. 96, pl. 128.

25. G. Rickman, *Roman Granaries and Store Buildings*, 1971, pp. 30–38, p.1 11, fig. 3 (plan); c. 145–150 A.D. J. E. Packer, *MAAR* 31, 1971, pp. 148–152, figs. 73–89; plans 11–12, p. 98.

26. A. Boethius, J. B. Ward-Perkins, p. 206, pl. 118; for stucco decoration, see Addenda 107.

27. W. L. MacDonald 1, pp. 63, 76, 133, 180, 186, pls. 74, 126 (plans). *Carettoni, Pianta*, p. 89, pl. XXVIII. P. Zanker, *AA* 85:4, 1970, pp. 499–544, figs. 33–37, 43 (reconstruction), 44.

28–30. E. Nash 2, pp. 170–171, figs. 895–901. W. L. Mac-Donald, pp. 94–121, fig. 8, pls. 96–125. K. de Fine Licht, *The Rotunda in Rome: A Study of Hadrian's Pantheon*, 1966. D. R. Dudley, pp. 187–190. W. L. MacDonald, *The Pantheon— Design, Meaning, and Progeny*, 1975.

31. A. Bartoli, *Curia Senatus*, 1963.

32–33. R. Krautheimer, *DOPapers* 21, 1967, p. 124.

34. R. Krautheimer, *DOPapers* 21, 1967, pp. 117–140, figs. 1–2; an Important discussion of early Christian basilicas. A. Boethius, J. B. Ward-Perkins, pp. 444, 514–515, 517–519, fig. 195. E. M. Wightman, *Roman Trier and the Treveri*, 1970, pp. 103–109, pl. 8.

35. P. MacKendrick, *Roman France*, pp. 78–79, 258, fig. 3.8.

36–37. Correction: *Have Imperator:* Suetonius, *Claudius* 21. D. R. Dudley, pp. 142–145. G. Cozzo, *Il Colosseo*, reprint, 1971, construction, machines, services. P. Quennell, *The Colosseum*, 1971, color pls., literary passages. M. Di Macco, *Il Colosseo*, 1971, post-classical history.

38–40. D. R. Dudley, pp. 203–205. A. Boethius, J. B. Ward-Perkins, pp. 271–273, fig. 104, pls. 141–142.

41. A. Boethius, J. B. Ward-Perkins, pp. 529–533, fig. 202, pls. 273–274. A. Carandini, 'La villa di Piazza Armerina,' *Dialoghi di archeologia* I, 1, 1967, pp. 93–120. H. P. L'Orange, *Art Forms*, pp. 76–79, fig. 26; *Likeness*, pp. 158–195; p. 175, fig. 1 (plan). J. Polzer, *AJA* 77, 1973, pp. 139–150, fig. 1 (plan).

42. A. Boethius, J. B. Ward-Perkins, pp. 254, 328, figs. 120, 127, pls. 134 f., 174.

43. G. Calza, *Scavi di Ostia* I: *Topographia*, p. 238, chronology. N. Neuerburg, *L'architettura delle fontane e dei ninfei nell'Italia (Memorie dell'Accademia di Archeologia Lettere e Belle Arti di Napoli* V), 1965, pp. 78, 89, 99, 186–187, fig. 171.

44. J. E. Packer, *AJA* 71, 1967, pp. 123–131, pls. 33–38, detailed analysis and description; *MAAR* 31, 1971, p. 70.

45. Comprehensive excavation, restoration, and urban renewal since 1955 by Institute for Urbanism, Split, and University of Minnesota (1968–1972) with new data for construction (*opus mixtum incertum*) and interpretation of entire (southern) lower and some upper floor of the palace. J. and T. Marasoviç, *Diocletian Palace*, Zagreb, ed. Zora, 1968; 'Gli appartamenti dell' Imperatore Diocleziano nel suo palazzo a Split,' *Institutum Romanum Norvegiae, Acta* 4, 1969, pp. 33–40, pls. 1–15; eds. *Urbs* 4, Split, 1965, articles by ten experts with condensed English version. J. J. Wilkes, *Dalmatia*, 1969, pp. 387–390, pls. 46–47, 49. S. McNally, *AJA* 77, 1973, p. 221. M. R. Werner, *AJA* 78, 1974, p. 184 (construction).

47. W. Helbig, H. Speier III, no. 2304, pp. 220–221. U. W. Hiesinger, 'Portraiture in the Roman Republic,' in H. Temporini I, 4, p. 812, fig. 4. E. K. Gazda, 'Etruscan Influence in the Funerary Reliefs,' *ibid.*, p. 868, fig. 14 (detail of head).

48. T. Dohrn, *Der Arringatore (Monumenta Artis Romanae* 8),

1968, pls. 2–3. Th. Kraus, pp. 21 f., fig. 3. R. Brilliant, *Gesture*, pp. 30–31, fig. 1.43.

50. R. Brilliant, *Gesture*, pp. 65–66, figs. 2.38–2.39. H. Ingholt, *Archaeology* 22, 1969, pp. 176–187; *ibid.*, pp. 304–318, Pergamon as location of original. W. Helbig, H. Speier I, pp. 314–319, no. 411. R. Winkes, 'Physiognomonia: Probleme der Charakterinterpretation römischer Porträts,' in H. Temporini I, 4, 1973, p. 903, fig. 3. G. Traversari, p. 11, fig. 1.

52. On function of building and findspot of statue, W. O. Moeller, *AJA* 76, 1972, pp. 323–327.

54. G. Daltrop, U. Hausmann, M. Wegner, pp. 23, 29, 93, fig. 22c. W. Helbig, H. Speier I, p. 323, no. 411. H. G. Niemeyer, pp. 43, 84, no. 12, pl. 5, earliest Imperial toga statue with the head unveiled.

55. H. G. Niemeyer, pp. 62, 110, no. 107, pl. 40.

56. A. M. McCann, *MAAR* 30, 1968, pp. 133–134, pl. XXX, 11 a–c. H. G. Niemeyer, pp. 63, 112, no. 121, pl. 43. D. Soechting, *Die Porträts des Septimius Severus*, 1972. M. Gjodesen, *Meddelelser fra Ny Carlsberg Glyptotek*, p. 52, figs. 55–56, compares a Severus head from a remarkable group of Imperial bronze statues found in Asia Minor.

57. Roman equestrian statues, with picture showing complete pedestals, H. von Roques de Maumont, *Antike Reiterstatuen*, 1958, pp. 38–95, figs. 37, 41–45.

58. H. von Heintze, *RömMitt* 63, 1956, pp. 56 ff., argued for Traianus Decius. H. E. Niemeyer, pp. 63, 113, no. 128, pl. 48; statuary type Hellenistic.

59. G. Becatti, p. 389, fig. 385. W. Helbig, H. Speier IV, p. 117, no. 3141, literature.

60. K. T. Erim, *Archaeology* 20:1, 1967, pp. 18–27; *AJA* 71, 1967, p. 233. J. Inan, E. Rosenbaum, pp. 180–181, no. 243, pl. 176:3–4, pl. 178:2.

61. G. Kaschnitz von Weinberg, *Mittelmeerische Kunst, Eine Darstellung ihrer Strukturen*, 1965, pp. 390 f., pl. 105, 1. W. Helbig, H. Speier II, no. 1449, pp. 268–270. U. W. Hiesinger, 'Portraiture in the Roman Republic,' in H. Temporini I, 4, p. 807, 814, 817, fig. 1, dates third century B.C.

63. T. Dohrn, *Der Arringatore* (*Monumenta Artis Romanae* 8), 1968, pls. 8–9.

64. W. Helbig, H. Speier I, no. 429, p. 331, 'Flavian revision' (H. von Heintze). G. Hafner, 'Das Bildnis des Ennius,' *Studien zur römischen Porträtkunst des 2. Jahrhundert v. Chr.* (*Deutsche Beiträge zur Altertumswissenschaft* 20, Baden Baden), 1968, pp. 22–28, would refer the A. Postumius Albinus coin and this portrait to the consul of 151 B.C. Cf. U. Hiesinger, in H. Temporini I, 4, pp. 817 f., fig. 3.

65. F. Johansen, *Meddelelser fra Ny Carlsberg Glyptotek* 30, 1973, pp. 110, 115 (*Résumé*), fig. 19, suspects this head is not ancient.

66. V. Poulsen, *Les portraits romains* I, 1962, p. 48.

67. R. Herbig, *Gymnasium* 72, 1965, p. 171, pl. 23. F. S. Johansen, *Analecta Romana Instituti Danici* 4, 1967, pp. 28–29, pl. 6. U. Jantzen, *RömMitt* 75 1968, pp. 170–173, pl. 63. D. Kiang, *Gazette numismatique suisse* 19, 1969, p. 33, dates 35–30 B.C.

69. C. C. Vermeule, 'Greek and Roman Portraits in North American Collections,' *ProcPhilSoc*, 108:2, 1964, p. 103. D. G. Mitten, S. Doeringer, *Master Bronzes from the Classical World*, 1968, p. 234, no. 228.

70. L. Fabbrini, *EAA* IV, pp. 663 f., Livia Drusilla. H. Bartels, *Studien zum Frauenporträt der augusteischen Zeit: Fulvia, Octavia, Livia, Julia*, 1963, p. 71.

71. Correction: Drusus died in 9 B.C. L. Fabbrini, *EAA* IV, fig. 789.

72. W. Helbig, H. Speier I, pp. 314–319, no. 411. R. Winkes, 'Physiognomonia,' in H. Temporini I, 4, p. 903, fig. 3.

74. G. Daltrop, U. Hausmann, M. Wegner, p. 10, pl. 4. R. Calza, *Scavi di Ostia: I Ritratti* 5:1, 1964, pp. 45–46, no. 62, pl. 36. W. Helbig, H. Speier III, no. 2310, p. 227.

75. M. Grant, p. 202, detail.

76. G. Daltrop, U. Hausmann, M. Wegner, pp. 35, 42, 106, figs. 27, 29. W. Helbig, H. Speier II, p. 528, no. 1752. G. Traversari, p. 41, fig. 28. Cf. K. T. Erim, *OpusArch* 33:16, 1973.

77. R. Calza, *Scavi di Ostia: I Ritratti* 5:1, 1964, no. 89, pp. 59–60, pls. 52–53. W. Helbig, H. Speier IV, pp. 74–76, no. 3085, portraits of Marciana, Plotina attributed to same master.

78. G. Traversari, pp. 38–39, fig. 26. W. Helbig, H. Speier II, no. 1288, p. 136.

79. Correction: MFA acquisition 16.286. C. C. Vermeule, *Greek and Roman Portraits* 470 B.C.–500 A.D., Museum of Fine Arts, Boston, 1972, no. 55. Inscription and bronze hand of Marciana: H. Metzger, *TürkArkDerg* 20, 1973, p. 118, figs. 3–4.

80. R. Calza, *Scavi di Ostia: I Ritratti* 5:1, 1964, no. 117, pp. 73–74, pl. 68. W. Helbig, H. Speier IV, pp. 70–71, no. 3079.

81. C. W. Clairmont, *Die Bildnisse des Antinous: Ein Beitrag zur Porträtplastik unter Kaiser Hadrian*, 1966, p. 54, pls. 31, 48.

82. A. M. McCann, *MAAR* 30, 1968, pp. 133–134, pl. XXX, 11 a-c. H. G. Niemeyer, pp. 63, 112, no. 121, pl. 43. D. Soechting, *Die Porträts des Septimius Severus*, 1972. M. Gjodesen, *Meddelelser fra Ny Carlsberg Glyptotek*, p. 52, figs. 55–56, compares a Severus head from a remarkable group of Imperial bronze statues found in Asia Minor.

83. G. Traversari, p. 83, fig. 60.

84. C. C. Vermeule, 'Greek and Roman Portraits in North American Collections,' *ProcPhilSoc* 108:2, 1964, p. 103. *Art of the Late Antique* (Poses Institute of Fine Arts, Brandeis University), 1968, no. 1, pl. 1.

85. W. Helbig, H. Speier, II p. 529, no. 1753, literature.

87. C. C. Vermeule, *Greek and Roman Portraits* 470 B.C.–500 A.D., Museum of Fine Arts, Boston, 1972, no. 74.

88. W. Helbig, H. Speier III, p. 230, no. 2315, literature. Bianchi-Bandinelli, *Late Empire*, fig. 24.

89. J. Inan, E. Rosenbaum, pp. 110–111, no. 114, pl. LXVII, 3–4. D. M. Brinkerhoff, 1970, p. 14, fig. 21.

90. J. Inan, E. Rosenbaum, pp. 166–167, no. 220, pl. CLXXX, 3–4. G. M. A. Hanfmann, *ProcPhilSoc* 117, 1973, p. 268, fig. 33; *Latomus* 103, 1969, pp. 288–290, pl. 113, figs. 1–2.

91. Now Sala dei Magistrati. Colossal, for insertion in a statue. W. Helbig, H. Speier II, p. 314, no. 1496.

92. E. Simon, in W. Helbig, H. Speier IV, no. 3003, pp. 12–14, dates before 250 A.D.

93. C. C. Vermeule, *Greek, Etruscan and Roman Art*, 1963, p. 222, fig. 230, from the region of Ostia. H. von Heintze, *Römische Kunst* Band III, 1969, pp. 183 f., fig. 181. W. von Sydow, *Zur Kunstgeschichte des spätantiken Porträts im 4. Jahrhundert n. Chr.*, 1969, pp. 44, 66. C. C. Vermeule, *Greek and Roman Portraits* 470 B.C.–500 A.D., Museum of Fine Arts, Boston, 1972, no. 77.

94. E. B. Harrison, *DOPapers* 21, 1967, pp. 81, 92, figs. 1–2. R. Calza, *Iconografia*, no. 141, pp. 227–228, pl. 78; 275–276, as 'provincial.'

95. W. Helbig, H. Speier II, no. 1578, p. 381. W. von Sydow, pp. 33 f. R. Calza, *Iconografia*, no. 143, pp. 231–233, pl. 80; 280–281, 283, 287. M. R. Alföldi, *Die constantinische Goldprägung*, 1963, pp. 129 f., fig. 304, as Constantine.

96. W. Helbig, H. Speier II, no. 1441, pp. 252 f. W. von Sydow, pp. 25 f. E. B. Harrison, *DOPapers* 21, 1967, p. 81, figs. 3–4. R. Calza, *Iconografia*, no. 142, pp. 228–231, pl. 79; 277–279. T. Buddensieg, *MJB* 13, 1962, p. 137, drawing of statue in apse.

98. E. B. Harrison, *DOPapers* 21, 1967, pp. 87–88, fig. 31, dates early 'Antonine.' Similarly, W. von Sydow, p. 152. R. Calza, *Iconografia*, pp. 268–269, figs. 331–332, 300–330 A.D. C. C. Vermeule, *Imperial Art*, pp. 58, 356, 364–365, from Athens.

99. Corrections: I. S. Ryberg, pp. 27–34, pl. 8, thorough discussion. E. Nash 2, p. 120. H. Kähler, *Seethiasos und Censur: Die Reliefs aus dem Palazzo Santa Croce in Rom (Monumenta Artis Romanae* 6), 1966, victory against pirates, 70 B.C. G. Hafner, *Aachener Kunstblätter* 43, 1972, pp. 97–124, figs. 1–37, from funerary monument of the Lutatii, Q. Catulus and Cerco, for triumph over Carthage, 241 B.C.

100. P. Romanelli, *Palestrina*, 1967, p. 31, fig. 40.

101. W. Helbig, H. Speier II, no. 2062, pp. 834–843. G. Hafner, *Aachener Kunstblätter* 43, 1972, pp. 124–142, figs. 1–3, argues for Pergamene influence.

102–105. Correction: The foundation ceremonies took place on July 4, 13 B.C., the dedication on January 30, 9 B.C. G. K. Galinsky, *AJA* 70, 1966, pp. 223–243. E. Simon, *Ara Pacis Augustae* (*Monumenta Artis Antiquae* 1). 1967. W. Helbig H. Speier II, pp. 673–695, no. 1937. On the Aeneas legend, G. K. Galinsky, *Aeneas, Sicily and Rome*, 1969. On the costumes, L. Bonfante Warren, 'Roman Costumes,' in H. Temporini I, 4, 1973, pp. 587, 615, fig. 1.

106. Correction: The relief was already known in the fifteenth century. J. M. C. Toynbee, *Animals in Roman Life and Art*, pp. 132, 134, fig. 57. G. Traversari, p. 24, fig. 14b. D. E. Strong, *Sculpture*, pp. 28, 93, fig. 52.

107. E. Nash I, p. 169, figs. 184, 186. C. Goudineau, *MélRome* 79, 1967, pp. 124–134. F. L. Bastet, *BABesch* 45, 1970, pp. 148–174.

108–109. F. J. Hassel, *Der Trajansbogen in Benevent*, 1966, p. 32, pl. 37:1.

110–113. R. Brilliant, *Gesture*, pp. 101–102, figs. 2.117–2.119. W. Helbig, H. Speier I, no. 12, pp. 8–12. A. M. McCann, *RömMitt* 79, 1972, pp. 249–296, pls. 111–122, redates to early Hadrianic period. F. Magi, *RömMitt* 80:2, 1973, p. 289 f.

114–116. G. D'Onofrio, 1965, pp. 178–183. L. Rossi, *AntJ* 48, 1968, pp. 41–46, on scene 97; *Trajan's Column and the Dacian Wars* (Ithaca, Cornell University Press, 1971).

117. 1966: At Banca Nazionale, Rome. C. W. Clairmont, *Die Bildnisse des Antinous*, 1966, pp. 20, 39 f., no. 5, pls. 7–8; possible connection with *templum Antinoi* in Lanuvium, 133 A.D.

118. I. S. Ryberg, *Panel Reliefs of Marcus Aurelius*, 1967, pp. 5–7, 21–27, pls. 15–17, figs. 14 a-c: from an arch of 176 A.D. *in Capitolio*.

120. W. Helbig, H. Speier I, no. 291, pp. 229–230.

121. W. Helbig, H. Speier III, pp. 14–20, no. 2126.

122–125. Correction: E. Nash I, p. 276, figs. 327–330. C. D'Onofrio, *Gli obelischi di Roma*, 1965, pp. 183–187. R. Brilliant, *MAAR* 29, 1967, pp. 230–236, 239 f., 247–250, figs. 65–66, 79–90, 93–97, 100–107.

126. L. Franchi, *Studi Miscellanei* 4, 1964, pp. 20–32, pls. 5–15. A. M. McCann, *MAAR* 30, 1968, pp. 66, 78.

127. R. Brilliant, *MAAR* 29 1967, pp. 123 f., 164 f. A. M. McCann, *MAAR* 30, 1968, pp. 74–78, pl. 19:1. M. Vilimkova, p. 39, pl. 86. R. Bianchi-Bandinelli, *Leptis Magna*, 1963, pp. 67–70 (arch), pls. 27, 34–35.

128–129. G. Traversari, p. 96, fig. 76. R. Turcan, *Les sarcophages romains à répresentations dionysiaques*, pp. 278, 298, 623–632, on seasons. For Dionysus on tiger, F. Matz, *Die dionysischen Sarkophage* 1, 1968, p. 157, 3, p. 307.

130. H. Wiegartz, pp. 65, 156–157, pl. 34a, Istanbul B.

131. H. Wiegartz, pp. 164–165, pls. 5a:2, 6a (architectural details). G. Ferrari, *Il commercio dei sarcofagi asiatici* (*Studia Archeologica* 7), 1966, p. 34.

132. F. W. Deichmann, *Repertorium* I, pp. 230–231, no. 558, pl. 86, recent literature; the authors note that no Christian symbol is preserved.

133. P. MacKendrick, p. 239, fig. 8.20. E. M. Wightman, *Roman Trier and the Treveri*, 1970, p. 150, pl. 14a.

134–135. W. Helbig, H. Speier III, no. 2354, pp. 276–283. G. Traversari, pp. 105–106, figs. 84–88. B. Andreae, *RendPontAcc* 41, 1968/69, pp. 145–166.

136–137. V. M. Strocka, *JdI* 83, 1968, p. 235, fig. 7. B. Andreae, *Opus Nobile, Festschrift U. Jantzen*, 1969, pp. 1–13, pl. 1. W. Helbig, H. Speier III, pp. 231–235, no. 2316; a consular procession.

138. E. M. Wightman, *Roman Trier and the Treveri*, 1970, p. 191, pl. 17c. P. MacKendrick, *Rhine*, p. 234, fig. 8.17.

139. J. A. Gaertner, 'Zur Deutung des Junius-Bassus Sarkophages,' *JdI* 83, 1968, pp. 240–264, fig. 1. *EAA* V, p. 592, color. F. W. Deichmann, *Repertorium* I, pp. 279–283, no. 680, pls. 104 f.

140–141. R. Bianchi-Bandinelli, *Late Empire*, pp. 70–83, figs. 66–71, 74. J. Ruysschaert, 'Essai d'interpretation synthétique de l'Arc de Constantin,' *RendPontAcc* 35, 1963, pp. 79–100.

142. Now in Vatican, Museo Pio Christiano. Correction: Left of center is Ezekiel's (Ch. 37) not "Esdras'" vision of dry bones reviving (E. Kitzinger). F. W. Deichmann, *Repertorium* I, pp. 20–21, no. 23, pl. 7:23a.

143. A. Grabar, *Sculptures byzantines de Constantinople (IVe–X siècle)*, 1963, pp. 30–32, 127, pl. 7.

144. C. Carducci, *Gold and Silver Treasures of Ancient Italy*, 1964, p. 64, pl. 65. D. E. Strong, *Plate*, p. 198. M. J. Vermaseren, *The Legend of Attis in Greek and Roman Art*, 1966, pp. 27–30, pl. 17.

145. D. E. Strong, *Plate*, p. 200, pl. 64 (detail). H. P. L'Orange, *Likeness*, p. 206, fig. 1. A. Grabar, *The Golden Age of Justinian*, 1967, p. 303, figs. 348–351, color.

Plates Identified by Roman Numerals

I. B. Kapossy, *Gymnasium* 74, 1967, pp. 34–45.

II. E. Akurgal, *Civilisations*, pp. 122–123, fig. 42, pl. 46b.

III. S. M. Scrinari, *RendPontAcc* 41, 1968/69, pp. 167–189, on the original location of the statue. R. Brilliant, *Gesture*, p. 96, fig. 2.105. R. Bianchi-Bandinelli, *Center*, p. 308, fig. 349, head in color.

IV. A. Ragona, *I Tetrarchi dei gruppi porfirei di S. Marco in Venezia*, 1963. The discovery of a foot from the group in Constantinople has proved that the group was brought in antiquity to Constantine's new capital and transported to Venice from there. R. Naumann, *AnnInst* 13/14, 1966, p. 138, and *IstMitt* 16, 1966, p. 199. Attempts to change the identification of the four rulers are surveyed by R. Calza, *Iconografia*, pp. 98–103, pls. 11, 22, 32, 37. D. M. Brinkerhoff, p. 21, pls. 26–27.

V. R. Bianchi-Bandinelli, *Center*, p. 117, fig. 120, detail.

VI. A. M. G. Little, *AJA* 68, 1964, pp. 62–66. C. L. Ragghianti, p. 89, fig. 5. A. M. G. Little, *Roman Perspective Painting and the Ancient Stage*, 1971, pp. 27, 37, pl. 1:2, pl. 7:1. R. Winkes, 'Zum Illusionismus römischer Wandmalerei der Republik,' in H. Temporini I, 4, 1973, p. 935, fig. 6. For a villa discovered in 1967 with magnificent wall paintings close in style to those of Boscoreale, see A. de Franciscis, 'La villa Romana di Oplontis,' *La Parola del Passato* 153, 1973, pp. 453–466, figs. 1–8, and *Connaissance des arts* 264, February 1974, pp. 48–56, with color illustrations. The hitherto unexcavated town of Oplontis (Torre Annunziata) was buried by the same eruption of Vesuvius as its neighbor Pompeii. References courtesy A. M. G. Little.

VII. Excavations (1956–) by G. Carettoni have identified the temple of Apollo and next to it a complex which may be the real House of Augustus, distinct from the 'House of Livia.' Repainted decoration is in earlier Second Style. G. Carettoni, *RendPontAcc* 39, 1966/67, pp. 55–75, figs. 3, 5; *NSc* 21, pp. 287–319; *ILN* 255, 1969, no. 3790, pp. 24–25, no. 6792, pp. 24–25; *BdA* 40, 1961, pp. 189–199. H. G. Beyen, *BABesch* 39, 1964, pp. 140–143. H. Bauer, *RömMitt* 76, 1969, pp. 183–204. R. Bianchi-Bandinelli, *Center*, p. 128, fig. 135, detail, color.

VIII. W. L. MacDonald, Ch. II, 'Nero's Palaces,' pp. 20–46, 125–127, architect Severus, pls. 21–34 (with plan). Th. Kraus, pp. 58–60, 188, fig. 28, pl. 94–95. New excavations since 1954, cf. G. Zander, 'La Domus Aurea: Nuovi problemi architettonici,' *Boll. del Centro di Studi per la storia dell' architettura* 12 (1958), pp. 47–64, plans, of 1958, Neronian, Flavian, Trajanic phases. F. Sanguinetti, 'Il mosaico del ninfeo,' *ibid.*, pp. 34–45, figs. 1–4. G. Zander, *Palladio* 15, 1965, pp. 157–159. *EAA* VI, 1965, p. 846 f. and color plate opposite p. 854. N. Dacos, *Dialoghi d'archeologia* 2, 1968, pp. 210–226; *La decouverte de la Domus Aurea et la formation des grotesques a la Renaissance*, 1969, pp. 5–9, 13–54, figs. 2–38; fig. 1, plan. R. Bianchi-Bandinelli, *Center*, pp. 130–137, figs. 139–145, 368, excellent color of wall paintings including entire wall of Plate VIII. C. L. Ragghianti, pp. 94, 114, 156, on possible relations with Pompeian Masters.

X. W. L. MacDonald, pp. 116–117, figs. 108–109. K. Fine de Licht, *The Rotunda in Rome*, 1966, pp. 94–146, esp. figs. 115–116.

XI. R. Bianchi-Bandinelli, *Center*, fig. 251, detail color.

XII. As excavated from Insula III, xi–2, J. E. Packer, pp. 177 f., pls. 60–67. W. Helbig, H. Speier IV, no. 3190, p. 150 (B. Andreae).

XIII. R. Bianchi-Bandinelli, *Center*, p. 299, fig. 336, color detail.

XIV. J. M. C. Toynbee, *Death and Burial*, p. 140, pl. 47. O. Perler, *Die Mosaiken der Juliergruft im Vatikan (Freiburger Universitätsreden* 16), 1953, p. 13, 43, pl. 2. E. H. Kantorowicz, *DOPapers* 17, 1963, p. 144, fig. 30. Th. Kraus, p. 271, pl. 353. H. P. L'Orange, P. Nordhagen, pp. 48–49, pl. 39. Important parallel in mosaic of the synagogue of Hammath-Tiberias: M. Dothan, 'The Representation of Helios in the Mosaic of Hammath-Tiberias,' *Tardo antico e alto medioevo, Atti del convegno internazionale*, 1968, 105, p. 103. A. Biran, *CNI* 14:1, 1963, pp. 16–17.

XV. D. M. Brinkerhoff, p. 55, fig. 66. R. Calza, E. Nash, p. 34, figs. 42–44, 53, 81. Cubiculum B in G. Becatti, *Scavi di Ostia IV, Mosaici e pavimenti marmorei*, 1961, pp. 27–28, no. 47, pl. 120; fundamental for history of *opus sectile, Scavi di Ostia VI*, 1969, pp. 123–138, many color plates. J. E. Packer, *AJA* 71, 1967, p. 126, pl. 35:16; center base originally for table, group stood in *viridarium*.

XVI. A. M. G. Little, *A Roman Bridal Drama at the Villa of the Mysteries*, 1972. O. J. Brendel, *JdI* 81, 1966, pp. 206–260. P. Boyancé, *RendPontAcc* 38, 1965/66, pp. 79–104. *EAA*, 1970 Suppl., pp. 916–922. C. L. Ragghianti, pp. 35, 95, color plates, preservation.

XVII. M. L. Vollenweider, *Künstler*, p. 123, pl. 94. G. M. A. Richter, *Gems*, p. 104, fig. 501. H. Kähler, *Alberti Rubens dissertatio de Gemma Augustea (Monumenta Artis Romana* 9), 1968, pp. 22 f., pls. 3–23 (details). A. Alföldi, *Die monarchische Repräsentation im römischen Kaiserreiche*, 1970, p. 243, pl. 18.

XVIII. C. L. Ragghianti, pp. 40, 92, color, attributed to a 'Palatine Master.' On other wall paintings in Cubiculum 4, J. Engemann, *Architekturdarstellungen des frühen Zweiten Stils (RömMitt* Suppl. 12), 1967, pp. 99–100, pls. 14–15.

XX. J. J. Deiss, p. 107. M. Grant, p. 185, color plate. Th. Kraus, p. 268, fig. 341.

XXII. W. Dorigo, p. 59, col. pl. 4. B. Andreae, *Studien zur römischen Grabkunst*, 1963, p. 140, pl. 74. R. Bianchi-Bandinelli, *Center*, fig. 316, color, head of Venus.

XXIII. W. Dorigo, p. 207, fig. 163. Th. Kraus, p. 213, p. XI.

XXIV–XXV. H. P. L'Orange, *Likeness*, pp. 158–195; p. 187, fig. 3. A. Carandini, *Ricerche sullo stile e la cronologia dei mosaici della villa di Piazza Armerina, Studi Miscellanei* 7, 1964; *Dialoghi d'archeologia* 1, 1967, pp. 93–120. M. Cagiano de Azevedo, *RendPontAcc* 40, 1967/68, pp. 123–150, dates villa 360–390 A.D. H. Kähler, *Acta ad archaeologiam et artium historiam pertinentia* 4 *(Institutum Romanum Norvegiae)*, 1969, pp. 41–49, plates. I. Lavin, *DOPapers* 17, 1963, pp. 244–250, fig. 110, possibly by North African mosaicists.

XXVI. P. Romanelli, *Palestrina*, 1967, pp. 63–69, color pls. 24–32, figs. 86–93. W. Dorigo, pp. 59–62, fig. 34, early second century A.D.

XXVII–XXVIII. P. H. von Blanckenhagen, *RömMitt* 70, 1963, pp. 100–146. W. J. T. Peters, pp. 27–32, figs. 16–21. A. Gallina, *Le pitture con paesaggi dell' Odissea dall' Esquilino, Studi Miscellanei* 6, 1964, pp. 1–45, pls. 1 (plan), 9 (new fragments).

XXIX. P. H. von Blanckenhagen, *RömMitt* 75, 1968, p. 121, pls. 42:2, 43. W. J. T. Peters, pp. 91 f., fig. 78.

XXXII. M. Grant, p. 148, color. W. J. T. Peters, p. 148, fig. 140. C. L. Ragghianti, p. 76, attributes to 'Master of Amandus.'

The majority of the preserved pictures of Pompeii, Herculanum, and Stabiae date in the short span between 63 and 79 A.D. and must represent most of the local ateliers. Attempts to distinguish individual painters have been made by M. Gabriel, C. L. Ragghianti, and L. Richardson. See the critical survey by L. Richardson, *MAAR* 23, 1955, pp. 110–116, 145, p. 152, nn. 111, 152. Richardson himself tries to distinguish seven painters in the House of the Dioscuri; cf. pl. XIX for his 'Io Painter.'

XXXIII. W. Dorigo, pp. 38–39, 47, color pl. 2. C. L. Ragghianti, pp. 82, 151, color, 'Visionary Master.'

XXXIV. C. L. Ragghianti, pp. 75, 106, 'Master of Amandus.' P. H. von Blanckenhagen, *RömMitt* 75, 1968, pp. 110, 121–127, pls. 33–35, early Third Style; reinterpretation of the myth produces a work which 'ranks with the Hellenistic original.' W. J. T. Peters, pp. 93–94.

XXXV. W. Dorigo, p. 39, fig. 14. M. Grant, p. 145, color. C. L. Ragghianti, p. 85, pl. 83, 'Visionary Master.'

XXXVI. W. Dorigo, pp. 58–59, fig. 35, modification of Hellenistic idea of space. R. Bianchi-Bandinelli, *Center*, p. 267, figs. 304, 306 (detail).

XXXVII. Correction: Tripoli Museum.
R. Bianchi-Bandinelli, E. V. Caffarelli, G. Caputo, *Leptis Magna*, 1963, p. 117, fig. 211, dates late second or early third century A.D.; *Empire*, pp. 262, 434, fig. 240 (detail). M. F. Squarciapino, *Leptis Magna*, 1966, p. 128, pl. 99. M. Wheeler, *Roman Africa in Color*, 1966, pp. 78–79, pl. 19.

XXXVIII. I. Lavin, *DOPapers* 17, 1963, p. 233, fig. 80.

XXXIX–XL. A. M. G. Little, *A Roman Bridal Drama at the Villa of the Mysteries*, 1972. O. J. Brendel, *JdI* 81, 1966, pp. 206–260. P. Boyancé, *RendPontAcc* 38, 1965/66, pp. 79–104. *EAA*, 1970 Suppl., pp. 916–922. C. L. Ragghianti, pp. 35, 95, color plates, preservation.

XLI. M. Grant, *Cities of Vesuvius: Pompeii and Herculaneum*, 1971, p. 164. C. L. Ragghianti, pp. 52–53, 140–141, pl. G:172, alleged works by 'Master of the Poetess.'

XLIII. C. L. Ragghianti, *Pittori di Pompei*, 1963, pp. 47, 103, color.

XLV. K. Parlasca, pp. 100–101, 268, pl. 16:1.

XLVII. A. F. Shore, pp. 13 f. on the Antonine male portraits.

XLVIII. A. M. McCann, *MAAR* 30, 1968, pp. 79–80, pl. 21, dates 199–200.

L. H. P. L'Orange, *Likeness*, p. 159, fig. 1. R. Calza, *Iconografia*, no. 37, p. 127, pl. 28:74, 76. A. Carandini, *Ricerche sullo stile e la cronologia di Piazza Armerina*, 1964, pl. 3:15–16. W. Dorigo, p. 138, fig. 101.

LI. W. Dorigo, p. 272, color pl. 39, postulates single master's unifying talent. Survey of recent dating attempts with pottery evidence favoring Justinian I in J. Balty, *La grande mosaïque de chasse du Triclinos, Fouilles d'Apamée de Syrie*, 1969, pp. 32 f.

LII. H. von Heintze, 'Das Goldglassmedallion in Brescia,' *Festschrift E. von Mercklin*, 1964, pp. 41 ff., dates 220–225 A.D. B. Andreae in Th. Kraus, p. 214, pl. XIII, color.